FILM WORLDS

DANIEL YACAVONE

FILM WORLDS

A PHILOSOPHICAL
AESTHETICS OF CINEMA

COLUMBIA UNIVERSITY PRESS NEW YORK

COLUMBIA UNIVERSITY PRESS

Publishers Since 1893

NEW YORK CHICHESTER, WEST SUSSEX

cup.columbia.edu

Copyright © 2015 Columbia University Press

Library of Congress Cataloging-in-Publication Data

Yacavone, Daniel.

Film worlds : a philosophical aesthetics of cinema / Daniel Yacavone.

pages cm

Includes bibliographical references and index.

ISBN 978-0-231-15768-1 (cloth : alk. paper) — ISBN 978-0-231-15769-8

(pbk. : alk. paper) — ISBN 978-0-231-53835-0 (ebook)

1. Motion pictures—Aesthetics. 2. Motion pictures—Philosophy. I. Title.

PN1995.Y275 2014

791.4301—dc23

2014016641

Columbia University Press books are printed on permanent and durable acid-free paper.

This book is printed on paper with recycled content.

Printed in the United States of America

c 10 9 8 7 6 5 4 3 2 1
p 10 9 8 7 6 5 4 3 2

COVER IMAGE: ROBERT SCHLATTER © GALLERY STOCK

COVER DESIGN: CHANG JAE LEE

References to websites (URLs) were accurate at the time of writing. Neither the author nor Columbia University Press is responsible for URLs that may have expired or changed since the manuscript was prepared.

Thanks to art, instead of seeing one world only, our own, we see that world multiply itself and we have at our disposal as many worlds as there are original artists, worlds more different one from the other than those which revolve in infinite space.

—Marcel Proust

You see, once you start down a road to make a film you enter a certain world. And certain things can happen in that world, and certain things can't. . . . So you begin to know these rules for your world, and you've got to be true to those rules.

—David Lynch

CONTENTS

ILLUSTRATIONS

ACKNOWLEDGMENTS

THE IDEAS AND ARGUMENTS IN THIS BOOK WOULD NOT HAVE COME together in the form of a monograph were it not for the support and encouragement of a number of institutions and individuals. My thanks to the British Academy for the award of a Postdoctoral Research Fellowship that enabled me to pursue the project in film theory and philosophy that evolved into the present book, and to the University of Edinburgh for hosting the Fellowship. I would like to thank past and present colleagues within the Film Studies Program at Edinburgh for their support of my interdisciplinary research, as well as for their helpful suggestions with respect to this book, especially Martine Beugnet, the late John Orr, Kriss Ravetto-Biagioli, and David Sorfa. For assistance and encouragement along the way (or earlier) many thanks to Ian Christie, Bill Germano, Andrew Klevan, Jane Sillars, Susan Kemp, Laura Marcus, David Martin-Jones, Annette Davison, Julian Kilverstein, Ben Winters, David N. Rodowick, Raymond Bellour, Christa Blümlinger, Dudley Andrew, Andrew Ward (and other past and present members of the Philosophy Department at the University of York), Tony McKibbin, Mark Cousins, Chris Fujiwara, Jason Gaiger, and Robert Sinnerbrink. Thanks also to my manuscript editor, Joe Abbott, my production editor Roy Thomas, and,

especially, Wendy Lochner, my editor at Columbia University Press, for her great patience and expert advice. I owe a special debt of gratitude to the wonderful teachers at Connecticut College who first opened my intellectual horizons to many of the worlds of films and philosophy explored in these pages; my thanks, especially, to the Philosophy Department and to its members Kristin Pfefferkorn-Forbath, J. Melvin Woody, Marijan Despalatovic, and the late Lester J. Reiss. Finally, I wish to reserve special acknowledgment for my parents and for Kathrin. Their support has made this and so much else possible, and this book is dedicated to them.

To make a film is also to construct a world. As viewers, we are invited to enter into this world, to share it with its maker(s) and with other viewers. When made, experienced, and understood as art, the virtual worlds of films, including all narrative ones, not only provide a form of experience that approaches in many ways our actual, embodied life experience but also mediates it in aesthetic ways, sometimes to powerful cognitive and affective ends.

Taking the multifaceted concept of the *world* of an artwork as its starting point and principal focus throughout, this book explores the nature of cinematic art from both filmmaking and film-viewing perspectives. To the degree possible, given the complex and historically variable character of the cinema throughout its history, it attempts to provide an overarching theoretical framework that captures and expands on the insights of a number of notable film theorists, critics, and filmmakers regarding the world-like structures and experiences of narrative films, including Gilles Deleuze's contention that cinema "does not just present images, it surrounds them with a world."[1] Yet it will also consider the relevance to cinema of long-established views concerning the created worlds of art and literary works, such as, for instance, that espoused by the Shakespearean

scholar A. C. Bradley, who in an oft-cited 1901 lecture proposed that "[an artwork's] nature is to be not a part, nor yet a copy, of the real world (as we commonly understand that phrase) but to be a world by itself, independent, complete, autonomous; and to possess it fully you must enter that world, conform to its laws, and ignore for the time the beliefs, aims, and particular conditions which belong to you in the other world of reality."[2]

I approach the subject of cinematic art by way of philosophical theories of the symbolic, phenomenological, and hermeneutic aspects of art in general, which all converge on important topics in classical and contemporary film theory. With reference to its goal to provide an alternative, general framework for reflecting on the artistic dimensions, and to some degree accomplishments, of films, much of this study may be described aptly as "metatheoretical." It is as much if not more concerned with analyzing and evaluating relevant theories of cinema, or certain of their major aspects (and of philosophical approaches to art as related to these), than with analyzing and understanding specific works or the aims and achievements of particular filmmakers. I do hope, however, that some of the ideas, concepts, and terms introduced (or reintroduced, as the case may be) will be seen as worth taking up and applying in more detailed analyses of individual films, styles, and genres.

By way of introduction to the leading term and concept of this study, what I conceive of as a "film world," in the artistic and aesthetic senses to be explained and discussed, is a singular, holistic, relational, and fundamentally referential reality. Not strictly identical with the film *work* that occasions and presents it, a film world possesses pronounced sensory, symbolic, and affective dimensions. It provides "virtual" and actual experiences that are at once cognitive *and* immersive *and* "sensuous." Both the creation and experiencing of film worlds are marked by complex and world-constitutive dynamics of transformation and immersion; these processes are not only relationally codependent but, via the anticipations of filmmakers and tacit understandings and expectations of audience members, mutually reinforcing. The transformation in question relies heavily on the given properties of the preexisting realities out of which a film is more or less creatively and skillfully made, while the viewer's immersion includes *but is not confined to* engaging with fictional characters and situations in a partly literally depicted, but still largely imagination-constructed, story-world. Taken to mean the full being or presence of a cinematic work of art as it is intentionally constructed, experienced,

and interpreted, a film world also constitutes a historical, transsubjective event of artistic and cinematic truth, as it concerns both cinematic and noncinematic life experience.

Apart from this specific film-as-world model, some readers may consider that a general inquiry into the aesthetic character of cinema exclusively is outmoded, for any variety of reasons. To speak of a given film as *art*, however, is not to deny its status as a historical document, a more or less accurate mirror or apt commentary on the society and culture in which it is made and seen, and as an intended or unintended vehicle for the communication of all manner of normative and ideological messages.[3] Addressing the matter with pithy eloquence and a dose of irony, noted critic Andrew Sarris has written that the "nature of the film medium" means "you always get more for your money than mere art."[4] Although other uses, forms, and values of cinema converge with specifically artistic or aesthetic ones, to understand the complex interactions among them as realized in any given work requires some understanding of any film's most typical artistic features and functions.

In the venerable tradition of aesthetic inquiry, coupled, however, with due regard for contemporary, skeptical arguments concerning the supposed autonomy of aesthetics (on "ontological" or similar grounds),[5] I assume that cinematic art may be theoretically and philosophically explored not in total isolation from surrounding historical, institutional, psychological, ethical, and other, nonartistic realities but instead by achieving a certain separation and distance from any or all of these, which, to borrow from the language of phenomenology, amounts to the attempt to "bracket them off," even if only temporarily or provisionally. Indeed, if we can no longer accept that studies pertaining to the nature and value of art stand in splendid isolation from all other departments of knowledge, possessed of their own metaphysical charter, so to speak, there is perhaps an equal and more immediate, intellectual danger in various, current forms of reductionism across the humanities. I refer here to a failure to cede to artistic creation and aesthetic experience both independent cognitive status and value, and a fully unencumbered "cultural space," in the fundamental sense that Joseph Margolis, for instance, has recently attempted to give to this phrase.[6]

Of course, there is always in practice some overlap between what Richard Dyer terms a "formal-aesthetic" approach to cinema, focused on the question of a film's "intrinsic worth" as art, and a "socio-ideological" one,

centered on any "film's position as symptom or influence in social processes."[7] Since at least the early 1970s, however, and as tied to complex cultural, historical, and disciplinary developments (too many to be rehearsed here), the latter approach has predominated in film studies, not least (but also not only) as a result of its substantial convergence with cultural studies as an emerging academic discipline and many of its typical concerns.[8]

Concerning a notable deemphasis of the cinematic work qua artwork David Bordwell has suggested that as a result of the widespread academic focus on film as a means of conveying sociopolitical and cultural messages and values, the "artistic aspects of cinema" have "often been ignored" (together with the "particularity of how cinema works as a unique art").[9] While this is certainly true, the *full* artistic dimension of films (including what may be specific to cinema), as distinct, for instance, from the narrative, emotional, technical, or even specifically perceptual dimension, is likewise often neglected in other, differently oriented approaches to theorizing film. These include the more empirical, conceptual, and problem-solving (as well as so-called piecemeal) approaches of several prominent authors (sometimes including Bordwell),[10] whose writings, I hasten to add, the present study draws on where relevant.

For instance, postclassical accounts of film narrative in its cognitive aspects have substantially enriched our understanding of how film stories are put together and understood in a dynamic, audiovisual medium.[11] They have opened up whole new avenues for film scholarship and brought a welcome level of conceptual and methodological rigor to thinking about stories told in cinematic form. In the process, however, and as a number of recent commentators have suggested, many such narratological accounts of cinema, as rooted in concepts and methodologies originating in the study of literary forms, and adapted to the moving image (with varying degrees of plausibility), have risked losing sight of aspects of the concrete perceptual, affective, and experiential (or "phenomenological") character of the film-viewing experience. But also and equally, it must be added, they have sometimes failed to acknowledge large domains of artistically relevant cognitive, symbolic, and inescapably "cultural" meaning, as I hope to make clear. While certainly not *denied* in the writings of theorists within this tradition, these areas of film art and experience, on which I will concentrate, are frequently sidelined, seemingly taken for granted, or assumed to fall within the provenance of film criticism exclusively.

Kristin Thompson's and Bordwell's shared conception of cinematic "excess," for example, valuably identifies a class of nonnarrative, artistic features of films and perspicaciously describes important aspects of their apprehension alongside, and in attentional oscillation with, narrative ones. This conception of excess, however, appears to suggest that all that constitutes "meaning" in film is strictly confined to either items of narrative import or to items of an autonomous and self-referential "artistic" (here meaning formal) significance, existing "for their own sake," as it were.[12] Such a theoretical premise risks neglecting what falls between (and outside of) these poles of creation and attention and that at the same time binds them together, and endows both story and cinematic form and technique with a work-defining, artistic meaning and value otherwise absent from each. I mean to refer here to what may be conceived as the expansive realm of "symbolic" import in cinematic art, in its cognitive and expressive registers alike, and as cutting across any form-and-content dichotomy that may be usefully applied to cinema. On a related note, what Mark J. P. Wolf observes with reference to the imaginary worlds of narrative works of all kinds— that "what might appear to be 'excess' from a narrative-oriented point of view, may prove to be necessary from a world-oriented point of view"[13]—is equally, if not more true, of the artistic worlds of films as here conceived.

Bordwell has proposed four other sorts of art that, in addition to "narrative art," the cinema may be seen to encompass: photographic, performing, pictorial, and audiovisual. In his view theoretical approaches may focus attention on one or more of these "conceptions of film art." (Moreover, since cinema is also an "emotional art," he also suggests that "it would be worthwhile to tease out the different sorts of emotion that each perspective tends to emphasize.")[14] While this all seems perfectly right, I believe emphasis should more squarely fall on the fact that every live-action narrative film, for instance, has all of these dimensions and interests simultaneously, even if some films may choose to foreground stylistic features relevant to one or more of these aspects, to the relative exclusion of others (as Bordwell also aptly notes). More generally, however, and as transcending these largely *formal* or *medial* categories, in speaking throughout this book of cinematic art, I do not, as will become clear, mean to refer to only medial, formal, perceptual or technical aspects of films nor to film style as more narrowly conceived. The artistic dimension of cinema, as here explored, encompasses the whole domain of the types of meaning and expression (i.e., feeling and emotive contents), as well as

created forms and structures, which are traditionally and still frequently associated with artworks of every form, type, and period, and their experience. In other words, my intended reference is to the whole of what is or can make cinematic works not only nominal but genuine instances of art, in certain accepted, relatively unproblematic, and descriptive senses of the term—as distinct, that is, from their natures as sensory spectacles, pure entertainments, and visually rendered narrative fictions (alone).

More specifically, the concept of cinematic art pursued in this book, and following the views of the principal thinkers cited and discussed, regards narrative films as both representational—in the most general sense of affording us with symbolically constructed models of experience and "ways of knowing"—and presentational, as inseparably connected to aesthetic perception and appreciation (for all that this latter notion entails). Correspondingly, whereas in much contemporary (analytic) philosophy of art, the "aesthetic" as a category is often taken to refer to the formal and sensuous properties of works as conceived and experienced apart from their represented and interpreted (or interpretable) "content," here it will be understood more broadly as applying to potentially all of a film work's distinctly artistic forms, meanings, experiences, and values, in contrast with its first-order nonartistic ones.[15]

In presenting the following account of the worlds of films as artworks, no attempt will be made to elucidate a theory of the aesthetic as such or on a priori grounds. I will assume, however, the general, continuing viability of such concepts as "aesthetic experience," the "aesthetic attitude," "aesthetic judgment," "aesthetic appreciation," and so on, as these may continue to be subject to critical examination and revision.[16] A somewhat more specific (although by no means exhaustive) notion of the aesthetic as a fundamental mode of human cultural experience and, to varying degrees, individual expression, with respect to cinema, will be developed and will emerge bit by bit, as it were, as we proceed. For the moment it is necessary to remind ourselves that the so-called aesthetic attitude is, properly speaking, a heterodox and complex affair in which a great deal of "cognitive" and "cultural" integration takes place and in which perception, intuition, imagination, reflection, and interpretation all play a part. As philosopher Alan Goldman has suggested, to be fully engaged with any artwork, including a film, is "not simply to pay close perceptual attention to formal detail and complex internal relations in the object's structure, but also to bring to bear one's cognitive grasp of those exter-

nal and historical relations that inform one's aesthetic experience, and to be receptive to the expressive qualities that emerge through this interaction. Knowledge that *can* inform one's experience of a work includes that of the artist's intentions, techniques, attitudes, problems overcome, and so on."[17]

In this context it must be remembered that just as not all art is narrative, not all narratives are artistic in either intent or experience. Moreover, it is possible, and not uncommon, to engage with artworks that tell stories, including films, on a predominantly narrative level alone, which (whatever else) is clearly not to experience and appreciate their full meaning and values as artworks. From the descriptive, as distinct from evaluative or critical, standpoint that we will for the most part adopt, all fictional narrative films may be seen to have some artistic aspects, as cinema's frequent designation as "popular *art*" or "mass *art*" implicitly assumes. Despite the suggestion of some past and present film theorists and philosophers of film, however, the easy or "natural" accessibility of the majority of films made today, or at any point in the past, to very large audiences, and their popular appeal, does not necessarily reflect some deep, fundamental truth about *all* cinematic art and the range of forms (relatively more or less demanding) it may take or allow for. Rather, as Noël Carroll has rightly stressed, it reflects on particular, relatively more accessible, *uses* of the medium and its now firmly established institutions.

Focused on films as artistically made and experienced "worlds," many of the arguments I propose in this study may be taken to apply not only to both celluloid and digital productions but to potentially all types of narrative films of all periods—from classical Hollywood westerns and musicals, to European and Asian "art films," from large-budget studio-backed films to small, independent productions. All may create and present worlds in the senses noted above insofar as they are aesthetically realized totalities possessed of sensory, expressive, thematic, and narrative dimensions (albeit, of course, with widely varying and unequal degrees of artistic ambition and success). Moreover, at least some of what is here maintained concerning cinematic world-making and experience is also applicable to nonnarrative and nonrepresentational films and cinevideo works as diverse as Norman McLaren's *Dots*, Andy Warhol's *Empire*, Stan Brakhage's *Dog Star Man*, and Douglas Gordon's *24 Hour Psycho*. Documentary films, as well, can be readily seen to create worlds in our present sense (the fact that they attempt to show us aspects of the "real world"

notwithstanding). With respect to so many of the techniques, materials, constraints, and artistic potentials of filmmaking, the worlds of films of these disparate kinds are all part of the same extended family, sharing more than just a common medium or media. Moreover, the proposed model underscores the necessity of conceiving cinematic art in a way that is not exclusively tied to the distinct features of celluloid (or "analog") filmmaking—since, as will be shown, a cinematic work and its constructed world cannot be wholly assimilated to the pregiven properties of any specific moving-image medium or format and its technological basis.

As the above comments and initial definitions suggest, the concept of a "film world" represents an attempt to bring together and to unify the full *cognitive-symbolic, affective*, and *hermeneutic* dimensions of a narrative cinematic work of art, as these work in, through, and beyond *perceptual* (audiovisual) and *fictional-narrative* features and structures. Correspondingly, my tripartite account of a film work and world proceeds through (1) various related theories of symbolization, particularly that developed by Nelson Goodman in his analytical conception of artistic "worldmaking" and the full referential nature of artworks; (2) phenomenological aesthetics, in the form of Mikel Dufrenne's to some extent Kantian account of artistic feeling and expression; and (3) the hermeneutical approach to art of Hans-Georg Gadamer, as rooted in Heidegger's critique of continental, post-Kantian sensationalism and formalism in aesthetics, and of a conception of art as an "event" of revealed truth.

Largely underrepresented in current film theory and the philosophy of film, these general approaches are by no means incompatible, as some readers familiar with one or more of them may assume. When taken together and to a degree synthesized with one another and related film theory and criticism, they aptly reflect film art's simultaneous appeal to our senses, emotions, and intellects. That said, this book does not undertake the task of *defending* the several, so-called analytic and continental aesthetic theories and philosophies of art discussed but, rather, seeks to *apply* relevant parts of them to cinema. And it seeks to do so in such a way that will not only better illuminate the artistic and aesthetic aspects of films and their worlds but serve to recommend and encourage greater interest in the use of these frameworks of ideas in a film theory and philosophy of film context. From a wider perspective, if it is accepted that cinematic works (and the worlds they construct) are complex, heterogeneous, and multimodal in terms of their address in consciousness, then their more

successful theoretical understanding and discussion may actually *require* a certain conceptual and methodological pluralism and eclecticism, cutting across established analytic and continental lines, as well as "cognitive" and semiotic ones, for example.

Apart from the above-mentioned authors, there is another prominent intellectual debt to be acknowledged, which may also help to orient the reader. As well as a critic, filmmaker, and cofounder of Paris's renowned Cinémathèque française, Jean Mitry was one of the first scholars of film history and theory in a university context (teaching at the Institut des hautes études cinématographiques and the Université de Paris). His massively detailed *Aesthetics and Psychology of Cinema* (published in 1963, only translated into English in 1997) is arguably the last great theoretical work devoted to cinema as art, prior to the pronounced shift toward the investigation of the specifically social-ideological nature and use of cinema that occurred in film theory and some serious film criticism in France and elsewhere very shortly after its publication.[18] An attempt to understand film art against the background of general aesthetic theory, Mitry's book (which I have frequent occasion to cite) is also at least one (needed) bridge between and among symbol-centered and phenomenological accounts of art and film. Through its critical engagement with both classical formalist and realist film theory, and its balanced critique of mid-twentieth-century semiotic, structuralist, and poststructuralist approaches to cinema, it also clearly points forward to Deleuze's highly influential philosophy of film, with which it has some clear and seldom-discussed affinities. Mitry is correct in a number of respects when he writes, for instance, that there is not just a gap but "a world between" the perceived space that actors and characters occupy on the screen and the space of viewers in watching it.[19] Along with this cinematically created world structure and experience, I am interested in the nature and effects of the distance and separation in question, together with how (as Mitry also inquires) this is simultaneously a closeness, an association, and a participation on the part of viewers.

Still on the subject of reference points and precedents: Dudley Andrew, an early champion and interpreter of Mitry in an English-language context (as well as of phenomenological approaches to cinema well before their current vogue), is one of the few scholars within disciplinary film studies to explicitly entertain the central idea of films as artistic worlds distinct from fictional story-worlds. He has done so with reference to

some of the same theorists, philosophers, and traditions with whom I will engage, even if, as it must also be added, Andrew invokes these, together with the common backbone and unifying theoretical ground of our present study, in a comparatively brief and provisional way.[20]

All that remains to complete this introduction is a brief summary of the book's structure and the sequence of its main arguments, some of which are cumulative in nature. The first chapter covers a good deal of necessary philosophical and theoretical ground and, as the reader should be aware, possesses a certain density of detail and argument, as a result. It forwards a series of interconnected observations and arguments concerning the need to make a fundamental distinction between the fictional world "in" a cinematic work and the more than fictional and narrative world "of" it, as including and enclosing the former (since, in aesthetic terms, worlds are not only the products of fiction and narratives in various media). This distinction, which is founded in recognition of both the representational and what may be termed "presentational" dimensions of films, is supported by critical consideration of significant philosophical and film-theoretical issues that cluster around existing logical and fictional, "heterocosmic," narrative-diegetic, and phenomenological conceptions of films as created and experienced worlds. I will argue that these differently oriented world-conceptions, as shared by some philosophers and literary and film theorists, are highly instructive and useful but also seriously incomplete in aesthetic terms. Thus, in pursuing a more holistic, less reductive model of the artistic world-character of a narrative film, it is necessary to move beyond them in certain specified directions.

Chapter 2 focuses more directly on the term and concept of *world* itself. In any cultural context of reference, worlds (plural) are seen to necessarily entail forms of symbolic thought and representation. The discussion here relies on a post-Kantian tradition of thought on symbolization and experience that has been relatively neglected in aesthetics and the philosophy of art (from at least the second half of the twentieth century to the present), as well as being seldom discussed in contemporary film theory and the burgeoning philosophy of film. Insofar as certain ideas and relevant works of philosophers such as Ernst Cassirer and Susanne K. Langer have suffered decades of eclipse by other continental and analytic movements and schools of thought concerning symbolization, art, and expression that have been favored in aesthetics and film and art theory (and the humanities generally), the tradition in question may not be fa-

miliar to many contemporary readers. It is, however, one indispensable source and background to our present understandings of the full "cognitive" aspects of filmmaking and film viewing, together with at least some cinematic affect. This is indicated in Goodman's powerful insight that "how an object or event functions as a work explains how, through certain modes of reference, what so functions may contribute to a vision of—and to the making of—a world."[21]

In further making a case for the relevance of this general philosophical tradition to both cinematic art and film theory, chapter 3 teases out the multifaceted relations between its basic positions and Mitry's and Pier Paolo Pasolini's symbol-centered descriptions of (all) artistic filmmaking, as also overlapping with certain aspects of Deleuze's. At issue is how the materials of a cinematic work (celluloid or digital), drawn from "natural" and cultural sources alike, and in the form of images and sounds both captured and constructed, are transformed into aesthetic features (or elements) in symbolic (and "virtual"), as well as physical-material, ways. In this process the original meanings and affects of these materials are typically both retained and surpassed for intended artistic purposes, in a fashion specific to cinema in at least some significant respects.

Chapters 4 and 5 represent what is, as far as I am aware, the first more systematic and wide-ranging attempt to apply Goodman's symbolic account of art and world-making to cinema. In chapter 4 I propose to show how film theory and criticism may make productive use of the five distinct processes for consciously constructing new worlds out of older ones that are identified and described by the American philosopher, given how these processes map onto recognizable stylistic features of films, and filmmaking techniques, that contribute to the creation of cinematic worlds. Goodman's related classification of types and functions of symbolic reference relations (assumed in his chronologically later account of artworks as exercises in world-making) is the jumping-off point, in chapter 5, for a consideration of the types of literal and, especially, figurative symbolization to be found in film art. Primary here is Goodman's groundbreaking recognition of the full and crucial role of symbolic "exemplification" in art, as a form of targeted self-reference on the part of works in all forms. Properly understood (and with some additions and changes of emphases in comparison with Goodman's original account), exemplification is considered central to a film's artistic presence, meaning, and interpretation. I will also argue (although more provisionally) that it provides a basis for a

new, alternative model of (self-)reflexivity, as a prominent feature of many artistically significant narrative films. Finally, this explication of multiple kinds of reference at work in art is brought to bear on the identification and classification of artistic styles in cinema. Here I offer in condensed fashion the ideas of what I term a film's constitutive "world-markers," together with the sort of stylistic categories of film worlds ("film-world types") that may be regarded as following from these.

Turning to the film-viewing experience, under the umbrella heading of cinematic affect as "expression," in chapter 6 I offer qualified support for certain models and theories of film-produced feeling and emotion that have been proposed recently, especially within cognitive film theory and the philosophy of film. These are presented, however, as but one important part of the total artistic picture with respect to the major affective dimension of films. In an attempt to sketch a more complete map of film "feeling," I propose a four-part typology of characteristic forms of cinematic expression, consisting of what I call "local" *sensory-affective*, *cognitive-diegetic*, and *formal-artistic* types, alongside a more "global" aesthetic one. Aspects of these forms of affective expression are argued to clearly correspond to ways in which the film viewer may be engaged with, and immersed in, a cinematic work in pronounced fashion. The discussion here is in some ways a microcosm of this study as a whole. Insofar, that is to say, that it attempts to show that whereas no current, single theoretical or methodological approach or paradigm in film theory (or the philosophy of film) is a sufficient conceptual lens through which to view the entirety of a narrative film as a singular work of art—affectively or otherwise—a number of them appropriately put together and applied to it may facilitate our understandings of certain constitutive *levels* or *aspects* of it.

As discussed in more detail in chapter 7, which also addresses the topics of time and rhythm in film worlds, the several forms of cinematic expression and immersion include what can be seen as a distinctly aesthetic form of cinematic affect that I call a film work's total (or global) *cineaesthetic* world-feeling. In accordance with Dufrenne's more general arguments concerning all aesthetic objects (and with its Kantian reference points), this fourth category of cinematic affect, expression, and immersion, largely heretofore unrecognized (at least in any more detailed, theoretical fashion) is conceived as bound to the so-called lived or felt time of a film (as well as an overall cinematic rhythm). The particular

connection between this complex aesthetic and experiential constellation of feeling and temporality, and the filmmaker in his or her role as artistic "world creator," is explored through the critical juxtaposition of the concept of cinematic world-feeling with a number of well-known and overlapping *auteur* and expression-centered views of film art.

The final chapter reflects the aforementioned shift to a hermeneutic frame of reference. In full acknowledgment that a more detailed and comprehensive hermeneutics of film worlds must await further development, I argue that along with being objectively accessible symbolic and artistic objects (or, more precisely, proposed symbol schemes), and "private," first-person aesthetic experiences, film worlds are also public, historical, and intersubjectively accessible *events*. As such, they may be conceived as the occasions for the disclosure of artistic truth that Gadamer (following Heidegger's reflections on art) articulates in his major work *Truth and Method* and other writings, wherein he maintains that the very presence of the artwork places a demand to be understood on its beholder. This is a communicative demand that is only met and fulfilled in an active participation, negotiation, and "dialogue" with the work in the context of cultural and artistic (and here, cinematic) tradition. Building on this existential hermeneutic account of the character and function of the artwork as transposed to cinema, and following in the hallowed critical footsteps of François Truffaut, I will maintain that film worlds possess, and are capable of conveying, two distinct, if also often overlapping, forms of knowledge and enlightenment, as pertaining, respectively, to "life" and to "cinema" (i.e., as art). Such truth, as a product of both film form and content, and at once revealed (or "disclosed") and interpreted, is claimed to be a major aspect of a cinematic work's interest and value, both cognitive and aesthetic.

FILM WORLDS

PART I
FILMS AND WORLDS

WORLDS WITHIN WORLDS

Fictions, Narrative, and Aesthetic Enclosure

REFERENCE TO THE CREATED AND EXPERIENCED WORLDS OF individual works is commonplace in the theory and criticism of literature, art, and film. Yet there is little consistency of meaning across disciplines and various critical and theoretical approaches, or even within them, with respect to this proposed description, or analogy. The numerous and varied senses of *world* in these contexts, as well as in general aesthetics and the philosophy of art, range from the clearly metaphorical (and often unanalyzed) to certain contemporary attempts to invest such "world talk" with more literal (and logical) meaning and precision.

Concerning any representational art form, there is an important but too often neglected difference between the world *of* a work and the represented or described world (or worlds) *within* a work.[1] Understandably, from one perspective, most theoretical treatments of cinematic worlds are confined to the latter. They seek to describe and understand the nature and comprehension of fictional, narrated, or so-called diegetic worlds of represented places and events in a common space and time inhabited by characters, which are (in some manner or another) referenced and communicated through a film's audiovisual form. These accounts are largely self-limited to what films are *about* in terms of a story rather than what

they also *are*, as created, unified works—together with what they may *mean* in nonnarrative (or extranarrative) and nonfictional ways.

In the position I take throughout this book, by contrast, it is vital and necessary to distinguish between the more or less skillfully constructed fictional story-worlds present within narrative films and the larger, multidimensional, and aesthetically realized worlds of films as artworks. The viability of this distinction is integral to many of the arguments that follow. To fully appreciate this, we must first look at some of the principal ways in which what I will term the *world-in* (as distinct from the *world-of*) films and representational and narrative works more generally, have been theorized. We will begin with logical and fictional worlds theory, which for some good reasons may appear to be at the most abstract remove from cinema.

LOGICO-FICTIONAL AND "MAKE-BELIEVE" WORLDS

Inspired by the theories of meaning and reference in the modern philosophical traditions of logical positivism and empiricism—associated with such figures as Gottlieb Frege, Bertrand Russell, and the early Wittgenstein, who asserted that "the facts in logical space are the world"[2]—one approach to the virtual and imaginary worlds presented by narrative works of all kinds regards them as built entirely out of certain kinds of abstract, quasi-semantic entities, or "propositions," as expressed in language.[3] This general view involves the adoption of what may be identified as the *world variance conception* of the meaning and truth status of the representational elements of works of (artistic) fiction.

Some references made by a work are factual (or ontologically grounded) as related to features of empirical reality, in the form of the corresponding, genuinely existing objects and properties that precede them. Others are said to be "objectless"; that is, they have no ontic counterparts or make no genuine references to anything that exists outside of human imagination and its many shared, cultural products. Thus, every work that communicates a story contains a kind of mixture or blend in terms of real and fictional persons, places, things, events, and so forth, as well as all their properties and relations as described by the work in words or perceived in its visual depictions.

For many thinkers who are committed to referential and causal theories of meaning and truth (and to so-called truth-conditional semantics),

it has been thought necessary to identify or construct a domain of some kind in which objects of reference that are fictional maintain their special mode of existence. Fictional propositions are true, if at all, only in some sense within the cognitive domains—the discourses, or "semantic fields"—where the nonexistent is taken to exist, such as the story-world of an artistic fiction. This remains the case even when such fictions are present in primarily visual works, like films, since sequences of images also may be thought to instantiate cognitive messages that generate linguistic interpretations and construct story-worlds.

To speak, then, of worlds in the propositional sense as *within* narrative works, including fiction films, is to refer to numerous story-worlds, and these are basically variant and hybrid worlds of actuality and possibility, of reality and imagination.[4] In every narrative fiction the true, factual, or historical is intertwined with the "false" and the merely fancied. The basic intuition here is that narrative "world-making" consists essentially of making imaginary modifications to parts or aspects of genuinely existing reality in ways that are more or less partial and subtle or extensive and obvious. In this view empirical reality—that is, the "real" or "actual" world—always remains the standard for the comprehension of every fictional and imaginary world. Representative of this propositional, world-variance position, Paul Bloom and Deena Skolnick defend what they refer to as the "intuitive cosmology of fictional worlds." This entails that "every time we encounter a new fictional story, we create a new world. The default assumption is that this world contains everything that the real world contains. We then modify this representation based on several constraints: what the story tells us explicitly, what we can directly deduce from specific conventions of the fictional genre, and, most importantly, how similar to the real world the fictional world is described as being."[5]

Not just philosophers, but a number of literary theorists have embraced this general paradigm. Marie-Laure Ryan, for instance, argues that the metaphor of "textual worlds," grounded in relations to discourse-independent objects of reference, is indispensable, in offering a less relativist theory of meaning as existing outside of texts.[6] David Herman, a fellow traveler in contemporary narratology, claims that the heady contemporary works of Ryan, Thomas G. Pavel, and Lubomir Dolezel "have sought to overturn the structuralist moratorium on referential issues, using tools from model-theoretic or possible-worlds semantics to characterize the world-creating properties of narrative discourse."[7]

There are also, however, a host of objections to various versions of the world-variance doctrine and what philosopher Kendall Walton calls the "Reality Principle" that it assumes.[8] In terms of our actual engagement with fictions, Walton is among those who have rightly recognized that truth in the discursive and rationalist sense (appealed to in standard propositional conceptions of work-worlds) is inadequate to account for the sort of imaginative commitments that we regularly make in our encounters with representational artworks. In his important book *Mimesis as Make-Believe* he accepts the existence of fictional or story-worlds that, when analyzed, are found to contain large sets of descriptive propositions.[9] Drawing on speech-act theories of language and meaning, Walton goes on to argue, however, that these are copresent with socially instituted "game worlds," which all appreciators of representational artworks create by intentionally playing, in their imaginations, self-aware games of make-believe. In these activities works (or parts of them) function as guiding props. The theory of tacit game-playing in relation to the representational arts enables Walton to make a general distinction between all matters of reader or viewer engagement with fictional characters, and situations in which they are placed, and the actual *truth status*, if any, of assertions concerning such characters and their various attributes and actions. (Consistent with this general view, in seeking to better understand fictionality in cinema, Noël Carroll has adopted a speech-act framework and an "intention-response model of communication" inspired by the work of Paul Grice.)[10]

Other philosophers of art, such as Joseph Margolis and Nelson Goodman, go much further still in raising fundamental doubts about propositional conceptions of fictional worlds within works.[11] Margolis also questions key aspects of the games of make-believe thesis as Walton's proposed alternative. Arguing against the views of Walton, John Searle, and others that the "imaginative work of the novel and pictorial representation" count as "fiction and make-believe," Margolis draws a distinction between what is "imaginative" and merely "imaginary": "simply put the imaginative is hardly limited to the imaginary."[12] In fact, in separating these concepts, he points to the "power of modern cinema," and to the "grand liberties in this respect afforded by filmic imagination," as showing how "the play of imagination is subtler and freer than propositional commitments."[13] Both Margolis's and Goodman's positions are motivated in part by a wish to steer well clear of an age-old Platonic legacy: the

pejorative sense of both the imagined and the fictional as equivalent to falsehood, and a corresponding diminishment of the full cognitive status and function of representational art.

Cinema and the Heterocosmic Model of the Artwork

Where does fictional-worlds theory and the different versions and objections to it, here only very briefly sketched, leave us with respect to cinematic worlds? Walton acknowledges that representational works are more than sets of propositions *and* more than imaginary ("make-believe") realities. In what must appear to be both a truism and a very substantial understatement, he writes that the "critic or appreciator needs to be sensitive to a work's features—the look of a painting, the sound of a poem—apart from their contributions to the generation of fictional truths."[14] It is quite clear that the complex sensory-perceptual, cognitive, and affective reality of any work of art, especially one as heterodox and composite as a film, cannot be reduced to fictional objects, representations, propositions, or a series of invitations to engage in acts of imaginative making-believe—if, that is, we are to be left with anything resembling *Citizen Kane*, *Chinatown*, *Éloge de l'amour*, or any other cinematic work as purposefully created and actually experienced in its full range of cognitive and expressive contents. From an aesthetic perspective a film, including its presented world, is not only or simply made (and intended) to refer viewers to aspects of common experience, as modified by creative imagination (freed from any burden of literal truth-telling). Rather, it is also something to be experienced "for itself."

When many critics and theorists (as well as filmmakers) discuss the worlds of individual films or directors—for example, the "world of 8½" or "Fellini's world"—they often do not limit themselves to literal contents, in the form of discrete camera-given representations, or, as Dudley Andrew argues in this context, to "a catalog of things appearing on screen."[15] Nor do they apparently mean to refer to fictional characters, places, and actions alone, or even the stories containing them, but also and more generally to a "mode of experience" (Andrew) that these films create.[16] The implicit concept of world appealed to thus often extends beyond the fictional reality or story-world abstracted from a film's formal and medial presentation; it also includes that presentation itself, making use of the properties and possibilities of cinema—entailing camera movements,

color schemes, rhythms, editing styles, music, production design, performance registers, soundscapes, and so on—as all contributing to the creation and experience of a readily identifiable cinematic world as a perceptual-imaginative and affective whole. To borrow philosopher Nicholas Wolterstorff's phrase, while film works do indeed "project worlds" of a fictional nature, they do so in their concrete, perceptual presence, as enabled by a medium that is capable of communicating audiovisually.[17]

In a cinematic work sensory and affective features are closely integrated with representational and semantic content in a way that is, moreover, far more pronounced than in any literary narrative. No matter how much films share in narrative and fiction-making processes to be found in other arts and media (and no doubt they share much), they are also fundamentally unlike any founded entirely (or primarily) in discourse. In and of themselves the worlds posited by logico-fictional and speech-act (or make-believe) conceptions of representational and fictional works are neither sufficiently "cinematic" (in the above senses) nor sufficiently *aesthetic* to be the basis of a world-model or mapping that more fully reflects the experience of film works and accounts for more, rather than less, significant artistic features of them.

Stepping back from philosophical and theoretical conceptions of work-worlds rooted in logical and linguistic paradigms, it is important to recognize that these have been preceded by another tradition of reflection on literature and the arts. Unlike the views I have mentioned thus far, this older scholarly tradition rejects the idea that created works are (or should be) primarily experienced, understood, and judged in close conjunction with the real world, and to logical and empirical truth, as a standard of reference. The long-standing position in question is associated with what has been called the "heterocosmic" model of art and artworks. It is anchored in a sharply drawn distinction between the abstract truths of logic and reason (or didacticism) and more concrete "ways of knowing" afforded by artistic perception and imagination. The noted literary theorist and scholar M. H. Abrams has traced the long and fascinating history of this general conception of art as entailing the creation of new worlds of experience, fashioned from sensuous and imagistic, as well as semantic elements.

As Abrams points out, Joseph Addison, Karl Philipp Moritz, Alexander Baumgarten, Kant, and other early and mid-eighteenth-century writers argued in various ways that a representational work of art is not in essence

a replication or alternative version of reality as it is familiarly known but a "unique, coherent, and autonomous world unto itself."[18] Artistic creation involves the construction of domains of experience that are very largely self-sufficient and self-referential. Departing from earlier conceptions of art as in one way or another anchored in the traditional Western *mimetic* doctrine of the imitation of nature, and instead drawing inspiration from the Judeo-Christian theological notion of the Creation as an autonomous, spiritual act, the work of art in this tradition is not as much a reflection or imitation as a human-scale *analogue* of the natural world freely created by God (in the form of a work created "second nature").[19]

It is noteworthy that the most developed early articulation of these ideas comes with the very birth of philosophical reflection on art (and beauty) in its more modern guise. More specifically, it occurs in the writings of Baumgarten, who is generally credited with founding aesthetics as a distinct branch of philosophical inquiry. In claiming for art a more autonomous status within human activity and reflective thought than had traditionally been granted, Baumgarten defends the idea of a work as a veritable world of its own with reference to Leibniz's logical and metaphysical conception of "compossibility" (i.e., the principle of internal coherence) as applied to poetic works: especially those Baumgarten calls "heterocosmic fictions," which frequently violate the known laws of nature and establish their own unique relations among phenomena (Abrams 177). As Abrams discusses, Baumgarten contrasts logic, which is abstract and general and signifies essences, with poetry, which is "determinatively particular, individual, specific" (174). A poem is considered to be a matter of representation that is "qualitatively rich, abundant, imagistic" and constitutes a "concrete whole" with a pronounced "sensuous appeal." Unlike the discourse of reason, poetry and imaginative literature convey a distinct poetic knowledge, which, in his *Aesthetica* of 1750, Baumgarten also describes as "esthetico-logic" (the logic of "sensuous thinking") and contrasts with rational thought and argument (Abrams 178).

Abrams aptly summarizes Baumgarten's subsequently highly influential position: "a poem provides sensuous knowledge of its own poetic world—a world governed by causal laws analogous to causal laws in our world but specific to itself; a world whose 'poetic' truth and probability does not consist in correspondence to the actual world but in the internal coherence of its elements; and a world that is not ordered to an end

external to itself but by an internal finality whereby all its elements are subordinate to the progressive revelation of its particular theme" (178). Although often articulated in different idioms, and in relation to different art forms, this basic view of the artwork qua self-possessed and singular world was widespread, even commonplace, by the early twentieth century. It may be found expressed in the critical and theoretical writings of figures as diverse as György Lukács, Wassily Kandinsky, John Crowe-Ransom (as also representative of literary New Criticism), J. M. Foster, and Vladimir Nabokov. It survives, as well, with compelling force, in J. R. R. Tolkien's theorization of the form of literary fantasy as always involving an act of "sub-creation" and the construction of a "secondary world."[20]

What is of primary interest to us is the heterocosmic view's more extensive taking into account of the fact that works not only refer to aspects of the real world, creating hybrid real-fictional alternatives to it, but also more actively transform reality via such borrowings. Thus they transcend "merely" logical or factual truth (or falsity) such as also prompts Gadamer, for instance, to write that the artwork's world appears *not* to permit "comparison with reality as the secret measure of all verisimilitude." Instead, "it is raised above all such comparisons—and hence also above the question of whether it is all real, because a superior truth speaks from it."[21] In other words, it becomes (also) a sui-generis reality, one that in some ways, at least, sets its own standards for its own experience and meaning, beyond all questions and putative problems of empirical fact and justified belief.

Although originally developed with reference to poetry (and offered in explanation of the creative genius of the poet), in its stressing of the sensuous and formal dimensions of works, this particular understanding of artistically created worlds and their experience was already in the eighteenth century also being applied to painting and music. In addition to carrying with it significant lessons for reflections on film as art, this doctrine of world-creation in and through art, going back to the very beginnings of philosophical aesthetics, also has substantial echoes in some contemporary, experience-based accounts of cinema. However, by way of phenomenology (in its post-Husserlian forms) combined with a (problematic) anti-intentionalism, and a rejection of narratological, cognitive, and auteurist approaches to cinema, some of the' theories in question may be seen to take central aspects of the heterocosmic idea to an untenable extreme. In relation to theorizing films and their worlds, in certain

respects they tend to confirm Abrams's critical conclusion that the claim that "a work is to be contemplated for its own sake as a self-sufficient entity, severed from all relations to its human author, to its human audience, and to the world of human life and concerns . . . accords only with selective aspects of our full experience of great works of art" (Abrams 187).

FILM MINDS, SUBJECTS, AND A WORLD APART?

In his book *Filmosophy* Daniel Frampton attempts to synthesize the insights of Maurice Merleau-Ponty's phenomenology of perception and Vivian Sobchack's cinema-focused interpretations of it, with Hugo Munsterberg's now classic, proposed analogies between film viewing and the elementary processes of visual perception and thought. In notable respects, however, Frampton's theoretical construct is also a contemporary cinematic version of the heterocosmic view, possessing some of its strengths, as well as some of its weaknesses. The latter pertain to the limitations of a conception of an artwork world, cinematic or otherwise, as an entirely self-sufficient perceptual experience, with perception, in this instance, extending to "lived" or "embodied" perception conceived in phenomenological terms.

Frampton agrees with Sobchack that a film not only presents objects and a world but also, and partly through the aegis of the camera-lens apparatus (and its movement), a cinematic seeing of those objects and that world, amounting to intentions and attitudes toward them. However, he replaces her radical model of a film as (for this reason) an "embodied" and perceiving subjectivity with that of a film as a disembodied and thinking "transsubjective" agency.[22] Thus, in one of his many neologisms Frampton posits the experiential existence of a "filmind." It is described as a creating and organizing form of distinctly cinematic consciousness governing films and taking up, purportedly, something like the awareness and perspective on phenomena of a conscious being or mind. Considered experientially distinct from the presence of the director as creator, or any implicit (or "invisible") narrating agency within the world of a film (seeming to present it), the filmind—sometimes also simply equated with the film "itself"—engages in creative formal and stylistic "film-thinking" about characters and situations. This serves to transform, to intentionally redesign, what is automatically captured by the camera in the form of perceptually recognizable objects and features into a virtual "filmworld,"

as something over and above such basic, mimetic representation; this process today extends to what Frampton regards as the particularly "fluid" and global transformations enabled by CGI technology.[23] As it unfolds in a film's viewing, this filmworld is concretely experienced as one perpetually created, intended, and maintained by the filmmind (akin in this respect to the reality-creating and maintaining dream of Lewis Carroll's Red King).

Based on what we have established thus far, this theory has some clear merits. To begin with, it recognizes that a film brings into existence a unique, creatively constructed world. This world consists of something more than representational and fictional contents alone and is also more than a simple sum or aggregation of such contents, since it also includes their highly formed artistic presentation. Such a world, within which viewers find themselves experientially immersed, is rightly seen to encompass the full formal and sensuous dimensions of films (falling under the heading of what Frampton terms "cinematics"), dimensions that, as Frampton notes with some justification, have tended to be neglected or at least deemphasized in a good deal of philosophy of film (at least to the time of his writing), as well as, we might add, in some semiotic, cognitive, and narratological film theory (Frampton 9). He persuasively insists that a better understanding of cinematic art necessitates more comprehensive study of these created worlds from the viewer's perspective, as in some sense temporally emergent perceptual and cognitive realities. In their fundamental character as interpretative and "transfigurative" (rather than simply imitating our direct perceptions) film worlds may, in turn, have a "transfiguring effect" on "our understanding and perception of reality" (Frampton 5–6). Yet there are also problems with Frampton's account, ones that are highly instructive in terms of our larger concerns in this chapter and those following. Some of these pertain to issues surrounding the viewer's experience of the "filmworld" in question and the creative intentionality behind it.

Frampton is surely correct in maintaining that the actual perceptual and affective experience of films as audiovisual works and the meanings that they manifest in such powerful fashion, as rooted in this experience, always exceed the actual intentions and (fore-)knowledge of the filmmaker, as well as the cognitive resources of any individual viewer. His conclusion, however—that, from the perspective "internal" to its concrete experience, the filmmaker cannot rightly or adequately be regarded (or

actually experienced as) the source or agency responsible for a film work and world's perceptual and artistic form, meaning, and creative transformations of reality—appears highly unwarranted.[24] Moreover, as ingenious and ostensibly appealing, in some ways, as the suggested alternative may be, in the form of a transsubjective "filmind," it is inadequate and to a degree self-defeating.

Making room for this distinctly cinematic mode of sensation, "thought," and creative intentionality in which films and viewers participate entails pushing the filmmaker and his or her collaborators out of the frame (almost literally), as it were. One of the motivations for conceiving of a film (at least to a certain metaphorical extent) either as a conscious entity (or mind) or as a perceiving self or subject (as in Sobchack's phenomenology of film, where a film is regarded as not only a "visible object" but also a "viewing" subject) appears to be a desire to preserve the self-sufficiency and experiential autonomy of a cinematic world as one wholly given to perception.[25] This enables this world to be seen and heard (as well as theorized) as the concrete result, or object, of the "thought," "perception," and "vision" of both the *film* and the *viewer* existing in a purported relation of immediate intersubjective communion—without, that is, any necessary reference to the *filmmaker* (including as a self-expressing "auteur") and his or her subjectivity, intentions, actions, and so forth. The supposed advantage of this strategy is, in Frampton's words, to avoid "watching a film with the idea that the film's actions are directly the result of an external historical person [which] removes the filmgoer from the film. Each action reminds them of the director making decisions and the mechanics of filmmaking" (31). Films and their worlds are thus seen to be safeguarded as self-enclosed perceptual and affective realities, generally free from extraperceptual biographical, historical, and personal-intentional mediations and distractions. It is difficult to accept, however, that a viewer's being aware before seeing a film, or being "reminded" while watching it, of directorial decisions, of the mechanics of filmmaking, or of the actual creator(s) responsible for its existence (and for at least *some* of its meaning content) necessarily removes him or her from its created world—especially when this world is defined (as in Frampton's account) as somehow *more than* a fictional (and imaginary) one. To assume this last is to court the dubious notion that engaging with, caring about, and taking seriously the presented world of a cinematic work during its experience requires a naive "belief" in its actual existence (or an active, global

suspension of disbelief concerning it) as supported by a film's creation and maintenance of so-called diegetic illusion.

Moreover, at least some major portions of the reality-based cognitive background of film experience, culture, and context are not somehow optional to a film world's "concrete" perceptual and affective being and to its characteristically cinematic experience but are partly constitutive of that very being and experience. For instance, the inescapable fact, which withstands any phenomenological, or indeed, "perceptualist" reduction of films, is that salient aspects of a film world as experienced are to varying degrees reliant on viewer awareness not only of the existence of a filmmaker (as the cinematic "world creator") in the abstract but also, often, of the authorial acts, intentions, and experienced "presence" of a *particular* director in his or her film. In other words, we must accommodate in theory as well as film viewing experience the real individual qua intending artist who may be appropriately considered chiefly responsible for a film world's singular existence and many of the artistic features (in some cases self-reflexive and autobiographical) it possesses (not *wholly* responsible for these, of course, given that cinema is also a collaborative enterprise and art).

Whatever position one adopts on notoriously difficult issues surrounding artistic intentionality, and whatever distinctions one wishes to suggest between cinema and other, more traditional, art forms concerning these, there is, at least, no contradiction or insurmountable difficulty in holding a position of what has been referred to as "moderate actual intentionalism."[26] This would entail, in this context, that (a) the filmmaker (or makers, to include the collaborators working under his or her artistic direction) is the true and full creator of a film's cinematic and artistic world (as a full perceptual and narrative-fictional reality), and yet (b) that the significance, meaning, and truth of any and every film world (and its parts) always, and necessarily—and for reasons that we will trace— exceeds the filmmaker's (or filmmakers') life (or lives), intentions, and activities. Indeed, to appropriately recognize and accept a filmmaker's actual artistic and expressive intentions is not necessarily to engage in any form of psychology that compromises either the objective status of a film work and world or the immediacy of its perceptual-affective experience on the part of viewers.

Beyond the specific issue of authorship and intentionality and their place in cinematic experience, although not solitary and sealed off, like the privacy enjoyed by each individual mind, films are, of course, recog-

nizably singular from any aesthetic or critical standpoint, as the hetero-cosmic view suggests. Nonetheless, and not in opposition to their sin-gularity, cinematic works are still highly situated and "networked" in a great many ways, participating through their symbolic aspects in external reference relations that are more or less proximate and unequivocal or remote and tenuous. Moreover, interpretation by viewers, as well as by critics and theorists, is in part the *very process of determining* the possible relevance and proper application of "external" knowledge (from the pa-tently obvious to the esoteric) to a film, including what pertains to other films, styles, and genres, to the filmmaker's possible intentions, to rel-evant critical and theoretical ideas, and so on. This is a process that, in addition, occurs (as it must) *during* the real-time, perceptual experience of a film and its world, which from one perspective brings it into (full) being. In the appropriate application of such relevant (prior) knowledge, as opposed to its mental bracketing or willed ignorance, viewers may lit-erally experience *more* of the singular, irreducible, presented world of *The Passenger* or *Casino*, for instance, and not (necessarily) less. Such rela-tively more knowledge informed perception often leads to quite literally *seeing* and *hearing* something more, or different, on the screen than one otherwise might, not to mention to often *feel* more deeply in relation to it.

I have raised these related, perhaps familiar, points rather emphati-cally because any adequate theorization of cinematic art, and of film ex-perience as aesthetic experience, must (one would think) fully acknowl-edge not only the sensory, perceptually given and affective dimensions of films but also the full extent of their intentional, cognitive, and symbolic (referential) ones (extending in some cases to what is sometimes simply referred to as a work's "context"). In our present view the latter are as constitutive, in principle, of their artistic nature—and of their perceptu-ally, cognitively, and affectively *immersive* and *transformative* aspects as "worlds" of their own—as the former. If we must continue to be wary of the pitfalls of the so-called intentionalist fallacy with respect to a film as much as a novel or poem, we must also seek to avoid the equally insidious doctrine that Peter Wollen, with respect to cinema, has aptly termed the "contamination fallacy." This involves considering "any work as complete in itself, an isolated unity whose intercourse with other films, other texts, is carefully controlled to avoid contamination."[27]

Of course, in some ways a film work *is* appropriately described as "com-plete in itself." It is, for instance, the source of a unique and novel sensory

experience, set in its own given temporal and spatial continuum, and a created object or event to which (normally) nothing is added and from which nothing is taken away once it is released to a public. But none of these well-known aspects of its singular mode of existence lend support to assumptions that it is freestanding or autonomous in the quite different sense of semantic isolation or muteness or that a film's understanding and appreciation as audiovisual art, or as cinema in its "purest" form, somehow requires no, or only minimal, extrawork knowledge during (as well as after) its viewing, on potentially all levels. Whether forwarded in the context of a formalist, perceptualist, or phenomenological account of cinematic art, it is a notable, if perhaps understandable, mistake, I would suggest, to conflate the distinctive and sui generis character of a film work and world with the idea that once its basic material—drawn from ordinary reality—has been "transfigured" in a film's creation, it has little in common with any other worlds (of film, or art, or otherwise) and is no longer in a highly active, and work-constituting, experiential relationship with these. In part through the recognized or imputed intentions of its real-world creators, a film's world is clearly in just such a relationship. A film present a new and singular cinematic reality—or "world"—yes, but one that is made, experienced, and has meaning only against the mental background of the old, the existing, the familiar, and the "real," even if by contrast alone. Although possessing a particular iconic and spatial-temporal concreteness, owing both to the photographic basis of the film medium (whether analog or digital) and its presentational (as distinct from merely representational or symbolic) nature, a film's created and presented reality, taking the form of what may be rightly described as a constructed and presented world, is always defined by what exists "outside," as well as "inside," it, strictly speaking—even if, although not, as must be added, not in logical, propositional, or didactic terms alone.

Many intervening, historical articulations of the heterocosmic model of artworks (including as part of the romantic movement and its successors) have, as Abrams points out, tended to overstate or misconstrue the nature and extent of the separation between the world of the work and what we take to be the real and familiar common world in some of the ways noted above. Yet, and as the more compelling 'neo-heterocosmic' aspects of Frampton's account may also be taken to usefully suggest, it nonetheless does bring us closer in many ways to what I will subsequently describe as the total created world *of* a film, as a formal and presentational con-

struction (rather than only a representational and symbolic one), than the propositional and "make-believe" models discussed thus far. This said, however, although the heterocosmic view helps bring into clearer focus the aesthetic limitations of logico-fictional (and imagination-centered) accounts of the worlds associated with representational works, this should also not blind us to the central insights of the latter, rooted in so-called commonsense metaphysics. For the acknowledged existence (however *existence* may be precisely defined here) of a vast plurality of imagination-enabled story-worlds, which sometimes engage Coleridge's famous "willing suspension of disbelief," is an important part of any theoretical account of the artistic dimension and potentials of narrative cinema. In accordance with philosopher Peter Lamarque's position, it is seemingly indispensable for making rational sense of the copious assertions we make concerning the unreal or "nonexistent" entities and animate beings found everywhere in literature and other arts, including narrative films, as well as for a coherent account of fictionality.[28] As we will see shortly, such story-worlds also transcend, in some ways at least, the individual works, forms, and media in which they are encountered.

THE TRUTH ABOUT FICTIONAL WORLDS AND FILMS

Despite notable differences among them, all concepts of fictional-narrative worlds—including propositional worlds, Walton's make-believe worlds, and Bordwell's "fabula" worlds of films, as highly constructed by viewers through perceptual-cognitive interpretations of their sights and sounds—are an attempt to capture our primary intuition that in some sense the actions of the characters of a fiction-film story (in this case) take place in a specially created, imagination-enabled or -assisted realm of being, not directly accessible to our senses (and including such characters and actions). If the traditional heterocosmic conception supports a view of the "sensuous" artistic singularity of film works, in their concrete totality, contemporary approaches in terms of the nature of fictional narratives support the idea, not necessarily contradictory, that films are, in part, also "texts" (of an audiovisual nature). They are figuratively "read" and comprehended always to some degree against the background of the world of empirical fact (among other things) and, more generally, require substantial interpretation of many kinds and with many (sorts of) objects.

For our purposes in relation to cinema, the key points concerning fictional worlds, or "story-worlds," and the characters and objects that populate them, are as follows. First, whether taking the form of the most psychologically rounded and identification-desiring worlds of the most conventional Hollywood films, for example, or those strange environments found in more experimental works from all periods that push at the outermost boundaries of narrative (and fictional) cinema normally conceived, such worlds are present within narrative films as experienced and comprehended by viewers. This applies regardless of how these worlds come about, are specifically engaged with, or are theorized.

Second, to varying degrees fictional and represented worlds (or, perhaps more precisely, some of their contents) transcend any *one* film or film narrative. In this sense, at least, they possess a certain autonomy and "ideal" existence. The "same" person, place, object, or event, whether fictional (Gotham City, Norman Bates) or existing in an actual past or present (Paris, Alexander the Great) yet fictionalized, may, for instance, be represented in more than one film. They may find form, that is, in as many different *versions* as there are films representing or making reference to them, for their own narrative (and artistic) purposes. Likewise, a number of different films, by the same or different maker(s), may be set in the *same* recognizable fictional world, e.g., that of Richard Linklater's *Before* trilogy, charting the lives of the same protagonists (played by the same actors) as they evolve through time. As in the case of so many sequels and remakes (and underpinning their very possibility, in one sense), each such film constitutes a different spatial-temporal view or version of a shared fictional world. Making this same point, Wolf recognizes that not only are imaginary worlds fully "transmedial" (constructed by other means than written texts) but logically independent of the narrative structures with which they are frequently conjoined or associated: "worlds function apart from the narratives set within them, even though the narratives have much to do with the worlds in which they occur, and are usually the means by which the worlds are experienced." For this reason, he adds, "storytelling and world-building are different processes."[29]

Third, and following directly from these observations, as Victor Perkins has argued in his suggestive article "Where Is the World? The Horizon of Events in Movie Fiction," to some degree at least, a "film's form and method are incomprehensible outside of a recognition that its story takes place, and its images both are made and found, in a world."[30] As

Bordwell and other theorists also maintain, film theoretical and critical recognition and exploration of exactly how such fictional and imaginary worlds are conveyed and constructed in films is essential if we hope to better understand processes of cinematic storytelling, some aspects of film style, and how fictional and narrative features and processes interact with other artistic (or distinctly aesthetic) aspects of films.

Finally, apart from their theorization, and as reflecting the mental schema and "intuitive cosmology" of fictional worlds that Bloom and Skolnick point to—coupled with the experience of many narratives and cinematic works—film viewers clearly and routinely *do* compare, contrast, and complete the represented, fictional domains appearing onscreen with whatever is taken as relevant (aspects of) reality, in the form of some aspect of the "real" and "true" world at any point in time. They determine for themselves, that is, what is to be taken as real or unreal in a film, what comports or deviates from offscreen reality, and, potentially at least, *why* these recognized similarities and differences are being offered. Indeed, to appreciate and understand films not just as stories told, and imaginary worlds with just enough "furniture" to produce a coherent and meaningful chronology of events, but also as the created and more broadly meaningful works of art they are, such comparisons (founded on the conscious fictional world recognition Perkins identifies) are often necessary. This is not least because film creators routinely take distinctly artistic advantage of this apparently natural human propensity (or, at least, one shared by many cultures at many times) to distinguish the real from the imaginary or fictional when confronted with artistic representations: as when, for instance, actual, historical figures (or places, or objects) are placed alongside fictional ones in order to generate particular meanings and affects in films. Such juxtapositions are a familiar vehicle throughout cinema for all sorts of formal thematic, allusive, reflexive, and conceptual significances, as well as a means to elicit emotions.

In sum, fictional story-worlds qua such worlds are clearly the object of considerable attention on the part of film viewers—even if they are only one of a number of experientially and (potentially) artistically significant parts of a cinematic work of art—and, in the case of a narrative film, the fictional story-world is not always, in its appreciative experience, the most important or primary aesthetic object of viewer attention. Therefore, although they are seriously incomplete in aesthetic terms, as the heterocosmic perspective may be taken to have long suggested, logical and

fictional-narrative models of worlds have a proper and, indeed, necessary place in any rounded account of narrative cinematic art, not least for that which they rightly recognize as existing *within* films and the minds and attention of viewers. Our present concern in this and the following chapters, however, is not with such fictional realities (and worlds) in and of themselves but with how they may be seen to be integrated with, and contained within, cinematic works as *aesthetic wholes*, in their interrelated perceptual, affective, and reflective dimensions—together, that is, with the nature of this integration and containment, insofar as it may be addressed and theorized in general terms. This focus now brings us rather naturally into perhaps more familiar film theory territory.

DIEGETIC WORLDS

If the fictional world of a work considered in something like propositional terms is defined in opposition to the real world of fact (as the standard of nonfiction), according to the widespread concept of diegesis, the "diegetic world" is associated with the content of cinematic representation or narration as distinct from the formal or medial (or "textual") processes of it. As one half of a purported, binary opposition, everything that falls outside of the diegetic is said to compose the "nondiegetic." Thus the musical underscore of a film sequence, for instance, or an insert shot of an object that cannot be plausibly located within the world the characters inhabit or know of (insofar as that world is established by the film), are often regarded as included within the mixed bag of a film's nondiegetic elements.

Like the logico-linguistic concept of a fictional world (and bearing similarities to it) the diegetic/nondiegetic division is not, as such, particular to cinema but may in theory be applied to all narratives. Etienne Souriau is credited as having first used the relevant concept in relation to cinema, in his 1951 article "La structure de l'univers et le vocabulaire de la filmologie." Souriau regarded the *diegesis* as the total "denoted" field or level of reference of a film, which contains represented characters and events, as comprehended by the viewer. Following Souriau, an aesthetician engaged in comparing the forms and functions of different art forms, Christian Metz and Noël Burch, from their respective semiotic-structuralist perspectives, also regard the diegetic in these terms. In Metz's film semiotics the concept is understood as pertaining to a film's narrative "but also the fictional space and time dimensions implied in and by the narrative, and

consequently the characters, the landscapes, the events, and other narrative elements, in so far as they are considered in their denoted aspect."[31] Burch argues that the diegetic aspect of a film is a matter of the "imaginary space-time" of its story-world and the sum total of its specific significations; as such, and counter to other theorists' strictly narratological use of the term, "there is much more to diegesis than narrative."[32] These are important attempts at definition to which we will return shortly.

Some earlier commentators, including Jean Mitry, expressed reservations concerning Souriau's appeal to the ancient concept of *diegesis*, counterpart of *mimesis*, in relation to cinema.[33] It is only in the past few decades, however, that the whole notion of the diegetic dimension of a film, and what is and is not properly considered within its confines, has come under more widespread and detailed critical scrutiny, in film music and sound studies, in particular. This is not at all surprising, given that its most frequent and familiar application is to music in film, which has been traditionally classified in binary terms as diegetic or nondiegetic.

Critics of the distinction and its necessity or value have highlighted instances in films—including recent mainstream Hollywood productions—where the presence of a specific piece or section of music can be neither easily nor usefully classified as wholly nondiegetic.[34] It is not always clear, that is, what sounds or music characters are or are not (represented as) hearing at any one point in a film or the exact nature of the source as being within or without the local and more global space in which the characters are seen to exist and act. Rescuing the distinction, as it were, has involved introducing a great deal of qualification and invoking other, intermediate classifications such as the "metadiegetic," "extradiegetic," and so forth.[35] These and other similar considerations have prompted the more fundamental question of why we need to erect such a divide between a world of characters and the total audiovisual experience of a film on the part of a viewer (which of course includes characters and their perceptions) in the first place?

One reason we might want to do this, although not necessarily the best, is that such a bifurcated model is necessary to support some postclassical theories of film narration, deriving from largely Continental accounts of language, discourse, and narrative (as rooted for the most part in Saussurean structural linguistics). These theories hinge on a posited distinction between the assumed invisible or self-effacing (i.e., nonexperiential) nature of a film's narrating *processes*, particularly as found in more

conventional cinema, in contrast to the experienced reality of its *product*. In this view the attention of the majority of film viewers (with respect to the majority of narrative films) is mainly, or only, focused on the latter: that is, narrated content in the form of diegetic sound, image, sequence, and "world." But if this particular narratological model is largely rejected, as seems reasonable on a number of other grounds,[36] why still insist on the binary conception of film works it reinforces?

Musicologist Ben Winters has recently argued that the claimed division should be abandoned and that what are normally thought of as nondiegetic features of films, such as musical underscoring (e.g., *The Third Man*'s famous zither score), be posited as existing within the world of films. This is justified, in his view, by the fact that all music heard by the viewer is simultaneous and copresent with his or her actual perception of characters, and comprehension of their perceptions and actions, with the music (in this case) dramatically effecting how the characters and their actions are perceived and understood. In other words, for the viewer the diegetic and nondiegetic belong equally to one and the same *perceptual or phenomenological reality* of a film. According to Winters, as joined by other theorists, for this reason there is little sense in considering nondiegetic music and other features as somehow detached or detachable from, and "outside of," the fictional reality of a film's storyworld.[37] In wider terms the whole concept of the nondiegetic is seen to be little more than a convenient film theoretical abstraction, ultimately resting on a number of unduly realist assumptions (some of which we have previously discussed) about the fictional worlds of films and of cinematic characters, as being essentially like real worlds and real people. It should be jettisoned, Winters and others suggest, in favor of viewer-experience-based models of cinematic works and worlds in their actual experiential concreteness (Winters points to Frampton's "filmosophy" as such a model, and other theorists suggest Michel Chion's conception of cinematic "audiovision").[38]

Apart from issues specific to film and music studies, such observations and arguments are part of a larger, more encompassing, challenge within some recent film theory that may usefully by termed the "phenomenological objection." This source of criticism targets not only the diegetic/nondiegetic distinction but other prominent aspects of film narratology, in both its structuralist-semiotic and cognitive-constructivist forms, which for the above-noted reasons are regarded as unnecessarily

intellectually abstract and abstracting from the presumed actual experience of films. Its principal idea (as reflected in Frampton's *Filmosophy*) is that the represented and fictional dimension of a film is part of a wholly independent, self-enclosed, and fully concrete perceptual-affective reality, of the sort already discussed. In this view perceptual cinematic form and narrative content cannot be meaningfully separated (on any level), as they may be in the case of literary narratives—which, as discursive and imaginary, rather than perception-based, are inherently amenable to semiotic and cognitive models and distinctions (having their origins in the study of literary texts) in a way that films simply are not.

The desire to be more authentic to the concrete audiovisual experience of cinematic works that drives this point is entirely appropriate with respect to these issues. Yet however much they are experientially coupled with the represented, fictional contents of a film—and that they are would seem odd to deny—those audio and visual features frequently termed nondiegetic are quite properly regarded as being outside and certainly *distinct from* a film's story-world (i.e., including all that the characters as characters are known to be aware of). That is, they are neither fictional nor "fictionalized," and in many instances are *presentational* but not *representational*, in the sense of making reference to particular objects in a way that characterizes all fictional worlds. Moreover, as I previously pointed out, these perceptual and stylistic features may sometimes be concretely experienced by viewers *as* so distinct, even when also perceived and interpreted as very closely conjoined with represented contents of images, sequences, and stories. All this said, and getting to the core truth of the "phenomenological" or experientialist argument in question and what it rightly emphasizes, it is also the case that such formal, audiovisual, and musical features of a film are never somehow "external" to its *total aesthetic reality*—that is, the *experienced* world *of* a film as an artwork.[39]

Thus we return, and predictably, to the difference between the (fictional) world *in* a film and the strongly suggested existence of another, "larger" world of a cinematic work, yet also, in this context, to some unnecessary and rather misleading confusion between the two. Nondiegetic sound and music, for instance, certainly should be conceived as existing within a total perceptual-immersive and affective reality of a film as this is in some respects "directly" known and experienced by viewers. And as I have already begun to argue, there is good reason to regard the reality in question as a unique world, at some (at least) notable remove from all that

falls outside it. But, as duly recognized by Souriau, Mitry, Metz, Burch, Perkins, Bordwell, and other theorists, whatever name this perceptual-affective (and meaning-bearing) totality goes under, it is surely distinct from that fictional-represented "world" that grounds the existence of characters and the coherence of their actions as constituting the narrated story of a film. A main source of the difference in question resides in the fact that, for the reasons considered earlier, the contents of the represented and fictional world exist as logically and "ontologically" distinct (imagined or imaginary) realities *within* a film (as in any representational work) as if on a different plane or level than other experienced features and aspects of it (not least because the features and aspects in question are "real" and not fictional).

Undoubtedly there are often substantial gray, or shadowy, areas for both viewers and theorists alike in terms of what may or may not be diegetic or nondiegetic within a given sequence, or even with respect to an entire film—that is, what is or is not part of the fictional reality in which the characters may be said, and seen, to exist and behave, and *when*. And a given feature of a film such as a piece of music, or an image-object, may move from one sphere to the other in the course of its temporal unfolding or, indeed, may exist in both simultaneously. Many classic film soundtracks (e.g., *Forbidden Planet, The Birds, A Clockwork Orange*), and more contemporary ones, are celebrated for continually entering and exiting the "diegetic world" and generating substantial emotion and meaning as a result. As Robynn Stilwell has convincingly argued, however, such borderline, and border-crossing, cases tend only to experientially reconfirm the "ontological" difference at the root of the distinction itself, as well as the more intuitively felt "fascinating gap" between the diegetic and nondiegetic.[40] Rather than abandoning the theoretical impulse behind the diegetic and nondiegetic distinction (in its original film-related sense), by virtue of denying the existence of the nondiegetic, what is needed is a recognition that, as a matter of viewer interpretation to some degree, whether any specific feature of a film belongs to the diegetic world or is outside of it at any given point in time is highly relative to the film in question. More specifically it is relative to a film's style, narrative and artistic intentions, interpreted meanings, genre considerations, and so on.

Indeed, and in wider terms, the specific nature of the relation between the created domain of characters and story events as a whole, on the one hand, and their cinematic, stylistic presentation, on the other, is hugely

variable. Perkins writes perceptively that while it may be "normal for a movie to stress and sustain the separation between the fictional world and the world of the viewer," some films present a fictional world in which "beings can respond to our watching. . . . In another, the film may have its actors step aside from their character roles and move apart from the fictional world so as to appear to address or confront us in their own right."[41] Whether conventional or unconventional, "transparent" and self-effacing or opaque and self-reflexive (in generally recognized ways), *any* specific relation between the (fictional) objects of representation, on the one hand, and their cinematic presentation, on the other (together with at least some of the meaning and affect generated by this relation) is still ultimately founded on the recognized difference in kind between the two. (As I noted earlier, this difference is likely a psychological and culturally conditioned one, which is also reaffirmed through the experience of many narratives and narrative films.)

It is right to stress, as Perkins does, that the story-world of a film may range from relatively more fragmentary, unstable, pretextual, and implausible, on the one hand, to more "three-dimensional," detailed, and realistic, on the other. All this will be the result of artistic choices and intentions on the part of filmmakers, as well as commitments to stylistic patterns and genre forms and expectations. Yet if the precise nature and characteristics of this fictional reality (the world-in a film), together with its relation to other cinematic and artistic features and meanings of a film, is always work-specific, its basic "ontological" and experiential durability (which Perkins also points to) would appear to be more universal. This is true especially since the fictional world of a work does *not* simply "go away" when in all manner of different ways it is brought to more conscious attention, and thrown into relief, by its specific cinematic presentation—and when, in addition, this presentation itself becomes a greater object of viewer attention and consideration.

The conceptual task at hand is to retain the fictional world-in a narrative film as created through a given work's literal representations taking on a fictional character and grasped and pieced together by viewers, however easy or challenging this may be in specific cases. Yet we must also fully acknowledge and describe a narrative film's singular cinematic and artistic (i.e., wholly work-specific) reality, as a perceptual, cognitive and affective one. One way to do this, I suggest, is to grant the *world-of* a cinematic work, as corresponding to this latter reality, and as transcending both the

literal and the fictional in all sorts of different directions, toward all man-
ner of objects of meaning, feeling, and attention that are *neither* fictional
nor denoted directly. (Nor, moreover, are they in all cases the "narrated"
products of cinematic narration, and thus "diegetic" in this specific sense.)

A promising starting point for elaborating on such a created and expe-
rienced *world-of*, at least as it pertains to the level of semantic meaning,
is to be found in returning to Metz's particular version of the diegetic
field of a film as largely a matter of "denotation." He argues this position
most persuasively in his earlier, prepsychoanalytic writings (collected in
Film Language). Metz's claims bear a close relation to ideas developed in
nonsemiotic French aesthetic theory of the mid-twentieth century, and
via this route they are clearly connected to one strand of the theory and
philosophy of artistic worlds that I wish to bring to bear on narrative cin-
ema, starting with these issues.

Representational, Expressive, and Aesthetic Dimensions

Metz's conception of the diegetic in cinema addresses the fundamental
difference between a film work's core denotations and its other equally
referential levels and aspects, wherein the two are in a relation of in-
terdependence but not identity. Drawing on the standard denotation/
connotation distinction central to Saussurean linguistics and semiotics
as inspired by it (but predating both), Metz contrasts cinematic denota-
tion—and, by extension the whole diegetic reality of a film as made up
of denotations—with all figurative connotation. So, for instance, a film
image (or image-sequence) from *The Seventh Seal* may denote (literally
represent) an itinerant circus couple and their young child. But through
their positioning within the frame, or the way they are lit, together with
the narrative, thematic, and allusive contexts in which these figures ap-
pear in the film, they may also be seen to connote, or figuratively refer to,
Joseph, Mary, and the baby Jesus. Even more in the direction of metaphor,
they may represent a hope for the future in the midst of a world struck
through with existential despair.

For Metz, as for many other film theorists past and present, denotation
in cinema (as literal representation) is largely "given" by the camera in the
form of the iconic and what he refers to as the "analogical" character of
film images, as highly recognizable pictures of things in the world. Such

iconicity and a recognition of basic representational contents of images on the part of viewers is, in most cases, so direct and easily apprehended that it may appear, at least, entirely natural in the sense of an act of direct unmediated visual perception.[42] Connotation, in contrast, is that nonliteral level of meaning in a film's representational dimension that, while rooted in such camera-enabled iconicity, also substantially transcends it, in being always (more) interpretive. This is to say, it is more fully (sometimes wholly) dependent on cultural and background knowledge (if still to varying degrees in specific instances, and not always specific to any *one* culture or community). Metz associates this entire "extra," nondenotational, and "cultural" significance with a film's "aesthetic" dimension, which by nature is subject to much greater creative control on the part of filmmakers than may be exercised over cinematic denotation (as recognizable representation) given the latter's more immediate, "natural" and near-universal (hence preaesthetic) character.[43]

Although philosopher Mikel Dufrenne is cited in *Film Language*, the fact that his phenomenological distinction between the represented and expressed worlds of works of art, as articulated in his pioneering *Phenomenology of Aesthetic Experience*, was an important inspiration on Metz's early views has received little comment, particularly in English-language scholarship. More specifically, Dufrenne's distinction (and the reasons for it) informs Metz's conception of the diegetic in film as the total field of literal and fictional representation, as well as the equation of the distinctly *aesthetic* aspect of narrative films with associational and figurative meaning (and an affective expression tied to it), which surpasses this representation.[44] Moreover, Dufrenne's own brief but important discussion of this underlying distinction in relation to narrative cinema, specifically (a subject to be treated in more detail in chapter 7), has not received the attention it merits.

Briefly encapsulated, Dufrenne maintains that although marked by all of the symbolically mediated "distance that separates the real from the represented," the represented, fictional world of an "aesthetic object" (that is, an artwork as it is experienced) is instead a kind of pseudo-world.[45] Unavoidably incomplete and schematic, it consists of relatively fragmentary hints or cues of a more expansive and extensive fictional and imaginary reality-continuum. Such a reality is, of course, impossible for a work in any form or medium to somehow perceptually convey in its entirety but rather may be only suggested to the mind of the reader

or viewer for its necessary completion in (as we say) imagination. (Here it may be added that as far as cinema is concerned, even given current technically sophisticated digital and multimedia productions and virtual environments, this schematism remains no less true today—and for the foreseeable future—than it was at the time of Dufrenne's writing in the mid-twentieth-century celluloid film era.) However, as partial and merely suggestive as it is in comparison with *actual* perceptually given (nonrepresentational) reality, basic representation in art provides a work with stable and generally recognizable spatial and temporal foundations, together with a "norm of objectivity" of which the audience is the standard or guardian.[46] In other words, as Dufrenne makes the familiar point, representational works, including narrative films, require audiences to make the imaginative contribution that brings a plausible physical and social context in which characters live and act into experiential existence, with the necessity for such a reality understood and readily granted.

Similarly, in *Film Language* Metz describes the cinematically "denoted reality" of basic film representations as a reality that "comes only from within us, from the projections and identifications that are mixed with our perceptions of the film."[47] Although expressed quite differently, Dufrenne's and Metz's views are in general accord, as it may be added, with the working assumptions of Bordwell and other more recent film theorists' and philosophers' so-called cognitivist and constructivist accounts of narrative film perception and comprehension. These thinkers likewise regard a narrative and successively represented story-world of a film as coming into existence through "scattered indications whose synthesis we continually effect," as Dufrenne writes of the aesthetic object's represented world. While always necessary, this task may be more or less demanding according to the work (and style) in question.[48] A film, like any representational artwork, may thus be seen to *borrow*, and actually represent, only what it needs from the real world for both its particular narrative and extranarrative artistic ends—whether these latter are more form-centered in nature or, as Dufrenne stresses, expressive-affective. Thus a film may be rightly seen as willingly dependent on familiar, extrawork reality, in this dimension, or level of its apprehension.

The key idea here (as the reader may already have gleaned) is that while both inevitable and necessary, the viewer's imaginative actualization or "completion" of the schematic represented (fictional) world of a visual work, including a film, is not the primary goal of an *aesthetic* experience

of it, nor is it necessarily the source of its most significant symbolization or artistically conveyed meaning and "truth." This is the case even if, as it must be added, and as will be a major topic of discussion in subsequent chapters (including with reference to Mitry's film theory) *most* artistic meaning and affect in narrative cinema is still built on, and *works through*, fictional representations, and narrative structures and processes as tied to these.

According to Dufrenne, beyond the primary (or first-level) representation of a manifold of both real and fictional objects, people, and places and their spatial-temporal coordinates, "if the aesthetic object offers us a world"—that is, one more complete, free-standing, and entirely *specific to* the work, in short, a singular aesthetic world—it is "in another manner and according to another mode which should be common to all of the arts, representational or not" (176). Cinema, he argues, is a case in point. Even in a medium in which represented worlds are conveyed with a perceptual immediacy, concreteness, and, in some cases, deliberate illusionistic intent, with respect to cinema made and experienced as art, the difference between the represented and what Dufrenne terms the aesthetically "expressed" (as the "other mode" quoted above) still remains powerfully in evidence. In film, as in any other form of representational work, in this view it is only a total work-generated affective "expression" that is capable of aesthetically rounding out and peering behind the representational face as it is seen, as it were. Such affective depth of a particularly artistic sort is achieved, Dufrenne argues, in and through a unique, unified, and all-pervading atmosphere of feeling coalescing into a recognizable whole. Genuinely artistic films, he maintains, use cinema's "technical possibilities," together with "all the resources of the image" (174), to achieve such a total expressivity.

Metz, like Mitry before him, was surely right to recognize the relevance of Dufrenne's insights to cinema (in ways not pursued in detail by Dufrenne himself). These notably include the idea of a schematic *world-in* a work (as we are calling it), which corresponds to its basic representational task or function—namely, that of establishing a fictional reality of characters and situations that is more or less clearly comprehensible, on the basis of its familiar elements, to viewers. The reality in question is therefore able also to serve as the jumping-off point for other forms or levels of creative meaning and expression. However, owing to the particular constraints of the conventional semiotic-structuralist framework

in which he was operating (to which, in a cinematic and artistic context, both Dufrenne and Mitry were opposed), what is largely lacking in Metz's film theory, and any semiotics of film, it can be argued, is the taking of the crucial and justified next step. This step, following Dufrenne, is to conceive this represented realm of character being and action as distinct from, but also integrally related to and combined with, a larger aesthetic whole that is equally if not more deserving of the description of "world." The meaning(s) and feeling(s) of this totality notably exceed what a "semiotics of connotation" (as a concept borrowed from linguistic and poetic studies) is itself able to identify and encompass.[49] While for Dufrenne, this larger aesthetic construct is primarily defined by a work-specific, affective, and aesthetic "atmosphere" (as we will later explore in detail), it is also, as he acknowledges, more than this. For an artwork "world" must also be seen to contain significant first-order formal features and aspects (known and experienced as such) and must be open to the entire domain of nonliteral symbolic meaning that Metz (but not Dufrenne) files under the heading of "connotation."

Indeed, as equally true of Dufrenne's conception of the represented world of the aesthetic object, from the perspective of narrative cinema as art, the strength and resilience of Metz's, Burch's, and other theorists' idea of the denoted or diegetic level of a film—as including everything from the recognizable representational contents of specific images and sequences to the entire comprehensible, imaginary world and its space and time—lies in just this recognition of the difference between it and all *nonliteral* symbolic meaning and affect. This includes all figurative and associational semantic contents requiring relatively more, and sometimes much more (and more specialized), cultural, artistic, and cinematic knowledge and experience on the part of viewers. Certainly this is the case when such meaning is compared with the primary, literally denoted, dimension, which is often sufficient for the purpose of a film's basic narrative comprehension on the viewer's part.

A MULTILEVELED WHOLE

As we have now seen, the diegetic in cinema may be rightly understood in the manner of the concept's first users as consisting of the totality of a film's representations, or "denotations" (including singular *versions* of both fictional and real but fictionalized objects, places, people, and

events). To this must be added the connecting thread of visually rendered narrative in a dynamic medium, as explained in detail by Bordwell, George M. Wilson, Edward Branigan, and other prominent theorists. But this all still amounts to a fictional, represented world *in* a film work and not *of* a film as a whole and as an artwork. Clearly, to create a fictional narrative is already, at least in the institutional context of the cinema, to make art, in some broad sense. However, although the fictional and uniquely cinematic world-in can be seen to represent a crucial and creative *selection* on the part of the work (or, more precisely, the filmmaker) from aspects of the "real world," the aesthetic experience, meaning, and value of this selection can only be determined holistically. Such will be a matter of the interface and interaction between these representational and fictional aspects and other nondenotational, nonnarrative features and intentions manifested in films. Moreover, any attention paid by the filmmaker to these connections or copresences will already be moving well beyond the denoted and the diegetic in or for itself (i.e., in Souriau's, Metz's, and Burch's original sense).

To reiterate, a film's fictional-represented reality, or *world-in*, is logically and ontologically autonomous and ideational yet still schematic, heavily real-world dependent, and in itself aesthetically incomplete. Constituting but one referential level of a cinematic work, its nature compels us to recognize the profoundly *leveled*, multiaspect (or dimensional) character of films. This in turn points to the advisability of a topological model of the cinematic work, in accordance with which the fictional world-in is but one level or layer, however important its presence or use with respect to the artistic meaning and interest of others. I use the term topological here in a quasi-scientific or mathematical sense, as referring to how the constituent parts or levels within a structure or system are spatially interrelated to both each other and the whole. Of course, such spatial arrangement of cinematic ingredients is not to be taken as literal, or confused with the composition of film images, or as separable from temporal, dynamic aspects of films in their event-like progression and character. Crucially, these different registers or levels of meaning and to some degree attention—diegetic and nondiegetic, literal and figurative (in different ways), fictional and nonfictional—may be present in what are the *same* sensible forms, signs, and perceptual vehicles, whether visual or auditory, simple or complex. Consequently, and for reasons to be further elucidated, despite this appeal to "levels," in these respects it is

perhaps better to approach both the film image and the cinematic work as a whole less like layered geographical strata and more in the nature of a complex, chemical mixture of formal and differently oriented symbolic elements, which remain for the duration of each film in fluid, temporal interaction. Although the represented world-in is but one level or aspect of a cinematic work—if, admittedly, the necessary or foundational basis for many others—viewers, in watching films, no less than theorists and critics in analyzing them, may by conscious choice, by mere habit, or by what amounts to mainstream cinematic conditioning, engage almost exclusively with it, and with the fictional narrative with which it is closely bound.

Some filmmaking modes, or types of narration—such as what Burch defines as the (now) ubiquitous "Institutional Mode of Representation" and the particular version of it at work in classical Hollywood cinema (as founded on the power of the "diegetic effect" of psychological, if not strictly perceptual, illusion in the represented dimension) together with what Bordwell analyzes as "classical film narration," which encourages viewers to see a film "as presenting an apparently solid fictional world"—may in various ways prescribe or emphasize such engagement.[50] And this attention to the fictional-represented world-in a film, as an in- and for-itself reality, may be maintained throughout a film's entirety or change during its experience in accordance with the strength and direction of individual viewer attention. Yet every film, regardless of its representational mode or general type of cinematic narration, still possesses the extranarrative (and extrarepresentational) levels and meaning dimension(s) here recognized, at least for all viewers attuned and attentive to them. These levels and dimensions are rightly associated with the artistic (or "aesthetic") features and capacities of films not least (but also not only) in relation to the affect they generate.

If the existence of such distinct but interrelated levels of meaning and attention in a film work is acknowledged, many sorts of recognized features of films may occupy one or more such "positions," or they may change, unpredictably and creatively, from one to another. So music, images, words, and sounds originating in the represented fictional reality (or with a discernible source there) can be seen to expand outward (or perhaps upward, as it were) to be or to become (as a film develops) part of its allusive or allegorical or reflexive or attended to technical and formal dimension. This point was made earlier (with reference to Perkins) in

relation to the self-reflexive relations sometimes obtaining between the fictional world-in a film and its particular cinematic (audiovisual) presentation. Another, more specific example concerns the "free indirect" or "mindscreen" presentation that filmmaker and theorist Pier Paolo Pasolini and, subsequently, Bruce Kawin and John Orr each have discussed in relation to postclassical cinema.[51] Bypassing the use of more conventional subjective point-of-view constructions, in films like *Red Desert* and *Three Colors: Blue*, this involves a disturbed central character's mental state or perception of *his or her* world (that is, the fictional, represented *world-in*, insofar as it is known to the character) gradually taking on a more global, meaningful, and objectified correspondence with specific audiovisual or structural features of the *world-of* a film work (e.g., as pertains to its color, rhythm, editing, soundtrack, etc.). In these cases such a correlation (assuming the aforementioned difference) between fictional-representational and formal-presentational features, and their levels, is not "invisible" in any sense, as perhaps in some more conventional films. Rather it is recognized and contemplated by attentive and artistically appreciative viewers and is very likely intended to be so recognized, in drawing attention to itself as an artistic and stylistic feature (meaningful as such)—in addition, that is, to this presentation also conveying and explicating the psychology of characters and their actions.

In sum, we have now started to develop a clearer picture, at least intuitively, of what the suggested world-of a film (as distinct from the world-in that it includes) may be seen to comprise. Represented and fictional realities, and the larger story-world of which they are a part, are contained within it in the manner of an active, functional, and interdependent integration toward specific artistic ends (with such integration obviously lacking from nonnarrative, abstract, and experimental films). While the fictional reality constructed and communicated is fundamentally *representational* and denotational, the world-of a film—as corresponding to the totality of a cinematic work as made *and* as experienced—should be thought of as (also) fundamentally *presentational*. Although the former has the uniqueness and stability of a representational schema that must be completed through viewer attention and knowledge, it is the latter—typically *when combined with representation*—that possesses much of the perceived singularity of form, affect, and nonliteral meaning associated with works of art, be they paintings, poems, dance performances, or films. Whereas, further, as both represented and imaginary, the world-in,

on its own terms possesses "only" a represented and fictional time and space (i.e., that of a story), the world-of also possesses an *actual* time and "space" (that of a film, and the images it comprises, as screened or projected), and also, as will be discussed in detail, an *experiential* or durational time (with some space-like properties). As we have already begun to see, but as I will attempt to show further, the very fact that the fictional world of a film and its represented events are enclosed within such a created and experienced spatial-temporal world of a film qua artwork—that I will refer to henceforth as a *film world*—has significant implications with respect to the theorization of cinematic emotion and feeling (or affect, more generally), temporality, immersion, reflexivity, authorship, and interpretation. In short, this "film-world hypothesis," as it might be termed, is a fertile one, with the potential to help us conceive of narrative film works in new and more illuminating ways.

The common theme that attaches to the approaches and positions surveyed in this chapter is that while all contribute something essential to its proper theorization, they are too limited to better encompass the full aesthetic dimension of a cinematic work and its world considered in more than (potentially reductive) fictional-representational, narrative, perceptual, and phenomenological (or neophenomenological) terms. They shed substantial light on some aspects of film art at the expense of leaving others largely in the dark. But this review of (what are for the most part) past and current semiotic, narratological, and some contemporary experience-based (phenomenological) approaches in film theory has been necessary, given the need to explain the principal differences between the "world" of a narrative film, as here conceived, and other uses and understandings of the term and its description, not only in the study of films but in literature and other arts. Moreover, the differently oriented film-world concepts and models we have discussed raise major theoretical and philosophical issues that must be dealt with in this context. Perhaps foremost among these is the kind and degree of autonomy, alterity, and singularity of films as artworks vis-à-vis noncinematic experience and human-occupied sectors of the "real world." The latter bears most importantly on processes of transformation at work in all filmmaking, together with what is transformed, and the effects and experience of both. An account of the worlds-of as distinct from the worlds-in films must also address, however, the spatial, temporal, and affective absorption and immersion, so undeniably pronounced in the film-viewing experience, which certainly includes, but

is far from limited to psychological and emotional engagements with fictional people, places, and events.

Yet before we can treat all of these subjects in greater detail, we must now start over, in some sense, and address more fully, and in more positive rather than negative (or critical) terms, the fundamental question of why it is at all advantageous and, as I contend, even necessary to think about cinematic works as creating and presenting symbolic-affective and artistic worlds (for experience) in the first place.

PART II
WORLDS OF SYMBOLS

THE FRAMEWORK OF WORLDS

Symbolization, Meaning, and Art

IN THE FIRST CHAPTER I ACCEPTED WITH CERTAIN QUALIFICATIONS the view widespread among theorists and philosophers that most films classified as narrative ones project fictional realities that serve to ground the existence and actions of characters in a relatively comprehensible time and space—and that in this special sense films (in common with literary narratives and perhaps certain other representational art forms), construct and possess "worlds." But, taking into account not only their narrative structure and fictional contents but other aspects, not least of which are those elements that are, broadly speaking, perceptual, formal, affective, and otherwise extranarrative, I have also offered the suggestion that, to an unprecedented and perhaps unique degree among works of fiction, films not only contain but *are* worlds. To be sure, these entities are more in the nature of virtual than material or physical realities, existing (as we say) on a plane of shared human intentions, invoking the imaginative responses of viewers.

Yet even granting this much, what justifies the stronger claim that in speaking of the worlds of films, we are speaking, in some sense, literally, as distinct from entertaining *no more* than a suggestive metaphor? How does a two-dimensional play of light and shadow translate into such a

"global," enclosed, and singular reality? After all, as even the sympathetic reader may be inclined to point out, although some of us may seem to live *for* films, no one is quite able to literally live *within* them in anything like the intriguing ways in which a number of films have imagined.[1]

In this chapter I will attempt to further articulate and defend the concept of film worlds by introducing a general perspective in the philosophy of culture and art that affirms the perceptual and symbolic construction of not only many kinds of artworks but other sorts of social and cultural realities (and, in some senses, human "reality" itself). Like the heterocosmic model but with different emphases, this view suggests that, as known and experienced, these can and should be conceived—and experienced—as singular worlds.

Some General Features of Worlds

In reflecting on what the world of ancient Rome, the fashion world, the world of cyberspace, the fictional worlds discussed in the previous chapter, and a great many other worlds all have in common, it becomes apparent that the English word *world* is an unusual and intriguing one. The *Oxford English Dictionary* lists more than twenty-five primary definitions. The broadest and most all-encompassing refers to the earth ("or other heavenly body") as the physical totality first charted in its full extent by the great explorers and cartographers of the sixteenth century.[2] According to a number of its relatively more modern definitions, however, as in the worlds mentioned above, the term refers not just to the globe that we all inhabit, or to any other potentially habitable planet, but to specific dimensions of the *life* of human beings who possess a common culture—or, hypothetically, the alien cultures of alien beings, as in the "strange new worlds" of *Star Trek* and other science fictions.

Along these lines, and reflecting a similar distinction made by the ancient Greek philosophers, both Heidegger and Gadamer (whose writings on art we will have occasion to return to) distinguish between a cultural "World," as the realm of human intentions and actions, and the naturally given "Earth" (Heidegger) or "Environment" (Gadamer), as the material substructure that supports and sustains (but also limits and constrains) human actions and possibilities.[3] As this broad distinction reflects, in speaking of such worlds as those of art, literature, sports, politics, business, and various academic and scientific disciplines, we are not referring

to any preexistent material or biological realities but rather to the shared works and products of human minds in the exercise of their cognitive, affective, and creative potentialities. In this primarily cultural sense or senses of *world* there is always an implied multiplicity: *the* world becomes many *worlds*, denoting (again from the *OED*) a "particular division, section, or generation of the earth's inhabitants or human society; with reference to their interests or pursuits" (or, alternatively, "a group or system of things or beings associated by common characteristics" denoted by a qualifying word or phrase).[4]

The existence of such common frameworks of meaning and action implies that the particularly human version of Reality-at-large may be carved up into different sections or areas, or partitioned into compartments, separating sets of events or experiences from one another. Such divisions occur on the basis of ideas, plans, purposes, and values as much as on any physical or geographical facts. In many contemporary academic disciplines and intellectual discourses the pluralism of worlds in this sense is frequently acknowledged, as it perhaps cannot fail to be, under modern and postmodern conditions of inquiry. But this occurs most often only implicitly, as a kind of background assumption of all specialized or technical ways of thinking, speaking, and writing. Broadly speaking, one of the most compelling (if also challenging) aspects of the experience of modern social and cultural life is that of a vast multiplicity of worlds, beyond the capability of the individual even to list, let alone to participate in. These worlds organize, divide, and frame the phenomenal appearances and meanings of things in many different ways. While some worlds are the products of collective cultural activity and intentions spanning generations, others, like the worlds of films, are the deliberate products of a small number of individuals or the creative offspring of a single, fertile imagination.

Worlds, in this cultural sense, then, including those created by filmmakers, have an external, extrasubjective, and social existence. As such, they are distinguished from the internal, private mental realm(s) of the self, as well as what phenomenological philosophers refer to as the *Lebenswelt* (lifeworld), not least because any number of distinct worlds of experience may either be a part of, or totally absent from, a single individual's consciousness and putative lifeworld.[5] Yet while always intersubjective and possessing some external, physical basis or grounding, the worlds under discussion are never material or physical realities (alone)

in the way that natural or physical spaces and places are. Indeed, almost all worlds that may be pointed to as existing within present or past cultures have, instead, a highly composite character. They reflect a meeting of material and "spiritual" forces of the very sort that human beings—and works of art—may also be said to possess.

Films certainly have such a necessarily dual, ontological status, as not only intention-bearing but "embodied" or "incarnate," in the ways argued by Margolis, for instance, with reference to all artworks.[6] That is, they comprise both material and directly sensible phenomena, as well as a range of psychological and ideational (that is, perceptual and conceptual) aspects—significations, ideas, beliefs, histories, traditions, and so on— that bring their emergent nature to the plane of our common mental and emotional life. The relations and interactions among these fundamental dimensions or components of worlds may be quite complex, and they establish their own unique patterns, given basic objective parameters of space, time, and causation, on one side, and our cognitive constitution and subjective conditions, on the other. The purely physical support structure of worlds may be quite minimal: the words of a book that, when read, manage to bring an entire fictional world into existence or a few props and background settings for a dramatic performance, sufficient to evoke our often latent but powerful "imaginary forces" (as famously called forth in the prologue for Shakespeare's *Henry V*).

Worlds are discrete and singular, yet they also clearly overlap with one another, more or less extensively, as if to form extended families. And certain numbers of them share the same contents (people, places, objects, representations), which may be integral parts of more than one world. The existence of multiple worlds (actual, and not merely logically "possible") entails that they are bounded or framed, that is, that there are physical or psychical borders that divide one from others. The worlds of films are bounded by the physical border of the screen, the filmstrip (in celluloid filmmaking), and the camera's viewfinder; the experiential boundaries of cinemas, or movie theaters (in traditional film viewing); and also the psychological boundaries of relevant, common beliefs and attitudes of viewers, such as, for example, that the two-dimensional action of the film is not physically contiguous with the three-dimensional space occupied by the viewer's body.

Not all cultural artifacts, perceptual objects, and purposeful activities amount to worlds, since most, in fact, are constitutive parts (more or less

central) of a world, or of many. Pragmatically speaking, and as Goodman—the leading philosophical advocate of "world-theory" in the arts and sciences, alike—maintains, whether or not a given symbolically constituted reality qualifies as a world of its own ultimately appears to come down to whether the experiences associated with it are illuminated by being conceived in such a way (together with precedents and expectations of historically given cultural and linguistic practices).[7]

In addition to having borders and an internal coherence and unity, a world in this most general sense must, it would seem, be (or appear to be) not adequately reducible to, or fully explicable in terms of, any set of intentional phenomena external to itself. (For if it could be so reduced or explained, it would, instead, be regarded as forming only part of some larger world-like totality). However, while worlds are marked by a pronounced structural and experiential alterity, in being other than or different from one another, the perceptual, cognitive, linguistic, or other boundaries between and among worlds are always only partial, relative, and shifting (and there may be uncertainty concerning exactly where a world begins and ends).

Continuing with this partial list of attributes considered in abstract terms, a world would appear to be a unified whole with distinct parts or aspects. Its unity is profoundly holistic in that it is more than one of the sum of the parts considered as parts. This is the case because each world sustains a unique network of internal relations, including such basic relations as meanings, or the symbolic significance that attaches to objects, events, and behaviors (and that may be found in *that* world and perhaps no other). Worlds also possess, or create, a location or setting where something, most typically concerted actions and interactions, happens (either in perceptual or bodily reality or, as we say, in imagination). This consists of some demarcated spatial or quasi-spatial area or dimension that helps to define the objects and activities present. Of particular importance in the cinematic context is that such spatiality may be virtual and non-three-dimensional in physical fact, as in the case of other imaginative, perceptual, or representational spaces. Finally, worlds are structured or ordered in many ways: they harbor cognitive categories of their own, often but not necessarily shared among other worlds, and recurrent patterns of action governed by accepted beliefs, norms, values, and so forth.

These features of cultural worlds in general—consisting of various admixtures of *mind and matter*, the *sharing of contents* (or "materials") among

them, the qualities of *singularity, boundedness, irreducibility, a whole with distinct yet integrated and functional parts, alterity, actual or virtual spatiality, forms of order and rule-governed activity*—are found, on reflection, to have a prominent place in the specially created and experienced worlds of films on multiple levels. In fact, a number of these features have already been broached in the first chapter, in relation to the differences between the *worlds-in* and the *worlds-of* narrative fiction films. Their more specific, cinematic manifestations and consequences will continue to have an important part to play in the discussions of the artistic structures, features, and elements of films that follow.

Yet it is clear that conceived only in terms of such abstract properties, worlds are still essentially empty, lacking any concrete "content" by which alone they can have an actual existence as experiential realities for inhabitants, members, players, viewers, and others who in some way share them. At a fundamental level, whether relatively more virtual or actual (e.g., in accommodating the presence of our bodies), all worlds in our present conceptions are composed of signs and representations (whatever else they contain). They always involve and require the *symbolization* of aspects of concrete, immediate sensory experience. In fact, as both Goodman and the neo-Kantian philosopher of science, history, and culture Ernst Cassirer have shown to great effect, all worlds in the sense that I am attempting to describe and define may be properly qualified and spoken of as symbolic.

Signs, Symbols, and Artworks: Three Traditions

Compared with other animals man lives not merely in a broader reality; he lives, so to speak, in a new *dimension* of reality. . . . No longer in a merely physical universe, man lives in a symbolic universe. Language, myth, art and religion are parts of this universe. They are the various threads which weave the symbolic net, the tangled web of human experience.

—Ernst Cassirer

To simplify greatly, but not inaccurately: throughout the latter half of the twentieth century, and into the twenty-first, two approaches in general semiotics have dominated scholarship in the humanities and social sciences. What they share is a concern generally, and paradigmatically, with all phenomena of intersubjective *messaging*, anchored in the fundamental

capability of an individual to make mental *associations*, which are raised to the level of intersubjective communications and the development of systems (or *codes*) for sharing intentions. This much applies not only to so-called natural signs and our varied responses to them but conventional relations among conventionally established signifiers and their purported objects. Both traditions hold to the insight that the study of such pointers and surrogates for aspects of direct experience is fundamental, a major key to our understanding culture and our claims to knowledge. From this common and now familiar ground, however, the two modern traditions in semiotics (or semiology) and several distinct intellectual paths within them, diverge.

What may be termed the "pragmatic-instrumentalist" tradition and paradigm has its root source in the seminal writings of the American scientist, pragmatist philosopher, and polymath C. S. Peirce. At the heart of much recent linguistic semantics and philosophy of language, the pragmatic-instrumentalist view favors so-called communication models of symbolic reference and tends to be empirically based and naturalistic (or "precultural") in orientation. Ultimately, in this view, signs of all kinds owe their existence to the survival needs for cooperation among the individual members of our biological species. They are conceived as cleverly invented tools that facilitate the sharing of subjective intentions, thus allowing for common understandings and concerted actions in a physical, Darwinian environment, translating into multiform social behaviors that are distinctly human.[8] Peirce's theory of signs, and its general orientation, may be considered at least one progenitor of some contemporary, naturalistic, and empirically based approaches in some disciplines within cognitive science. Through this route and others, this first tradition also exercises present-day influences in cognitivist or perceptual approaches to a range of issues and problems in the philosophy of art and film and in some film theory.

With reference to the latter it should be noted, however, that there is also much wider general agreement among film theorists of various stripes that film images in their communicative dimension frequently possess characteristics of all three of Peirce's canonical, major sign types: icons, indices, and symbols.[9] They may, in other words, stand in the *iconic* relation of perceptual resemblance insofar as they "merely" denote the objects they "contain"; an *indexical* relation insofar as many of their properties are determined by photographic and related causal processes or

conditions, forging an "ontological link" between object and referent; and (generally closer to our main concern in relation to cinema as art) a *symbolic* relation insofar as they evince culturally and cognitively mediated connections to what is potentially the entire realm of human-recognized, intentional (mental) objects. Thus, no matter how remote it may also sometimes seem from specifically artistic realities and issues, this tradition (like its main rival) has valuable insights to contribute to a theory of the worlds *in* and *of* films and to cinematic art.

The other dominant and to some degree philosophically opposed tradition, as it were, traces its origins to Saussure's linguistics and largely (although not entirely) French structuralist and poststructuralist thought. It has exerted an enormous influence on cultural anthropology, sociology, psychology, and cultural and literary theory. As is well known, this large branch of semiotic theory centers on relatively autonomous systems of communication (symbolic structures) that are culturally and ideologically coded in various ways, above or below their immediate pragmatic and social-communicative functions. Such structures and codes, including languages and bodies of myth (and interpretive or ideological formations), as well as texts and other cultural productions are seen as rooted in the use of what Saussure has famously defined as the arbitrary sign. This is a sign that derives its meaning via its relation to other signs in a closed system rather than through any "natural" perceptual correspondence (e.g., verisimilitude) to the empirical reality to which it refers (or, more accurately, to which actual speakers choose to apply it). For many theorists within this second broad and historically ramified tradition, the collective signs and codes existing within systems of communication are cultural and ideologically freighted; they shape, and often constrain, human thought through the propagation of certain binary distinctions and dichotomies, for instance. Such processes, operating in one way or another in all cultural media and artistic production, including cinema, are often seen to reinforce particular worldviews, ideologies, and sociocultural narratives; one major task of the theorist is to identify and lay bare these structures for critical scrutiny.

Although Metz's Saussurean (and later Lacanian) semiotics is less concerned with the specific represented content of films vis-à-vis their cultural messages for audiences (the focus of most film semiotics), and more with the formal, narrative-cinematic and quasi-linguistic structures governing their presentation (in the form of a diegetic reality), it

has exerted a major influence in this theoretical vein. Metz's complex and, as some might argue, at times convoluted negotiations of the extent to which cinema might be considered and studied as "language" highlights that whereas the pragmatic-instrumentalist tradition was, from its very nineteenth-century origins, concerned with all nonlinguistic forms of communication (e.g., gestures, visual depictions) as much as discourse proper, the linguistic-structuralist tradition attempts to apply insights originally formulated in relation to linguistic semantics to other forms of cultural communication and representation, including the nonverbal arts.

Perhaps inevitably, insofar as narrative filmic representation is perceptual, or iconic, but also highly reliant on cultural conventions, within film theory there is also substantial overlap and intellectual hybridity between these two preeminently "naturalist" and "nonnaturalist" semiotic traditions. Peter Wollen, in his influential *Signs and Meaning in the Cinema*, for example, turns to Peirce and his famous classifications of symbols, icons, and indices to modify certain aspects of a still generally (and self-identified) structuralist account of cinematic communication and expression, thereby differentiating it from Metz's semiotics.[10] In a very different way, Deleuze's philosophy of film adopts Peircean concepts and vocabulary, which are innovatively combined with Bergson's theories of time, memory, and imagination—all in a way explicitly distinct from, and critical of, structuralist and semiotic approaches to cinema in the Saussurean tradition.

However, often overlooked today, in film theory, as elsewhere, there is yet a third general tradition of thought on the symbolic construction of reality, bound to what might be called the symbolic-expressive—or, for short, "expressivist"—paradigm. German in origin, this approach descends from the philosophy of Kant and his immediate contemporaries and successors (e.g., Herder, Goethe) and runs through to the thought of Hegel and Alexander von Humboldt. In the twentieth century it is reflected in Cassirer's philosophical anthropology (articulated in his seminal, multivolume Philosophy of Symbolic Forms), Langer's aesthetic theory, and, in some important respects, Goodman's philosophy of symbolic reference, art, and "worldmaking." George Lakoff's and Mark Johnson's influential writings (jointly and individually) on the power of metaphor to shape our conceptual categories and, hence, to "make worldviews,"[11] has also been justly seen as a legacy of this Kantian and post-Kantian

tradition (which, within the fields of social theory and history, respectively, also counts Norbert Elias and Lewis Mumford, among its notable members).

As I have mentioned, the pragmatic-instrumentalist paradigm is anchored in empirical and naturalistic thought (in some respects behaviorist or neobehaviorist), stressing what are deemed to be species-wide, pan-human communications needs. Structuralism and its many successor positions are often associated with radical forms of historical, cultural, and epistemic relativism. The third tradition may be seen to occupy an intermediate position between the natural and culturally specific, or "normative." It has been concerned, since its inception, with the basis and rational justification of the *Geisteswissenschaften* (the humanities) and, as part of this post-Enlightenment interest, to identify the correct placement of art amid the major, symbolically conditioned avenues for the representation of human experiential reality.

This standpoint locates the origins of human signs of all types in certain processes of abstraction, classification, or categorization, taken by the mind with respect to the presentations of sense experience. As ubiquitous as pan-human symbol making and use is, it is regarded less as an aid and accompaniment to higher level perception and more reflective thought, as existing in some way apart from it, than one of its foundation stones or enabling conditions. Semiotic devices and constructions, in other words, are more than a set of exceptionally helpful and versatile cognitive tools, serving to make the natural environment more navigable; nor are they conceived as a highly consequential adjunct or addition to *already* fully formed minds and societies.[12] Symbols, in the broad and inclusive sense favored by this tradition, are, by contrast, the initial means and method by which an otherwise disarrayed, ephemeral, and generally chaotic sensory manifold comes to some semblance of organization and, therefore, to intelligibility. Rather than preexisting, or somehow preformed, that which is symbolized in one or another media of representation is only capable of formation and articulation on the basis of prior possession by the cognitive subject of schemes of categorization, that is, some so-called grid-work of interpretation placed over the deliverances of immediate experience.[13] From this originally Kantian perspective, then, the generic concept of the symbol, as already incorporating other sign types and functions, is not a reflection on pragmatic communication and its contexts, the ways and means of transferring and exchanging infor-

mation among subjects per se. Rather, it is the (arguably) logically prior representation (or categorization) of the immediately given material of sensible experience. Also distinguishing it from the structuralist-semantic model, the "symbolic" in this sense is not one form of code but the cognitive basis for the use of any code.[14]

It is this last-introduced general framework of ideas—as taken up in aesthetics and the philosophy of art, together with film theory—that offers the most promising support for an improved articulation of the *full* symbolic dimension of cinematic works and their worlds (or world-like nature). This perspective also converges with a prominent tradition of thought within film theory itself, focused on the symbolic basis of both basic filmic communication and cinematic art (as involving artistic "expression" in a number of senses). Here, as we will discuss shortly, we may find thematic unity and common purpose in the writings of such figures as Mitry, Pasolini, and Deleuze, who reject orthodox film semiotics, whether recognizably Saussurean or Peircean, as it is transmitted through relevant writings of Metz, (early) Barthes, (early) Wollen, Eco, and several other theorists. Mitry, Pasolini, and Deleuze each see Saussurean semiotics as failing to sufficiently appreciate, or engage with, the "expressive-constitutive" and pre- or protolinguistic grounds of symbolization in cinema. Prior to pursuing this subject in detail, however, and as one final preliminary to it, it is well worth devoting the remainder of this chapter to some of the specific, cinematically relevant insights concerning symbolization and art that the tradition in question, as it developed through the twentieth century, has offered.

Symbolic Forms and Feeling

Exerting an important intellectual influence on figures as diverse as Albert Einstein and art historian Erwin Panofsky, Ernst Cassirer has recently been called a "singularly important and underappreciated thinker" both as a philosopher and as one of the greatest twentieth-century intellectual historians.[15] Attempting a grand synthesis of Kant's critical Idealism (positing innate mental categories of understanding) and Hegel's conception of the historically evolving human mind or spirit (*Geist*), his extension of the aforementioned expressivist paradigm with respect to conceiving the nature and function of symbolic thought eventuates in a position today often referred to as "cognitive pluralism."[16]

Cassirer maintains that our symbolic categories, which have their original root in "expressive, non-verbal symbolism,"[17] free the human subject (or potential subject) from the immediate conditions of moment-to-moment, here-and-now experience characterizing a precultural, or natural, presumably animal mode of existence. Myth, language, art, religion, and science as the symbolic forms, or basic cognitive orientations that Cassirer identifies, are seen to emerge progressively and to supplement one another in collective mental development. Given general spatial, temporal, and other structuring principles of the mind, each symbolic form is predicated on a distinctive set of relations among the human subject, the intentional symbol, and the symbolized object or phenomenon. In truly dialectical fashion, these symbolic channels represent the ways in which we come not only to know the world but also to know ourselves, through a pronounced *objectification* of direct perceptual and bodily experience. To create and use symbols, which Cassirer memorably describes as the "organs of reality" is to take up a position in relation to sensible reality that defines both reality and the self.[18] The focus in his version of *Lebensphilosophie* (life-philosophy) is not confined to just the thinking self, as a disembodied, so-called epistemological or Cartesian subject, but the integral feeling, desiring, and, above all, *expressing* self.

For Cassirer a symbol, no matter how abstract and conceptual, is in its actual use a concrete and stable externalization of individual expression, upon which all dynamic aspects of cultural life depend. Each of the major symbolic forms provides a kind of truth that the others (by virtue of their different cognitive structures) simply cannot reach. In this sense each has its own epistemic charter and value, as an interpretative mode or relation to immediately given sensation. In the case of the *concrete products* of the different major forms of symbolic thought and expression identified—for example, each individual work of art, scientific model, and mythic tale—these different, basic modes of human symbolic relation to experience are combined with (a) a particular content and subject, and (b) a unique mode of presentation and structure; the latter is readily accessible to our faculties of perception (as it must be) but also partly dependent on the nature and properties of (c) the physical medium of symbolization in question.

Art, for Cassirer, is historically rooted, like myth, in "expression" proper (*Ausdruck*). At first closely combined with but then gradually separating off from language (as "representation" or *Darstellung*) and myth (as

Lévi-Strauss also maintains), art comes to be fully recognized as an autonomous and coequal form of expression and cognitive representation.[19] In his view the symbolic representations (and interpretations) that we (properly) recognize and appreciate as works of art are among the most exemplary of all symbols, with regard to the accomplishment of the primary symbolic function of mediation between our direct sensations and our self-conscious reflections. That is, they are found to be situated midway between the Kantian poles of the human mind of "sensibility" and "understanding." Indeed, although there is some precedent in Hegel's aesthetics, Cassirer is seemingly original in theorizing the work of art as a kind of intermediate, Janus-faced symbol, pointing to both itself and its subject of representation simultaneously. It rests approximately halfway between the concrete and qualitative, but only vaguely self-referential and self-centered, protosymbols of myth, ritual, and religion, on the one hand, and the fully "self-conscious" but also arbitrary (or "free") and self-effacing ("transparent") symbols of rational discourse, wherein individual, signifying elements are entirely system-dependent or bound in both their syntactic and semantic relations (e.g., the fully developed linguistic sign), on the other.

The most relevant difference between myth (and to some degree religious thought and feeling) and art, as symbolic forms per se, lies in the fact that the expressive images of the latter always involve (some degree of) awareness of the constructed and mediated nature of their represented realities, on the part of both artwork creator and perceiving subject. Such a self-consciously mediated presence of the object-image in the work of art, and that which it represents, is thus, for Cassirer, of a different order than in mythic expression.[20] The symbolic form and, by extension, the created worlds of art claim for their audiences a truth, to be sure. But this is much less a direct and literal truth than that which the products of the vast domain of what Cassirer terms the "mythic consciousness," past and present, claim (and also notably different from the sort of objective truth that scientific representation allows for). In this account, if aesthetic symbolism instead seeks truth only "within appearances," it is also very typically, if not invariably, suffused with a pronounced affective content. For art has not wholly relinquished its aboriginal ties to a mythical consciousness that is a preconceptual and prerational one, entirely lacking any general separation of fact from value, or concepts or propositions from subjective feelings, attitudes, desires, and so forth. It

should be noted that despite its stress on feeling in art, this view contrasts with the so-called Canonical Expression Theory of art, associated with the aesthetic idealism of Benedetto Croce and his followers, wherein the genuine artwork is seen to exist not in the physical world but in the mind of the artist whose feelings it expresses through the work as but a conduit for them. As Cassirer argues, however, this is to neglect the full input of the medium and of formal structure in art.[21]

Coming closer to our primary concerns, it was left to Langer and Goodman, two North Americans in the analytic philosophical tradition, to substantially build on Cassirer's positioning of art as among the major symbolic forms of representation, in ways that are only touched on by the Weimar philosopher. While both later thinkers incorporate these major insights into much more detailed and developed theories of the subject, they draw different lessons and proceed in very different (if at points also intersecting) directions. Whereas Goodman pursues the primarily perceptual, formal, and rational orders and structures of artworks in their reality-shaping power and in the form of singular worlds constituted by processes of symbolic reference relations, Langer pursues the realm of subjective feeling and its objective expression in the essentially "presentational" form of art (which even extends, in a particular way, to literature).

A student of Cassirer, as well as a translator and interpreter of his work, Langer sees Cassirer's understanding of symbolization as "hewing the keystone" for a new aesthetics.[22] In her *Philosophy in a New Key* and *Feeling and Form*, two canonical, if today far less frequently cited and discussed, works of twentieth-century aesthetics, she argues that it affords the basis for a more comprehensive and persuasive expression-rooted theory of art than had previously been forwarded. The realities that works of art symbolize and present are, for Langer, aspects of the life of subjective "feeling," defined as nothing less than all human experience, which defies satisfactory articulation in language as the cognitively dominant, discursive form of representation.[23] In general accord with Baumgarten's central "heterocosmic" distinctions, yet still stressing the "rationality" of art, she holds that while also selectively abstracting from, objectifying, and thus transforming experience, the "presentational" (analog) symbolic mode of art does so in a fundamentally different way than do language and logic as "discursive" (digital) symbolism (or, indeed, than do nonartistic visual and environmental signs and signals).[24] In marked contrast to Goodman, whose cognitivist aesthetics focuses on the artwork as a com-

plex network of symbols (in various kinds of more or less direct reference relations), a work, in Langer's view, is a *single* indivisible "symbol," or objectification, of subjective feeling given fixed and external form. As existing in a concretely realized object or performance with a special aesthetic sort of existence, such feeling is thus amenable to intersubjective access and reference.[25]

The brief appendix of *Feeling and Form* is entitled "Note on the Film." It represents an ancillary effort on Langer's part to make a place for cinema within her general philosophy of art. Despite a film's photographic and indexical ties to the physical reality before the camera, and its narrative and dramatic aspects, she sees cinema as, like all art (representational and abstract), a matter of the objective conveyance of subjective (felt) reality. Looked at critically and with the benefit of hindsight, Langer's account of cinema is suggestive and flawed in equal measure.[26] One of its main merits is a stress on the fact that a film work as a whole is a form of "presentational symbolism" that transforms its represented contents (taken from the world of actuality). Beyond the verisimilitude of cinematographic representation (in and of itself), it creates and sustains an artistic "illusion"—in the very specific sense of a virtual, highly affective, and immersive aesthetic reality, or "appearance."

In keeping with Cassirer's philosophy of symbolic thought, Langer also rightly (if somewhat implicitly) upholds the crucial distinction between the medium of cinema and its "formal" (i.e., artistic) uses, with the admission, however, of certain necessary constraints and advantages the latter places on the former in the interests of artistic creation. As Carroll has discussed, the crucial distinction in question has periodically been overlooked or marginalized in film theory. This has frequently come at the price of avoidable confusions and misplaced reductions of properties of cinema's creative use (formal, artistic, narrative) to medium: prompting, for instance, Carroll's proffered slogans for film theory of "forgetting the medium" and of attending to "*use* rather than *medium*."[27]

Finally, while the symbolic dimension of film worlds on which I will elaborate is closer to Goodman's aforementioned understanding of a work of art as a complex *network* of interconnected referential functions (symbols), it equally supports (and is supported by) Langer's contention that an artwork, as a whole and as experienced, conveys, through a presentational mode of abstracting and objectifying symbolization, a unique, embracing, irreducible, and work-generated "feeling." This view

anticipates Dufrenne's more or less simultaneous (but independently ar-
rived at) concept of total aesthetic expression and the world atmosphere
of an artwork, as well as what I will later describe as the "world-feeling"
of a cinematic work.

ART-MAKING, FILMMAKING, AND WORLD-MAKING

Nelson Goodman begins his study *Ways of Worldmaking* with an ac-
knowledgment of his intellectual debt to Cassirer's philosophy of sym-
bolic forms (via Langer's translations and advocacy).[28] From one vantage
point Goodman's scheme of major symbolic relations, or functions, as
first advanced in his highly influential *Languages of Art*, is a kind of ab-
stract formalization of much of what Cassirer earlier argues concerning
differences and similarities between art and language. This includes the
ways in which at certain times, and in certain contexts, symbols may refer
to their own properties (what Goodman refers to and theorizes as *exem-
plification*). With good reason Paul Ricœur has suggested that in some
respects Goodman both extends and radicalizes Cassirer's account, in
arguing that language, science, and art are constituted by different con-
ceptual and symbolic systems that construct worlds (or specific "versions"
of the world) according to the functioning of the cognitive and referential
categories and frames of reference particular to them.[29] The underlying
unity of these most fundamental forms of representation is preserved in
Goodman's view, however, by the common presence of the same basic
types of symbolic reference relations that he identifies (viz., denotation,
exemplification, expression, and allusion).

Yet, and as he stresses, Goodman approaches the problems of art and
art-making with a very different philosophical orientation, seemingly
far removed from the critical idealism of Cassirer and the naturalistic
"life-philosophy" of feeling and art espoused by Langer. As advised in
the explanatory preface to *Ways of Worldmaking*, whereas Cassirer's ex-
plorations of symbolic forms are deeply historical and anthropological,
his own approach to the concept of a vast plurality of symbolically cre-
ated worlds is formal, analytic, and synchronic. It is, in other words, al-
most completely ahistorical, as well as intentionally "nonintentional" (in
philosophical parlance)—that is, nonpsychological—in orientation. As
a logically minded Humean empiricist, Goodman addresses the inter-
actions between "nonverbal symbol systems" from the vantage point of

his particular brand of philosophical analysis, as rooted in a pronounced nominalism in logic and ontology.[30]

Providing sometimes radically different, even seemingly opposed, ways of ordering and rendering experiential or empirical reality more comprehensible, worlds, for Goodman, are made entirely of symbols that function together within larger systems. Each such system, or scheme, presents a distinct but potentially "right"—that is, explanatorily sufficient, coherent, and illuminating—version of reality, or "the way things are."[31] There is no means of reducing such different world-versions to a single set of master symbols or concepts, a set that, in any case, would have no more direct relation to a precategorized reality than the versions in question.[32] The focus on the making, perceiving, and understanding of the symbolically constructed worlds to be found in the arts and sciences alike both supports and is a consequence of the major theme of Goodman's aesthetics, that "the arts must be taken no less seriously than the sciences as modes of discovery, creation and enlargement of knowledge in the broad sense of advancement of the understanding" (102).

With its romantic-sounding ring and suggestion of godlike or Faustian powers of creation out of thin air (or "nothing but symbols"), the title of Goodman's cited study can be somewhat misleading. "Worldmaking," as a cognitive activity, as well as sometimes also a practical or technical one (involving, as in the case of art, physical and material realities) is primarily a matter of creatively transforming chosen features of cultural realities that *already exist*. Goodman stresses that just as scientific worlds, and our "everyday, practical" worlds are built on or over their historical predecessors, so, too, are specially, self-consciously made artistic worlds created from parts of other, older ones, as well as the established, external realities to which they refer (17). Thus, from a comparative perspective, at least, world-making in art is always fundamentally a "remaking," whereby the worlds of existing artworks, and other relevant symbolic worlds or world systems (and the patterns and conventions that they have established) are transformed in accordance with the artist's intentions, skills, and individual style (6). Through such transformations and innovations (often beginning with the commonplace), new artistic worlds are founded, bringing with them new interpretations of that which is most real in experience.

Ideas similar to those proposed by Goodman have inspired numerous twentieth- and twenty-first-century artists working in many forms and

media, including experimental and narrative cinema. Supported by their various writings and pronouncements, which build on central tenants of classical formalist film theory (including those found in the writings of Arnheim and Eisenstein), so-called structuralist filmmakers Hollis Frampton and Michael Snow, and the innovative *nouveau roman* novelist-screenwriter-director Alain Robbe-Grillet, have recognized (it appears) a particular kinship between the view that experiential reality (as well as knowledge) is the result of an unending, humanly relative process of symbolic construction and the idea that cinema is a particularly powerful and multifaceted means for making new perception- and reality-shaping orders and schemas also amounting to (as I claim) new worlds. In the works of these filmmakers such worlds, or world-versions, are created through a highly creative use of editing, camera movement, zooming, and framing, in particular.

Peter Greenaway, however, provides perhaps the clearest example of the translation of these general, symbol-centered themes and ideas into filmic practice. Greenaway's approach to cinema, rooted in an evident preoccupation with symbolic representation, is deeply "antirealist" in the general senses of both the core arguments and the assumptions of realist film theory, as well as any philosophical position tantamount to so-called naive (or commonsense) realism. While he is on record as being inspired by French structuralist and poststructuralist thought in this respect, his films also (and without contradiction) provide a particularly clear and highly self-reflective example of filmmaking as symbolic "world-making" in Cassirer's and Goodman's senses. From early, neo-avant-garde works such as *A Walk Through H* and *The Falls* to later, more conventionally narrative ones, Greenaway's films, in both form and content, call special attention to artistic filmmaking as a higher-order creation of new forms and meanings, derived from the more extensively shared, suprasubjective, and fully formed materials of entire world systems made up of the individual "signs" of cultural life.

As numerous critics and theorists have noted, and as the director himself has suggested in interviews and DVD commentaries, at the center of Greenaway's cinematic corpus are the myriad ways in which symbol systems impose order on what is "naturally" disordered and unknowable, through objectification and repetition, among other means.[33] Their specific forms and subjects, drawn from the major symbolic forms of art, myth, language, religion, and science that Cassirer identifies, have

ranged from the theory of evolution (a paradigmatic taxonomical enter-
prise) in *A Zed and Two Noughts* to architecture in *The Belly of an Architect*,
mathematics and the iconography of sex and death in *Drowning by Num-
bers* to the seventeenth-century artistic, literary, and mythological arche-
types of the *Draughtsman's Contract* (figs. 2.1 and 2.2). For film scholar
David Pascoe, "above all, Greenaway's films offer an inventory of the tools

FIGURES 2.1 AND 2.2 The world as representation in Greenaway's *The Draughts-
man's Contract*.

for representation" and both present and reflect on numerous other "artificial orders and structures" through the lens of those cinematic ones that he, and other filmmakers, consciously create.[34] Yet in the context of fictions more or less fully realized, they also consciously foreground the *relation between and among* existing classificatory or representational systems and the ways in which such world-making schemas may be creatively combined in the medium of cinema, as its own hybrid vehicle of simultaneous cultural and individual construction, reflection, and expression. All of this is part and parcel of what has been variously referred to as Greenaway's "taxonomical" (Pascoe 21), "encyclopedic," "cartographic," and "museum film" aesthetic, one that has also been compared with that of Joyce, Borges, and British painter R. B. Kitaj in these respects (Pascoe 42, 52). Such an approach to film and art-making is also highlighted in the forms and contents of Greenaway's interactive artistic installations and exhibitions—as well as clearly signaled in some of their (Goodman-esque) titles such as "Some Organizing Principles" and "100 Objects to Represent the World" (Pascoe 204–6).

As his critics and supporters alike often claim, Greenaway's films are clearly far removed in form and content from a great deal of relatively more conventional narrative cinema, as well as many prominent "art cinema" styles. In ways to be discussed, however, and with reference (in chapters 4 and 5) to Goodman's epistemologically rooted theorization of art-making as "worldmaking," and the particular processes and major types of symbolic functions it is argued to involve, what Greenaway's filmmaking exemplifies about art and cinema as symbolic communication and expression amounting to creative transformation (as the foundation for the meaning and experience of his own films, and others) may still be justly considered paradigmatic of *all* cinematic world-making, from the most story- and character-driven to the most reflexive, conceptual, and abstract.

To pause now and take stock: I have offered in this chapter what may be considered a preliminary or background analysis of worlds as cultural and symbolic constructions. The position I have adopted is that works of representational art, including films to a preeminent degree, are in important respects continuous with such culture-forming and -sustaining domains of human meanings, interests, and actions: notwithstanding their primarily virtual as distinct from physical mode of existence. Cinematic works contain *signs* (capable of being conceived and analyzed in

accordance with various traditional semiotic approaches) but also make use of more interpretation requiring *symbols*. Moreover, cinematic works are *themselves* symbolic representations and presentations of experience taking a specifically artistic and aesthetic form. As the "third tradition" of reflection in general symbol theory that we have identified maintains, this involves self-reference on the part of films to their own created forms and experiences as objects of attention, as much as to their represented contents. While inescapably "cognitive," in the sense of involving, and greatly contributing to, reflective knowledge, neither in theory nor practice must the "symbolic form" of art, in cinema or elsewhere, entail any diminution of an artwork's feeling dimension. In contrast, in singling out the unique and characteristic properties of artistic symbolization (as distinct from other forms of representation), the expressivist tradition in question helps provide a way of seeing the intellectual and affective poles as not only entirely compatible and copresent but necessarily conjoined. Finally—and further supporting what I suggested in my overview of existing conceptions and models of films and (or as) worlds in the first chapter—the views here discussed also point to various processes of creative transformation and audience immersion as central to the dynamics of artistic world-creation and experience as forms of symbolic understanding and experience. Our next task is to examine the specific cinematic manifestations of these transformative and immersive processes and their observable results.

THREE

Cinema is a living medium when it forces the filmmaker to make the symbols by which he expresses himself come alive.

—Federico Fellini

FILMS ARE EXPERIENCED AND VALUED IN THE KNOWLEDGE THAT familiar realities are not only being shown but are being transformed, as if "before one's eyes." Without doubt there is no one recipe for artistic filmmaking. And creative originality on the part of a filmmaker, however explained, continues to differentiate films with more artistic merit from standardized cinema products designed for mass consumption, as but one of today's prepackaged and presold commodities for the delivery of leisure-time entertainment and little more. Granting this much, in seeking to better understand the symbolic transformations of experience inherent in cinematic art, we must address the sorts of processes that go into turning the highly disparate materials of filmmaking, drawn from highly disparate sources, into complex and "moving" artistic worlds (no matter how comparatively rare some of these processes and the artistic intentions behind them might be in the total cinematic landscape, past and present). In broad outline this is the focus of the present chapter, as well as the two following it. Yet to theorize further about the *how* and *why* of this transformation, we need first to identify *what* is transformed.

The question of what the basic, or "raw," material of cinematic art is, analogous perhaps to the words of a poem or the stone of a sculpture,

is as old as film theory itself. And there seems no one simple and un-equivocal answer. In a well-known 1934 essay, Erwin Panofsky argues that owing to its photographic basis, a film's material, which he somewhat problematically *equates* with the film "medium," is "physical reality as such," the arrangement and appearance of which the filmmaker works with and on for the camera.[1] Taking a contrasting perspective to Panofsky's, V. F. Pudovkin states in his classic 1933 essay "Film Technique" that a "film is not *shot* but *built* up" and that the raw materials of this creative construction are "separate strips of celluloid," already imprinted with photographic images.[2] Pudovkin's definition thus minimizes, or at least takes for granted, as it were, not only what Eric Rohmer has called "the camera's *foremost* power, to transfigure reality on the plane of shooting,"[3] but also the activities, choices, and intentions that precede the generation of images on those strips of celluloid and determine their content, as well as some of their meaning. A good deal of the difference between the classic realist and formalist positions in film theory boils down to the ideas that (genuine) film art consists of working on (or with) *either* the physical, material world and its given perceptual appearance *or* the images, sounds, and signs already abstracted from it (via the camera) and waiting to be creatively organized into meaningful and expressive forms on the editing table—or, today, use of a digital, nonlinear editing suite.

Even apart from the ways in which digital technologies and processes may now call this dichotomy between physical reality and camera-given images into question, it is deeply problematic. For the "material" of cinematic art must be seen to include both objects in the real world, as selected, arranged, lit, and framed for the camera, and the images it produces, which are, in turn, edited, retouched, and otherwise manipulated versions of this more extensive process, occurring in both celluloid and digital-video filmmaking, in both live action and animation. A concept of cinema as art must at least have the potential to accommodate these and a number of highly consequential preimage and presound recording stages of filmmaking: encompassing, for instance, screenwriting, location scouting, casting, production design, staging, lighting, framing, and any number of other activities, all of which are also fundamentally creative, transformative, and work-constitutive in their own ways. In broader terms, we cannot confine either the film artist's (or artists') material or his or her most significant creativity to any one stage or aspect of the clearly many-staged, highly complex, and collaborative creative process that

filmmaking typically involves.[4] Nor can the profoundly heterodox and irreducibly "composite nature of filmic material," in Burch's apt phrase,[5] be reduced to any one sort of thing.

François Truffaut's *Day for Night* (1973) is often celebrated for *its* celebration of what (with reference to the film) Diana Holmes and Robert Ingram refer to as the "transformational processes whereby film can absorb the most disparate elements of ordinary life, the most awkward and unexpected events," and endow them with a formal, fictional, and expressive significance.[6] In its primary foregrounding and exploration of the relations between "film and life," *Day for Night* not only shows the results of cinematic transformation but dwells on the pretransformed existence of its many materials, allowing the viewer to compare their onscreen and offscreen, pre- and postfilmic, modes of existence. In doing so, it constitutes only a more self-conscious and concentrated amplification of the inescapable comparative and contrastive dimension of *all* film viewing and interpretation (certainly of an aesthetic kind). This includes, but also surpasses, that constant "fiction-making" comparison on the part of viewers discussed earlier, as concerning the relation between the fictional, or represented, *world-in* a film and known facts of reality outside of it.

In *Day for Night* Truffaut himself plays the central character, the director Ferrand at work on an international production entitled "Meet Pamela," which is being shot in the French Riviera city of Nice. In one early sequence Ferrand is seen consulting with the film's prop man, Bernard, in the hallway of the hotel in which the cast and crew are staying. As evidence, if any were needed, of the multitasking ability possessed by, and often required of, filmmakers, Ferrand, while conversing on another matter, notices a vase sitting on a table. Finding it suited for a particular interior setting in "Meet Pamela," he requisitions it for the film in progress (as we may perhaps surmise, Truffaut also requisitioned objects unexpectedly discovered during the shooting of *Day for Night*) (fig. 3.1). Indeed, Ferrand's action is testament to that perpetually appropriating gaze of filmmakers, for whom every aspect of life is an open field of material to be captured and used, sometimes rather ruthlessly.[7] Later in the film, the vase is shown in its new home on the set of "Meet Pamela," decorating the character Séverine's (Valentina Cortese's) dining room, while a sequence of the film-within-the-film is being shot.

Holmes and Ingram note that the vase is a "doubly fictionalized object," appearing in both the narrative of *Day for Night* and "Meet Pamela."[8] Yet

FIGURE 3.1 Conscripted film world materials and a vase as more than a vase in Truffaut's *Day for Night*.

it is (even) more than that: the vase functions as a double metaphor and metonym for the filmmaking process. Outside of the world of each film it is simply a vase. But as represented within *Day for Night* and "Meet Pamela," it is a constitutive element of both. As such, like any other object or prop brought inside a film's magic circle of transformation as it is being created, it is (potentially) part of a singular, dense, and complex narrative and symbolic (including here, self-reflexive) network, which greatly determines the object's (artistic) significance. In Ferrand's "Meet Pamela," the fictional film-within-the-film, the vase plays a very modest supporting role as one of a number of ornaments decorating the background of a room in which two of the main characters interact. In Truffaut's *Day for Night*, however, it serves the very cinematically self-reflexive and global, metaphorical function here suggested—one further emphasized by the insistent movement of Truffaut's camera toward the vase later in the film, ending in a screen-filling close-up.

Although endowed with such new contextual and figurative significance in *Day for Night*, which it does not possess in its ordinary (real-life) mode of existence, the vase remains recognizably a vase. Yet, of course, the transformation at work in filmmaking is seldom only a matter of arranging or combining preexisting materials whose perceptual appearance (and other features) remain more or less the same in the finished work as

they do outside of it. The film's English title and its original French one (*La nuit américaine*) refers to the practice in Hollywood and elsewhere of using lens filters to shoot scenes representing night during daylight hours. As indicated by both of these titles and the process to which they refer, filmmaking also consists of making its materials something other (and sometimes radically other) than what they are normally seen or heard as being, on perceptual as well as fictional-representational levels: from day turned to night, and the faces and bodies of actors and actresses becoming those of the characters they are playing, to soap "becoming" snow (as in the final sequence of *Day for Night*), or images of Chicago or Toronto transformed into (a fictional) New York City. Admittedly, some of these transformations may be relatively invisible in the finished work, given that viewers may not be in a position to recognize or know the materials or processes behind the image; nor may the work do anything else (i.e., for artistic purposes) to encourage specific reflection upon them. Others, however, are highly visible, literally and figuratively, and films sometimes call particular attention to them as part of their intended designs, and the running artistic "commentary" on a film's fictional and represented (denoted) *world-in* on the part of its particular cinematic and stylistic presentation.

As *Day for Night* emphasizes, the diverse classes of materials used in the creation of a film—concrete physical objects and events; less tangible, perceptual realities (e.g., the manipulated light referenced in the film's title); language (in dialogue, voice-over narration, titles), all manner of culturally coded images and visually rendered symbols—enjoy some different and active manner of existence prior to the camera's pointing and rolling (or recording). By the same token, during a film's creation much of its constituent physical material (as captured by the camera) is, of course, relatively untouched by it in the sense of not being "used up" in the manner of the marble of a sculpture or the paint of a painting. Foregrounded by *Day for Night* at every opportunity, such physical and ontological duality of profilmic materials (including objects, places, and actors)—as recognizably existing (in different ways) within and without the cinematic work simultaneously—gives creative filmmakers access to extranarrative domains of associational meaning and affect (transcending the diegetic world) that are foreclosed to some other, nonphotographic art forms and media. In the case of performing human and sometimes animal "materials" (e.g., the cat in *Day for Night* that obstinately refuses to act

on cue), this independent, extrawork "life" of materials (adding to what Burch refers to as the "refractory" quality of that which the filmmaker works with) is a literal one.[9]

No doubt most of the materials conscripted for use in any art form largely preexist the beginning of the activities of the artist, having all manner of anterior, preaesthetic meanings and uses, comprising both the settings of natural worlds and the so-called furniture of practical and cultural ones. But the especially pronounced, more tangible extent to which this is true of the materials of camera-based filmmaking sets cinema apart from many other arts, including drama. This owes not only to cinema's photographic (iconic and indexical) substratum but its status as thoroughly "hybrid" (Gerald Mast calls it "the most hybrid artistic process in human experience"),[10] together with what Langer refers to as its "omnivorous" character,[11] in combining, as it does, so many recognized aspects of other, older art forms and modes of communication and representation, verbal and textual as well as visual, and in pronounced temporal as well as spatial dimensions. In addition to music in films, one finds the transposed reflections on the screen of still photography; painting; the narrative forms of the epic, the novel, and the short story; tragic and comedic drama; dance; design; fashion; and video and computer-generated imagery (as well as, in some cases, other arts and crafts). Additionally, in so-called intertextual terms, whereas novels, symphonies, paintings, or works of architecture may not only reference other works (in the same or different form) but seek to concretely include aspects of them in their own design, cinema is distinguished by its far greater ability (in terms of medium properties) to incorporate (some of) the *actual* text, sounds, image(s), and spaces of works in *all* these other art forms, not to mention images, sounds, and sequences of other films. Clearly, what distinguishes this additional class of potential materials is their being at one remove, at least, from quotidian physical and social reality, having already undergone at least one prior, first-order transformation into artistic (or artistic-cinematic) form and meaning before appearing in a film.

In sum, as theorists and filmmakers have long recognized the sheer variety of the natural and human materials filmmakers have at their disposal for transformation in the pursuit of artistic meaning and expression is unprecedented. With reference to today's hi-tech production environment, while digital filmmaking, and the full range of CGI processes and effects, may in some ways alter the particular courses of the

material-to-work appropriations from reality filmmaking involves, they certainly do not dispense with or negate them. Indeed, given the computer's power to augment familiar realities (and almost create them from scratch) on a virtual plane, there is today, if anything, a huge expansion of this range and variety.

Brought to reflective attention by *Day for Night*, a number of these basic and oft-remarked-upon facts about filmmaking as a transformation of the preexisting (and often as a "transfiguration of the commonplace," in Arthur C. Danto's phrase),[12] on cinematographic, narrative, and extra-narrative levels (sometimes simultaneously), are systematized in the film theory and criticism of Jean Mitry and Pier Paolo Pasolini. Both filmmakers as well as theorists, Mitry and Pasolini each address the subject of a film work's constituent materials, and their cinematic and artistic transformations, in the context of charting the relation between the medium (and what are deemed its basic features, or "ontology") and its symbolic and aesthetic uses. Moreover, they each do so in ways that are in keeping with the symbolic-expressivist tradition I have described and a number of the specific arguments and more general themes to be found in Cassirer's, Langer's, and Goodman's aesthetics, in particular.

These instructive similarities are rooted in the ways in which Mitry and Pasolini explicitly seek to go beyond linguistics-based paradigms in semiotics (as greatly in vogue at the time of their respective writings), toward a broader conception of the referential and expressive dimensions of films and their created worlds. They independently perceive the need for a film *semantics* that is more amenable to the specific nature of narrative cinema's "presentational form," in Langer's terms, as simultaneously audiovisual, concretely realized, cinematographic, formally hybrid, and profoundly durational, as well as fictional-narrative (and with a capacity for "discursive" meaning and expression in a different mode than language). Indeed, both of these thinkers, who are later joined by Deleuze in this respect, hold that with its "iconic" images and recorded sounds—together with the cinematographic relations among space, movement, and time—cinema is always much closer to experiential reality than (the general symbolic form of) language, the latter being a multipurpose tool of practical communication possessed of such well-known attributes as being highly conventional, closely systematized, and abstract. Yet as Mitry, Pasolini, and Deleuze also insist, the film image is still at a highly mediated technological, subjective, and sometimes artistic remove from

any ordinary (and three-dimensional) perceptual and imaginative en-
gagement with the common "lifeworld." In other words, film images
(and films as wholes) are too bound to prelinguistic, perceptual reality to
be part of a "language" in their communicative dimension yet too con-
structed, intended, and culturally and individually mediated to be experi-
enced and theorized as perceptually "real" or "objective."[13] Consequently,
they are inevitably more than, and different from, the indexical, camera-
produced objects of experience modeled in realist and phenomenological
film theory, on the one hand, and the highly systematized, conventional
structures of encoded signs emphasized in most semiotic (Saussurean)
conceptions of cinema, on the other.

For these reasons and others, Pasolini's semiotic "heresy,"[14] Mitry's
call for a "semiotics beyond linguistics" (rooted in the recognition that
"cinema before being a language is a means of expression"),[15] and De-
leuze's embrace of and Bergsonian modifications to Peirce's extralinguis-
tic concept of the sign, all reflect a general conception of cinema and of
cinematic art consistent with Cassirer's and Langer's formulation of the
complex aesthetic "symbol," and a work of art (as a unified whole), as
prototypically occupying an intermediate position between language and
"myth," subjectivity and objectivity, the abstract and the concrete, feel-
ing and thought. Moreover, and awaiting further explanation below, it is
perhaps the form of cinematic art in particular—coming, of course, well
after the origin of the symbolic-expressivist tradition—that provides the
most persuasive support for, and examples of, this symbol-centered para-
digm (alongside, it should be added, aspects of the heterocosmic view of
art and artworks). This is true not least in regard to the ways cinema may
effect a synthesis and represent a pronounced amplification of the sym-
bolic, affective, and "world-like" properties of all artworks.

JEAN MITRY: FROM OBJECT TO SIGN TO SYMBOL (AND ART)

Mitry's *The Aesthetics and Psychology of Cinema* has been widely seen as a
reevaluation and attempted reconciliation of central aspects of the major
realist and formalist accounts of cinema coming before it.[16] This synthesis
is achieved, in part, through a particular conception of relations among
(1) the "profilmic" reality that the film camera records, (2) the film im-
age resulting from it as a perceptual reality and its recognized contents,
and (3) the singular spatiotemporal, cognitive, and affective network or

structure in which the image is placed—a structure that is both formal and expressive, as well as fictional-narrative.

These three aspects may be seen to reflect both *stages* in the process of filmmaking and experiential *levels* of a finished film seen and interpreted. They are intended to describe the abstraction and transformation a cinematic work effectuates, wherein three-dimensional images of things in the world—acting as wholly iconic (or analogical) "signs," in what Mitry considers a "psychological" as opposed to standard semiotic (linguistic) sense—become artistic "symbols" that together constitute a "world" created by a film.[17] However, in this primary movement toward the symbolic and aesthetic (with the two more or less equated by Mitry), the profilmic object and the image as its recognizable analogue are never simply left behind or eclipsed. Rather, they inhere in the film image as one part of the fully fledged artistic symbol. Mitry regards this as roughly analogous to the semiotic notion, as stressed by Barthes and others, that in the language system all figurative connotations contain the literal denotations that they build on and to which they are bound.[18] Yet, and perhaps more to the central point, it is also a consequence of what I have described here as the particular enclosure of the represented (denoted) world constructed by a narrative film, within the presented world *of* it as a work of art in total, with the latter including, but certainly not confined to, what might be adequately theorized as connotation.

Brian Lewis has noted that just as in Cassirer's and Langer's aesthetics, the bedrock of Mitry's film theory is a conception of the "concrete" visual symbol of art and the "unique powers of non-discursive symbolic expression."[19] Unlike the discursive linguistic sign (as general and "arbitrary," or highly conventional) a film image (including its full range of references) is "always new and original," and, for this reason, there can be no proper film grammar, or fixed lexicon.[20] Pointing to the camera's "reproduction of concrete reality," Mitry stresses the "aboutness" of film images ("images *of* something")[21] as the starting point of cinematic art. Psychologically tied to the specific objects they recognizably present and stand-for in concrete fashion, they have various natural and cultural meanings; and because the film image is pictorial, it is always potentially richer in certain respects than any discursive formulation.

Yet, as Mitry also argues, this character of the cinematic image is only the "ontological" basis, and means or instrument, as it were, of the cinematic work. For such filmic *reproduction* is but the material-causal and

psychological-perceptual beginning for a complex symbolic construction, in which film editing is a major part and which includes but is not limited to the establishment of a represented story-world. In its characteristic movement "from the concrete to the abstract" filmmaking starts with a "concrete representation of the world and its objects. Then *it exploits these direct data as instruments of mediation*" (58). Every film image is a singular perceptual reality, and the contents and connections to the "real world" that it visually reproduces and presents (in this unproblematic sense) are generally recognized as such. The image, however, as the product of the camera, is in turn material for transformation into a formal, expressive, and symbolic reality possessing a meaning (or meanings) unique to the cinematic whole of which it is a part. Such work (and interpretation) dictated meanings *always* transcend (and in some cases render moot or even contradict) any number of (other) natural and cultural meanings of the real or imaginary extrawork object(s) of which the film image is a perceptual "analogon" (88).

In his explication of the dynamic in question, Mitry analyzes a close-up image (and the sequence to which it belongs) from Eisenstein's *Battleship Potemkin*, wherein pince-nez spectacles dangle from the eponymous battleship's steel hawser. Belonging to the ship's doctor, who has been seen thrown overboard in the sequence preceding it, owing to the context in which they appear, the image of the spectacles comes to assume not only a unique narrative meaning but also a metaphorical (metonymic) one—as concerning the represented downfall of an entire social class by virtue of a revolutionary act on the part of the sailors. Mitry takes the meaning in question to show that in cinema when the image does signify directly (in something roughly like the linguistic semantic sense), it tends to signify "*something quite different from what it shows*," (e.g., simply a pair of spectacles, or a fairly ordinary vase), "though it does so *through what it shows*" (39). Such a problematizing of the reference relation, as it might be called, follows from the fact that the intended meaning in question is something beyond, and not inherent in, the object filmed and presented; it stems, rather, from what the film as a constructed and intended work, and as providing a new context for the object, instills in its cinematic image. Thus, while in its concrete psychological presence as "represented reality" the film image strictly speaking "*means* nothing," as it is experienced, "it symbolizes, generalizes, and refers all concrete reality to the abstract. It becomes "transcendent" by being the analogon

of a reality with which it stops having any phenomenological association. Consequently, it becomes the *sign* of what it reveals" (88).

Such considerations prompt Mitry to distinguish between film images as (a) "represented data," equivalent to the psychological, "reality-capturing" aspect of cinema, and (b) intentionally formed "representations" resulting from all of the stylistic resources of filmmaking, and as ultimately constituting a film's aesthetic aspect. He writes that "*as represented data,* film images prove to be similar to the 'direct images' of consciousness, but, *as representations,* they are aesthetically structured forms" (75). Evident hyperbole aside, Mitry is right to argue further that "*nothing will ever be understood in the cinema as long as the represented data are regarded as its final thematic purpose. It is all too obvious, in mediocre films, that the theme is contained in these data, this 'narrative'*" (51). Crucially, Mitry's distinction (which he reiterates in a number of different ways) may also be seen as valid and operational not just on the level of the individual film image but throughout the whole diegetic dimension, as copresent with but still distinct from both nondiegetic form and presentation and a good deal of referential content.

As has been discussed, films have many types and whole levels of meaning that are nonliteral in nature. Or, rather, they transcend the literal in ways long thought to be characteristic of exemplary works in other art forms, the grasp of which depends on "the intelligence or cultural awareness of the reader," as Mitry aptly observes (376). Reflecting a difference between the *world-in* and the *world-of* films, and also between (all) basic representation and aesthetic expression, Mitry's core claims speak to the fact that the "iconicity" of the film image, or, if one prefers, its denotation—entailing "the logic of everyday life," or "experienced reality" (376)—is distinct from, yet the foundation of, both basic storytelling in film and the wider expanse of cinematic art (in both descriptive and normative senses).

Throughout *The Aesthetics and Psychology of Cinema* Mitry explores how nonliteral, contextual meaning necessarily works in and through concrete cinematographic representation. With reference to his *Battleship Potemkin* example, as well as to the opening of *Citizen Kane*, and as is true (he argues) of all cinema, he maintains that "we are informed *through* a reality presented *first of all* for what it is but almost always indicative of *something else.* In fact, we are informed *of* something *through* something. It is *through* the pince-nez that we are informed *of* Dr. Smirnov. . . . It is

through the glass ball slipping from Kane's grasp that we are informed *of* his death" (51). Crucially, however (and to further extend the point), through the perceptually concrete film image we are not informed *only* of (a) a literal, narrative fact—Kane is dead, the doctor has been thrown overboard—which may also be conveyed in innumerable different cinematic ways with little difference to the fictional fact. But, also and simultaneously, we are encouraged to grasp what (b) these deaths mean or symbolize in *thematic or conceptual* terms (as interpreted) *and*, beyond this, to understand (c) the film work's unique artistic-cinematic form, or design (and use of relevant techniques), *as intended to convey* both (a) and (b), as the literal (narrative) and figurative meanings in question. All of this assumes, of course, that a cinematic work often calls the viewer's attention to its (i.e., the filmmaker's) artistic intentions toward objects, events, and ideas (as will be further analyzed in chapter 5).

Here it should be noted that in some of Mitry's examples, including the image of the spectacles in *Battleship Potemkin*, the higher-order contextual and symbolic meanings and intentions conveyed and grasped through association and juxtaposition, drawing on both the viewer's imagination and constructive memory (as well as perception), are relatively obvious (one must assume) to original as well as present-day audiences. In the case of *Battleship Potemkin* this is a reflection of the stylistic formula of Eisenstein's work in its early, more didactic mode and the film's particular ideological, as well as aesthetic, intentions. The image and sequence in question (and the film as a whole) are clearly not interested in the multivalence, ambiguity, and complexity of symbolic articulation of ideas and emotions that characterize nonliteral significance in many other artistically ambitious films. In choosing the example, Mitry is surely aware, however, that this makes his main points stronger, not weaker, by showing how even all relatively more obvious and directed cinematic communication on a thematic level (although still, in this case, highly culturally specific and knowledge-dependent) operates one register above, as it were, the perceptually recognized contents of images in themselves. And further, it is dependent on the simultaneous creation of an expansive interconnected, formal-structural, and symbolic network of meanings and associations—"a whole universe of forms and relationships," as he writes (12)—which is unique to every film. This last point serves to return us to the observation of Deleuze (quoted in my introduction), of which we may now begin to better appreciate the full significance; viz., "a film

does not just present images, it surrounds them with a world." In other words, a film (or rather the filmmaker or -makers) creates a surrounding, contextual whole, which gives symbolic and aesthetic meaning and value to images and their sequence(s) (and thereby to that world), beyond the narrative structure that powerfully assists in the cinematic world-making project. Indeed, Mitry also speaks expressly of the multifaceted, semantic, and affective structure a film presents (as opposed to only *represents*) as its "world" (which is also described as a "reconstructed" or "postfabricated" one, with reference to its transformation of basic representational contents) (80, 275). One could say, in sum, that while camera-given representation binds films and their experience to "the world"—in an often more direct, transparent, and powerful sensory fashion than other arts—the "aesthetic organization of these moving pictures towards a specific signification" (71) is partly responsible for the fact that the work is also the creation of a new, singular world.

Throughout his detailed arguments, Mitry reminds us that such a world is the product of a creative and artistic intentionality on the part of the filmmaker(s). This ensures that a cinematic work is not only a representational field of recognizable objects and events existing within a fictional story nor, however, only a formally structured, distinctly cinematic presentation (of these objects and story). But it is also, and profoundly, an expressive *interpretation of*—or "discourse upon" (275)—some aspect(s) of extrawork reality both in general, as corresponding to a film artist's "worldview," and with respect to the particular external realities or subjects with which a film is concerned. In this sense the true "subject" of a film qua audiovisual artwork is not (or, more precisely, not confined to) that which it literally denotes and depicts—for example, the life of Napoleon, a tragic love affair, the inner workings of a disturbed psyche—but "what it offers to our eyes, our emotions, our intellect, through its interpretation of the world" (340). Such an interpretation, in other words, includes, and is revealed by way of, these specific, literal subject matters and concrete objects of representation alike. On this subject Dufrenne, echoing but also expanding on Merleau-Ponty's statements along similar lines, writes that "art liberates a strange power in the humblest things it represents, because representation surpasses itself towards expression, or, to put it another way, because in art the subject becomes symbolic."[22]

For the work to achieve this goal, which is both cognitive or information-bearing and expressive-affective, and for the subjective (i.e., singular, perspectival) artistic and stylistic interpretation in question to be grasped (in any representational work), this *interpretation of* X on the part of the constructed film image, sequence, and work, must, in Mitry's words, be "isolated" from the image's literal *representation as* X, or, as one might better say, meaningfully and purposefully *differentiated*, made to stand out as over and above it. It must be differentiated, that is, from the extrawork reality to which the film, in this case, visually refers us, while at the same time "replacing it" with its own artistic-cinematic *version* of that reality (as Goodman would stress). In one of Mitry's examples, drawn from painting, it is only relative to an actual field of corn (even in the form of a generalized memory-image of one on the part of the viewer) that we are able to fully appreciate Van Gogh's style, "thoughts," and feelings, as both informing and transforming this subject matter, in a way typical of his art (340), and, to some degree, of the more general style or styles of painting—for example, symbolism or postimpressionism—to which the painting may also be seen to belong.

Thus, the argument continues, in all representational art forms—and contrary to what some more stringent formalist and expressivist conceptions of art (and cinema) maintain—the factual "objectivity" of (denoted) representation in no way hinders, but instead allows for, the full "subjectivity" of expression and its artistic significance. And cinema is no exception. Indeed, Mitry argues coherently and fairly persuasively that in some respects it has a head start in this expressive and artistic process, given, that is, the powerful and more immediate ways in which a film may establish a represented (and fictional) world as "concrete fact," through the film image's copresence as both "psychological sign" (or "analagon") of reality and artistic symbol (340). In a nutshell: the medium's oft-heralded perceptual (photographic) realism may be thought to establish a baseline, which, as means rather than as end, allows the viewer to recognize and appreciate a filmmaker's creative and transformative treatment of a given object of (lifeworld) perception, as a new and alternative version of it. Such a version stands out against the familiar reality in question (within the minds of viewers).[23]

Arguably, Mitry actually goes too far in pressing cinema's exceptionality in this case since, as in his own example, a representational painting

(and certainly a highly realistic or mimetic one) may be equally "concrete" in the relevant and necessary sense. The difference between cinema and other representational arts here, although far from negligible, seems instead to be much more one of degree than of kind. It is perhaps best thought of in terms of the psychological power of address of such a typically iconic and indexical medium. Any comparison with other arts aside, the basic premise here is sound. As I have suggested, it is one that Mitry explicitly finds in Dufrenne's aforementioned concept of the represented and expressed *sub-worlds* of aesthetic objects, which, fused through the aegis of an individual style, create its full and genuine aesthetic "world."[24] As Mitry summarizes, closely following Dufrenne: "The aesthetic quality, that *extra* quality, is measured by the distance separating the represented from its representation, that is . . . the distance separating the original object—its elementary meaning, its specific emotional qualities—from the meaning and values it acquires from its representation. This is what we mean when we speak of *creative form*" (341).

For the moment, the key summary points to take on board here are two: just as in all vision-based forms, but more so in the cinema, a work's creator(s) use known, recognizable, concrete reality and its perception or recognition as a conduit for creative interpretation, transformation, and expression via an artistic style and intentions. But, for the full measure of its nonliteral meaning, and "personal" (e.g., creator-specific) style and affective expression to be grasped, so too must the viewer, in experiencing a film as art, be aware—either on their own, or with the substantial assistance of the work and its creators as prompting such awareness—of that which is simultaneously presented, referenced, and transformed. If in narrative cinema basic, camera-provided representation is but a stepping stone for the conveyance of a singular creative interpretation of reality (and related affect), it is, in these senses (and amplified by basic features of the medium) both a necessary and artistically beneficial one. Here, and from a normative artistic and aesthetic perspective, we return to the *specifically aesthetic* function and potentials of a cinematically represented and fictional *world-in* (as I described in chapter 1), as a formal and referential means rather than a (narrative or emotional) end in itself—given, that is, its particular perceptual and psychological presence, concreteness, and relative objectivity, as per cinematographic (and more contemporary digital) reproduction, recording, and registration. While these latter features of cinematic representation are ones that realist theorists such as André

Bazin, Siegfried Kracauer, and Stanley Cavell stress, these same theorists have also tended to underemphasize many of their higher-order transformative and aesthetic potential(s). Thus, we come to consider the full "world-making" powers of the dialectic of cinematic representation and expression that Mitry and Dufrenne (as well as Deleuze) call specific attention to, as taking cinema *away* from a single, given "real world" (of perception and experience) as much as toward it.

Pier Paolo Pasolini: Filmmaking as Visual Poetics

The main themes of *The Aesthetics and Psychology of Cinema*, and some of its specific arguments concerning cinema's symbolic transformation of reality, are also to be found in Pier Paolo Pasolini's (roughly contemporaneous) writings, including his widely reprinted 1965 essay "The 'Cinema of Poetry.'" Coming at the subject from a markedly different cultural and intellectual (as well as filmmaking) background, however, Pasolini's account of artistic filmmaking also offers some novel ideas and insights highly relevant to our primary concerns.

As well as being one of the most significant narrative filmmakers of the second half of the twentieth century, Pasolini was an accomplished poet, painter, and influential film critic and theorist. His writings on cinema have been described aptly as a "very personal blend of linguistics, politics, and existential concerns," with a "particular relationship with praxis" (not only that of his own films but also that of other directors).[25] In "The 'Cinema of Poetry'" he attempts to summarize the filmmaker's artistic activity in a discussion that is mindful of film's temporal and sequential but still presentational form.[26]

Like Mitry, Pasolini sees the differences between the film image and written and spoken language as unbridgeable, since the two are anchored in patently different relations to the sensible reality from which they abstract in order to represent.[27] Again like Mitry, Pasolini's conception of cinema stresses the fundamentally "concrete" audiovisual basis of cinematic communication and of the a priori familiar and expressive nature of the basic material with which the filmmaker begins: "familiar" and "expressive" in *both* natural, or pan-human, and culturally specific ways. Akin in some ways to Eisenstein's earlier attempt to identify and locate the unique meaning content of film images in "sensual and imagist thought processes,"[28] Pasolini wishes to connect films to the imagistic

(and temporal) form and content of visual and episodic memory, and dreams, as well as to ordinary, externally directed visual perception. In the aggregate, these are seen to form the subjective visual landscape of inner conscious life. They represent the subject-centered "place" from which all cinematic communication, as well as genuine and expressive cinematic art, springs.

Pasolini appreciates that the images of dreams, waking life, and memories of past sights and scenes often convey meanings and feelings to us—and sometimes multiple, complex, and mixed ones. These sorts of imagistic mental representations are not nearly as closely bound together and conventionally fixed as the senses and literal references of spoken or written words, and they cannot be encompassed in any sort of comprehensive dictionary. While necessarily subjective at their point of origin in individual minds, a great many of these mental image-contents, and their more general or specific meanings and associations, are, however, found to be interpersonally shared and communicable by visual and other sensory means. Pasolini's term for this broad category of semantic (or proto-semantic) materials—which he considers in some respects analogous to the words of a language that furnish the poet with his or her working material—is *im-signs* (in Italian *imsegni*, short for "image signs").

Regarded as the primary stuff of conscious (and perhaps unconscious) life, insofar as it is capturable in imagistic form, im-signs "prefigure and offer themselves as the 'instrumental' premise of cinematographic communication."[29] They are not only mental pictures but "signs" in the sense of having recognizable, transsubjective meanings either within given cultures or communities, or across them, and prior to any appropriation and use by filmmakers. Reminiscent of Cassirer's arguments as to the origins of aesthetic symbolism and expression in the "mythical consciousness" to which it still bears some similarities, for Pasolini, below the rationally constructed, causal surface of every narrative film, even the most conventional, lies a prerational and, as he suggests, "mythical" power of the medium and its art to connect with the stuff of lived, experiential reality prior to its translation into the abstract schemas and grid work of the language system.[30]

The proto- or paralinguistic and highly expressive gestural signs of faces and bodies that frequently accompany our verbal communications, as well as what Pasolini calls "environmental" (i.e., natural) signs, are major subtypes of im-signs. Together with dream-signs and memory-signs,

they are seen to form the basic semantic elements of cinematic expression. As Naomi Greene notes, Pasolini's introduction and discussion of these "infinite and noncodifiable 'natural communicative archetypes' as the base of cinematic language" is an idea that Deleuze draws on considerably in formulating his own, now much more discussed (as well as far more developed), typology of (1) prelinguistic "images," as "movements and processes of thought," and (2) presentational "signs" of memory, dream, and affect as "ways of seeing these processes and thoughts" (as distinct from linguistic and other types of signs).[31]

Pasolini's concept of the im-sign captures the core truth that prior to their creative incorporation a great many of a film's constitutive materials in the form of the image-objects the camera transmits are not objective in the sense of pristine and unmediated like the features of a newly discovered landscape. They are, rather, shared among minds in one or more communities or national or international cultures, as belonging to collective consciousness (and perhaps also something like the Jungian collective unconscious). Because of their highly informal mode of existence and distribution, any endeavor to use im-signs to create an aesthetically significant and expressive film, or to establish a distinctive cinematic style, entails a film artist's gaining, or attempting to gain, some *significant manner of personal, creative ownership of them* and, in so doing, to invest them with a new and additional feeling and meaning. Pasolini's own highly poetic, gestural, and oneiric films, such as *The Gospel According to Saint Matthew, Oedipus Rex*, and *Theorem*, reflect one version of this process, and its artistic achievements, in exemplary fashion.

Cassirer has argued, primarily with regard to the universal form of myth, that the phenomenal world is "ready-made" for symbolic appropriation because of the expressive affinity between humans and their environment. Similarly, and despite his insistence on the subjective, "primitive," and "irrational" provenance of the im-signs that constitute primary creative materials in the hands of the filmmaker, Pasolini stresses that they are neither parts nor reflections of "brute reality" since "all are sufficiently meaningful in nature to become symbolic signs."[32] As selected and used in filmmaking, they come "pre-interpreted," which is to say, freighted with all sorts of collective sociocultural, as well as personally authored, meanings and affective resonances. At least to some degree, viewers can be counted on to recognize and understand im-signs, as the stuff of common life experience. For instance, in Pasolini's chosen example, a

cloud of steam surrounding a turning wheel may represent (metonymi-cally) a train in motion onscreen, which in turn may prompt a number of related associations and affects (to do with movement, technology, travel, etc.) both germane to the narrative and transcending it. As he explains, the filmmaker "chooses a series of objects, or things, or landscapes, or persons as syntagmas (signs of a symbolic language) which, *while they have a grammatical history invented in that moment*—as in a sort of hap-pening dominated by the idea of selection and montage—*do, however, have an already lengthy and intense pregrammatical history.*"[33] While at any given point in time im-signs encountered on screen may be more or less conventional or clichéd as a result of their past cinematic use, they are also familiar prior to, and apart from films, that is, from other domains of individual and cultural experience and its representation. Such familiar-ity and history is akin to a symbolic short-hand that cinematic storytelling and artistic expression alike draw upon. In relation to the latter, and add-ing to Pasolini's argument, it must be stressed that from one perspective it is not in spite of but because such "images" may already be cinematic clichés at the time of their use that they can forward artistic, as well as general symbolic, significance in films. This is because, as Deleuze also insists in assigning them a key role to play in what he conceives as dis-tinctly modern or postclassical cinema, their very overfamiliarity is a sig-nificant platform for aesthetic transformation in the hands of great film artists. They, like poets in the case of metaphors, find ways of endlessly renewing such images, endowing them with new and unexpected signifi-cance in a process that represents yet another way in which film-world creation may be aptly described as a symbolic transformation of experi-ential reality at any given point in time.

In some respects Pasolini's theory of im-signs places much greater stress than Mitry's account on the a priori shared cultural meanings of cinematographically represented image-objects prior to, and after, their incorporation within the spatiotemporal, edited structure of a film and thus apart from any specifically *work-generated* context and meaning. [34] In Pasolini's view, however, as in Mitry's far more systematically devel-oped account, a narrative film consists equally of situating preexisting profilmic materials (here defined as some collection of im-signs) within a relatively clear, comprehensible narrative and audiovisual *structure*, one that extends or alters whatever their prior meaning contents may be. Such a structure follows established filmmaking conventions, narrative and

otherwise, to various degrees, yet it remains open and flexible enough to be innovated, expanded, and altered by individual filmmakers, often in the light of precedents set by past works (in something like the manner Bordwell, Staiger, and Thompson describe narrative "paradigms," as known and established cinematic "devices," that work together in more individualistic, functional networks or "systems," which, in turn, serve to constitute specific narrative styles).[35]

More specifically, and as a direct consequence of all that has been said, Pasolini argues that the artistically ambitious filmmaker faces three distinct but profoundly interrelated tasks. These mirror, to some degree, Mitry's tripartite breakdown of a cinematic work's semantic and expressive constituents (viz., of profilmic *objects*, psychological *signs*, and narrative-artistic *symbols*) together with the means through which they are linked. First, the filmmaker must choose and "extract" im-signs—that is, take them out of their originary or customary contexts—and place them in a new filmic one; this occurs on the level of a film's imaginative conception and planning and during its actual framing, shooting, editing, and so forth. Second, for the purpose of storytelling having extracted for use powerful im-signs, ones that "say something to us" from the chaotic "jumble of possible expressions," the filmmaker assembles them into a coherent cinematic-narrative structure within which they acquire new mutual relations.[36] However creative and original, such a structure must remain amenable to cause-and-effect reasoning of some sort to ensure the literal comprehensibility of its denoting elements. Courting some confusion, it must be said, Pasolini terms this unique, work-created, and nongeneralizable system of meaning "governing filmed objects" (to quote Metz's gloss on Pasolini's concept) the individual "grammar" of a given film.[37] From this perspective—and *still not yet at the level of singular aesthetic import and expression*—a given narrative film is a system that both uses but always surpasses (in its individuality) the cultural meanings (and codes) attached to its representations. It does this together with, it should be added, the particular cinematic techniques or structures—what Metz calls "cinematographic paradigms"[38]—which it may share with any number of other films—for example, parallel montage constructions, shot/reverse shot patterns, narrative framing devices, and so on.

Echoing Mitry's view that in cinema, in contrast to literature, for instance, the imagistic and concrete is the only major road to more abstract figurations and expressions, and that this general route of transformation

is central to cinema as art—as distinct from basic filmic communica-
tion—Pasolini maintains that in order to more than simply tell a story
such a comprehensible symbolic-narrative structure must also be made
aesthetically expressive, through more and different creative acts and in-
tentions. This represents the third, and what he identifies as the specifi-
cally "artistic," stage or aspect of the general process outlined, one of fully
giving "a purely morphological sign its individual expressive quality."[39]
This task is achieved through the creative decisions of the filmmaker
about how im-signs operate in relation to the whole of the film: not just
in terms of fictional narrative content and literal meaning, however, but
in terms of both global cinematic form and nonliteral (e.g., thematic, allu-
sive, reflexive) meaning. For Pasolini such nonliteral and "extranarrative"
significance and expression is the clearest and most powerful manifesta-
tion of a fully fledged artistic film style.

Although there is some sense in which this "third-level" manifesta-
tion may be considered an "extra quality" of a narrative film, in Mitry's
phrase (anticipating talk among later theorists of nonnarrative "surplus"
or "excess" equated with the distinctly aesthetic aspect of narrative films),
Pasolini stresses that the aesthetic dimension is not an afterthought, an
addition "on top of" literal representational and narrative construction.
For genuine film artists, from the conception of the work onward, these
stages are interrelated and inseparable (as Mitry also observes). Indeed,
while Pasolini tends to present them as discrete, sequential steps in a
process, if we accept this analysis, they are also, and necessarily tempo-
rally overlapping and in some cases, one imagines, simultaneous. For
instance, returning to the suggested first "task," owing to the plethora of
available and potential im-signs, their *selection* on the part of filmmakers
is in itself a major exercise of creative artistic and cinematic intelligence.
As Pasolini writes, in the creative moment or act "the choice of images
cannot avoid being determined by the filmmaker's ideological and poetic
vision of reality," which is already operative at the time of a film's con-
ception (whatever precise form this takes), and as thus mediated, "the
language of im-signs" is already subject to a pronounced "subjective co-
ercion."[40] (In his first "Kino-Eye" lecture, Dziga Vertov stresses a roughly
equivalent, largely mental, activity on the part of the filmmaker, which
he considers a form of cinematic "montage" well in advance of a film's
shooting and physical editing.)

Viewing this model and suggested process from a wider perspective, for all manner of reasons (financial, institutional, generic) some films undeniably privilege literal and logical comprehensibility in their representations and storytelling over more figurative and associative (and background-knowledge-requiring) meanings and affect. Others, on the relatively more artistically centered or experimental end of narrative cinema (in this sense), may do something like the reverse. Indeed, the second half of Pasolini's "'Cinema of Poetry'" is devoted to contrasting what he terms a "cinema of prose," associated with mainstream, conventional Hollywood-style cinema, and a specific mid-1960s "art cinema" mode of filmmaking, which, on the basis of his critical-theoretical framework, he terms a "poetic cinema." (This distinction, it should be said, not only anticipated, but fed directly into, Deleuze's binary categories of a more conventional and objective "action-image" cinema and the post–Second World War cinema of the "time-image," which tends to privilege and cultivate, rather than avoid, the disruption of cause-and-effect reasoning, ambiguity of meaning, often pronounced self-reflexivity, and the global conveyance of shifting subjective states of mind and feeling.)

Moreover, there are, of course, comprehensible films that tell stories and contain cultural and natural "signs" and the expressivity (i.e., affect) these entail, without intentionally creating *art* (at least in a normative sense of the term) and without exhibiting any particularly notable individualistic style. By the same token, no matter how artistically intended, innovative, or successful, *all* narrative films, by definition, possess some basically comprehensive narrative structure and draw on preestablished filmmaking techniques and traditions. This variability accepted, in summary of Pasolini's basic view, all cinema is symbolic construction and manipulation in its cognitive dimension (in a sense close to Goodman's world-making, as we will see)—which, if and when combined with artistic intentions, a distinctive style, and work-generated affective expression (all three of these aspects being mutually constitutive) may also be or become genuinely "aesthetic."[41] In these ways, and in common with Mitry's film theory, Pasolini's schema helpfully reemphasizes that the relation between the narrative structure of a film (and its fictional *world-in*), on the one side, and its aesthetic meaning and expression, on the other, is not only codependent, but variable, relative, and work-specific, rather than fixed in any a priori terms.

If Pasolini's general framework is accepted, it must also be stressed that the selection, isolation, and artistic use of that vast range of elementary materials in the nature of im-signs is still only the most *basic*, atomistic level of film-world creation and transformation (as the Italian theorist-director at points appears to acknowledge). The objects of this creative alteration and representation, its cognitive and affective consequences, and the key processes involved also operate on relatively higher levels of creator and viewer imagination, intention, and attention. And just as the conceptual apparatus and description of physical processes on an atomic scale will differ from those on a molecular or macroscopic one, so, to extend the analogy, do the higher-level (in this sense) aspects of film worlds call for different theoretical models and frames of reference.

CINEMA'S EXPRESSIVE MATERIALS: A FIRST GLANCE

Thus far in this chapter we have focused on some of cinema's raw materials that are primarily cognitive, or sense-bearing. In rather brief, condensed form, Pasolini addresses another major issue of consequence for cinematic world creation and experience, one that is invariably bound up with the articulation of his "poetic" conception of the filmmaker's creative activity. Discussed but not particularly emphasized by Mitry, this involves what Metz has termed the "problem of filmic expressiveness" and, more specifically, how "aesthetic expressiveness" in cinema is and can only be (in Metz's view) "grafted onto natural expressiveness."[42]

As we have considered, the poetic model of filmmaking in question entails emphasis on the transformation of the preexisting and the conventional into something novel, figurative, and aesthetically expressive in a pronounced and symbolically dense fashion. This process may be seen as roughly analogous to the poet's creative use of his or her inherited base language. Implicit here, however, is that in cinema, as in other art forms, rather than disappearing or changing in appearance and affect entirely, the "natural" or "innate" psychological expressiveness of materials—colors, gestures, actions, sounds, objects, events—captured in or by cinematic images *inheres* in each finished film to some degree. Not only this, but it may "shine forth," to borrow Heidegger's term for the process he describes with respect to the perceptual and affective presence of a traditional artwork's constitutive material, or "Earth," as inhering and persisting in the work's total created design. (In Heidegger's later

thought such materiality is reflective of "matter," as such, which in the work of art is dialectically fused with what he terms "World," as human-made cultural reality.)[43]

However, like an organism native to one environment that not only survives but thrives in a new, different, and sometimes apparently hostile one, something of the original "language of expressive reality" (in Pasolini's phrase) as clinging to the film object (or im-sign) survives its transformational passage into the singular symbolic structure of a film as a narrative and aesthetic world—that is, in its newly acquired status as a virtual and aesthetic element within it. Sometimes this is survival by accident, as it were, and sometimes it is clearly a consequence of a filmmaker's creative purposes.

Within a given film world, a profilmic object chosen for representation—such as a human face with a particular expression—may retain all or most of its prior or inherent ("real world") psychological significance and emotive power, even as now under harness, so to speak, to the designs of that particular work and world. As Pasolini writes, if the "pregrammatical qualities of spoken signs have the right to citizenship in the style of a poet," so, too, may expressive features of objects and persons having made this journey into a cinematic work in-progress have the "right to citizenship in the style of a filmmaker."[44] The citizenship to which Pasolini refers remains, however, a highly precarious one, apt to be revoked. For, in general, both such innately expressive (affective) qualities and the representations that occasion them are highly liable to be altered, suppressed, or even exiled from a film-in-progress's confines for failing to serve its specific narrative, symbolic, and aesthetic intentions and interest. As is also true of other higher-level creative facets of filmmaking that both Pasolini and Mitry identify, the main reason why the "affective" judgment, responsibility, and challenge in question is faced by the film director in most cases, at least (as opposed to any one of his or her collaborators) is aptly encapsulated in Michelangelo Antonioni's description of the director as the one person who not only "fuses in his mind the various elements involved in a film" but is "in a position to predict the *result* of this fusion."[45]

We will return to the important issue of the "naturally expressive" in much greater detail in the context of a broader based analysis of the affective and emotional experiences of films and their worlds (in chapter 6). For the moment it suffices to observe that it is precisely because filmic

representation, both celluloid and digital and including its narrative and aesthetic uses, is so well suited to powerfully conveying such expression (and, indeed, to powerfully amplifying it) that it must often be somehow controlled, and frequently altered, in the context of artistic filmmaking, broadly defined.

FILM SEMANTICS AND BEYOND

The theorists discussed in this chapter advocate a conception of cinematic art rooted in a general semantics of the film image, which yet recognizes that filmic representation is far too culturally contingent and contextual, nuanced and dense to be reduced to the terms of any formal semiotic system. In general, what is required is, in Mitry's words, a "semiology beyond linguistics" and a schema or model "based on the constantly changing casual and contingent relationship between form and content."[46]

In placing symbolic structure and transformation at the heart of filmmaking, while stressing the differences between cinematic and linguistic communication without ever losing sight of a film as a unique aesthetic object or event, aspects of these theories are in many ways more useful in developing a more holistic account of film worlds as art worlds, and their symbolic basis, than Metz's semiotics, for instance (and other theories of the film sign it has directly or indirectly inspired). This relevance owes, not least, to a greater focus on (often) less literal symbolic and affective expression in narrative films and its aesthetic relation to the literal ("denoted"), together with the guiding conception that films transform (to some degree) all that they present to our vision, hearing, and minds.

The worlds of film works are self-enclosed, integral, aesthetic wholes. But, as I have already stressed, they are also dependent, for their capabilities to mean and express in artistic ways, on the making of external references, to the extent the film image, as Deleuze rightly notes, is always "legible as well as visible."[47] The transformations to be found in filmmaking are never only formal, for instance, as they go hand in hand with creating new meanings, new referential relationships, new possibilities for film narrative and thematic content. Crucially, however, and to evoke Panofsky's art-historical distinction, this involves not only the most common and public schemes of signification, or "iconography," but also that more singular "iconology" of works that is a matter of symbolic

meaning relations that the artist, here filmmaker, him- or herself has a far larger hand (if seldom an entirely free one) in creatively shaping and developing.[48] Such freedom stems in part from the meaning relations in question transcending medium-given features of cinematic representation and their "natural," universal, and psychological effects and affects (in a way similar to that which Metz claims for cinematic "connotation").

In sum, a film's aesthetic (or, preaesthetic) constituents are in part the products of an operation of cultural mining and extraction from among preexisting realities, material and nonmaterial (or ideational) alike. For the most part these are already symbolically mediated and informed, just as they are also already "naturally" imbued with varying degrees of affective content channeled through traditional cinematographic or video-digital representation. The creation of a novel and aesthetically expressive totality within which these individual "units" function as expressive parts is, in turn, bound to a new and singular narrative-cinematic structure created by the filmmaker(s) on the basis of principles that are always a matter of convention and tradition, on the one hand, and an originality and innovation that is specific to individual film worlds (and their creators), on the other. However, as characterized by artistic ends rather than those of entertainment alone, for instance, the criterion guiding this latter process is not simply that of literal intelligibility or of "telling a story" in the clearest, most direct, and transparent fashion. Rather, it is also the creation and conveyance of all manner of (related) figurative meaning and affect through original forms that incorporate, yet at the same time transcend, whatever meanings and affects are possessed by the materials used in a film's creation (i.e., as owing to nothing more than their natures and histories). Thus, in the general and synthetic view at which we have arrived, first, the central differences between work-constitutive *materials* and resulting *aesthetic elements*, between *conventional signs* and *artistic symbols* in a cinematic work are upheld, and, second, the productive interaction between these—in, through, and around—a fictional-narrative story and story-world (world-in) is also strongly affirmed.

EN ROUTE TOWARD A MORE SYSTEMATIC FRAMEWORK FOR understanding the full transformative and referential (i.e., symbolic) character of narrative cinematic art, and to put what we have discussed in a larger perspective with respect to form, style, and creativity, we may now turn to Nelson Goodman's explorations of world-making in the arts and beyond. Reflections on films as world-versions in Goodman's idiom,[1] can improve not only our understanding of some of the processes that Mitry and Pasolini identify but also those processes operating on relatively "higher" levels of film-world creation and aesthetic significance. Here we will move even farther away from any more purely communicative preoccupations of conventional film semiotics and toward new ways of thinking about symbolic and associational meaning and reference in films in their artistic guise.

Despite the striking relevance of Goodman's core themes, as well as some of his more detailed categories and distinctions, to filmmaking and viewing, cinema makes only the briefest of cameo appearances in *Ways of Worldmaking*. It is confined to the suggestion that just as there may be seen to exist a Camille Corot "world" and a J. M. Whistler one, established by the works of these painters, so, too, is there a recognizable "Resnais"

world, referring to the films and style of celebrated director Alain Resnais.[2] As I have already mentioned, Goodman's treatment of world-making in art concentrates on macrolevel processes involving meaningful relations between and among existing artwork worlds as symbol systems or structures, as much as what each also takes from perceptual reality. Here we may extrapolate from Goodman's analysis and also extend the arguments of Mitry and Pasolini in a certain direction. If the great majority of cinematic world-making materials are always already "at hand"—provided by the precedent of existing films (and their constitutive features) and a huge variety of perceptual, symbolic, and cultural realities, as well as the underlying natural phenomena they organize—what truly comes into being for the first time in the creation of a cinematic work are the aesthetic elements fashioned from them and the total form or structure they constitute. In line with Goodman's cognitive conception of art as a mode of knowledge, the structures in question are each one of an unending succession of different ways of looking at and thinking about reality, as so many created versions of the "the way things are" (with, for Goodman, a work as a whole being such a world-version).[3] These in turn provide new models and additional sources of material for future cinematic creators.

Goodman identifies five general processes for "building a world out of others" (7). Since world-making is always also remaking, these processes are, as he suggests, ways of describing and thinking about the *constitutive differences between worlds* as a result of the physical and perceptual changes that materials shared between many worlds undergo. In other words, these are essentially comparative processes and categories. They pertain in an artistic context to similarities and differences among artistic work-worlds, recognized by audiences and critics, as well as between them and the everyday structures and habits of experience. These symbolic-cognitive processes, translating into, and reflecting, stylistic options and strategies for meaningful, intentional world-creation on the part of artists (and others), are labeled "composition/decomposition," "weighting," "ordering," "supplementation/deletion," and "deformation" (or distortion).[4]

To further build on Goodman's scheme, these world-making processes, which are applicable to all the arts, do not maintain an exact identity or equivalence across them. They should, rather, be thought of as allowing for considerable variation in accordance with the medium and materials in which they are put to work. Unavoidably pertaining to both "form" and "content" (reflecting the holism implicit in the concept

of an artwork "world"), each will manifest itself under a different guise. Together with an artist's creative vision, they are partly conditioned by differences among media, historical and stylistic traditions, modes of perception and reception, and underlying spatiotemporal structures.

These processes, or methods, have been widely and successfully adopted for cinematic purposes—if, of course, under other labels and influences, and often led by creative intuition as much as rational design. However, and proposed by Goodman as part of a philosophical framework intended to address the highest or broadest forms of symbolic transformation at work in virtually any cultural context and cognitive activity (explicitly including scientific inquiry, as well as artistic creation), it is not surprising that, in their application to cinema, each has relevance to multiple dimensions of filmmaking on multiple levels. They involve transformations of all manner of materials pertaining to a film world as a totality, as well as the symbolic components with which they are (or become) attached.

Mirroring their exposition in *Ways of Worldmaking*, I will move through these basic means of constructing worlds (or world-versions) sequentially, drawing out this multivalence and what seems to me to be their particular cinematic relevance. As some readers will no doubt recognize, and as I will note and expand on where relevant, in some specific cases what they generally describe converges with types and catalogs of transformative organizations at work in filmaking that have been identified and created by several film theorists, past and present (including as part of realist, semiotic, neoformalist, and Deleuzian conceptions of film style and narration). We will see, however, that these suggestions and approaches gain a greater resonance, take on new meanings and associations, and become even more persuasive in aesthetic terms, in the context of both Goodman's transarts framework and our (earlier) focus on films as created and experienced worlds.

CINEMATIC COMPOSITION AND DECOMPOSITION

Goodman defines the general world-making process of composition/decomposition as a matter of the entities a given symbolic world does or does not contain, as a result of wholes divided into parts, distinctions made, features combined, and logical classes (of things) created (7). As a committed nominalist and empiricist, he regards objects or things as

largely the creatures of the schemes of categories we accept or choose to apply in our sense experience. In artistic terms this translates into differences between work-worlds with respect to *what* represented objects and properties they contain or acknowledge the existence of. Thus, it includes, for instance, the sheer fact of what is in a work *being there*, as the public manifestation of the artist's selection for inclusion among all available and relevant realities, as Pasolini also stresses with respect to filmmaking.

In a film, composition and decomposition might most naturally be taken in a visual and spatial sense to refer to what is and is not present in the image, the shot, the frame. And, in fact, Goodman's descriptions of these twin processes—as including the creation of meaningful wholes through "combining features into complexes," the division of wholes into component parts, and a breaking down of "kinds" into "subspecies" and "component features" (7)—has much in common with Deleuze's mathematically oriented characterization of the cinematic "shot": as, that is, a "closed system" whose parts "belong to various sets, which constantly subdivide into sub-sets or are themselves the sub-set of a larger set," through framing and other means.[5] Less abstractly than Deleuze, Mitry emphasizes the reality-shaping nature of visual composition for the fixed film frame, arguing that because of, and relative to, it, "represented reality becomes a compositional form. . . . This 'formalization' is the equivalent of transformation. Reality is transformed."[6]

Such transformative meaning- and feeling-generating power of the act of framing, of what happens when the representation of a person, object, or event is (a) isolated, or cut off from others, and (b) made the focus of attention—or, in contrast, (c) deemphasized within the confines of the frame or bisected—is familiar to anyone who has ever used a still camera or has cropped a photograph, for example, in software programs like Photoshop. This capacity and its potential creative effects/affects are seemingly multiplied exponentially when framing is coupled with the movement-in-time dimension of cinematography, and when it occurs within both the narrative and the larger artistic structures of a film, as part of the wider conjunction of framing, editing, and sequential structure handily encapsulated in the French term *découpage* (for which there is no exact equivalent in English).

French film theorist, screenwriter, and director Pascal Bonitzer's concept of "deframing" (*décadrage*), which Deleuze also adopted, can be seen

as a cinematic manifestation of what Goodman describes as decomposition. As found in the films of Bresson, Antonioni, Straub and Huillet, and Duras, in Bonitzer's examples, this involves objects, and notably the human body, being fragmented or pushed to the edges of the film image rather than occupying the traditional center. Achieved through the use of nonconventional angles and employment of the frame as a "cutting edge" or limit, rather than a containing space, Bonitzer draws a parallel between this technique or style and the use of the frame and nontraditional composition in some modern painting. Such decomposition may have a host of potential thermatic and psychological meanings with respect to what I have termed the represented *world-in* a film and its presentation: including the creation of a "trans-narrative tension" that "story does not eliminate," as Bonitzer argues with reference to deframing,[7] exemplified more recently in Martel's *The Headless Woman* with its ubiquitous widescreen deframing of bodies and selves.

In some films, as Bonitzer's concept identifies, the frame functions as a denial of offscreen space in that it is seen, and sometimes felt, as more of a constraining limit or boundary than that pronounced continuum of presence and action that Bazin famously equates with the film frame and screen as a movable and permeable "mask."[8] We may, however, equally point to the pronounced, often dynamic *actualization* of offscreen space in other films and cinematic styles, which, through image, sound, or both in conjunction, more actively engages the viewer's imagination, as a familiar way in which composition/decomposition is effected. This points to the key fact that like the other four processes for building cinematic worlds to be discussed, this perhaps most primary one involves contributions from the creative imagination of viewers or direct perception or both, simultaneously, just as it may have pronounced temporal as well as spatial dimensions. Of course, cinematic art is not confined to the arrangement and representation of only those solid, bounded, distinct objects that may normally constitute our everyday perceptual or phenomenal lifeworlds, which are sometimes "deframed" or otherwise broken down into spatial or temporal parts (fig. 4.1).

In a film we are always presented not just with chosen objects but "chosen aspects"[9] of them—perceived *properties* and *qualities* that, when put on display, cast the objects in question in a new light but also stand apart from them as abstracted or otherwise detached. A mainstay of avant-garde and experimental film practice, there is also an artistic tradition of such dynamics in narrative cinema. The composed or decomposed,

FIGURE 4.1 Bressonian deframing and abstraction in *Lancelot du Lac.*

framed or deframed content of narrative film worlds may include shapes, shadows, colors, visual textures, which, while (most often) tied to represented objects, may be free-floating and, to some extent, granted their own independent existence and cognitive and affective value as images, or parts of images, as well as aesthetic elements within a newly fashioned work-world. As discussed in the influential "haptic" theories of Laura U. Marks and other writers, this encompasses the presentation of parts of the human face and body as a kind of perceived textured "landscape" and an expressive surface. These parts are sometimes captured in disorienting close-ups, as in the opening sequence of Resnais's *Hiroshima mon amour*, for instance, and throughout Lynch's *Lost Highway* and Teshigahara's *Woman in the Dunes*. With respect to a more global transformation, pertaining to the overall presentation of filmic contents, the abstractive, dematerializing power of video-image technology (analog and digital), in contrast to the celluloid film image, has also been used to great effect in modern and contemporary films, including those that creatively juxtapose the two formats.[10]

Through use of such compositional techniques and formats, and the resulting styles, some film worlds, to paraphrase Shakespeare's Hamlet, contain more and different entities, thing-types, or objectifications than are "dreamed of" in *other* film worlds, or in other human worlds, more generally. But whatever is composed or decomposed within the framed

image, if what it is, or was, outside of the cinematic work is still somehow recognizable, then its experience may be a comparative one: that is, a true "re-cognition" of something known and familiar when encountered in a film world as an altered reality. Returning to a point I made in the previous chapter (with reference to Mitry), this much entails awareness on the film viewer's part of the given image or sequence as being *a transformation of* the quotidian object or phenomenon in question.

Together with framing and deframing, and the use of on- and off-screen space attendant upon it, the *reframing* of an already established space through camera movement is a characteristic cinematic manifestation of simultaneous composition and decomposition. It entails a space being highly visibly (rather than "invisibly," e.g., through some forms of editing) decomposed and then recomposed with a different focus or object of attention. Often this functions as an alternative to, or in complex combination with, editing, which may serve a similar function but with different meaning and affects. While reframing may be conjoined in a given shot or sequence to a character's changing perception or internal awareness—as occurs repeatedly in Kieslowski's *Three Colors: Red*, for instance, so as to become a key structural and thematic motif of the film[11]—it may also operate entirely apart from any external or psychic movement or perception of a character. Like many artistic techniques and devices in narrative cinema, it therefore has both subjective and objective forms and uses in relation to the narrative and representational *world-in* films.

Taking all of these forms, composition/decomposition as a cinematic world-making process can be taken to apply to the total organization of a film's artistic presentation, with reference to the presence or implied absence of particular visual and auditory entities (or their imagined extensions) constituting it and their relation to the whole, including, but not confined to, the primary viewer-recognized denotations (representations) constituting its fictional and narrative reality. It thus encompasses both the creative selection of film-world materials and one prominent aspect of their artistic use in relevant aspects of mise-en-scène and framing. Especially in representational films, which of course narrative fiction films are, it can, for these reasons, be seen as foundational among the world-constructing techniques (and features of works) Goodman identifies, one on which all the others depend in some way. This is largely in keeping, as we have seen, with Mitry's and Pasolini's (and to some extent Metz's) understandings of "concrete" audiovisual (cinematographic) representation

(in the form of the perceptual analogue, the "psychological sign," and the im-sign) as the basis for the bulk of artistically transformational meaning and expression in cinema.

FILMIC WEIGHTING (OR EMPHASIS)

Like italics used for emphasis in a written text, the second world-making process Goodman identifies, "weighting," is a matter of *accent*, of how particular features or elements or objects found in one or more symbolic world(s) are given more or less relative emphasis in another. This may be put in another, perhaps more familiar way, as a matter of which particular aesthetic features or elements present in a film's work-world are stressed or foregrounded at the expense of others. Like composition and decomposition, weighting throughout the worlds of films may be taken to apply to represented objects, events, and dramatic characters and certain of their actions in the narrative, or the immediate properties and appearances of any of these. But it may also apply to expressive qualities and formal features, where these amount, in Goodman's words, to a "departure from the relative prominence accorded features in the current world of our everyday seeing."[12] Additionally, and significantly, it may be extended to the very techniques used to achieve this accentuation and to their stylistic, historical, and reflexive meanings, which may likewise be emphasized in films.

One higher-order form of weighting in film-world creation is a matter of recognized versions of two or more films that address the same familiar, historical subject, for example, with the differences between them conceived in terms of what is comparatively emphasized or deemphasized. Carl Theodore Dreyer's *The Passion of Joan of Arc* (1928) and Robert Bresson's *The Trial of Joan of Arc* (1962) treat the same historical personage and events. Yet, as analyzed by Deleuze, for instance, through different approaches to mise-en-scène and shot scale (close-ups, medium shots) the two films exemplify differences in weighting by way of differences in composition/decomposition and "ordering" (Goodman's third world-making process), among other means. Not confined to form alone, these differences result in different meanings and what Deleuze terms the total "spiritual" affect these films convey.[13] Weighting also may be seen at work in cinematic *remakes* where the remade film world has, consciously or unconsciously, a different set (or sets) of emphases than the

original. This is highlighted in Lars von Trier's and Jorgen Leth's *The Five Obstructions*, for example, with respect to notable formal, thematic, and generic differences between each of the highly disparate versions of his own 1967 film *The Perfect Human* that Leth, following von Trier's strict rules, fashions out of cinematic material provided by the original work.

In a more literal sense of "foregrounding," weighting equally pertains to how the contents of the film image (the "composed" or "decomposed") are perceptually (i.e., spatially and temporarily) foregrounded or back-grounded, through staging, framing, camera movement, shot scale, and lens and focus choice (and alternation), for example, as well as editing. In all of these respects a given film can bring something to our explicit attention within the framed image, and within the represented and fictional reality of a work, that would not normally be so "selected" (i.e., noticed, emphasized, or otherwise accorded special importance) in everyday life-experience or, indeed, in other films. Often these are small details that while literally present and available in a perceptual environment, including one of interpersonal interactions, may "normally" be imperceptible—for example, the nervously twitching eye of a drummer in a crowded ho-tel ball room (as the end point of a remarkable aerial tracking shot in Hitchcock's *Young and Innocent*), bubbles forming in a cup of coffee in a Parisian café (in Godard's *Two or Three Things I Know About Her . . .*), and the letters that make up the word *MURDER* (scrawled backwards on a door and a mirror in Kubrick's *The Shining*). Such specially highlighted details brought to the viewer's attention often play a vital narrative function, for instance, through the story information they convey. Yet, as in each of these examples, they may also have formal, affective-expressive, and reflexive values, interests, and effects apart from, or combined with, their more direct, and strictly speaking, narrative ones (not least, in two of the above noted examples, the generation of suspense).

Of course, not only such small or normally invisible (or inaudible) perceptual details may be foregrounded and thus emphasized within film worlds to great artistic effect. Equally possible are larger patterns and grand designs, in which many people and events (sometimes spanning hundreds if not thousands of years) become connected in complex ways. These latter may be outside the normal scope or range of episodes of ordinary perception, and of some worlds of experience and knowledge, in which it is impossible to sufficiently transcend the spatial, temporal, and causal limits of individual perception and subjectivity, and because

of this outlier status they may attain the literal or figurative vantage point expansive enough to observe them.

Much of the above falls under the heading of what Kracauer associates with cinema's "revealing functions" and the large category of "things normally unseen," which films may call particular attention to, including "many material phenomena which elude observation under normal circumstances" owing to their being too "transient," "small," "big," or "overfamiliar."[14] Of course these "functions" may operate together. The picking out of small details in a represented environment, for instance, and literally or figuratively zooming in or telescoping them, on one hand, and providing the "wide view" of objects and events, on the other, are not mutually exclusive in a given film world. The dialectical oscillation between the small/close and the large/far, in this respect, whether spatial or temporal, is in itself a powerful tool of cinematic world-making, of a special sort and magnitude seldom found in other art forms. The visual style of Sergio Leone's second operatic western "trilogy"—*The Good, the Bad, and the Ugly; Once upon a Time in the West; and A Fistful of Dynamite*—is anchored in the seesaw alteration between close-up magnifications of minute details of faces and bodies, and their extensions—six-shooters, cowboy hats, clothes, boots, musical instruments—and panoramic landscapes captured in wide-shot. In these film worlds the concrete, individual, and intimate is thus thematically, as well as visually, juxtaposed with vast, impersonal natural and historical realities that sometimes mock, and sometimes ennoble, the characters and their more immediate concerns. As the innovative, and much imitated, sound design of Leone's westerns also highlights, such oscillations may be auditory, as well as visual, a product of emphasis in a film world's represented soundscape—from far to near, and back—which creates its own rhythms, hierarchies, and sense of distance and proximity, in formal and thematic interaction with the moving image.

ORDERING IN FILM WORLDS

A third process Goodman identifies—that of ordering—pertains to how what is recognizably present in a given world (according to its composition/decomposition), as stressed or unstressed (through weighting) is patterned and positioned in comparison with other worlds. In other words, it involves the spatiotemporal *arrangement* of parts. As Goodman

suggests, many patterns of perception and meaning alter with the different ordering of the *same* elements, such as when the same block of time is divided up in different ways via different clocks or calendar systems, or when the same geographical area is represented in a road map versus a contour map.[15]

Like the reading of a novel or witnessing of a stage play, the experiencing of a film extends in time (that is, in our own literal, clock time), so intentional ordering in the form of *division* (or its lack) is a major aspect of cinematic world-making. In some respects it is much more significant in a film than in a literary work, given that films are intended and normally experienced from beginning to end in one sitting (notwithstanding current home viewing and on-the-go technologies). With specific reference to the presentational structure of Kubrick's *2001*, Michel Chion perceptively writes that "the question of whether and how a film is divided into parts, and whether and how the segmentation is marked, lies at the heart of film narrative." But just as significant, and included in the generation of extranarrative meaning, is whether and how a film prominently exhibits its "divisions" or "covers them up" (with this latter concealment typical of the "classic sound film").[16] Apart from the large-scale ordering of a film as a whole, the most basic example of this process in cinema involves the deliberate arrangement of shots and sequences. In view of its nature as an art form that is inescapably structured and conditioned by temporality, *sequencing* is a paradigmatic example of ordering in film, as, most simply, the filmmaker's decisions as to what comes before and after what.

In essence, Metz's typology of cinematic "syntagma"—formerly, at least, a topic of much discussion and debate in film theory—is but one linguistics-inspired, and narrative-centered, description of how the various constituent parts of relatively autonomous audiovisual units of a film (e.g., sequences, by any other name) may be differently ordered by filmmakers according to a range of available, more or less conventional options and choices (with these conceived in linguistic-semiotic terms as cinematic "paradigms").[17] Within Metz's semiotics such orderings include "bracket syntagmas," which consist of a series of brief, thematically related scenes as "occurrences that the film gives of typical [visual] samples of some order of reality" (126) that are independent of narrative and spatiotemporal chronology (this syntagmatic category, in particular, anticipates our forthcoming discussion of symbolic "exemplification" in film art), and "parallel syntagma," as the alteration between two or more

image sets tied to different narrative times or spaces (as famously present in Griffith's *Intolerance*, with its historical time and space crosscutting).

Apart from such structural-semiotic classifications, despite cinema's inescapable A to B to C linearity on a presentational and perceptual level—the proverbial "one damn thing happening after another"—the power of ordering in film often comes to the fore most noticeably and compellingly in relation to so-called nonlinear variations in narrative structure. (As it is hardly necessary to point out, a succession of film images may be linear but the representations of the story-world need not be.) Nonlinear film narratives like *The Killing, Bad Timing,* and *The Eternal Sunshine of the Spotless Mind* move back and forth in virtual time and alter spatial distances in ways that establish a world order based on principles other than the most literal chronology or the most clearly demonstrable cause-and-effect relationships, as associated with many continuity-style films. (As Bordwell reminds us, however, even in classical Hollywood–style cinema the frameworks of time, space, and causality in films may be relatively more functionally distinct and independent from one another.) From the standpoint of film-world creation as opposed to experience, when Deleuze compares and contrasts the nonchronological "sheets of the past" in Welles's and Resnais's films with the equally nonchronological "peaks of present" in Robbe-Grillet's, as two opposing forms of modern "time-image" construction in narrative cinema,[18] this is to compare and contrast two complex modes of ordering in cinematic world-making. In these cases, as in others, it pertains to the arrangement of shots or sequences and represented events on the basis of conceptual and often quite abstract relations between past, present, and future, from *both* objective and subjective perspectives, sometimes fusing reality, memory, and fantasy in ambiguous fashion.

The *same* (or similar) subject, event, or reality as organized, arranged, and presented in multiple and different ways within the *same* film world, in a way that has a thematic and conceptual significance (as well as a more purely formal one), is also a recognized aesthetic strategy. Discussed by Yvette Biro, and recently analyzed as "serial form" by András Bálint Kovács in relation to Resnais's *Muriel* and other works of 1960s and 1970s European art cinema,[19] this manner of presentation has analogues in twentieth-century painting and literature—from Andy Warhol's multiple portrait celebrity silk-screens and Gerhard Richter's "color grid" paintings, to Raymond Queneau's and Italo Calvino's literary experiments

as part of the mathematics inspired OuLiPo group—in addition, that is, to serialism and related movements in modern classical music.

Godard's *Vivre sa vie* has been aptly described by Perkins as "a series of dialogues on which Godard's camera plays a suite of variations, offering both an actual *mise en scène* and a string of suggestions as to how one might film a conversation."[20] This "counterfactual" presentation draws particular attention to the differences in received meaning, tone, and feeling of the presented situations that thereby result—that is, the contribution of the specifically chosen cinematic and aesthetic *how* (in each instance) to the denoted and narrative *what*. Violating realist cinematic conventions, while seemingly natural for and within its filmic world, in Bergman's *Persona* the same pivotal, intimate exchange between Elisabeth Vogler (Liv Ullman) and Sister Alma (Bibi Andersson), with the same dialogue, is shown twice in succession: the conversation presented first from over the shoulder of the speaking Alma (in order to show the face of Vogler reacting to her words) before reversing the camera's view to capture Alma's face while speaking (figs. 4.2, 4.3). The resulting repetition-with-difference serves to reveal new facets of each character's psychology and the nature of the events represented and their various meanings, as well as bringing the film's thus exemplified structure and certain cinematic conventions (acknowledged through their transgression) to the knowledgeable viewer's attention in a dramatic way.

In films like *Persona*, Resnais's *Smoking / No Smoking*, and Tarantino's *Jackie Brown*—where the centerpiece money exchange con-game is presented from three distinct temporal and spatial perspectives, one after another—such a prismatic form of presentation, with the effect of time arrested and wound backward, provides an opportunity to revisit fictional events in a particularly concrete and fluid way that appears to have few equivalents (natural or nonnatural) outside of cinema. Such presentation provides the viewer with multiple points of comparison and contrast on the planes of character perception and motivation, as well as cinematic form and style, suggestive of possible means in which the entire narrative *could* alternatively have been presented.

Kurosawa's seminal *Rashomon*, like the seemingly countless films that followed in its footsteps, is organized around different versions of what are and are not the "same" events. This oft-copied serial structure explicitly reflects on the characters' multiple and seemingly exclusive perceptions or experiences of a given phenomenal reality (in this instance, a

FIGURES 4.2 AND 4.3 Serialized presentation as a form of film world ordering in Bergman's *Persona*.

violent confrontation between three people). In effect, such story-event repetition amounts to the inverse both of Bordwell's related concept of the "parametric" narration of some films and directors' styles and of the abstract "formal dialectics" Burch champions in his *Theory of Film Practice*. In these styles and approaches the actions and perceptions of a film's characters are seen to appear (or be interpreted as) dictated by more abstract, formal patterns and structures—tied to a work's "artistic" and cinematically self-reflexive goals (as in many of Godard's films)—as distinct from (more conventional) dramatic and story-centered motivations.[21] In *Rashomon*, in contrast, it is the fictional action and a particular theme, namely the subjective origins (and perhaps end point) of all human experience and its moral and ethical consequences, which appears instead to determine (even overdetermine) the film's unconventional, and at the time of its making, radical formal and narrative *order*.

In a narrative context, sequencing and ordering are most often closely connected in one way or another (however attenuated) to the film image's (and sequence's) denoted or figurative content, as well as the rational progression of story events. Yet it is certainly not confined in binary fashion to either exclusively conveying or supporting narrative-fictional occurrences, as more familiar and dominant film styles might suggest, on the one hand, *or* to making this process wholly subservient to abstract formal patterns, on the other. Ordering may involve prominent and simultaneous interactions between a film's represented story-world (world-in) and other aesthetic and symbolic dimensions of it, in some cases resulting in a contrapuntal dynamic, both highly expressive and (self-)reflexive. So, for instance, as temporal markers dividing the film's episodic narrative, the serene, highly composed, fixed-camera and color-saturated images of the Scottish Highlands landscape constituting the postcardlike chapter markers in von Trier's *Breaking the Waves* collide with—and thus contrastively amplify—the frantic spontaneity of the gritty, flat-lit, color-drained, handheld-camera images that compose the film's live-action representation, reflecting the desperate emotional needs and impulses of the characters.[22]

Creative ordering in (and of) the worlds of narrative films as a matter of both structuring represented contents and providing them with specific meanings has, on occasion, also been highly thematic or *programmatic*. Here the ordering principle in question is drawn from some sphere of shared, cultural life (art, geography, myth, religion, history, etc.). A num-

ber of Greenaway's films make use of this strategy, as I have already noted. In Kieslowski's *Dekalog* insightful and often highly oblique reinterpretations of the Bible's Ten Commandments act as a world-making principle that divides and orders the represented world of a Warsaw apartment block and its troubled inhabitants into ten overlapping stories, each juxtaposed with a different commandment. This particular means of ordering would appear to be an area still rich with untapped possibilities for creative narrative filmmaking.

Another prominent aspect of ordering in narrative cinema involves where and when to begin and end the story told. But, as in all genuine artistic creation, this typically narrative consideration is inextricably bound to figurative, thematic, and literal content, as well as to cinematic form and style. The opening and closing of, entrance to and exit from, a film world, including beginning and ending title and credit sequences, may dramatically shape the feeling and meaning of all that follows (or that which is retrospectively reflected upon), and serve to define that world and work.[23] Like all the processes under discussion as a means of visual and audio transformation of experience into symbolic form, opening and closing images and sequences often act, in the manner of Saul Bass's celebrated title sequences, for instance, as microcosms and metonyms of film worlds as formal and thematic wholes, as well as fictional-narrative ones.

Finally, and clearly subsumed in all of the artistic-symbolic forms of ordering in films here briefly discussed, editing, in all its techniques and varieties, from the most literal, story-driven, and functional to the most abstract and expressive, creates narrative, formal, and affective orderings in cinematic worlds, at the same time as it influences and reacts to composition and weighting. Indeed, since the second decade of the twentieth century it has been the most prominent work- and world-defining form of ordering within cinema, not only making possible sophisticated storytelling but also communicating figurative and conceptual meanings and conveying emotion. As Burch analyzes in *Theory of Film Practice* (something of a handbook for cinematic world-making in its formal aspects), even the most basic of edited transitions may involve not only placing elements of action side by side but also categorizing them relative to each other according to narrative, formal, and affective principles that are (potentially) different for every film (or scene within it).[24] Moving from a wide master shot to a series of close-ups, or the use or avoidance of a

conventional shot/reverse shot pattern (a mainstay in the construction of many narrative film worlds), means classifying and organizing each shot and its different types of content into often highly complex groupings, associations, and priorities of graphic, narrative, and expressive kinds. As fairly obvious to any cinema-literate viewer, the sort of editing a filmmaker (or editor) employs—such as, to mention a few notable examples, Eisenstein's intellectual montage, Kurosawa's matching cuts, Renoir's lyrical dissolves, Kubrick's "brutal" straight cuts,[25] Roeg's kaleidoscopic transitions, and "Beat" Takashi Kitano's offbeat, highly elliptical patterns—shapes the perceptual, affective, and thematic nature of a film world in ways that transcend literal representation and fictional narrative (in their construction and comprehension).

CINEMATIC DELETION (FILTERING) AND SUPPLEMENTATION (MULTIPLICATION)

The fourth generic world-making process in art (and beyond) that Goodman identifies, deletion/supplementation, involves what is taken away from, or added-to, any given world relative to others. One basic manifestation, in many ways at the root of all others, is found in the psychology of perception, which Goodman draws on in elucidating this process. Here deletion refers to the entire range of phenomena associated with the fact that our perception is always highly selective, attending at any moment to only a small fraction of what is present and available within the sensory manifold. Both deletion and supplementation have their origins in all the ways in which the smallest, sketchiest, or most fragmentary cues in a perceptual environment are often sufficient for us to sense, interpret, infer, or otherwise construct an entire object or scenario. Although in all pragmatic contexts "we are likely to be blind to what neither helps nor hinders our pursuits,"[26] as Goodman succinctly puts the matter, and while even the strongest human (or nonhuman) memory relies on extensive filtering and editing, we are also inveterate suppliers of missing information and perpetual cognitive constructors, whether on the most basic level of sense experience or, in the case of our encounters with narrative cinema, our effective comprehension of plots and stories.[27]

Conceived more broadly, however, and from an aesthetic standpoint, but still often within the realm of what is perceived versus what is not, deletion and supplementation (i.e., as the "excision of old and supply of

some new material") are also the stock-in-trade and modus operandi of many artists. (Goodman cites the minimalist lithographs and sketches of Alberto Giacometti in this context, which suggest complete human bodies solely through depictions of heads, hands, and feet.) Artistically created worlds that rely for their making and meaning on these two, usually copresent movements of creation—involving the "extensive weeding out" and filling in of represented realities or their formal and sensory vehicles—are often also reliant on one or more of the processes of weighting (or emphasis), ordering, and composition/decomposition.[28]

In the arts deletion frequently takes the form of fragmentation or abstraction. As in verbal or other forms of metonym, through symbolic functioning, one part or piece of the whole comes to represent it, while yet retaining an expressive value of its own—for example, in the manner of the ruins of a castle, or the fragments of a sculpture, as famously celebrated in all their emotive and metaphorical significance by romantic poets. In cinema a number of readily recognizable directorial styles are built on the practice of symbolic deletion, more particularly as bound to perceptual fragmentation. Bresson's films immediately come to mind in this respect. In describing his own practices and suggesting a model for other filmmakers to follow, Bresson writes, "See beings and things in their separate parts. Render them independent in order to give them a new dependence"; "Don't show all sides of things"; "One does not create by adding, but by taking away."[29] These principles are powerfully followed in the director's remarkable *Lancelot du Lac*, for instance, where through close-ups and matching cuts, a jousting tournament is ruthlessly paired down to a repetitive and hypnotic series of close-up images of banners, horses' legs, and splintering lances.[30]

Owing to the representational possibilities allowed by the nature of the frame and the presence of offscreen space, as well as editing, for film artists wishing to pursue it, cinema is particularly well suited for such part-for-whole representational minimalism, wherein a hand is often enough to represent a body, or a street sign and a bit of wall an entire city. In Bresson's work this creative program of symbolic-aesthetic deletion also extends into the arenas of performance and speech, where acting, dialogue, and the vocabularies of the dramatis personae are often reduced to bare expressive or functional essentials. The French director's approach to actors as outwardly nonexpressive "models" is intended to filter out ("filtering" being a similar or subsidiary process to Goodman's deletion)

much of the tonal and gestural language that in cinema, as in the theater, has evolved into an eminently legible shorthand code of meaning and affect. Yet this common "language," as Bresson is right to point out, is sometimes all too easily relied on by actors and directors alike, to the extent of forming a kind of conventional "noise" in and around representations and actions that may also prevent the conveyance of a deeper (or at least different) work-created expression.

Once the shooting of a film is completed and the editing stage begins, the majority of filmmaking (in most cases) is given over to a global process of deletion (and filtering), taking the form of what Andrei Tarkovsky refers to as "sculpting in time." This is as a process of starting with a surplus of audiovisual material and discarding all of that which is deemed narratively and aesthetically inessential.[31] More generally, with the temporal ratio of footage shot compared to what appears in a finished narrative film (shot on celluloid) frequently twenty to one (at least)—and in the case of Coppola's *Apocalypse Now*, and a number of Cassavetes's films, reportedly closer to one hundred to one, or even higher—at a basic level, deletion via editing, and all that it entails, is a crucial and near-ubiquitous feature of both celluloid and digital filmmaking.

Supplementation, as a combined formal and referential *multiplication* or *addition*, is a feature of cinematic world-making that is no less common and potentially significant than deletion, as its polar counterpart. Consider, for instance, the use of mirror images and other visual reflections in the mise-en-scène of films like *The Lady from Shanghai*, *Performance*, and *The Double Life of Veronique*, that multiply characters and objects and may have all sorts of mythical, psychological, and reflexive meanings to impart as centered on the enigmas of identity and personality and the often fluid and ambiguous relation between reality and illusion, waking life and dream. Supplementation is also reflected in visual superimpositions and dissolves in films, whereby images of people, places, and objects are combined with others—for example, the multiplied landscapes and interiors in *The Searchers* and *Wild Strawberries*, joining in lyrical fashion different spaces and times; or the surreal superimpositions of bodies and faces in *Un chien andalou* and *Persona*, and in the poignant marital confrontation staged through transparent/reflective glass in *Paris, Texas*, as all creating new composite, animate entities like those found in Max Ernst's oneiric collages. Still on the level of the image and the edited sequence, matching cuts and rhyming compositions, notably present in the

films of Ozu and Kurosawa, are other means of visual supplementation and addition through doublings and conjunctions.

One, perhaps more basic and radical, application in cinema of supplementation and deletion involves the relative amounts of basic visual information that is provided to the viewer, concomitant to the narrative. In a fiction film context, this may range from a bare minimum, allowed by the medium to support construction of a cogent story line, to a point of sensory overload, or oversaturation. The continuum here corresponds to the different demands made by different films on direct, visual sensation, on one side (vis-à-vis the richness of their images), and appeals to imagination and the discharge of cognitive tasks in the apprehension of a work, on the other (vis-à-vis such things as making metaphorical associations and grasping allusions), as these relative priorities are asserted across many genres and styles.[32]

In these terms Derek Jarman's *Blue* exemplifies symbolic and artistic deletion at its cinematic extreme, with no visual content or representation, save for monochromatic blue image, accompanied by voices and sounds. *Blue*, of course, is a historically marginal case. In comparatively more conventional films symbolic deletion (or subtraction) often translates into the perceptual or experiential minimalism of a single represented location, as in Hitchcock's *Lifeboat*, or of a highly abstract and nonspecific environment (e.g., von Trier's stage-bound and near sceneryless *Dogville*). In other cases it involves sequences or entire works confined to a single angle or point-of-view perspective, such as Kiarostami's *Ten*, with the "eye" of the camera fixed to the dashboard of a Tehran taxicab for the duration of the film. Given the quite deliberate withholding of comparatively standard or customary spatial and visual context and information—which may well be experienced as such a departure from the experiential norm in relation to both narrative cinema and other life contexts—the meanings and effects of such perceptual deletions in these films (and many others that might be cited), go hand in hand with a more than conventionally active interpretative negotiation between work and viewer.

Visually, as well as through sound, some film worlds push a contrasting aesthetic of supplementation (or addition) to the limits of their viewer's perceptual capacities and sometimes beyond. Tati's *Playtime* uses 70 mm film technology and the widescreen (spherical) format, with a 1.85:1 aspect ratio, to stage simultaneous action in multiple areas of the frame (with sometimes as many as four discrete fields of action), thus making full use

FIGURE 4.4 Widescreen compositions with multiple centers of attention in Tati's *Playtime* as radical visual and narrative multiplication.

of the temporal and spatial axes of the film image (fig. 4.4). The viewer is compelled to constantly shift the focus of his or her attention to attempt to take in the entire spectacle, as well as follow the basic narrative thread. A similar challenge is posed in Figgis's *Timecode*, with its split-screen deployment of no less than four separate images within the frame, the contents of each image situated in its own, often entirely noncontiguous sector of represented time and space. In these cases one film in effect provides the sensory inputs and experience of many, such that a number of individual viewers may watch *Playtime* or *Timecode* and, depending on which parts of the screen they attend to at particular moments (to the necessary exclusion of others), each will experience a "different" film in a more than figurative sense. Here the sheer quantities of visual information and the multiplication of perceptual and imaginative elements verges on a kind of cinematic sublimity, in the basic Kantian sense as an overwhelming of the sensory and imaginative faculties, both momentarily and cumulatively, which can be thrilling, disturbing, and exhausting in equal measure.

Other noted cinematic work-worlds retain the customary single image per frame, but overload visual information through dense and cluttered mise-en-scène or insert-shots cutting into the main represented time and space, opening up multiple perceptual and imaginary spaces. Godard's

mid-to-late-1960s so-called collage films are bursting with sights, sounds, images, stories, ideas, and polemics, all constantly colliding with one another to create a remarkably dense perceptual and cognitive experience. Aptly reflecting Godard's mantra during that heady era that "everything should be put into a film,"[33] they present worlds founded on such an aesthetic of addition and multiplication of objects and spaces, forms and signs, one that is reflected in the very titles of the films in question (e.g., *One Plus One, Two or Three Things I Know About Her*). This is the selfsame multiplication of sensory and symbolic realities that in *Two or Three Things* and *Pierrot le fou* also contribute to his character's psychological and existential struggles with mid-twentieth-century image- and media-saturated urban life.

Since its emergence in the 1920s, synchronized film sound has provided a wealth of possibilities for creative deletion and supplementation in cinematic world-making. A good deal of sound design is predicated on how *much* or how *little* is heard relative not only to the content of each image and the narrative but in relation to ordinary, extrafilmic standards of auditory experience and the sound component of other lived and represented worlds. In this latter respect a cinematic "defamiliarization" of experience equating to a recognized creative transformation of it is as much at play in sound as in image. Robert Altman's characteristic overlapping dialogue achieved through a pioneering use of multitrack recording is the sound equivalent of filling the frame with multiple centers of attention. It represents a radical auditory multiplication in comparison with most other film worlds, as well as a fascinating distortion of our ordinary attempts to listen to multiple sounds, or conversations, at once. In contrast, the reduction of direct or natural sounds in Lynch's *Eraserhead* (supplemented by the addition of nonnatural ones), or their elimination altogether—as in the impromptu minute of silence in a busy café in Godard's *Band of Outsiders*—are both forms of auditory *deletions* that can be as interesting, powerful, and transformational in films as any purely visual reduction or separation. Whether focused on sound or image (or both), and like most of the other processes of world-making under consideration, artistically meaningful supplementations and deletions of these kinds may pertain to the diegetic world-in, or what falls outside of it, or, as discussed in chapter 1, may involve both at the same time or in succession.

DEFORMATION (OR DISTORTION) IN FILMS

Goodman's fifth and final process, deformation, initially appears more limited in scope than any of the others and is always conjoined in practice with one or more of them. In *Ways of Worldmaking* it is also labeled "distortion" and "reshaping."[34] As Goodman's chosen examples of symbolic and aesthetic deformation make clear—particularly Picasso's remarkable series of painted variations on Velázquez's *Las Meninas*—this constructional device pertains primarily to one work's creative, referential inclusion of another, with emphasis on perceptual form.[35] Along these lines, deformation may be taken to refer to artistic versions and variations where aspects of content, theme, subject, or story remain constant from one (earlier) work-world to another (subsequent) one, while, simultaneously, aspects of formal structure and presentation are radically altered to thereby reveal something otherwise hidden or overlooked in the original work-world.

Here one can point to certain more formally creative and abstract or oblique film reworkings, as opposed to "straight" remakes. These reimagine their sources (in a different historical or cultural context, for example) and interpose a new formal structure, using a different vocabulary of cinematic and aesthetic elements. Chris Marker's *La jetée* and Lou Ye's *Suzhou River* are, on one level, cinematic dialogues with *Vertigo* in the form of creative deformations of it, wherein the artistic styles and sensibilities of these directors meet and engage with Hitchcock's. In Hsiao-Hsien Hou's breezily elegant *The Flight of the Red Balloon*, Albert Lamorisse's classic 1956 short *Le balloon rouge* is reworked into the fabric of a more expansive, feature-length story through the formal and thematic vehicle of a student's digital-video remake of it.

Such "intercinematic" interaction between one world and another may also take the form of a creative *self-encounter*. This is the case in Leth's aforementioned four versions of his own earlier *The Perfect Human* (in *The Five Obstructions*), with the new films being intriguing examples of successful deformation accomplished through many formal devices, including animation techniques, such as rotoscoping, that expand the traditional formal vocabulary of narrative cinema. Also featuring pronounced and fascinating referential deformations and distortions (of characters, events, locations) the formal and reflexive transformations that mark the creation of Wong Kar-Wai's *2046* out of the narrative and thematic mate-

rial of his earlier *In the Mood for Love* are far too numerous and intricate to list here. Together they may be seen to invoke all five of Goodman's "recipes" for creative world-making and surely several more avenues for the articulation and transformation of symbolically functioning materials and elements. These result in the creation of what may also be experienced and analyzed as a two-film, past-present-future spanning work with little precedent in contemporary cinema in terms of its thematic scope, formal daring, and artistic ambition. All of these examples are sufficient to highlight the fact that creative deformation and distortion may be integral aspects of all *adaptation* in which representational, narrative, and thematic elements, as found in novels or plays, paintings and operas, are translated into cinematic terms and into the individual styles of filmmakers, with the meanings and affects of the source material changing, sometimes dramatically, as a result.

Going further and more metaphorically afield from Goodman's specific formulation, but still relevant to the general concept, since *genre* models have become deeply ingrained in so much cinematic practice, across time periods, national cinemas, and film styles, these are a major target of conscious and creative distortions. Films that modify genre forms and themes are recognized and appreciated against the standards set by the most conventional examples of the western, the horror film, the gangster film, and so on. Convention, or, in Goodman's favored idiom, symbolic (or cognitive) "entrenchment," is established by those classical and foundational works that have served to define the "standard model" at some earlier stage of cinematic tradition.

Indeed, if this general process is to apply to the relative distortion of any familiar, established world of experience within a new artistic one (with the latter providing a platform for comparison between the two, in a way that reflects back on formal and structural features), then *parody*, for instance—which M. M. Bakhtin refers to as an "intentional dialogized hybrid" posing a confrontation and argument between two languages, styles or modes of representation of a subject[36]—may be seen as another of its manifestations, with a long and varied cinematic tradition. As the example of parody indicates, distortion and synonymous terms should not carry any of the negative connotations of their ordinary (and sometime film-critical) usage, as entailing a misunderstanding or misappropriation of one work by another. Rather, this common process can be aptly taken to refer to any exaggeration centered on perceptual and symbolic form that

is recognized *as* exaggeration according to relevant and relative standards of normalcy: for instance, the conspicuous visual distortions of German expressionist cinema or all manner of manipulations and enhancements of the appearances of people, places, and objects achieved today by means of digitized image technology.[37]

In highlighting that all art-making is creative remaking, not only deformation/distortion but all five world-making processes lend support to a general raising of the aesthetic reputation and status of parody (and the humor it may entail), genre revision, and the remake, as well as other forms of cinematic "quotation."[38] In accord with the suggestions of a number of noted film historians, including Bordwell, Ian Christie, and Christopher Frayling, such recognition is long overdue in film criticism and theory, in opposition to the expressed or implied depreciation with which these modes and practices in and of themselves are sometimes met with in contexts of critical discussions of consequential or "serious" film art. If, as has been stressed, little if any of a film's constitutive material is truly new or "original," there is no a priori conceptual or theoretical basis on which to discriminate against such uses of previous films, including in the form of intentional "distortions," as always and necessarily bereft of originality or creativity. As a corollary, deformation/distortion and the larger dynamics of artistic creation as recreation and recycling, of which it is a part, clearly suggest a more critical and nuanced picture of both artistic creativity and originality in cinema than is sometimes painted.[39]

An Abstract and Nonessentialist Scheme

Goodman rightly remarks that the five basic processes of symbolic world creation and transformation discussed here are separate and distinct only at the level of theory and analysis.[40] Indeed, despite the specific examples of each that I have cited as illustration, no sooner do we descend from these heights of abstraction, and pursue a path in the direction of filmmaking practice, than we find that these five "ways" have no genuine boundaries to set them apart since they conspire with one another and are interrelated in complex, individual-work-instantiated patterns. In a cinematic context there is perhaps an even greater force to Goodman's additional disclaimer that his stated world-making techniques are by no means the only "ways that worlds are made" but, rather, only some

conspicuous ones that are, as he puts it, "in constant use," both within and without the customarily bounded realm of art.[41] With respect to the potentials of the film medium and of cinematic form open to directors as world-creators, they are by no means exhaustive and could be further explicated, subdivided, and combined in a variety of ways while also keeping in mind that "the aesthetic possibilities of a medium are not givens,"[42] as Cavell writes in relation to cinema.

Moreover, each process may also in effect provide the world-making material for the organizing procedures of others—as when, for instance, a particular form of composition or ordering is accented (or weighted), or a form of cinematic deletion is part of the deformation of an earlier, referenced work-world. This overlapping is perhaps even more strongly the case in filmmaking versus the creative process in other arts, given the amount and diversity of materials and elements that the creation of every film involves and the sheer number of individual creative manipulations and ad hoc strategies undertaken, not to mention individuals with a creative hand in the process. And, of course, it is not just film directors that are constantly engaged in these and other processes of world-making but cinematographers, production designers, art directors, costume designers, sound designers, composers, and others, working in coordinated fashion under the creative control (more or less) of directors (and sometimes producers).

As is true of film directing, in all of the cinematic arts and crafts corresponding to these and other occupations, there is a near constant creative exchange, interaction, and influence between cinema and the works and worlds of other arts, mined for their valuable materials as modified, arranged, and rearranged in the aforementioned ways and others. Moreover, on the plane of theory and criticism, as nonmedium essentialist descriptions of how new artistic worlds are fashioned out of older ones (artistic and nonartistic alike), the processes here described have the advantage of providing specific transart (or "transmedial") categories for illuminating comparisons among the works and styles of films and filmmakers (and particular artistic features of films) and those of painters, poets, novelists, and composers.

As the above descriptions, and those of the previous chapters have implicitly assumed, there are many other general, preaesthetic (and to a degree presymbolic) cinematic transformations of the "given" or the profilmic that (nearly) all films share in. This is because they are the more

universal (in some cases unavoidable) products of the physical and causal nature of the film medium or, as it is necessary to add today, various cinematic media. The subject of detailed discussion within classical film theory (carefully cataloged in Rudolph Arnheim's *Film Art*), these include literal two-dimensionality, the virtual presence of (represented) objects that are physically absent, the reduction of perceptual experience to two sensory channels (sight and sound), and a particularly cinematic conjunction of perceptual and imaginative time and space, together with a radical concentration and distillation of actual time and space. All of these features certainly help to distinguish cinematic presentation and representation from that of other art forms and ordinary perceptual experience and to differentiate film worlds from other artistic worlds. Moreover, all are often used in highly creative fashion by filmmakers.

This being said, I have instead focused throughout this chapter on just some significant kinds of world-making transformations, deviations, and emphases that result from specific creative choices and often highly individuated artistic uses of the medium, as distinct to what may be more fully credited to its intrinsic properties. Attention to such processes brings to reflection on cinematic art a more detailed, symbolically and aesthetically focused variation of the "functionalist" and nonessentialist (or non-"medium foundationalist") account of cinematic form and style that Carroll has long advocated—often in rather general terms, and as centered on "elements and relations intended to serve as means to the end of the film."[43] Here, the ends in question, which help to account for (if not always to "justify") the means, are artistic and aesthetic (broadly speaking). Finally, and in related fashion, although I have not emphasized the point, as transposed to cinema, these processes, which are largely *formal* rather than medial (and yet not divorced from film "content") are neither *celluloid-* nor *live-action-film*-specific. They are everywhere also at work in digital cinema and in animation, as well as in the various hybrid live-action and animation formats that are increasingly prevalent. Indeed, creative filmmaking in these formats may allow for additional and typical stylizations, supplementations, deviations, distortions, and so on.

All of these patent advantages and potentials for film theory and criticism notwithstanding, while Goodman's schema of the most prominent "ways of world-making" helpfully illuminates the creation of cinematic art from one rather abstract, high-level, and strongly cognitively oriented perspective, it does not fully encompass it. These methods of transforma-

tion and their various effects represent but one starting point for theoretical reflection on cinematic world creation, and our attention to such processes as applicable to films, styles, and directors' bodies of works must be supplemented by other considerations bearing on the construction and experience of film worlds. In relation to these we will find it most useful to begin with other, in some ways more primary concepts and distinctions within Goodman's philosophy of art and world-making. They center on the basic types of representational symbols, and their artistic employment, as to be found everywhere one looks in the *worlds-of* (and *-in*) narrative films, as also substantially contributing to their aesthetic function and in some cases allowing for it.

REPRESENTATION, EXEMPLIFICATION, AND REFLEXIVITY

An Alternative Approach to the Symbolic Dimension of Cinematic Art

At this point we should speak of the symbolic function of any work of art, even the most realist.

—Jean-Paul Sartre

WITH FAR MORE CREATIVE AND EXPRESSIVE POTENTIAL THAN communication via conventional signs and codes, although also incorporating these, we have seen that filmmaking may be aptly described as a form of symbolic world-making. It entails the use of preexisting materials of many kinds organized and synthesized in novel, artistic ways in the interest of creating new meaning relations. The resulting structures prompt both the materials in question and the natural and human realities to which they are attached to be seen and *thought of* differently, as a result of the contextual displacements typical of world-making. But if these creative processes in cinema and other arts (including those Goodman identifies) are variable and overlapping, the modes of symbolic reference that make up their content are more clearly independent of each other. The acceptance of a basic multiplicity of symbolic forms, functions, and objects of reference, beyond what is encompassed in other theories of the film sign, is key. Just as we have found that the macroprocesses of world construction help us to better understand the sorts of transformations marking artistic filmmaking practice, so we can now explore, in somewhat closer detail, how certain well-known features of films with

artistic aspirations and merit make use of fundamentally different forms of pictorial and verbal reference.

CINEMATIC REPRESENTATION AS DENOTATION

Goodman's art-as-world-making thesis, concerning how systems of symbols in cultural praxis constitute the cores of worlds (or world-versions), builds on the "general theory of symbols" and their functions, as first laid out in his earlier *Languages of Art.*[1] This influential study centers on the nature of symbolic reference itself, both within and without the practices of art. Tied to his philosophical nominalism and an "extensional" view of reference and meaning (indebted to the views of W. V. Quine), Goodman argues that the most common type of reference made by visual representations is a matter of *denotation*. The idea that denotation is the "core of representation"[2] clearly returns us to the diegetic concept of a denoted aspect or level of a film constituting the basic *world-in* a cinematic work in the form of a representational and fictional narrative-supporting construct (see chapter 1).

To denote, in the first instance, is to name or fix a relation, otherwise "arbitrary," between a symbol and an item in empirical experience. This process may involve no more than the attachment of a label that, in this minimal sense, serves to pick out and identify the item—for example, when we attach the label "Napoleon" to certain pictures. Conceived in terms of pictorial reference-making, then, representation may extend, as it does in narrative films, to fictional characters, situations, places, and entire worlds that have no literal, embodied existence. As we saw in chapter 1, denotation, and what Goodman terms predication, in narrative films is both literal and fictive (or figurative). Thus an image (in the form of a medium-close shot) of a figure leaning against a bar counter in Wim Wenders's *Paris, Texas* denotes in multiple literal and fictive ways simultaneously: as an image of a person, of a woman, of an actress (Nastassja Kinski), of a fictional character (Jane, as the object of the protagonist's quest), of that character at a certain space and time within the fictional represented world and story of the film, and so on. For Goodman, however, basic visual representation, or "depiction"—including the use and interpretation of photographs—is seen to operate largely apart from natural, perceptual resemblance between image and object in the world and

instead through conventional, culturally informed attribution. This view runs counter to Metz's understanding of denotation in cinema as almost exclusively a matter of visual resemblance or natural "analogy," with the photographic basis of traditional film images ensuring that they are first and foremost *iconic* of their referents.[3]

The general problem of the extent to which the basic representational aspect of visual images is a cultural acquisition or an innate capability of the human mind is a familiar topic in the contemporary philosophy of art. The consequences for film theory of adopting one or the other of these supposed "perceptualist" and "conventionalist" alternatives concerning how the film medium and aspects of film viewing experience should be conceived has also been the subject of a great deal of attention among theorists and philosophers.[4] Anchored in the observation that in *some* system of representation literally anything may "stand for" almost anything else,[5] Goodman's now famous, strongly conventionalist position that visual resemblance is not only not a *sufficient* condition but is not even a *necessary* one for successful pictorial representation (i.e., recognition) is a counterintuitive one. It is both literally and figuratively "iconoclastic." The substance of the many criticisms that have been leveled against it is the claim that iconicity (the visual resemblance between signifier and signified) simply must be admitted to play at least some more prominent if not, strictly speaking, necessary role in pictorial representation. It seems highly plausible that there are, in fact, so-called perceptual constraints at work throughout visual communication. And, depending on how it is specifically interpreted,[6] Goodman's conventionalism concerning our most basic comprehension of pictures may appear far too strong. However, making more room for resemblance with respect to literal representation (or denotation) in visual art and, more pertinently, cinema does not (as Metz also recognizes) obviate the symbolic character of the relation.

Jenefer Robinson, Dominic McIver Lopes, and Dudley Andrew (with reference to cinematic representation, specifically) are among the philosophers and theorists who have justly recognized that the chief merit of Goodman's provocative account of the symbol function of denotation is properly acknowledging that no matter how they are generated, pictures, like linguistic expressions, must often not only be viewed but understood for both what they are and contain as symbols.[7] Mitry writes that a film "absolves us of the need to imagine what it shows us, but . . . requires us to imagine *with* what it shows us through the associations which it deter-

mines." This ensures that in cinema the image is *both* a perceptual "window" and a cognitive "frame."[8] Indeed, the presumed opposition between taking film images to be iconic of their referents (and more or less fully accessible to anyone with normal vision), or as having semantic contents that are preassigned by means of culturally specific, informally adopted codes that film viewers must in some manner learn and master, is a false or, at most, a dialectical one, quite susceptible to a synthetic resolution. Neither so-called seeing-theory nor sign-theory is a truly self-sufficient alternative in any more complete (and less predisposed) account of film viewing communication.[9]

Further, and more germane to our central concerns, many of the most significant aspects of films *as works of art* are simply not explicable in terms of the most literal representational or denotative function of the film image, no matter how this is theorized—that is, whether in perceptualist (and naturalist) or conventionalist (cultural-semiotic) frameworks. The conditions and capacities associated with our successful recognition of the contents of pictures in the ordinary, pragmatic contexts of their communicative uses are, in and of themselves, still below the threshold level of an aesthetic apprehension and appreciation, at least in the majority of cases involving artworks (including photographic ones) and our encounters with them. On this basis, regardless of how conceptually sophisticated or flexible it may be, no general theory of basic pictorial representation or recognition (nor, it should be added, of meaning and emotion as tied to it exclusively) applied to cinema will be able to adequately account for a film's artistic or aesthetic dimensions. Modifying Goodman's formulation (seen as supported by the existence of nonrepresentational art) that denotation is neither "necessary nor sufficient for art" in general, and following Mitry, in the great majority of narrative cinematic art (as representational), denotation would appear necessary but still far from sufficient.[10] For this reason, among others, in defining and understanding a film as an artwork, as distinct from a focus of inquiry limited to the narrative dimension and its construction, we must move beyond "mere" denotative representation as rooted in the iconic and indexical properties of film images (as well as contemporary theories of depiction that are perforce limited to what amounts only to literal denotation) and instead consider other forms of meaning relations.

Returning to Goodman's cognitive aesthetics: as has also been recognized by other philosophers, his treatment of visual denotation as

largely if not entirely conventional, and its attendant difficulties, does not threaten the substantial insight and value of his identification and descriptions of the other major forms of symbolization present and in play in artworks defined in contrast to literal representation.[11] Nor does it work against their multifaceted, and largely uncommented upon, relevance to cinema, as will be my principal focus of interest in the first half of this chapter. Such nondenotational forms of reference may likewise be seen to constitute a great deal of a film's characteristically aesthetic "content" and meaning, as closely bound with and often articulated through its cinematic and artistic presentation, and "form" in this sense.

ARTWORKS AND EXEMPLIFICATION

Developed by Goodman and his occasional coauthor Catherine Z. Elgin, the concept of *exemplification* is a major and original contribution to the analysis of presentational symbolism and, a fortiori, to the theorization of cinematic art. Its importance lies primarily in its acknowledgment that a symbol—and an artwork (as an object made up of symbols)—may, and often does, refer to extrawork realities by *referring to itself.* Binding together a work's perceptual properties and the interpretative discourses that assign them meanings, exemplification provides a highly productive way of thinking about those qualities of sensory presence and alterity, self-reference and self-definition, central to the heterocosmic view of art worlds while also squarely situating them in relation to the extrawork (and "real world") realities and processes of signification that give them transsubjective meaning.

The key notion of exemplification is defined as "possession plus reference," and Goodman illustrates it by pointing to the function of samples in everyday life and commerce.[12] A paint sample (or "chip") consisting of paint on a piece of cardboard functions as a sample of a type and color of paint by drawing attention to some of its properties as an object (the precisely shown color, shine, and texture of the paint on the surface) but not others (e.g., the size, shape, thickness of the cardboard, or the chemical composition of the paint).[13] The same is true of a tailor's cloth swatch, where some properties (thickness, pattern, texture, weave, type of material) and not others count as relevant for its purpose and use as a sample.[14] These sorts of things are, of course, symbols. But unlike others (e.g., the vast majority of spoken or written words and pictures that

make reference) they actually *possess* at least some of the properties to which they also refer. While the denotational symbol, including a pictorial one, is founded on an *absence*, pointing elsewhere to some real or imaginary object(s) to the extent that it may become virtually *transparent to* that which it refers, the symbol in exemplification is never a so-called arbitrary (or mobile), or transparent, one. Instead, it admits and calls attention to its own sensory presence, freely displaying some of its own properties so that it may also signify the same or similar properties to be found in experience *apart from, or outside of,* it—for example, the property of "squareness" as exemplified in Joseph Albers's pioneering abstract paintings. This clearly contrasts with common linguistic reference and differs, as well, from denotation or depiction (as the general form of identifying reference by means of pictures), wherein the object portrayed in the picture is not possessed by it as an object (or, at least, not in the same way).

From a particular analytical standpoint the concept of exemplification can be seen to address the fundamental duality or ambivalence of the representational artwork qua symbol. It both draws attention to itself, as a physical, incarnate, and sensory object, and participates in a cognitive-reference relation or function, pointing to something it shares with any number of other real (or, perhaps, fictional) objects or beings. Indeed, in this major aspect there seems to be a clear connection between the exemplification relation Goodman assumes and Cassirer's seminal thesis concerning the "symbolic form" of art, the exemplars of which are characterized by *self-representation* as well as extrinsic representation. Of course, properties of artworks, including films, do not behave in the clearly planned, determined, and well-ordered manner of those of commercial samples. They are seldom easy to discriminate individually, and they comingle and cooperate, in the sense of highlighting or foregrounding perceptual aspects *of one another* in a holistic fashion. Nor, crucially, and as Goodman maintains, are exemplifications in art confined only to intrinsic, sensory qualities of works as the target object of self-reference.

Exemplification always involves recognition of the presence of a general property or quality (of things) brought to reflective attention by some object of direct perception. Yves Klein's paintings exemplify "blueness" in general (with all of its potential natural, psychological, and cultural-symbolic associations) through the artistic employment of a very specific (in fact, artist-created) shade of blue paint. In this instance the exemplifying feature (the paint on the canvas and its color) and that to which it

refers (blueness) are very closely related (almost identical)—hence they stand in a more "literal" relation, in Goodman's terms. However, through its equally sensory features a Jackson Pollock painting may exemplify temporal rhythm, or a Caspar David Friedrich painting may elicit properties such as holiness or tranquility. In such cases as these there is a (much) greater "metaphorical" distance (as Goodman suggests) between the exemplifying features (e.g., circular patterns of paint advancing across a rectangular canvas; a painted landscape *and* the way that it is composed, colored; etc.) and the quality or idea to which these works refer and act as individual "samples." This is because, of course, unlike being blue, temporal rhythm is not the sort of property *actually* (objectively) possessed by paintings as perceptual objects (alone), whereas it is so possessed by musical compositions, for instance. Such more mediated, figurative distance between the features of works accessible to our senses and that which we are able to interpret them as exemplifying is even more pronounced with respect to artistic exemplifications of "holiness" or "tranquility" or "anxiety," which are, obviously, states or qualities more literally belonging to (and associated at times with) people, or, in some cases, perhaps, non-artistic objects and places in their anthropomorphic aspects.

While denotation generally aims at reference that is empirically determinate (i.e., we don't use the word *dog* to identify a passing cat), exemplifying symbols are generally more "open," or indeterminate, considered as tools of reference-making (and therefore more demanding of interpretation). At the same time, however, the exemplifying symbol is individual and nonarbitrary, maintaining a connection between at least some of its own intrinsic properties and those of the object of reference. And it is this aspect of the relation that fosters the more concrete and "particularizing" modes of representation (the so-called concrete universal) that we associate with much of representational art.

Goodman argues that the symbolic function of exemplification—which is found in both abstract and representational art (where it often works in conjunction with literal representation)—is a characteristically aesthetic one, since it is the source of much of a work's cognitive interest and stylistic import. *How, what,* and *whether* any given work exemplifies is a frequent, underlying subject of artistic interpretation and debate. Indeed, the fact that what properties an artwork is seen to exemplify "vary widely with context and circumstance"—historical, cultural, individual—

is acknowledged in Goodman's suggestion that in relation to a number of issues the question of "what is art?" should be replaced by "when is art?"[15]

Moreover, and as we can add to Goodman's and Elgin's account, the relative presence of exemplification can help to distinguish between *more* and *less* artistic uses of any medium, including film in its celluloid or video-digital forms Along with obviously lacking fictional denotation, most industrial films, home movies, historical recordings, and many (although certainly not all) documentaries feature far less in the way of concentrated, complex, and self-conscious exemplification than many narrative films, and certainly less than, e.g., *The Cabinet of Dr. Caligari*, *On the Waterfront*, *The Conformist*, and other canonical cinematic works. Thus, the thesis of "possession plus reference" may be seen as one alternative, and relatively more precise, means of distinguishing between artistic and nonartistic uses of cinema, in referential terms. The presence and relative amount of exemplification is certainly a more useful yardstick in this respect than Metz's appeal to a "wealth of connotations" as constituting the difference between a "medical documentary"—as almost entirely rooted in literal, visual denotation and one predominant type and level of meaning—and a "Visconti film," in the French theorist's memorable example.[16]

Since, to repeat, in exemplification only *some* of the properties of any familiar sample or model participate in the task of reference, there is an intention-governed selection of those properties on the part of the maker or designer that is necessary for, and precedes (in the logical sense), the sample's or model's ability to function as such. [17] The same is true of the more sophisticated exemplifying symbol in art. However, just *having* the relevant perceptual properties to which a meaning is conjoined is not enough, since the symbol, and work (in this case) must in some way "show them off," as Goodman writes,[18] or "highlight" them, as the noted analytic philosopher Bas C. Van Fraassen suggests in support of this widely applicable understanding of the workings of some symbols in the arts and sciences.[19] In other words, in exemplifying, the object as symbol must somehow *foreground* the specific properties of itself that it wishes to put to external, referential use. Thus, "the properties that count in a purist painting are those that the picture makes manifest, selects, focuses upon, exhibits, heightens in our consciousness—those that it shows forth—in short, those properties that it does not merely possess

but *exemplifies*, stands as a sample of."[20] These are just the properties that in most cases (at least) the artist consciously intends to call to the attention of his or her audience, as somehow relatively more pertinent or revealing of the subject than others, and which are also at the forefront of the work's aesthetic experience and interpretation.

In the process of exemplification the self-highlighted perceptual aspects of a sensible symbol are abstracted away or, in Goodman's terms, "projected" out from it.[21] They are attached (by its interpreters) to relevant "predicates" (labels), or apt descriptions, within any given cognitive, historical, cultural, and artistic formation, in the processes of the work's understanding and critical interpretation.[22] This is not only a question of a signifying or semantic function on the part of visual art, for instance, but of a concrete, visually demonstrative one. In practice, the grasping of an artistic exemplification, which "actualizes" it, is typically the result of a recognition on the part of audiences that possess the requisite degree of acquired cognitive (and cultural) background and sensitivity to interpret perceptual features in certain ways. Through exemplification (in this view) works refer us not only to specific real or fictional objects of *denotation* (basic representation), wherein a certain and unequivocal specificity and concreteness in reference-making is the desired end. But they also refer to more abstract and general concepts (including that of "art" itself, in some instances), together with sensory and human qualities.[23] In effect, exemplification is largely a matter of the ways in which, through their concrete and sensory forms (even, that is, when their exemplifying features are representational), artworks actively and often intentionally invite the linguistic descriptions that constitute what we take to be our understanding of them, and the full semantic or thematic appreciation of what they have to "say to us," through self-pointing or highlighting.[24]

One reason that the conception of reference *plus* possession, or possession *plus* reference, is so germane to art is its insistence on the fact that some meaning content is physically or perceptually embodied in a singular created form, as opposed to the generic product of the fixed structures of discourse. Monroe C. Beardsley, Margolis, and Carroll, among others, have argued that the properties that artworks may be thought to exemplify are most often *not* those for which we have labels and descriptions ready at hand, in marked contrast to denoted objects of representation. Although these philosophers cast this as a potential weakness of Goodman's concept as applied to art, it is instead a reflection of the fact

that rather than embracing only permanently *fixed* properties of works, exemplification is above all a contextual *relation* involving actual, historically situated and intending artists and their audiences, participating in relevant common traditions and interpretation that produces novel recognitions about works and about the worlds (or worlds) with which they are concerned.

Cinema as an Exemplifying Art

Symbolic exemplification appears central to the worlds of film works of art as created, experienced, and interpreted. Indeed, cinema in its artistic uses may be seen as even more deeply rooted in different forms of exemplification than other arts, through such selective self-highlighting of literally and "metaphorically" work-possessed properties of different types. The particular sort of relations between literal representation and figurative meaning common in films, which we have already discussed, is key here.

As we have seen to this point, in their medium-given and -recognized perceptual facticity and concreteness, as bearing an "analogical" relation to reality, film images (and sequences) are a powerful vehicle for new artistic significance as rooted in figurative, associational meanings still (very) closely tied to perceptual features. As Mitry's arguments may be taken to lend persuasive support to, given their (often recognized) status as elements of the global perceptual-symbolic and artistic presentation that we posit as the *world-of* a film, artistic exemplifications may stand out for attention to a greater degree in cinema than other arts. This is by virtue of the marked contrast between basic cinematic *denotation*— as concrete, seemingly "natural" or "given," often powerfully iconic, and constitutive of the fictional-represented *world-in*—and the extranarrative symbolization (exemplification), which, while copresent with denotation, transcends and stands out from it and the represented, diegetic world. Beyond this fundamental dynamic, which reflects a duality at the "ontological" heart of a cinematic work of art as literally representational and fictional-narrative, but also, and equally, figuratively and artistically significant and expressive, there are other reasons why cinema may be considered an art of exemplification as much as an art of reality.[25] These are related to factors well within the intentional, creative control of filmmakers.

Films are able to adopt a wide variety of sensory and cognitive modes and registers of address in aid of artistic exemplification. In comparison with other forms, there are simply more and different means—an entire arsenal—at a filmmaker's disposal for the aforementioned "self-highlighting" of artistic features (or of features as artistically significant, to be more precise) in the minds and attention of viewers as a way of constructing and conveying specific ideas and expressions. Such significance may be articulated through the camera's "intentional" view and movement, entirely apart from, or in dialectical relation with, that of actors and characters, for instance. As not only audiovisual but temporal and sequential, films can also *dwell* on certain of their constructed images and sounds, thus "showing them off" for aesthetic consideration, together with whatever they (may also) literally or figuratively represent. And, of course, through editing, films may also return to and *repeat* these for artistic emphasis. As we have seen, the function of exemplification ensures that the full experience and interpretation of art is never free from linguistic description and interpretation but must work in and through it. In the case of cinema, however, language, with all of its potential for emphasis, self-description, and self-characterization, may be literally present in the form of voice-over, intertitles, filmed text, and so on. As Godard's films have shown over more than a fifty-year period, this may add immeasurably to cinematic exemplification as a means of conveying meaning and feeling that fuses, intersects, or counterpoints both image (i.e., literal cinematic representation) and story (fictional narrative and drama).

Cinematography, camera placement and movement, editing, staging, design, music, and lighting may all be seen to take up what amounts to a particular *perspective upon* the represented *world-in* of some films—which is, of course, for films to draw attention to (exemplify) some aspect of themselves as created and intended *works* and, thus, to generate extranarrative (and extradiegetic) referential meaning via the intentions of the filmmaker(s). Moreover, and as I have already discussed, as channeled through the specific formal and technical means of cinema, the transart world-making techniques of weighting (which, as a matter of emphasizing and highlighting perceptual features, is particularly close to exemplification in Goodman's account), ordering, composing/decomposing, filtering, deleting, framing, and so on, transform quotidian realities and create new or less-familiar ones. Yet they may simultaneously serve to

emphasize, foreground, comment on, and draw attention to certain possessed properties of films in their functioning as artworks (not least these very processes) for viewers attentive to them. Even if not all films and filmmakers take full advantage of them to pursue the communication of meanings and affective-emotional contents beyond basic story contents—and do so in creatively original and experience-illuminating ways—there are seemingly far more individual means of such self-highlighting of features on the part of films afforded to creative filmmakers than to artists working in other media.

Finally, cinema affords many different channels, in fact far more than any other art form, for "(self-)reflexivity," which has rightly been seen as a major aspect of many artistically valuable films and cinematic styles. Reflexivity may convincingly be seen as but one rather specialized form of artistic exemplification. Like allusion, or the exemplification of formal properties (soon to be discussed), reflexivity as a feature of style is one more (optional) tool or instrument, albeit a very efficient and sometimes more direct one, employed by a cinematic work to exemplify certain of its own perceived features in order to convey (or better convey) certain thematic, conceptual, and expressive contents and meanings. In line with how reflexivity in film and other arts is generally defined, however, in this case such exemplified meanings (objects of reference) invariably pertain to *cinema* itself, of which every film is a particular example (or a single "sample").

In more conventional narrative cinema, for instance, important artistic exemplification (in any of its basic forms) may be relatively more accessible, recognized, or prominent, given that nonliteral and nondenotative symbolization tends to take rather more obvious and direct forms. Yet this is not always the case, and it is unwise to generalize in this respect or to suppose that familiar film-studies classifications such as "mainstream," "Hollywood-style," "popular," "art house," and so on can always be supported here, given the great plurality and diversity of narrative cinematic art and the intentions of film-world creators.

In sum, through various forms of exemplification that we will now consider in greater detail, a film world is constantly kept in motion, and transports the viewer along with it, in two directions. Sometimes alternating, but sometimes virtually in the same instant, it figuratively expands outward to make contact at many points with other, larger realities, and

the symbols, signs, and objects of reference they involve, yet it also contracts inward, to reflect on its own specially created virtual and artistic reality, its own cinematic work-world.

FORMS OF EXEMPLIFICATION IN CINEMA

Literal exemplification, which Goodman describes as involving what are commonly thought of as the "formal" aspects of works, is as prominent in cinema as it is in painting and other static arts of vision (as his main examples). Like abstract, experimental films (where denotation is either relatively minimal or virtually lacking altogether) narrative films may draw special attention to features of light, shadow, color, composition, rhythm, and movement, which thus come to possess a meaning (or an additional meaning), whether thematic, psychological, metaphorical, reflexive, or allusive. A film's being in CinemaScope (or another widescreen format) is a formal-medial property of it as a created whole, the result of a choice preceding its shooting. In films such as Frank Tashlin's *The Girl Can't Help It*, Godard's *Le mépris* and *Tout va bien*, and Nicolas Ray's *Bigger Than Life* (whose title may also be seen as exemplificational in this respect), the format and its effects are also artistically foregrounded, drawing viewer attention to the compositional frame as possessing a number of possible meanings and associations relating to the narratives, themes, and styles of these films. Likewise, a film's relative lack of close-ups may become a highlighted symbolic-aesthetic property of it when a sudden close-up at a significant moment underscores (for some interpreted purpose) the general absence of such framing. Rather than such formal features and techniques carrying an artistic exemplification of some idea, quality, or feeling in themselves, this is instead a matter of how these are seen (or heard) and interpreted, within the context of a film and its world as a whole (and within the context of cinematic and artistic traditions), and given the expectations and memories of viewers.

In Goodman's original view, and as I have already discussed, the possession of exemplified properties need not be literal and physical, or more directly sensible, but may instead be metaphorical.[26] It is recognized that artworks have meaningful features that they do not actually possess as materially instantiated and that their higher-order or imputed properties are not reducible to merely perceptually presented constituents. Thus a Van Gogh painting can exhibit, draw its beholder's attention to, both

color, which it literally has, and madness or love or some other attitude or emotion, which, not having the animate capacity to feel, it "possesses" only metaphorically as a visually accessible but not sensory property.[27] Similarly, a film may literally exemplify a particular color or color scheme (e.g., as in Kieslowski's *Three Colors: White* and Jarman's aforementioned *Blue*), or quick cutting, or the play of light and shadow, or medium-close shots—all of which are empirical properties films possess as either physical objects or perceptual experiences alone. Yet a film may also exemplify melancholy, voyeurism, the concept of justice, Plato's allegory of the cave, or any other anthropomorphic and abstract realities "only" figuratively. The same holds true for any sensory qualities (including those involving touch or texture, referred to as "haptic," or those theorized with reference to synesthesia) that cinematic works foreground but that, while literal and physical in noncinematic experience, are possessed by films in a nonliteral (nonactual) fashion only. As is characteristic of a great deal of symbolization in art, however, even when such reference is nonliteral in this specific sense, it still operates through, rather than bypasses, particular perceptual features of films, features that are foregrounded for attention through all the means at the film artist's disposal, with this thus qualifying as exemplification.

Some critics of the concept of exemplification and its suggested role in art have focused on the expression of feeling and emotion it is seen to encompass. They have viewed it as an overly cognitive attempt to bind all expressive content to pale and abstract reference relations. Goodman himself candidly admits that this view may well "invite hot denunciation for cold over-intellectualization" of aesthetic experience.[28] Certainly this concept appears insufficient to account for *all* (and perhaps even most) of a film's affect and emotion, as instead stemming from more immediate and relatively unreflective recognition of an image's contents, or more direct sensory affects of formal features, some of which may have an artistic significance in films (as will be considered in the next chapter). It does also appear, however, that there is a class of aesthetically relevant feeling contents in cinema, the instances of which, like certain qualities or concepts, are conveyed through self-reference, entailing conscious attention to films as intentionally constructed objects and artistic experiences. Here it may be simply noted that in artistic uses of any medium, feeling and emotion may be as much an "idea" articulated and intellectually grasped from an affective distance, as it were, as something more directly

communicated and actually felt by audience members. More generally, as Goodman observes quite correctly, "Emotion and feeling . . . function cognitively in aesthetic and much other experience."[29] Citing this point specifically, Kristin Thompson has stressed the importance to film theory of Goodman's view that to be engaged with any artwork is to be involved with it "on the levels of perception, emotion, and cognition, all of which are inextricably bound up together."[30] While keeping in mind that a film's reference to formal properties, external cultural realities, and abstract themes and concepts may all carry an affective charge, I wish to focus on exemplification as centered on these rather than on the expression of feeling per se.

Since we are attempting to address the total symbolic structure of cinematic works and worlds, even if only in schematic fashion, following on from noting the presence of "metaphorical exemplification" in cinema, it should be mentioned that metaphor itself (also including metonym and synecdoche) is a well-known and studied feature of many films, associated with artistic practices of many of the most renowned filmmakers.[31] In cinema, as Goodman argues is true of artworks generally,[32] metaphorical expression may be seen to cut across symbol functions. Metaphors may be generated by denotations or exemplified properties, either through literal reference also to be taken figuratively or through additional levels of apt descriptions or interpretations, which certain properties of cinematic images and sounds invite viewers to entertain and apply. While literal representation in films most often crosses into the territory of metaphor by means of semantic conventions—that is, in the vision-based evocation of preestablished metaphors of common speech or literature—the relation of exemplification is of much more potential artistic relevance and interest. Here, by contributing to the making of novel associations and showing up heretofore unrecognized relationships among things, events, and character actions—most often in terms of the sharing of properties among screen-depicted phenomena—film metaphors connect up with the world-making processes described in the preceding chapter, including, for instance, visual deletion as related to *metonym* and ordering as related to *synecdoche*.[33]

Together with literal (or "formal") and metaphorical exemplification, another significant form of symbolization that involves directed self-highlighting on the part of artworks is based on difference and absence.

Goodman refers to this as "contrastive exemplification."[34] It is tantamount to a reference by an artwork of something interesting about what it does *not* literally possess as this is highlighted in some fashion by what it *does*. As Lopes suggests, in discussing the importance of the concept, this form of exemplification is at work in artistic *versions* and *variations* (of other works) of all kinds, given that "variations represent their antecedents by means of differences in content, not just shared contents."[35]

Contrastive exemplification in cinema does not apply only to remakes and different film versions of the same stories, subjects, and events, however, but also to less direct relations among films qua films, or any extra-work realities signified by a conspicuous absence and difference. For example, to the cinema-literate viewer a great deal of the power and interest of Sokurov's *Russian Ark*'s revolutionary form—composed entirely of a single, continuous ninety-six-minute long shot achieved through the use of a digital video camera—is its exemplification by contrast and omission of the narrative, formal, and affective roles of editing in films, precisely by virtue of notably lacking it. Moreover, this patent absence has a specific historical, cultural, and stylistic significance. Given the centrality of the editing process and of different theories and practices of montage in "official" early Soviet cinema (e.g., the films of Eisenstein and Pudovkin)—together with the fact that *Russian Ark*, entirely set in the Hermitage museum, is concerned with centuries of Czarist-Soviet history—the film's dramatic renouncement of editing is a provocative and reflexive instance of an exemplified feature of a film's presentational form being in complex, internal dialogue with its subject, theme, and setting. Thus this contrastive exemplification is not simply one of many figuratively referential aspects of the film but serves to significantly define its style and meaning as a work-world.

A final major form or species of exemplification is *allusion*, which is symbolically "indirect," in the sense of being a matter of "possession plus reference" at a (larger) series of removes.[36] As such, it is a principal way in which works become linked and connected to other works (and world-versions) and thus cohere into larger established categories such as genres, movements, and traditions. Here again cinema's hybrid and composite (and, as Langer says, "omnivorous") character provides it with a seemingly limitless allusive capacity, able to range at will into "higher" and "lower" realms of common cultural experience.[37] If each

film constructs its own world, then allusion to other films, and other works and forms of art, is a way of building bridges among these, allowing our thoughts and feelings to pass from one to another and back again.

Although not strictly necessary for this form of reference, and methodologically deemphasized by Goodman, the actual intentions behind the vast majority of artistic exemplifications distinguish this concept of allusion—and its present application to films and their worlds—from various influential theories of "intertextuality."[38] What Goodman and Elgin (separately and together) theorize as indirect exemplification also transcends what allusion is often seen by literary and film theorists to involve—namely, express or implied references to the represented contents of (other) works of cinema, art, literature, and myth. Instead, it pertains to associations that a work prompts with potentially *any* extrawork reality that is less directly present within the interpreted structure of a work-world, including historical facts, philosophical or scientific concepts, and knowledge concerning creators or performers.

Clearly, allusion may be a major part of a narrative film's aesthetic experience and artistic structure and intentions. Recognition of such reference often requires relatively more specialized or sophisticated background knowledge on the part of audiences. As Goodman aptly remarks: "representation, [more direct] exemplification, and expression are elementary varieties of symbolization," but as indirect exemplification, allusion "to abstruse or more complicated ideas sometimes runs along more devious paths, along homogeneous or heterogeneous chains of elementary referential links."[39] In describing the sorts of complex interactions between symbolic functions that take on aesthetic significance in film worlds, we will shortly look at some examples of such "devious paths" of association-making in cinema.

REFLEXIVITY AS SYMBOLIC-AESTHETIC EXEMPLIFICATION

Recognition of the importance of the exemplification relation in art helps to lay the groundwork for a new, and much needed, alternative model of (self-)reflexivity, which, although a ubiquitous term and concept in film theory and criticism, is still relatively underexamined, at least in systematic terms. Apart from the way in which all artistic exemplification is a matter of self-reference on the part of artworks (to their significant aesthetic features) and is thus akin to self-reflexivity in this general sense, it

may be considered a specific type of reflexivity. Indeed, conceiving of this feature of many film works and worlds as a version of exemplification (one that is literal and metaphorical simultaneously, as it were) avoids some of the difficulties inherent in existing accounts of (self-)reflexivity in film theory, as these are closely bound to the theorization of modernism, postmodernism, and some "Brechtian theses" (to cite a relevant, well-known article by Colin MacCabe), as well as other frameworks.[40] More positively, this connection with symbolic exemplification may also be seen to further unify, and add conceptual support to, a number of perceptive observations on reflexivity in cinema now scattered about in a number of writings by well-known film theorists and critics.[41]

Remaining, for the moment, with Goodman, in his and Elgin's later development of the idea of artistic exemplification, and without discussing reflexivity under this name, mention is made of the way that some characteristically modernist buildings (we may think of Paris's Centre Pompidou) intentionally exhibit their functional "structure"—girders, pipes, ventilation ducts, elevators, and so forth. Not only do they make these visible, but the buildings in question call attention to these practical features, which thereby come to possess an aesthetic significance as part of a particular architectural vision and program.[42] This is in obvious contrast to concealing such practical and structural features, as many older architectural conventions and styles would dictate. Allowing for relevant, major differences among the media, this general practice may be considered roughly analogous to one major form of cinematic reflexivity involving a film's highlighting aspects of its "structure" as a film, in spatio-temporal, formal, or narrative terms (as was briefly touched upon in the previous chapter, in relation to the world-making process of ordering).

For example, a familiar form of such reflexive exemplification as involving narrative structure pivots on the specific relation between the *world-in* and the *world-of* a film. Memorably present in *Psycho*, and, more recently, *The Prestige* and *The Skin I Live In*, it entails a particularly surprising turn of events that serves to cast all that came before it in a film in a new and emphatic light. Conspicuous attention is thus drawn by the film not only to *what* story information has been presented to, and withheld from, the viewer (and often characters) and *when* but also *how* this was actually accomplished (by the film and its creators) in specific formal-stylistic and storytelling terms, and its broader artistic meaning. This, in turn, may well prompt reflection on the artistic ends and possibilities of

different, or alternative, narrative structures within cinema, more generally. In contrast, some of the films I have previously cited in relation to different means of *ordering* as a world-making process—e.g., *Vivre sa vie*, with its twelve titled episodes, or *tableaux*, as its main subtitle immediately announces (thus drawing further attention to this particular presentation)—also clearly illustrate an overt exhibition of cinematic structure, in this case formal or presentational structure, as relatively independent of story and plot.

Apart from narrative or formal structure, per se, reflexive exemplification in cinema has many other vehicles and objects, including simultaneous reference and self-reference to subject matter, other films, particular cinematic techniques, and aspects of dramatic performance and character—all of which, as present and recognized in films, may prompt focused reflection on cinema's history, technology, and processes of filmmaking and film viewing, on the part of viewers. Its target objects of reference may, for that matter, entail all of these together, as in "uber-reflexive" films like Michael Powell's *Peeping Tom* and Lynch's *Inland Empire*.

Here it is helpful to recall that in contrast to denotation, which moves from "symbol to what it applies to [i.e., some empirical object] as a label," exemplification is an opposite movement in thought from the concrete (here, artistic) object functioning as a symbol to "certain labels that apply to it or to properties possessed by it."[43] Put differently, the basic cognitive relation remains one of reference-making, but it starts out with a perceptual object functioning as a symbol and ends with a proposed linguistic (in this context, film critical and stylistic) description of certain of its features. Thus, to take a fairly basic example, the image of a film camera pointing out toward the viewer at the beginning of Godard's *Le mépris* (operated by Raoul Coutard, the film's cinematographer) or at the ending of Haskell Wexler's *Medium Cool* (operated by Wexler himself, as both cinematographer and director) literally represents (or denotes) in both cases a familiar object—a film camera. Yet, in ways that relate to their narrative action and main themes in provocative fashion, these images simultaneously figuratively exemplify each film's status as dependent upon a camera as not only an impartial and objective tool of representation but an inescapably subjective means of mediating, interpreting, and organizing experience and of turning familiar reality into an "alternative" world. In the case of *Le mépris*, as an additional, or combined reflexive exemplification, Godard's opening voice-over, with which the image of the

camera and its lens is paired, opines that cinema may "substitute for our gaze a world more in harmony with our desires." He also states that *Le mépris* is the "story of that world." In other words, and as characteristic of artistic exemplification's typical movement from the particular to the general (and back again), it is a story that on one level is "about" *all* cinematic world-creation as much as "about" *Le mépris*'s specific, fictional reality, as the representational and narrative vehicle in and through which the more general subject, or idea, is addressed.

When, in the course of viewing and in subsequent interpretation, critics, theorists, and other knowledgeable viewers attach such labels and descriptions as "self-reflexive," "self-aware," "auto-critique," "Brechtian," "acknowledgment of the viewer," and so on, to the above-noted images and sequences (and many others like them), they are not, of course, describing only what those elements refer to (denote) literally but what they, and the work, evoke and elicit by symbolic association. In this case, the camera (and its image) is transformed from the particular to the general, as *its own idea*; it is no longer a single piece of equipment but is (in these contexts) the necessary transformative instrument of all filmic creation, including the film in which it appears. Here I must reiterate that the labeling and describing at work is never "merely" descriptive, since the meaning(s) of film images, sequences, and works are experienced and understood in certain ways (and not others) as a direct result of such attributions.

From this perspective, then, (self-)reflexivity must be understood as a specific symbolic, artistic, and stylistic feature of a highly "self-conscious" kind possessed by some films as created and intended artworks. It is not an automatic or inherent feature of the film *medium* as a medium (specific to it) or, for that matter, a *universal* feature of cinematic presentation/representation or perception as such—although it has been sometimes theorized in both of these ways, on the basis of suggested (and frequently tenuous) analogies between, for example, *all* cinematography and "self-reflexive" human perception and vision, or *all* film editing and self-recursive mental processes and consciousness.[44] Instead, reflexivity is here aligned with (1) specific creative and referential uses of cinema (that are in no sense simply medium-given), which are, therefore, (2) stylistic and historically shaped and evolving, as well as (3) the result, and special exhibition of, artistic intentions. Conceived in this fashion a film's (self-)reflexive dimension may be more convincingly brought under the

broad umbrella of a fascinatingly varied centuries-old (if not millennia-old) tradition of reflexive exemplification in the arts and literature. It is this history that some filmmakers (as a matter of choice rather than necessity) have both consistently drawn from and contributed greatly to expanding. Of course, for a variety of artistic, actual, and perceived commercial reasons—as relating to the maintenance of a certain form of artistic and fictional "illusion"—other filmmakers (sometimes in accordance with specific styles and the conventions of filmmaking modes and genres) have instead chosen to refrain from exemplifications that focus on a film's relation to its own form and medium (as a way of expressing something about it) in a relatively more prominent, forceful, or explicit way. Whether or not consciously, their films thereby emulate, or at least share this in common with, notably nonreflexive artistic traditions and practices epitomized by the nineteenth-century realist novel, some theatrical traditions, and certain classical (or premodern) styles of painting.[45]

This said, however, while some confusion on the point may motivate its scrupulous avoidance in some film practice (and frequent misrepresentation in film theory), as I stressed in the first chapter, although a film's reflexive level of meaning and apprehension may be "outside" (i.e., distinct from) its denoted confines and its represented fictional and narrative world-in, it is still situated firmly "inside" the total artistic (perceptual and cognitive) field of participation a cinematic work establishes. Thus, rather than something being necessarily *taken away from* a narrative film's experience (as a work and as a whole) that would otherwise be operational within it were it not *for* self-reflexive presentation and foregrounding, it is instead always something else *added to* what is (and remains) present in terms of the "fictional world" a film generates, for instance, and other referential forms and functions. Put more simply, reflexivity does not necessarily undermine or dissolve a film's fictional story-world, nor does it prevent or prohibit viewer engagement with it as such or as an imagined or imaginary reality within which viewers may be psychologically and affectively immersed to varying degrees.

Like exemplified features generally, reflexivity is highly relative and variable in terms of its presence across the stylistic spectrum of narrative cinema, found in various modes, movements, and genres (including, one must not forget, classical Hollywood comedies and musicals). It is certainly not confined to modern, or "modernist," and contemporary "art cinema," for instance, where it tends to be a prominent and critically

noted feature of the films of Godard, Haneke, Wenders, Egoyan, Kiaro-stami, and other innovate filmmakers. Reflexivity is likewise both relative and variable in terms of the specific meaning contribution it makes to the symbolic-aesthetic dimension of films. As Robert Burgoyne, Sandy Flitterman-Lewis, and Robert Stam have observed, the aesthetic and con-ceptual ends of reflexivity in cinema are as diverse as its specific means.[46] The semantic, referential content of reflexive features within films thus may, or *may not*, have various cultural critical and "counterideological" meanings, including those that many theorists (e.g., MacCabe, Stephen Heath, and Fredric Jameson) have with all good intentions attempted to invest self-reflexivity as part and parcel of an alternative, nonillusionist (i.e., nonmainstream Hollywood-style) mode of cinematic presentation. No doubt in some notable films reflexive forms and techniques play a substantial part in an intended, or "self-conscious," critique of the illu-sionist tendencies of much commercially viable narrative cinema and the dominant cultural ideologies its particular audiovisual form is seen to up-hold. Yet as some contemporary horror films and comedies are more than sufficient to demonstrate, films may be at once highly (self-)reflexive and also ideologically moot or reactionary as opposed to social-critical or politi-cally progressive in any sense (as both Stam and Carl Plantinga note). The specific artistic and potentially sociopolitical meaning of a film's reflexive exemplifications is, in other words, always context- and work-dependent and does not automatically signify whatever it does about either itself, about cinema as a whole, or about wider cultural realities through its lens. Nor, for that matter, and as perhaps cannot be stressed enough, is the presence of reflexivity in a film, any more than the long take, voice-over narration, or allusions to other films, in and of itself any guarantee of artistic or philosophical profundity or value.

Finally, like other forms of exemplification, the intermittent presence and variability of (self-)reflexivity in cinema owes to its high demand for relevant background knowledge on the part of viewers—even if, that is, for latter-day, cinema-literate audiences, especially, the "literacy" in ques-tion may be relatively more common and less specialized. It is quite likely that many contemporary viewers would not find it particularly difficult to recognize the major cinematically self-reflexive aspects of Hitchcock's *Rear Window* or Michael Haneke's *Funny Games*, central to the meaning and interpretation of these films, for instance, given the ways in which these aspects are right on the perceptual and narrative surface of these

works. But, doubtlessly, other films, equally as interested in addressing particular aspects of cinema (and its global, national, and local history and practice) through "highlighting" perceptual and referential features of themselves as films—for example, Kiarostami's *Close-Up*, Godard's *Notre musique*, and Leos Carax's *Holy Motors*—are considerably more demanding in this respect. These films, like others, require prior possession of more detailed information concerning cinematic history and techniques, the past works of their directors, more general cultural and historical knowledge, and so forth, to grasp the full import of their reflexive meanings.

As is the case with other symbolic functions at work in the created world of a film, including the other forms of artistic exemplification we have considered—literal (or "formal"), indirect (or "allusive"), and contrastive—reflexivity is rooted in a film's "objective" perceptual features (as it must be, on some level, to be communicated). Yet reflexivity is not only context- but also response-dependent, since it is only actualized, like a current running through a completed electrical circuit, when cognized by viewers either during a film or after watching it. In its most subtle guises its manifestation may await the instruction provided by film critics and theorists in the discourse of interpretation. As particularly well placed for such recognition and often attentive to it, they may helpfully draw the attention of other "nonprofessional" viewers to its presence and (possible) particular significances. In other words, the necessary role of interpretation as rooted in context and cognitive background entails that there are no unrecognized exemplifications (of any kind) in cinematic works, even if, that is to say, they exist as potentials not yet realized by viewers.

I cannot pretend to deal here adequately with such a large subject clearly deserving of a separate, detailed study.[47] Yet from this brief discussion (coupled with earlier observations), it should seem plausible to the reader that a properly theoretical approach to the reflexive in cinematic art from its historical beginnings to the present may be rooted in the concept of symbolic exemplification, working together with an overlapping distinction between the represented-fictional (or "diegetic") *world-in* a film and a *film world*, as the presentational and artistic whole that encompasses it, and much more besides. Such a framework serves to focus attention on the relative, holistic, and contextual attributes of reflexivity as a property and function of cinematic style. As a component of many narrative films standing in relation to other aesthetic, symbolic, and rep-

resentational features, including literal denotations and an imagination-enabled story-world, it is protean in its possible forms. But to be completely clear on the point, neither is it necessarily in *competition with* these features, nor does it (always) entail a denial, bracketing, or disruption of a film's created fictional reality (and of viewers' pronounced imaginative and affective involvement with it), as is so often mistakenly suggested, implied, or assumed by theorists—ironically enough, both those who actively support and those who actively condemn self-reflexive cinematic strategies and techniques. If nothing else, this overly simplistic, either/or view substantially overlooks the previously analyzed imaginative resiliency of the fictional world-in a film, as rooted in the self-awareness of film viewing, together with our "bifocal" ability as cognitive subjects to "deal with" the representational and presentational, literal and figurative, fictional-narrative and perceptual-aesthetic dimensions of films simultaneously.

Symbolic-Aesthetic Interaction and Integration

Having outlined (in fairly abstract terms) the various forms of reference in operation in a film world by virtue of its transformation of its chosen materials, and having seen how some of the resulting aesthetic features or elements may be interpreted as constituting these worlds in various ways, it is necessary to address (more concretely) their profound *interaction* in films. For quite clearly it is not just the recognized presence of individual symbolic functions in a film and the meanings they serve to convey in isolation that is constitutive of its total experience, or indicative of its artistic interest and significance, but also, and especially, the novel relations among these, in consequence of their deliberate, creative integration.

This fleshing out and bringing to artistic life of reference entails work-created, and to some degree work-specific, relationships, not just between the various types of exemplifications but also between these and cinematic denotations (i.e., as making both internal and external references). Turning to films by Kubrick and Godard—chosen here in part for their canonical familiarity, as well as for their representing very different but equally creative and artistic approaches to narrative cinema—we will first consider what may be regarded as "local" manifestations of such interaction, as pertaining to specific film images, sounds, and sequences. These

brief illustrations will be followed by some reflections on the existence of a more "global," concerted interaction of symbolic forms and functions that occurs on the created and experiential scale of a film work and world as a whole.

Whatever particular aspects of a film world can be picked out from the whole and identified as important aesthetic features may function symbolically in multiple ways that are grasped more or less simultaneously by viewers on the basis of both cinematic experience and knowledge (together with the seemingly innate human capacity to discriminate between distinct levels of meaning and reference in a given image or object). To take a fairly basic example: consider the famous low-level tracking shots down the labyrinthine corridors of the Overlook Hotel in *The Shining*, utilizing the then recently invented (and now ubiquitous) Steadicam, coupled with the movement of Danny's (Danny Lloyd) tricycle. As a means of *literal representation* together with conveying a certain narrative action and development, these sequence-shots serve to further establish the spatial geography of the building's interior, which plays such a vital role in the actions of the characters as the story unfolds. Much more than this, the image sequences in question simultaneously *express* a range of feelings: disorientation, claustrophobia, anxiety, and mounting suspense. Some of these affects can be attributed to what the child may be perceived or imagined to be feeling in the situation, while others pertain more strongly to what the viewer may more immediately feel while watching it (or indeed, to where the two may overlap). The represented movement, however—coupled with the jarring yet hypnotic oscillation between the amplified sound of the tricycle's wheels alternately passing over thick carpets and hardwood floors—also serves to crystallize a particular constellation of affect into what T. S. Eliot famously called an "objective correlative."[48] In other words, it creates a perceptible symbolic-affective figuration unique to the film and, hence, a *metaphorical exemplification* that may be understood irrespective of the recognized presence in the viewer of any of the feelings in question and what the character is empathetically understood to be feeling. (The sequences and this feeling thus contribute to *The Shining*'s particular manifestation of what I will later analyze as the total "world-feeling" of a cinematic work.)

Additionally, however, for viewers who recognize it, the literal, readily perceived action also *formally exemplifies* the unusually composed and emphasized forward-tracking movement of the camera as such, record-

ing and re-presenting it. Not only is such camera movement a virtuosic display of technique, and a crucial stylistic and structural principle of the film's design, but it is also a powerful variation on the elaborate, temporally extended forward and backward camera movement found in all of Kubrick's feature films (as partly indebted to the acknowledged influence of Max Ophüls) and widely associated with the director. It is to these other films and instances that these sequences thereby *allude*, together with exemplifying this aspect of Kubrick's signature style (and of his cinematic worlds built upon it); they thus invite comparison between the form and meaning of the camera movement in *The Shining* and in other films. Finally, for viewers aware of it, the moving-camera images and sequences also call attention to the formal-technical and aesthetic capacities and potentials of the Steadicam specifically (here operated by its inventor, Garret Brown), the subsequent uses of which also provide a fascinating lens through which to retrospectively view its early appearance and use in *The Shining*. In sum, the vision-based polysemy found here—as following from all such multiple but integrated and near-simultaneous, sensible, affective, and cognitive (and affective) functioning of roughly the same aspect or feature within a film—is, it must be stressed, to be found in a good deal of narrative cinema. On reflection it is also a significant part of its characteristically artistic, and artistically interesting and successful, uses and experiences.

As well as being one of the most visually beautiful films ever made, *Le mépris* is arguably one of Godard's most technically and formally accomplished works. This owes, not least, to the combination of Raoul Coutard's cinematography, Georges Delerue's celebrated score, and an innovative use of the widescreen ("Franscope") format, the long-take sequence shot, and expressive color. But it is the ways in which such formal aspects semantically and affectively interact with characters, story, and drama, on the one hand, and exemplifications pertaining to a host of cultural objects and phenomena—and (reflexively) to the film's own creation, sources, and cinematic context—on the other, that makes it such a compelling and rich aesthetic experience. Another example of symbolic integration in cinematic art on the "local" level of the sequence (or scene), as drawn from *Le mépris*, is worth pursuing in some detail. Together with the complex integration and overlapping of referential and artistic functions, it also serves to highlight some (possible) relations between such reference-making and the artistic-stylistic features and transformations addressed

in the previous chapter in terms of specific, higher-order world-making processes.

In the couple's rented Roman apartment, just prior to the bitter marital quarrel that occupies the narrative and thematic center of the film (intermittently extending over nearly twenty minutes of screen time), Camille, played by Brigitte Bardot, dons a recently purchased black wig, denoting her as a brunette with a distinctive hairstyle. Entering the narrow bathroom where Paul (Michel Piccoli), with hat and cigar, reclines in the bathtub, Camille asks him if the wig and its style suits her, to which he tersely replies that he prefers her as a blonde. She retorts that she prefers him without the hat, which he then claims to be sporting in order to look like Dean Martin (referring to Martin's character Bama, in Vincente Minnelli's 1958 film *Some Came Running*).

Literally foregrounded (or, in Goodman's analogous term, *weighted*) through the situation represented, and through cinematic *composition*, with the narrow bathroom forcing her into the perspectival front of the image, Camille/Bardot's appearance exemplifies brunette actress Anna Karina, together (for cognizant viewers) with Godard's famous on- and offscreen relationship with her. Since, that is, both Karina's hair color and its particular style—as so prominently showcased in Godard's earlier *Vivre sa vie*, including in its opening titles sequence—are here referenced and visually echoed through Camille's temporarily altered appearance (figs. 5.1, 5.2).[49] Made two years before *Le mépris*, *Vivre sa vie* established Karina as the director's on- and offscreen muse, the two having been married shortly before its making and having separated by the time of *Le mépris*'s shooting (an Italian poster for *Vivre sa vie* that prominently features Karina appears early in *Le mépris*). Throughout the couple's argument, Camille/Bardot adopts a number of poses and gestures highly reminiscent of Karina and her character in *Vivre sa vie*. Most notably, after being slapped by Paul, and still wearing the wig, she is captured in a profile close-up, pressed against a white wall, head down, in images that mirror recurring shots of Nana/Karina in *Vivre sa vie*, especially those occurring within the earlier film's highly reflexive and autobiographical "Oval Portrait" sequence (often interpreted as a cinematic celebration of affection for Karina on Godard's part as much as for the character of Nana on the part of her young suitor, within the film's story).[50]

Appropriately enough, given this particular allusive and self-reflexive context, Godard's and Karina's highly public relationship is present in *Le*

FIGURES 5.1 AND 5.2 A dense network of reference and association in Godard's 1960s cinema centering on Anna Karina (*Vivre sa vie*), Brigitte Bardot (*Le mépris*), and a hairstyle.

mépris in the form of a schematic, cinematic *distortion* of it, one that approaches (self-)parody through the highly ironic, mediating presence of Bardot, the "blonde bombshell," as a perceived stand-in, or distorted double, for brunette Karina, who had played the female lead in Godard's three previous feature films. Bardot is at once Camille and the most famous

female celebrity—and blonde star—who could possibly be cast in her role. Through the symbolic mode of *contrastive exemplification* her presence serves to underscore Karina's conspicuous absence from the film. As constructed by means of this clever mirroring, within a *mise-en-abyme* film concerned on so many different levels with the often puzzling relations among film, art, and life, the costume and mise-en-scène in this sequence thereby establish two distinct yet overlapping channels of meaning, as well as emotion and affect. One (Paul and Camille) proceeds through *denoted* fiction and drama (and the represented world-in the film); the other (Godard and Karina) proceeds through its artistic presentation (as part of the experienced world-of the film) and (by way of it) *allusion* to extrinsic, autobiographical realities the film creatively incorporates.[51]

Visually, as well as through dialogue, these differently oriented yet also converging referential meanings are also supplemented (and further supported) by prominent "intercinematic" allusions to *two other* seemingly passionate yet mismatched and slowly disintegrating romantic relationships—namely, as they are portrayed in Minnelli's *Some Came Running* and Roberto Rossellini's *Voyage to Italy* (also more literally present in *Le mépris* in the form of a cinema marquee), respectively. These two films provide a rich source of world-making material for *Le mépris*. Indeed, when (or if) viewed in comparison with them, Godard's film can be seen as radically amplifying, "recasting," and reverently distorting (in Goodman's sense) not only many of their themes and tragic-romantic narrative situations but prominent formal features, including the arresting widescreen (CinemaScope) compositions, languorous long takes, and bold primary color schemes of Minnelli's film, all of which are present and accounted for in the argument sequence in *Le mépris*.

There are also other potential, and less (directly) autobiographical, allusive pathways here, which move in the direction of comment on film genre, in this case the suspense thriller and film noir (or neonoir) iconography. Camille/Bardot's altered appearance may be taken to look back on, or indeed anticipate, several films, from Hitchcock (*Vertigo, North by Northwest*) to Lynch (*Mulholland Drive, Lost Highway*), in which a femme fatale and love interest metamorphoses to the extent of her visible hair color at a pivotal dramatic moment within the story and plot. When taken in the context of noir—with which *Le mépris* shares many "deconstructed" characteristics—Camille/Bardot's temporary transformation (and

Karina's presence-in-absence) foregrounds the bifurcation of female presence in noir through conventional dualisms (blonde/brunette, good/ evil, innocent/guilty, chaste/promiscuous).

In all of the ways noted (and which could be significantly expanded in a number of directions), *Le mépris* aptly illustrates the notable multiplication of the (forms of) references that even a single cinematic image or episode may sustain when juxtaposed with the work as a whole, translating into a remarkable cognitive and affective density. Although, as I mentioned previously, and as numerous commentators have pointed out, such density is a pronounced stylistic hallmark of Godard's films of the 1960s and beyond (and of particular film styles or modes with which they may be associated), this complexity and richness of extranarrative meaning, and its "multitrack" character, is also to be found, if in admittedly different manifestations and degrees, in most creative, artistically ambitious and interesting narrative films.

With respect to the aesthetic features picked out, this one episode from *Le mépris* also shows the extent to which character and performance may serve as a nexus for multiple and overlapping referential articulations with extranarrative, artistic significance. Through their sheer bodily presence, voices, mannerisms, and so forth, but also their typical roles, and the genres and specific films with which they are associated, actors and actresses, as film-world "material," are frequently associative bridges connecting the different cinematic worlds through which they freely travel, as it were. Indeed, all casting in filmmaking, as a creative and transformative activity in-itself, requires particularly close consideration on the part of filmmakers to denotational, expressive, reflexive, and allusive meanings tied to performers, as quite literally "living symbols." This of course includes a great deal of anticipation on the filmmaker's part regarding what the use of certain actors or actresses, stars or nonstars, may communicate or express through existing cinematic and wider cultural associations. Such deliberations and fine judgments are not dissimilar to those that may also surround the use (and choice of) preexisting pieces of music in a film or the decision to opt for an original musical score instead (that is, with less associative aspects). Casting decisions may have equally "global" consequences for aesthetic meaning and feeling, with the power to shape the entire tone and meaning of a cinematic work-world, as numerous filmmakers have admitted and discussed.

GLOBAL AND TEMPORAL SYMBOLIC CONSTRUCTION

Unlike paintings and still photographs, which present their symbolic world-structures all at once as it were, in the simultaneity of spatial presence to hand, temporally conditioned artworks like films add a crucial dynamic and dialectical element to symbolic interaction on larger—and longer—scales. It is the unfolding progression of sequences and episodes, rather than discrete shots and images, and their contents that primarily condition and enable such interaction. In what might be analyzed as the horizontal, "melodic" structure of a film (as distinct from its interrelated, vertical, and "harmonic" ones), one or perhaps several types of symbolic articulation may come to the fore and temporarily supersede or dominate others as a film unfolds.

Aptly, in this connection, one finds Goodman's only substantial, explicit reference to cinema in *Languages of Art*. He suggests that in Resnais's and Robbe-Grillet's *Last Year at Marienbad*—a landmark in the evolution of nonlinear cinematic narrative and formal experimentation—denotation, expression, and formal exemplification as "fused or in counterpoint" are equally present and prominent. Yet they are featured in alternating fashion, since "the narrative thread, though never abandoned, is disrupted to let through insistent cadences and virtually indescribable sensory and emotional qualities." (With reference to which particular symbolic function temporarily outweighs others in a film or any artwork, Goodman pertinently adds that "the choice is up to the artist and judgment up to the critic.")[52]

To further expand on Goodman's typically trenchant and here rather underdeveloped observations, in the course of narrative films, after a foundation of literal and fictive denotation has been well established, via, for instance, establishing shots, exposition in dialogue, and so forth, such representation may then recede—literally, with respect to perceptual contents of images, or figuratively, with respect to its relative importance as an object of viewer attention, knowledge, and feeling—while, at the same time, formal exemplification comes to the fore. Or, in marked contrast, expression and one or more types of exemplification together may serve to deemphasize mimetic representation from the beginning of a film, while, for instance, viewers await the piecing together of a comprehensible narrative structure.

An even more pronounced and telling example than *Last Year at Marienbad* is *2001: A Space Odyssey*. A great deal of the film (nearly two-thirds) is given over to a meticulous "hyperreal" denotation of extraterrestrial environments, with an emphasis on conveying the fictional *world-in* of the film with maximal visual clarity and definition. This is achieved through in-built set lighting, superfast lenses, the use of highly detailed models and other special effects, and an avoidance of subjective point-of-view shots and constructions (and the psychological and perceptual impressionism and ambiguity often attached to them).[53] Such factual, third-person objectivity and a visually rendered and documentary-like concern with concrete physical details and processes mirror, and overlap, the emotionally detached observing and reporting activities of the astronauts on their interplanetary mission.

This mode of presentation (in combined film formal and referential terms) visibly changes at a critical narrative and thematic juncture—the HAL computer's "murder" of astronaut Frank Poole and HAL's subsequent deactivation—to a relatively more abstract, character-centered, and highly affective expression. The surreally emotive "death" of this artificial intelligence (with all its figurative suggestiveness), as brought about and witnessed by astronaut Dave Bowman, within the interior of HAL's "brain,"—drenched in red light (suggestive of the blood-vesseled interior of a human organism)—and to the accompaniment of a poignant song (exemplifying youth, earthly life, and childlike innocence) is presented with a visceral immediacy all the more startling in contrast to the affectless detachment of much of what preceded it (fig. 5.3). This more figurative-associational and subjective-affective stylization is amplified—to the point of near total abstraction—in the exemplification of light, shape, and color, largely loosed from strong or clear denotative moorings, in the famous passage through the "Stargate"—as witnessed from the transfixed astronaut's implied perspective, complete with a series of color-altered extreme close-up images of his eye (fig. 5.4)—until, that is, the film once again returns to somewhat more concrete representational ground and a relatively more detached, observational, and denotative framework on the "other side" of the Stargate. Although more perceptually iconic and transparent, compared to the cosmic trip leading up to them, the profoundly mysterious events depicted here are full of metaphorical and allusive import and uncanny affect, as well as narrative ambiguity. This

FIGURES 5.3 AND 5.4 From objective denotation to subjective exemplification and expression in Kubrick's *2001*.

is courtesy of, for instance, now complex and highly disorienting subjective point-of-view dynamics and the incongruous presence of antique human works of art and design in the mise-en-scène representing an alien interior. The final, fascinating balance, struck between emphatically concrete, literal, and objective fictional representation (denotation) and more abstract, nonliteral, and subjective exemplification (formal, allusive, reflexive) in *2001* as a whole, is epitomized by the film's final image of the floating "Starchild" approaching Earth.

As a relevant side note, this image, the subject of so many different interpretations and more or less enlightened commentaries with respect to both its figurative and narrative significance, is a useful case in point concerning how a cinematic work's most important global exemplifications may be pregnant with a number of meanings that may be taken

up into coherent and illuminating interpretations of the film as a whole and that may, as in this case, cast all that has come before in a new light. Because to artistically exemplify (as opposed to denote) is precisely *not* to secure strictly determinate, empirical reference, this image does not possess any entirely fixed and unequivocal significance, either *within* the film's story-world (as much as we can determine) or outside it, in contrast, that is, to the clear certainty of what is *literally* pictured: a giant fetus. If relatively less ambiguous, but still provocatively multivalent, much the same may be said of the image of the burning sled ("Rosebud") in *Citizen Kane,* as perhaps the most famous single exemplificatory symbol in cinema, and one with equally global and multivalent significance (allusive, metaphorical, reflexive) to the experience and interpretation of that film's created and presented world. In uncharacteristically unreflective moments, critic Roger Ebert more than once suggested that "if you have to ask what something [in a film] symbolizes, it doesn't."[54] To the contrary, and as per a key difference between ordinary discursive symbolization in language, and artistic symbolization, far from not asking what an artistic symbol (rather than a "sign") in a film means, we almost always *must* "ask," i.e., interpret, discuss, debate. This is not least owing to the fact that although the symbolic in cinema (in common with all visual art) still often relies on preestablished conventions, it does so to a substantially lesser degree than in linguistic discourse (or logical-mathematical symbolization). Partly making artistic style possible, the symbolic relations cinematic artworks typically draw on are both multiple and semantically open-ended; that is, they allow for many alternative ways of referring to the same subject.

Returning to our main concern, the multiple tracks or functions for the generation of meanings, and their shifting interactions on the scale and level of the image and sequence as well as of a film in its entirety, provide one model for describing, mapping, and conceiving the semantic "landscapes" of the cinematic worlds they play a large role in creating. These functions and interactions coexist with a film's concretely represented audiovisual environment as so many mental layers through which it is seen and heard. It seems intuitively obvious that a cinematic work of art, conceived of as taking the experiential form of a specially created world, is particularly rich and complex, from any communicative standpoint. Indeed, whether found and interpreted in the more artistically ambitious products of Hollywood filmmaking practices and traditions

or located on the experimental fringes of narrative cinema, the dense interlocking or "knotting" or "weaving" (as are perhaps better terms) of reference relations in films is clearly often more complex than can be adequately accounted for by way of one or two binary distinctions alone, such as Metz's denotation/connotation dichotomy. Yet such complexity and appeal to multiple associations on multiple levels of attention and interest is commonly accepted, and expected, to mark artistically success-ful and valuable paintings, both classical and modern (e.g., Bronzio's *Al-legory of Time and Love* and Picasso's *Guernica*), as well as plays, poems, and novels in all styles and from all periods. In works in these forms, as in films, symbolic comprehension, insofar as the individual audience member is able to pursue it, is part and parcel of the aesthetic experience of a work, as much as are awareness and appreciation of sensory and formal properties.

All of this falls under the heading of what Goodman refers to as "symptoms of the aesthetic" (or, more precisely, the aesthetic functioning of a physical object), which include (a) exemplification; (b) "relative re-pleteness," where many aspects of a given symbol may sustain multiple, significant meaning relations; and (c) "multiple and complex reference, where a symbol performs several integrated and interacting referential functions, some direct and some mediated through other symbols."[55] In cinema the multiplicity, complexity, and repleteness in question is, as we have seen already (and as I will discuss in more detail in the next two chapters), affective as well as cognitive. A good deal of what is per-ceived as the "depth," positive "ambiguity," "truth," and "profundity" of many canonical narrative films, in all styles, from all periods, is rooted in these characteristics of distinctly artistic symbolization, as involving the integration of denotation, literal and metaphorical exemplification, allusion, reflexivity, and so forth. As certain films, such as *Tokyo Story*, *L'avventura*, and *Pickpocket*, demonstrate, however, such total referential (symbolic-aesthetic) detail, multiplicity, and complexity may be quite dis-tinct from the actual or apparent simplicity or minimalism not only of a film's audiovisual style but also of its story, plot, subject, or setting. Such discrepancies point again to the distinctions that I have been stressing throughout between all of these and the symbolic-aesthetic aspects under discussion, as well as between the cinematic world-in and world-of.

To varying degrees the individual, personal experience of watching and more fully appreciating an artistically creditable narrative film work

requires, like the project of making one, the grasping of symbolic connections, recognizing formal patterns and structures, and being challenged by references simultaneously appealing to form and content, representation and expression, perception and imagination. Far from being perceptually fully accessible and in that sense cognitively transparent, cinematic art addresses us in many ways that require a kind of perpetual multitasking—at least, that is to say, if we are to gather for ourselves anything approaching a film's aesthetically relevant semantic and expressive content.

STYLE, EXEMPLIFICATION, AND CINEMATIC WORLD-MARKERS AND TYPES

There are a myriad of divergent conceptions of artistic style, many of which are associated with divergent conceptions or theories of art itself. There is a widespread consensus, however, that if style is not (strictly speaking) essential to art and art-making, it contributes significantly to the aesthetic interest and value of works and plays a key role in interpretation.[56] It does so directly, since the stylistic properties a work possesses are often also aesthetic ones.[57] For Goodman, style is "a complex characteristic" that is conceived as a matter of the interpretative classification of work-worlds, with unavoidable reference to their symbolic functions as artworks.[58] In a particularly insightful review of *Ways of Worldmaking*, Ricœur observes that "the identification of the style of a work contributes to the understanding of its way of world making. And this is not a secondary task, since nothing is more hidden than the actual stylistic traits of a work."[59] Here the French philosopher and literary theorist is directly echoing Goodman, who writes that "the discernment of style is an integral aspect of the understanding of works of art and the worlds they present," adding that "a complex and subtle style, like a trenchant metaphor, resists reduction to a literal formula. . . . Just for this reason, the perception when achieved increases the dimensions of our comprehension of the work."[60]

From this symbol-centered and cognitive perspective, style is clearly not confined to any one symbolic function—for example, what the cinematic work "says" (i.e., with respect to its denoted subjects) or literally (formally) exemplifies or alludes to. But because in art exemplification is frequently the most prominent and significant symbolic function, a

larger part of stylistic classification is a matter of what is literally (and metaphorically) exemplified, or foregrounded. And like the referential process of exemplification, style is also fundamentally selective. While it can apply to form or content, or both, literally and strictly speaking it is always a matter of some and not all perceptual features of a work—namely, those that are most relevant to what are interpreted as the work's artistic functions and values.[61] A comparative classification that goes beyond "mere classification," in being not only of taxonomical or historical interest but unavoidably overlapping with artistic perception and understanding, the conception of style that is hinted at in the above-quoted passages can be seen to complete the circle of artistic world-making in cinema. Just as transformational intentions and processes that create new worlds out of the material of older ones are a matter of relations among worlds, so, too, is the conjoined stylistic classification and interpretation of the finished work-world anchored in distinctly aesthetic relations between it and others.

To reiterate, a film's style, in this sense, is not simply announced by it, as if residing in its entirety on its perceptual surface. Rather, like the recognition of all individual "exemplificatory" features contributing to it, it very often requires relevant knowledge and efforts of interpretation on the part of viewers, listeners, or readers. As opposed to the views of some theorists that such applied knowledge is somehow merely supplemental to the aesthetic experience of a film, or only a matter of post hoc analysis engaged in by critics and theorists—who cultivate, as Bordwell argues, a wide range of extrawork, discursive practices and institutions *about* films—it appears, rather, a condition for such a more-complete film-viewing experience to occur at all.[62] Jean-Marie Schaeffer makes the germane point in arguing that "generally, no object presents itself 'spontaneously' as an aesthetic object; we have to constitute it as such, that is, we have to approach it in a certain way, distinguish between those properties that are pertinent and those that are not."[63]

Most good filmmakers, and certainly great ones, intend as much as possible that everything included in a film has some (more or less vital) artistic significance within it and that it contributes to the whole in some fashion. Yet no one feature or element of a film is *automatically* or necessarily significant in the most aesthetically telling or important ways. There are less-significant and even "trivial" stylistic features that may fall outside of the most "interesting interrelationships with the ever developing

fabric of other features involved in organizing our aesthetic experience" of the work.[64] Like every other aesthetic-symbolic feature, despite being an "objective," standing component, these must not only be realized in the artistic event of a film's experience but must be *claimed* for the work during it, as well as in the more or less formal and articulate discourse of postexperience reflection and debate. Thus, for instance, in reflecting on Tarr's *Sátántangó*, inquisitive and literate lay viewers interested in more fully understanding and appreciating the film as a cinematic work of art, as well as professional critics and theorists, must try and point out how and why the number of edits, or the amount and types of camera movement, or the framing of people and their dwellings are among the prominent and truly meaningful stylistic features of this film world (in explicit or implicit comparison to others). They also must determine if, how, and why these and other formal properties reflect on the literal and figurative meaning of the film's representations and narrative, while at the same time serving as the very means by which they are concretely conveyed.

There is also a further hierarchy with respect to symbolic-aesthetic features, however, since not every aspect of a film deemed stylistically significant is as important as others. To refer to this hierarchical arrangement and position more clearly and perspicuously we can here introduce and adopt the term *world-marker*. Cinematic world-markers, I suggest, are what are deemed on reflection to be the most important, defining, or interesting symbolic-artistic and stylistic features of a work's constructed world (including but not limited to those pertaining to the fictional world-in). They may take any of the forms of expressed, thematic, formal, denoted (represented), or reflexive features of films—from lighting patterns to thematic subject matter, from the performative style of actors to the use of offscreen space. So, for instance, *The Conversation*'s disorienting, multilayered soundscape, the diagonal angles and compositions of Welles's *Othello*, *The Seventh Seal*'s metaphysical questionings, and *Manhattan*'s high contrast black-and-white cinematography are all prominent world-markers in the sense I wish to forward.

These examples are obvious ones, at least to cinephiles, drawn from well-known films, and one might readily expect a film's most prominent and defining exemplifications to be as close to the stylistic surface, as it were, as they evidently are here. Each film, however, has as many world-markers as can be pointed out and persuasively argued for and, as with style in art more generally, in historical practice they are contingent

and variable. What may be a key stylistic (i.e., aesthetic-symbolic) feature of *The Night of the Living Dead* or *Sunrise* changes with the creation and experience of subsequent film worlds and with the evolving habits, interests, conventions, and subjects-believed-in-need-of-address within the community of critics, theorists, cinephiles, and filmmakers, as well as larger historical and cultural changes and differences among audiences. Additionally, and like the world-making processes pertaining to its creation, rather than being necessarily cinema-specific, a given film's world-markers may, in form and function, have much in common with those found in the created worlds of music, painting, and literature as pertaining, that is, to the sorts of features—tones and rhythms, colors and compositions, narrative voice and plotting—that works in these different forms and media may exemplify and share with films. Such world-markers are thus "intermedial" or "transmedial" in nature (to evoke currently fashionable film theoretical terminology).

To this point the situation we have traced under the general heading of cinematic world-making as symbolic creation and transformation is one where world-making materials (drawn from other actual or virtual worlds) become symbolic-aesthetic elements, when they are purposefully appropriated and used, taken up into, a cinematic work-world as a whole that provides them (additional) meaning. World-markers are those select aesthetic elements (or groups of them) that from a comparative perspective—that is, when the work is experienced, interpreted, and analyzed in relation to others (as, to some degree, it must always be)—are most persuasively defining of film's presented world in aesthetically relevant terms. In other words, and most generally, the theory of film worlds lends support to, and is in turn supported by, our intuitions concerning what chiefly renders one work different from many, yet still like certain others, from the standpoint of artistic style.

As I am positing them, a film's world-markers are *global* in import, with respect to its total aesthetic form, even if they are manifested episodically, as is often the case. Typically, however, they also have some historical and stylistic meaning and interest in their *own right* when *detached and abstracted from* the work-world in the contexts of interpretation and comparative study. Thus, like the concept of artistic style per se, they may provide the basis for identifying, discussing, and better understanding wider, supraindividual cinematic styles (i.e., in the historical-comparative sense of the term), genres, movements, trends, and so forth. For instance,

genres, like individual films, may be seen to have their own "worlds," and hence "world-markers," in the sense in which Bazin writes of the world of the cinematic western, with its own rules, patterns, processes, and archetypes, as involving both "semantic" and "syntactic" elements, to also evoke film genre theorist Rick Altman's terms and categories.[65] Thus *The Searchers* is and presents a singular cinematic and artistic world that is recognizably also a western world (just to the extent that it is considered a western). Through the aegis of Ford's style, the two "worlds" in question—that of a film and a filmmaker, and a genre—may be in productive artistic tension, but they are certainly not incompatible.

I wish to suggest that among the most valuable and interesting aesthetic classifications of films, or types of cinematic artistic worlds, are those that are made with reference to one or more of a film's distinctive world-markers. Many such classifications may be binary, dividing film worlds into opposing historical and stylistic categories, such as the "time-image" and "movement-image" film worlds featured in Deleuze's writings or the "modern" and "postmodern" ones in Jameson's.[66] But these are, of course, rather broad and general film-world types—too much so, in fact, for many film scholars interested in finding more fine-grained, formal, and historical variations.

Other conceivable categories might be much more limited in scope, counting far fewer films among their category members. Some may hinge on world-markers involving narrative structure and the contents of fictional representations. For instance, "multiple" or "parallel reality" film worlds, such as *The Saragossa Manuscript, Trans-Europe Express, The Double Life of Veronique*, and *Mulholland Drive*, where the presented world-of the work contains more than one fictional world (world-in)—or, at least, one that is notably fractured. Other such schemes might center on mise-en-scène, including what might be termed the "designed" or "decorative" film worlds of Jacques Demy, Aki Kaurismäki, and Wes Anderson, wherein (a) the appearance of all of the environments that characters inhabit is a highly coordinated one with respect to color, or displays a certain type or period of design, for instance, and (b) this serves some "higher" and global referential or thematic purpose, either with respect to a given film or to the creator's oeuvre, of which it is a prominent part. More film historical, contextual, and "intertextual" film-world types may follow from the presence of specific, prominent world-markers that are rooted and understood in more specifically cinema-referring terms.

Here we could single out what may be described and explored further as contemporary "post-European art cinema" worlds, including works by the Hungarian director Béla Tarr, and the American born but naturalized French Eugène Green. These film worlds are created, experienced, and intended under the strong influence of a seemingly now past "golden age" of European art cinema (as eulogized by Susan Sontag, for instance, with reference to Tarr) and derive a great deal of aesthetic resonance and meaning from their position vis-à-vis this tradition and legacy. More specifically, through formally exemplified features, as well as represented and narrated content, the worlds of films like *Sátántangó* and *Werckmeister Harmonies* (fig.5.5), and *Le pont des arts* and *The Portuguese Nun*, may be persuasively interpreted as creatively engaging with the works of Antonioni, Tarkovsky, Jansco, and Bresson, among other canonical European auteurs (many now deceased), in the form of allusion, homage, and a notably shared stylistic vocabulary.[67] Once grasped, these simultaneous incorporations and references add substantially to the appreciation and value of the film worlds in question, while simultaneously putting distinct periods of localized (European) film history in interesting juxtaposition.

There is, in short, no practical end to the number and specific types of film-world classifications that may be identified and argued for in film

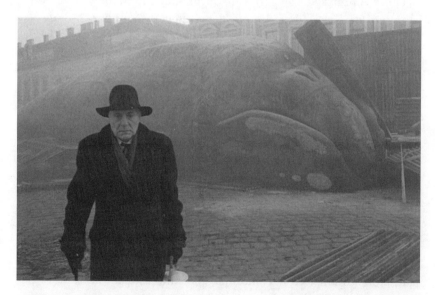

FIGURE 5.5 Tarr's *Werckmeister Harmonies* as a post–European art cinema film world.

theory and criticism (beyond, that is, those that pertain exclusively to a number of films by the same maker). Today, of course, such criticism and interpretation extends to all of the many less formal, online outlets available to viewers and film lovers as platforms for discourse and debate about films and their artistic features, including their symbolic exemplifications and their merits (seldom, of course, under the specific theoretical label of "exemplification"). Such critical arguments concerning cinematic world-markers and types stand or fall on the same grounds, and are constrained by the same standards, as any general interpretation of a film work's artistic (including all exemplified) features.

Perhaps the foremost potential interest of these sorts of "globally" relevant aesthetic classifications is that they clearly cut across more common stylistic classifications of films on the basis of, for example, period, movement, genre, and director.[68] Centering, as they ultimately must, on both the forms and contents of the cinematic-artistic reference-making we have considered in this chapter, and as following from identification and interpretation of world-markers, they may thus reveal new, sometimes unexpected, artistic features of films as a direct result of such groupings and juxtapositions. This revelation may, in turn, lead to the creation of new film-world types (and markers) in an open-ended process of inquiry and discovery.

From Film-World Creation to Experience

Through focusing mainly on their construction in filmmaking practice from a theoretical vantage point, we have now come some way in understanding why film worlds are "symbolic" and how their referential, communicative functions are directly related to their artistic and aesthetic being and value by way of creative transformations: regardless of whether these transformations are understood in terms of Pasolini's "poetry" of im-signs, Mitry's compound visual signifiers, or Goodman's world-making strategies. These functions, however, which correspond to the more objective character and existence of film worlds, as it were, and which are more amenable to sufficient description in third-person terms using semiotic categories of analysis (broadly defined), are still only a skeletal part of a film's work-world as an also concretely ("bodily") experienced and profoundly temporal *event* in the viewer's world. Cinematic transformation, and certainly the phenomenon of viewer "immersion" in

the worlds of films, is also rooted in first-person, psychological realities that are generally outside the scope of Goodman's particular symbol- and cognition-centered aesthetics, for instance. Yet our recognition of such an experiential and, in some senses, psychological dimension of film worlds—together with the more "personal" aspect of their creation—surely need not abandon a combined symbolic and expressivist framework, such as the one forwarded by Cassirer or, in a specifically cinematic context, as reflected in central aspects of Mitry's, Pasolini's, and Deleuze's film theories. In each of these cases there is a far greater emphasis (than in Goodman's account) not only on artistic intentions, the temporal experience of works, and more imaginative and affective engagements with films but also (and as stressed by Cassirer) the broad field of feeling.

For Goodman, as we have seen, all art worlds remain primarily the vehicles for the articulation and conveyance of semantic meaning contents. They are cast as repositories of one kind of knowledge, to the general deemphasis (although surely not denial) of the sensory and affective features and dimensions that other philosophers of art from at least the time of Kant have deemed central. In our present quest for a nonreductive (or, at least, considerably less reductive) concept of film art, Goodman's model of world-making via cognitive reference relations as applied to cinema, as useful as it is, is thus inevitably and irredeemably partial. A case in point is his much-criticized "intellectual" theory of artistic expression (here meaning feeling), according to which it is considered solely in terms of symbolic exemplification (and metaphor), for this cannot fully account for all of a film's (or any artwork's) conveyed feelings and emotions, as more immediately and actually grasped and internalized by viewers and yet still possessing artistic significance.

Surely not confined to a more intellectually detached contemplation, and narrative and referential comprehension at a psychological "distance," aesthetic engagement with films typically involves the more sensory and expressive communicative potentials of artworks. As made actual, these correspond to more genuinely *qualitative* as opposed to analytically individuating aspects of films.[69] Such engagement typically includes some more intimate experience of "being with" cinematic works and their represented contents. We do not only witness film worlds and reflect on their meanings, such as a scientist, or an advanced alien intelligence, might observe and contemplate a microscopic environment, or Earth, from an abstracted distance. We also, in a sense still to be made

clear, may be said to "enter" the worlds of films. Moreover, and crucially, in the case of some cinematic works the actualization of some portion of the artistically relevant and often intended reference-making we have discussed is likely only available by virtue of such feeling and immersion on the part of viewers.

It may not have escaped the reader's attention that *time* has thus far played only an indirect role in my treatment of film worlds. (It should also be pointed out that the made and experienced temporality of artworks plays only a minor role in Goodman's cognitive aesthetics.) To continue to attempt to achieve a genuine, nondistorting synthesis, however, our account of cinematic art must address the viewer's experience of films in the here and now of their temporal and spatial unfolding, together with the several temporal dimensions of films, more generally. With attention to these we must attempt to explain, that is, why, and to some extent, how, the worlds of films are "lived" and felt (qualitative) aesthetic experiences, fully engaging our senses, sensibilities, and emotional capacities, as well as advancing and expanding our *thoughts* about familiar, often taken for granted realities—or, indeed, more novel ones—that cinematic art asks us to confront.

The aesthetic theory of film worlds thus reaches a key juncture, in terms of methodology. Other approaches and traditions, such as that of phenomenological aesthetics in its more convincing articulations and aspects, seem to furnish a natural and apposite additional framework for our address of cinematic expression, affect, and temporality vis-à-vis the unique powers of films to draw us into their created realities. I must emphasize, again, however, that the general (and gradual) shift of focus and method of theoretical approach to be followed is not inconsistent or incompatible with what has been established in more analytic, objectivist, and cognitive-semiotic terms. More specifically, I will be attempting in the remaining chapters to supplement the descriptive and analytic "symbolic ontology" of film worlds, which has drawn most heavily (although not exclusively) on Goodman's aesthetic cognitivism, with a critical, affect-centered phenomenology of film worlds as art worlds and, subsequently, a provisional hermeneutics of them.

PART III
WORLDS OF FEELING

FORMS OF FEELING

Mapping Affect and Emotions in Films

FILM WORLDS ARE FELT AS MUCH AS THEY ARE PERCEIVED AND known. Indeed, it is their global affective character, in a sense to be explained, together (and in interaction) with other expressive aspects, that accounts perhaps most directly for their singular, world-like mode of existence. For reasons that will become more apparent as we proceed, a better understanding of a distinctly *aesthetic* affective presence in cinema, and of related phenomena of viewer engagement and immersion, necessitates first achieving a firmer hold on the complexities of the conveyance of feelings and emotions by narrative films more generally.

Although it is certainly appropriate to pursue this subject under the single heading of "expression," this may also be a source of semantic and conceptual confusion.[1] The term has a variety of meanings in relation to art and its reception, and there seems little consensus about the relative priorities of these senses for aesthetic theory or even what sort of phenomena, exactly, are being referred to by its use. Such polysemy and, in some cases, outright ambiguity is also found in discussions of cinematic expression, as a "widely recognized point or purpose of films,"[2] whether or not these purport to be concerned with any specifically artistic or aesthetic variety of it.

By tradition, expression refers to the conveyance of feelings, emotions, or other uniquely human properties or qualities, such as character traits, in and through artworks by means of their sensory forms and representations.[3] But it may also be taken to refer more specifically to the artist's communication of his or her own thoughts and feelings: a revelation of inmost subjectivity somehow transmitted by or through a work, as reflected in the canonical "Expression Theory" of art, associated primarily with the writings of the Italian idealist philosopher Benedetto Croce and his British follower R. G. Collingwood (together with earlier romantic conceptions of art).[4] Finally, artistic expression has been taken to mean any creative stylization and original artistic interpretation of familiar realities that has affective as well as formal aspects, as in German expressionist cinema or the typical works of expressionism as an early twentieth-century movement in the fine arts. As we have seen, it is expression in something more akin to this last sense, in particular, which is at the center of Mitry's account of film as art, as it is in Pasolini's. There are important ways in which all of these familiar meanings of the term may overlap in cinematic art, as we will consider. Yet for the bulk of this chapter I will be using *expression* primarily as a shorthand description synonymous with any affect, feeling, or emotion prompted by a film that is actually felt to varying degrees by an engaged viewer, beyond being only intellectually recognized as somehow present.

In the past few decades a number of theorists and philosophers, including those with backgrounds in other disciplines (e.g., psychology), have concentrated a great deal of attention on emotion in narrative cinema. The topic has been discussed and analyzed mainly in relation to representational and narrative-fictional contents of film images and sequences, as generating emotions and other sorts of affective responses through perceptions, beliefs, and other cognitive states of viewers. In keeping with the frequent equation by theorists of cinematic works (and worlds) with visually composed narratives and fictional story-worlds, many of the varied sources of affective expression in films (not least owing to their sensory and formal properties) have been somewhat overshadowed by, for example, debates over the nature and extent of character and situation "identification" and whether, and in what senses, film-viewer emotions are "real." The relations among expression, as intentionally placed affective and emotive content, and formal and aesthetic features of cinematic works have tended to be neglected in these problem contexts (so much

so, in fact, that some of these discussions and arguments could be transferred to the study of literature with few, if any, alterations).

Yet in attempting to give due recognition and provide a proper place for feeling attached to nonfictional and nonrepresentational features and qualities of narrative films as distinctly audiovisual and presentational objects and works, it is also crucial not to engage in an equally problematic full-scale retreat from all that is representational, cognitive, thematically normative, and reflective in film viewing or from the many types of symbolic mediation it involves. Such a retreat characterizes some recently forwarded anti-Cartesian accounts of film affect and sensation.[5] Drawing on various extracinematic theories and philosophies of affect, sensation, and embodiment in Continental theory and philosophy, these are explicitly or implicitly cast as alternatives, better grounded in actual phenomena of film-viewer perception and immersion, to the cognitivist views favored by other analysts.

Avoiding such polarization of approaches, and overly binary theorization, a more reasonable and productive course, it would seem, is to admit a multiplicity of sources of feeling in cinematic experience: cognitive and noncognitive, perception- and imagination-based, visual and aural, image- and soundtrack-elicited alike. This recognition points to a strategy of assigning specific sorts of expression and affective dynamics to appropriate *parts* or *levels* of films and to different ways of experiencing them.

Like the different, interlocking forms of symbolic reference constituting the semantic structure of cinematic works, instances of these distinct sorts of affective and emotional conveyance and response may be quite tightly and complexly intertwined in specific films and in our viewing encounters. To a degree, however, they may still be usefully isolated for the purposes of theorization. And, just as isolating and identifying a cinematic work's and world's constitutive, symbolic functions can serve to reveal which of these (or which interactions among them) tend to be relatively more artistically important, so, too, can differentiating between a film's affective and expressive components in more systematic fashion help to identify the extent and nature of their respective contributions to its aesthetic experience, interpretation, and the human truths it may disclose.

With these aims in mind, it is perhaps most helpful to begin with consideration of how feeling in cinema has been typically dealt with in recent cognitive and analytic film theory and the philosophy of film. Several

writers adopting this approach, and building on research on human emotions generally, have established intellectual frameworks and connections that appear consistent in some important respects with the analysis and typology that, as I am suggesting, emerges quite naturally from the direct experience of many films.

FEELING, EMOTION, AND IDENTIFICATION

Among most contemporary philosophers interested in the topic, emotions are not conceived of as a species *of* the genus of feelings, but are, rather, to be distinguished as a class *from* feelings, taken as all merely physical states and affections of which we happen to be consciously aware. The label of *emotion* is, in other words, reserved for affections that have intentional objects so that with respect to the experience of any "proper" emotion, it is always possible, in principle, to find an accompanying state of belief as to the identity of its source or subject. Several current film theorists and philosophers of film follow this preference in regard to divorcing emotions from feelings (including, from a more cultural and media-studies perspective, Brian Massumi in his influential writings on affect).[6] The distinction also happens to have a more general precedent in writings on cinema, where terms such as *mood, tone,* and general *atmosphere* are often used to refer to palpable, affective qualities that have identifiable sources but no single, definite objects—unless, as we will see, the object in question, responsible for a genuine and distinct emotion, is a film as a whole, or some significant part of it.

Carl Plantinga, one of the leading theorists of emotion in cinema, flatly states that "a cognitive approach holds that an emotional state is one in which some physical state of felt agitation is caused by an individual's construal and evaluation of his situation."[7] Emotions are, in other words, always accompanied by beliefs—or, as some philosophers prefer to hedge their bets, so-called belief-like states—whether or not these are fully articulated during the occasions when emotions are felt. In his comprehensive study of affects in narrative cinema, which aptly characterizes most mainstream films as veritable "emotion machines," the psychologist Ed S. Tan concludes that the "one postulate" recent Anglophone philosophical accounts of film have in common "is that some form or other of cognitive activity mediates between the stimulus and emotional response."[8] Such a view is encapsulated by Berys Gaut as the "cognitive-evaluative theory of

emotions."[9] In what is now a small library of writings on the expressive potential of fiction films in this sense, Plantinga, Carroll, Greg E. Smith, Murray Smith, Gaut, and others adopt essentially the same general position, assuming the causation of all proper emotions by our perceptual construals, or thoughts. With the connection between the representational contents of images and their emotional values, if any, thus assured, they tie film emotions to viewer knowledge and to the designs of (mostly) mainstream films, wherein this cognitive activity is seen as supported by more clearly comprehensible narratives, genre expectations, and a general visual and spatial-temporal realism and naturalism, as opposed to major formal stylization or narrative experimentation.[10]

Predictably, there has also been a critical reaction and response by other writers to this strongly cognitivist position as borrowed largely from mainstream philosophical studies in such fields as ethics and philosophy of mind. For example, drawing support from some famous insights of Wittgenstein concerning the indivisibility of our mental acts and the external facts that supposedly cause them, Malcolm Turvey has argued that the standard account in terms of cognitive objects and evaluations that precede emotional experiences fails to fit the phenomenological facts: at least in many cases of visceral or "gut-level" emotions that many contemporary films not only elicit but quite obviously aim to elicit.[11] As we will see, however, so long as it is not assumed that *all* emotions (or emotive responses) instantiated by films are clearly mediated by beliefs or other cognitive states linked to fictional representations, there is certainly an advantage in distinguishing between (a) such explicitly informed or "higher" states of feeling content and (b) other sorts of more immediate (and perhaps natural, and universal) affective responses, including (but not limited to) "raw" feels, shocks, surprises, and other, sometimes noticeably physiological, reactions to what appears on the screen or the soundtrack.

Another point of contention is the extent to which emotional engagement and response in cinema are secured primarily through character identification or through viewer perception of narrative fictive situations apart from any particular attitude or feeling about characters and as the locus of what Carroll refers to as emotional "prefocusing" on the part of filmmakers. This latter is seen to involve specially designed situations in the diegetic dimension assisted by the entire range of medium-specific enhancements, including camera position, editing, lighting, use of color,

and, of course, musical underscoring, which establishes criteria that amount to reasons for having certain emotions, ones that overlap with such situations in noncinematic experience.[12] Despite their much-argued differences, however, in one way or another both of these accounts turn on specific feelings generated by and through the viewer's engagements with literal or fictive representations within the story-world (what I have termed the *world-in* a film); they thus fall somewhere short of reaching the plane of the aesthetic, as it might be said.

Drawing on Burch, Bordwell, and other writers whom he collectively refers to as "story theorists," Tan makes heavy use of the concepts of the "diegetic effect" of films and their fictional worlds. He also recognizes, however, that not all production of emotions by films is "situational," that is, based on the viewer imagining himself or herself present within the reality established by a fictional narrative.[13] In fact, he distinguishes two basic kinds of emotions present in film experience: fictional emotions and artifact emotions. "F-emotions" (in Tan's abbreviation) are the result of the viewer's acquiescing and submitting to the so-called magic window of the diegesis and having thus entered into the story-world of a film, re-acting almost as if present in some capacity in that world. "A-emotions," however, are aroused or elicited by a film when it is regarded as an object and a created artifact, viewed and thought of from an external or non-imaginatively engaged and fiction-accepting standpoint.[14]

Unlike F-emotions, which for all the intensity they may muster remain essentially vicarious from a factual, "real-world" perspective, A-emotions may be as fully genuine, as "real," as any of those triggered elsewhere in life (even if they are seldom of the kinds associated with physical consequences). Plantinga, who generally accepts Tan's distinction, suggests that "exhilaration at a particularly brilliant camera movement" and the "pleasure and enjoyment" of one film's allusions to others are prime examples of A-emotion, which is always at least implicitly mindful of a film qua created object and artwork.[15] Such emotions are, in other words, fundamentally about the cinematic work, in recognition of its created nature and functions. They require gaining some more work- and self-aware perspective on the viewer's part about broadly artistic uses of the medium to certain creative and meaningful ends, together with entailing the possession of the knowledge this may entail.

Such "distance," however, does not mean ignoring narrative-fictional realities and what we have defined as the world-in films. But, as in Plan-

tinga's second example, such emotion necessarily involves some grasp of a film's nonliteral or nondenotational representations, of just the sorts we considered in the previous chapter under the heading of artistic exemplifications (e.g., allusions). These remain separate as a class from those emotions that may be felt only in consequence of the viewer's implicit decision to participate in the fiction-making enterprise. In basic terms, such F-emotions, but not (necessarily) A-ones, require the film viewer to imaginatively assume the position of a participant or witness with respect to the action of the narrative, to be imaginatively immersed within it in a more general way. This may be termed "imagining from the inside," in Murray Smith's phrase, which echoes philosopher R. K. Elliott's earlier, more general notion of experiencing any representational artwork "from within" its posited reality as opposed to "without" (i.e., experiencing it from a greater psychic distance, as a created rendering or simulation).[16]

Tan's account of the typical feature film as nothing less than a near-perfect device for triggering emotions rightly makes an allowance for the ontological and experiential differences between a film work's fictional representations (which combine to form the story it narrates) and features of the larger created, presentational whole of which these are part. In other words, this is in keeping with our present distinction of the world-in and the more encompassing world-of a film. The analysis also aptly suggests that cinematic emotions may be plausibly divided between those that are more pertinent to art and to the aesthetic dimension (i.e., as work-centered, involving attention to extranarrative features and intentions) and those that primarily pertain to film as a medium exceptionally well-suited to constructing fictional domains and credible characters to inhabit them and be engaged with as such, and sometimes exclusively. Moreover, Tan's distinction remains useful even if, as Plantinga argues, the two types of emotion may be often simultaneous and indistinct in their particular instances in actual film experience.[17]

Given the overriding focus of his study on F-emotions, however, Tan, like Plantinga, devotes comparatively little attention to further explicating A-emotions or the sorts of real relations obtaining between each type. Nonetheless, here again falling into that pattern of recent theory we have already observed, he tacitly assumes that (a) the only "world" of a film in which the viewer may be affectively immersed while experiencing it is that of *diegetic fiction*, and (b) that a great deal of what pertains to the work qua artwork, and to aesthetic attention (or the "aesthetic attitude"),

is generally antithetical to a pronounced experiential absorption and immersion, given the lack of reflective spectator distance the latter is assumed to involve.

Yet if film worlds are more than story-worlds, then it is also likely that not all strongly immersive feeling and affect is a function of engaging in particular ways with represented situations and the fortunes and misfortunes of dramatic characters. In fact, at least some generally comparable expression and potential for immersion is shared by both narrative and nonnarrative films, the latter typically having no characters or diegetic fiction to speak of; it is also part of the experience of artworks in other forms and media, narrative and representational, and nonnarrative and nonrepresentational, alike. There seems to be no a priori (or empirical) reason why cinematic expression and its fostering of immersive engagement should be confined to an attribute of the diegesis or to acceptance of the fiction and its many ramified, ontological projections, as such, or why this process should be fully reducible to these in theoretical terms. Put more simply, we may accept the distinction of A- and F-emotions as a useful starting point without concluding that all cinematic immersion is a matter of "emotion-belief" focused entirely on character, story, and plot situations. As I will discuss in more detail in the next chapter, it is equally born of an intentional, active, and participatory engagement with a film as a work of art and an unfolding sensory, as well as cognitive, experience compelling our attentions and feelings as such.

Apart from the distinctions outlined thus far, cinematic experience typically encompasses numerous levels or kinds of feelings and emotions, ranging from the most visceral and reactive to the most complex, subtle, sublime, and reflective. Clearly, as most theorists recognize, not all of these responses elicited or in play for film viewers are of the same kind, nor do they have the same sorts of sources or objects. In consequence, I believe that film affect and emotion are too variable and complex to be satisfactorily treated from any one systematizing theoretical perspective, or single model, such as psychological-cognitive, phenomenological, "sensuous," or "haptic." Each of these now common theoretical perspectives, however, proves to have some utility in approaching and understanding the manifestations of this prominent dimension in which cinema finds a major ground of continuity with other, older arts.

Cognitive theories provide some valuable insights into some forms of emotional or affective engagement and immersion in some film worlds

(as artwork worlds) or, perhaps more precisely, some *parts* or *moments* of them. But these appear to be bought at the price of too narrow a focus on certain F-emotions, as we have considered. Indeed, if we start from the traditional premise, supported by the more broad-based views of such thinkers as Cassirer and Langer, Mitry and Dufrenne, among others, that it is affective expression of certain kinds (or with certain goals) that in part distinguishes the experience of art from other experiences in the vast domain of symbolic representation, we will inevitably come to perceive the methodological sources of this limitation of the scope of recent treatments of film-created emotions in specifically aesthetic terms. Most cognitivist approaches, we must remember, are anchored in "everyday" perceptual and psychological dynamics that are specific neither to cinema nor to art,[18] and yet are explicitly seen, with some clear truth, as always operational to various degrees when we engage with films. This focus generally (and to some extent, necessarily) emphasizes cinema's realism, in the sense of the mimetic or substitutional potentials of the medium, over its more creative transformational ones. While narrative cinematic art clearly pertains to, and makes use of the former, it is equally, if not more, a matter of the latter.

LOCAL AND GLOBAL CINEMATIC EXPRESSION

With all these considerations in mind, we may attempt to roughly map the total affective field of a narrative film. It may be seen to comprise three forms of *local* expression, together with one more *global*, composite expression or "world-feeling" of an aesthetic nature. To an extent mirroring the previous analysis of "local" and "global" integration and interaction with respect to the forms and objects of symbolic reference in film, these terms are here intended in a primarily temporal and experiential sense, as opposed to any literal physical and spatial one. Plantinga distinguishes between some specific types of emotion in the experience of films on the basis of the relative temporal duration of the emotions in question. Those that are "long-lasting" and "spanning significant portions of a film" (e.g., suspense) he terms "global," and those that are "intense" and "brief in duration" (e.g., surprise and elation) are "local."[19] Although my use of these designations overlaps somewhat with this recent author's, given our different, more expansive concept of the world of a film, these same terms have an additional, deeper, and differently oriented significance

here. Moreover, local expression, in my present sense, which might also be called episodic, pertains to potentially *any* emotions, feelings, and affects that are associated with specific and given images, sounds, and sequences (or entire dramatic scenes). The main point is that in the temporal movement of *North by Northwest* or *Caché*, as in almost any narrative film, specific emotion-eliciting images or sounds are soon succeeded by others, and so forth, which typically involve other, often quite different and contrasting affects. By comparison, global expression, as the label suggests, pertains to a film work as a temporal whole and as incorporating and integrating some number of local or episodic affective sources.

More specifically, local cinematic expression may be seen to comprise three general forms: (1) the *sensory-affective*, which tends toward the immediate, visceral, and "natural" (i.e., likely biologically "hardwired" in contemporary parlance); (2) the emotive-cognitive, or what I will refer to as *cognitive-diegetic*, working through fictional representation and imaginative participation or identification of some sort; and (3) the *formal-artistic*, involving responses to features of a film that center on their evincing aesthetic properties of form, design, and artistic intentionality and significance (fig. 6.1).[20]

Each of these basic types of expression may be distinguished from the others in terms of its most typical causes or sources in a film's presented images and sounds (although these may also be shared), as well as phenomenological differences in the viewer's awareness of, and attitudes toward, such "objects." As distinct or as overlapping as they may be in any given film, these varieties of local cinematic expression are complemented by *one* global or total form of aesthetic affectivity, to which at least some of them contribute. To revert to our primary distinction with re-

FIGURE 6.1 Cinematic Affect and Emotion.

spect to literal representations as establishing a film's fictional reality, and the formal and figurative presentation that creates a larger semantic and affective context for this reality's experience—that is, a film world—this last category of affect is as much *of* a cinematic work as *in*, or part of, it.

FORMS OF LOCAL FILM-WORLD EXPRESSION

Sensory-Affective Expression

What I call sensory-affective expressions are likely the most familiar and ubiquitous throughout cinematic experience, accessible to audience members of every description. They represent the most direct and immediate, nonreflective feeling responses prompted by perceptual attention. They may also lack a specific narrative or fictional (together with what I will describe as "formal-artistic") cause or basis per se. In an eponymous book the philosopher of mind Jesse Prinz uses the phrase "gut-level emotions" to designate specific feeling contents that seem to lack cognitive objects, at least at the time of their occurrence.[21] Prinz, Jon Elster, and other recent writers on the nature of such emotions take these to be wholly unreflective affective reactions to certain perceptual stimuli or internal, physiological changes.[22] Along these lines, such feeling elements or emotional triggers are the least culturally and symbolically mediated sort of affect in film experience. They are a matter of the most "natural" of expressive contents, readily accessible in the cinematic event and routinely called upon by filmmakers to elicit elemental, panhuman affects.[23] Such elementary, perceptually given sources of stimulation result in what psychologists refer to as emotional invariants or universals, to the extent that the cinema harnesses them, in the form of two-dimensional simulations, for shocking, entertaining, and, sometimes at least, more creative, artistic, and thematic purposes.

In relation to composition, movement, gestures, rhythm, and above all editing, Eisenstein, Pudovkin, Vertov, and other early Soviet filmmakers were at the forefront of systematically studying and practically exploring this first general mode of filmic expression, in an attempt to incorporate it into cinematic narratives conceived as total audiovisual experiences. Other early film pioneers like Griffith and Murnau may be seen to have pursued this vast medium potential on a rather more intuitive basis. The practices and techniques used by filmmakers and, today

especially, special-effects engineers and sound designers, to produce sensory-affective expressions are, of course, numerous. They may result from editing, in-frame motion, camera movement, the use of sound effects and music (both in themselves and in concert with the image), CGI manipulations, and all manner of kinesthetic and audiovisual capacities for stimulating the viewer's innate physiological mechanisms. In adding sounds to sights, and using the elements of shock and surprise, there appears to be no end to the sorts of instinctual, sense-driven, virtually instantaneous states of feeling that films can provoke. As may be seen in many early avant-garde films, such as *Man with a Movie Camera* and *Entr'acte* (where the camera is memorably taken on a roller-coaster ride, some of the movement, force, and speed of which is transferred to the viewer), this is a mode of filmic expression and contact with audiences that, while never wholly independent from the specific representational contents of the film image, may be the most "indifferent" to them (and sign and symbol relations) even in the context of a narrative film.

However, it is not only aspects of a film's particular sensory and formal presentation that may provoke such local affect but, rather, imagistic content *per se*. This second subtype of episodic sensory affect returns us to the topic of naturally or inherently expressive filmmaking materials borrowed from our common lifeworlds (briefly discussed in chapter 3), which can now be addressed in greater depth. This expression is strongly tied to what Souriau first termed the "profilmic" and what Metz refers to as the "filmed spectacle" as distinct from the spectacle *of* a film.[24] Such affect is a consequence of the sheer, readily recognized (mimetic) presence onscreen of a grotesque, painful, joyous, shocking, or erotic object, event, or situation, for instance, rather than the proximate consequence of its narrative-fictional position or purpose or, for that matter, its specific cinematic and artistic presentation. In other words, this affect is defined by an unbroken connection to what a film either necessarily *retains* or *allows for*, in affective terms, from the objects, bodies, faces, gestures, or other naturally (and to some degree, culturally) expressive materials it represents and uses, apart from whatever (further) creative and stylistic transformations these may have also undergone in the artistic filmmaking process. As described by Mitry, reliance is placed here on "the obvious power of an intrinsically moving reality," which the basic, iconic "image-data" of a film captures and transmits.[25]

Accounting for some significant part of their mass appeal, filmed objects and events may, as it is hardly necessary to argue, generate much

the same feeling responses that their actual, sense-experience-occasioned counterparts would if encountered in everyday, bodily present, three-dimensional reality. (Conforming to what film experience has seemingly long suggested, some recent scientific studies of the subject have concluded that for some feeling-related areas of the brain, real objects and their imagistic representations are close to indistinguishable in this emotive respect.)[26] While in both a celluloid and digital context such affectively charged representations are typically indexical—that is, physically causally connected to that which the film camera has recorded—this is not necessarily a determining factor in the generation of such feeling contents and response. This is because sensory-affective expression of this kind is present not only in relation to all forms of animation, for instance, but also representational painting, drawing, and sculpture. Yet to the extent that, first, the indexical relation carries through into the ease of apprehension of the contents of film images, and, second, given the standard level of verisimilitude typical of (although not essential to) the photographic and live-action film (with its attendant, psychological impacts), this sort of sensory-affect may be considerably amplified in cinema relative to other forms and media.[27]

Any such retained profilmic affect may be used in all sorts of creative, interesting, and artistically significant ways, as is perhaps most obvious in the many different aesthetic functions and appearances of the facial close-up (where the very word *expression* has another, pertinent sense). Yet, on the other end of the spectrum, as often requiring little in the way of artistic creativity, a blatant, highly manipulative employment of this mode of affect, as tied to the visual exhibition of a highly stimulating, shocking, taboo or confrontational subject matter—as a cinematic end rather than means—is, of course, not only possible but a hallmark of so-called exploitation cinema.[28] In a way that supports our present classifications, however, there may also be only the finest of lines between art and exploitation in this respect, which directors like Tod Browning, Walerian Borowczyk, and Alejandro Jodorowsky have notoriously attempted to walk in films such as *Freaks*, *La bête*, and *El topo*, in seeking to channel such affect in thought-provoking ways.

Returning to our previous discussion of cinema's world-making materials: in an artistic context any such "given" emotive contents (or so-called valences) must, it appears, be harnessed, controlled, and manipulated in such a way as to serve a filmmaker's creative ends and intentions, as Mitry, Metz, and Pasolini maintain. Lest one suppose that the "problem"

of the natural (or inherent) affective expression of materials in cinema emphasized by these theorists is a critical or theoretical supposition alone, we need only briefly reflect on the considerable amount of creativity, resourcefulness, and technological innovation that has been devoted to altering and controlling the profilmic affective "messages" often transmitted by the faces, voices and body language of performers; by colors, light, and natural sounds; and by much else besides, in many and varied filmmaking modes, genres, and styles throughout cinema's history. Here we find ample evidence that such manipulation and transformation to more creatively manage this expression has indeed been, in practice, both a difficult and necessary task. In the planning of any given film, as well, decisions to shoot in a studio rather than on location, or in black and white rather than color, may be artistic as often as practical or economic, informed by these considerations pertaining to the avoidance of unwanted affective "interference" stemming from the nature and appearances of the properties of almost anything present within the frame or on the soundtrack.

As an opportunity for enhanced creativity, as much as an obstacle to it, however, the specific and varied ways in which such *mimetic* sensory-affective expression has been (successfully) harnessed and employed has, in turn, shaped the signature artistic styles of a number of filmmakers considered among the greatest. A few well-known examples drawn from canonical European art cinema include Bresson's efforts to proscribe naturally (or conventionally) expressive gestures, movement, and voices of actors; the general avoidance of the expressive facial close-up in Rossellini's neorealist films; and the lengths to which Antonioni and Tarkovsky (and their cinematographers and production designers) have gone to alter the natural, or found, color of objects and places in making films, including painting (or repainting) natural landscapes and parts of cityscapes (in *Blow-Up* and *Red Desert*) and using lens filters and postproduction effects (in *Stalker* and *The Sacrifice*).

Crucially, the transformative use of such expressively "radioactive" materials, which may impact all that surrounds them in a film in both expected and unexpected ways, as a means to larger aesthetic ends, may not only involve their suppression, reduction, or substantial modification; it may also entail their pronounced, highly intentional amplification. Thus, in the films of Dreyer and Cassavetes the unquestionable affective power of the human face in close-up (stressed in the writings of Balázs,

Eisenstein, Deleuze, and many other theorists) is not minimized through avoidance but creatively maximized. The same may be said in relation to the inherent beauty and sublimity of natural landscapes featured in the films of Ford, Herzog, and Malick. Such instances allow and encourage us, as students of the medium and its art, to also stress the potentially positive aesthetic aspects of giving relatively freer rein to the natural expressivity of constitutive profilmic materials captured in their filming/recording, in relation to the total design of a film world (including its fictional characters and events, spatial and temporal structures, and reflexive and thematic meanings). Sometimes this occurs at the relative expense of narrative considerations and may be in (productive) dialectical tension or conflict with narrative and other formal and artistic elements.

In sum, and to return to our main focus, apart from its potential second-order, artistic meanings and uses, and whether it is stimulated mainly by the formal or medial properties and techniques of cinema *or* by the representational (mimetic) contents of images, any particular instance of sensory-affective feeling tends to be transient in a film's unfolding, either momentary or quite short-lived. Such affect may be detached (in principle) from the fictional story-world of a film with which it is usually, and more or less loosely or integrally, combined. The phenomenon in question is a familiar one: it is readily apparent from viewing, and being affected by, certain images, or sequences in relative isolation—when, for instance, we flick through cable television channels and view bits and pieces of several films—while knowing little, perhaps nothing, about their characters and stories. Or, perhaps more interestingly, it is revealed in one's notable affective responses to film previews when, again, as viewers we have often little or no narrative or dramatic context to draw on, apart from genre or similar expectations.

Finally, and most consequently, under this heading, and as taking any of the specific forms discussed, local sensory-affective expression always follows proximately from a direct, actual, external *perception* on the part of the viewer, as my designation "sensory" is intended to indicate. Indeed, its particular character is most prominent in contrast to that which is (or is also) intuited, imagined, or conceived in film experience. As such, this affective response is inherently *audiovisual* and a cinematic product of "presentational form" (in Langer's sense), far removed from what may be at work in relation to any linguistic (symbolic) mediation. It thus has little genuine counterpart in any form of literature, however poetically or

imaginatively "imagistic." Just the opposite may be argued, however, with respect to the next form of local cinematic affect, the cognitive-diegetic, which is in many respects comparable, at least, to the expression at work in novelistic literature and other narrative forms.

Cognitive-Diegetic Expression

I began the present reconsideration of cinematic affect and emotion by noting that what happens in, and in relation to, a story-world—as generated through the film viewer's combined perceptual and imaginative engagement with fictional characters and the situations in which they find themselves—is often assumed to be the site of the most primary, important, and meaning-determinate affective interactions in and of a film. In everyday experience we are familiar with the conjunction of feeling and imagination in the narratives we construct and tell ourselves and each other in what can be considered a primary cognitive strategy for organizing our lives, apart, that is, from any special, purposefully created and formally presented fictional and artistic narratives—which, from this particular perspective, are but elaborate extensions in culturally instituted forms of the basic narrativizing propensity of the human mind (a propensity that, as Barthes has written, "is present at all times, in all places, in all societies").[29]

Cognitive-diegetic affect is, then, basically the virtual film version of the emotive aspect or dimension of many and various kinds of life-situations in which people might find themselves. Such expression follows from our willing, fiction-accepting engagements with stories, together with their human or humanlike characters, actions, and situations. And it may occur in conjunction with either first- or third-person perceptual or imaginative perspectives. Of course, in contrast to real-life conversations with other people, when we may both imagine and feel the unusual events a friend recounts to us in the theater of our individual imaginations, and also distinct from the descriptions of life-situations found in works of literature, narrative films provide concrete and specific images and sounds to aid, supplement, or lead, but also in some ways to constrain, our already emotion-laden imaginations.[30]

Familiar forms of local, cognitive-diegetic emotion are generated through the capability of a film to virtually place the viewer in the temporal and spatial position of a character or even an inanimate object. Or,

in contrast, it may follow from promptings in which we, as viewers, take up the position of an imaginary witness in the midst of the action in the perceptual and cognitive role of an unseen human, "ideal," or "godlike" observer of story events. Not only through the point of view and movements of the camera, but through framing, mise-en-scène, and editing, as tied to narrative structure, we may seem to cross no-man's-land "with" Colonel Dax (Kirk Douglas) and his men in *Paths of Glory*; slowly approach the ominous Bates house in *Psycho* "in the place of" Detective Arbogast (Martin Balsam); or glide through empty hospital corridors toward a ventilation system in *Syndromes and a Century* "as if" we are a phantom or percipient speck of dust. And, accordingly, we may be disposed to experience many distinct feelings by virtue of these literally represented but still partly imagined situations, insofar as we are willing to "enter" and become immersed in the represented story-world (however much this may also seem an automatic part of narrative film viewing).

Another, arguably distinct, form of cognitive-diegetic expression in cinema is emotion that accompanies the apprehension of certain represented situations or events independently of the above-noted dynamics of point of view or, for that matter, any considerations of the viewer imaginatively placing him- or herself in the psychological "shoes" of a character (or even object). Instead, as Carroll has argued, with recourse to his concept of emotional "prefocusing," as the "raising of various preordained emotions," this entails viewers' simply taking part in an affectively charged, virtual reality, as reproductive of one with which he or she is already familiar (at least as a *type* of experience), either from ordinary life or the prior experience of other films (or both).[31] These include the (now) clichéd situations and episodes of the on-again, off-again love affair and its emotional roller coaster, the frightening alone-in-the-home situation of defenseless (for the most part young female) victims of psychopaths, the inevitable denouement of a courage-testing *mano a mano* gunfight, and so on.

Indeed, and as Carroll's numerous discussions of the general topic persuasively suggest, some genres privilege cognitive-diegetic expression more than others. In fact, it seems as if entire cinematic genres may be defined in large part by reference to the relative prominence of this type, as compared to expression that is clearly little more than sensory-affective. Melodrama, romance, some forms of comedy, and the classic western and gangster films are particularly rooted in cognitive-diegetic

expression. Here desired audience responses in the form of so-called garden-variety emotions are aided and abetted by markedly realistic settings and actions, as opposed to more patently "unreal," impossible, or fantastic ones (which may tend to inspire more detached or merely bemused attitudes). Such genres provide a familiar and stable representational playing field for vicarious participation in the emotional lives of characters, in contrast to many contemporary action, science-fiction, and disaster film blockbusters. In the latter cases, genuine affect is not, it would appear, dependent on highly implausible projections of oneself into such unlikely places and situations as earthquake zones, runaway trains, or battles with hostile aliens bent on destroying our planet. Rather, a great deal of affective intent and response in these latter sorts of film entertainments appears to be more a matter of relatively mindless and instantaneous visceral perceptual and bodily effects of the dynamic spectacle of movement, sound, and light (often enhanced through CGI technology), in one extreme manifestation of what Bordwell describes as "intensified continuity style" filmmaking.[32] Here the sensory-affective at its most confrontational is at least coequal with the cognitive-diegetic (and potentially, at least, formal-artistic expression, to be addressed shortly). Indeed, there is little doubt that in some narrative films, characters, settings, and events provide little more than a pretext for the conveyance of perceptual novelties and thrills, wherein the current cinema quite consciously makes its closest approximation to amusement park rides,[33] versus more imaginative or "vicarious" involvements.

Yet even the most special-effects- and shock-laden horror and action films also provide some role, still often a prominent one, for cognitive-diegetic affects (e.g., as involving narrative suspense, as well as perceptual shocks). The horror film, in particular, in both classic and more contemporary iterations, trades on the highly deliberate mixing of both modes of feeling content, either simultaneously or with one setting up the affective "payoff" of the other, as in, for example, Dario Argento's *giallo* thrillers and John Carpenter's *Halloween* (both key templates for the much-maligned "slasher" film subgenre). In these films and countless others the use of now-ubiquitous point-of-view editing and camera movement techniques provides for an imagination-based, perspectival identification and anticipation, coupled with more purely perceptual shocks and affects.

If sensory-affective expression begins and ends with certain, immediately given perceptual contents and more direct psychological stimulus

and response, from the aesthetic standpoint of laying the foundation for prominent artistic figurations and exemplifications of various kinds in narrative cinema, cognitive-diegetic expression far surpasses the more elementary, relatively "mind-independent" form. While also necessarily grounded in what is presented to our organs of sight and hearing (coupled with whatever unconscious, constructional activities occur in connection with cinematic perception), it is the bridge that connects the film viewer's capacities for comprehension of the representational contents of the film image with emotional contents and response. In fact, while most recent, philosophical analysts have concentrated on the link between constructed narrative situations and the elicitation of a limited range of standard, stock, or garden-variety emotions by filmmakers—of the ever-reliable kinds that are (now) expected by popular audiences—the import of their favored approach in terms of "cognitive-evaluative" or "situation-assessment" models is far more profound. For, in opening the door to the manifold ways in which films and their worlds may describe and represent social and psychological situations, and dramatic characters and their interests and motivations (in order to foreground and convey the affective dimensions of any of these) they may equally invite consideration of highly complex, often much more subtle, emotions. These take correspondingly complex, often uncertain, objects. And given that the "cognitive" and representational basis of such emotion in films is clearly part of their symbolic dimension, many of the artistic means and strategies for producing expression of this type, and particularly of its instances that are of greater aesthetic interest and value, are those symbolic functions and uses, and the world-making processes built on them, I have attempted to explain in the preceding chapters. In fact, a film world *as a whole* may be regarded as a feeling-facilitating "cognitive object."

The strong link to representation and narrative is the main reason why instances of cognitive-diegetic expression tend to be longer lasting in their impacts than the typical shocks and surprises of the sensory-affective. Whereas the latter form of local affect is responsible for causing sudden intense blips on the seismographic recorder of conscious emotional response in film viewing, the former tends to produce plateaus and hollows of somewhat longer duration involving emotional highs and lows that typically extend through entire scenes or episodes of narrative development. The strongest, most characteristic form of this affect-type, however, tends to remain either scene- or episode-specific and, if relatively

more enduring, still takes a film's story-world (world-in) as its general object. Most important for our present purposes (and as also recognized by Tan), despite its great potential in this direction, such cognitively and narratively mediated expression still need not, and quite often does not, involve any implication or acknowledgment of a film qua artwork: according to which expression is valued insofar as, among other reasons, it is more singular to the specific intentions of film artists as realized in the medium and in an artistic style. However, whether having more novel or more familiar objects and causes, if and when such feeling contents are also *conjoined with* some significant attention on the part of the filmmaker (in the process of creation), and especially of the film viewer (in experiencing the work), to the artistic form (and style) that presents and occasions it and its interpreted meanings, cognitive-diegetic expression takes on a more distinctly aesthetic character. For it then consciously involves not only the represented "what" but the formal and stylistic "how" and the artistic and intentional "why" of a representation, situation, or technique.

Formal-Artistic Expression

Art is achieved when the emotion is the *product of an intention successfully* (i.e. convincingly) *executed* and not just a reality incidentally impressive in itself.

—Jean Mitry

The idea that expressive properties of artworks are associated primarily, and as a class, with aspects of created and perceived form, as distinct from content, is a traditional one (certainly traceable as far back as Kant's aesthetics). In critiquing the idea that art is a more or less direct reproduction of "our inner life, of our affections and emotions," Cassirer writes trenchantly that art "is indeed expressive, but it cannot be expressive without being formative." [34] With specific application to cinema the same basic notion is articulated by Mitry, who argues that "it is only through the agency of a form that the audience can be led to discover the thoughts of the filmmaker, to share his feelings and emotions."[35]

A film's localized and formative expression may be contrasted with both immediate sensory-affective stimulation and cognitive-diegetic emotion as exclusively tied to, or caused by, fictional story events and characters. This expression arises in consequence (more or less direct) of

some attention to specific features of a cinematic work *as a work* rather than as a purely perceptual reaction to a filmic sight or sound or an imagination and thought-aided connection to the fictional reality a film establishes (alone). At the same time, however, formal-artistic expression frequently *works through* either or both of these in representational and narrative cinema. Indeed, the affective cinematic features in question are "formal" not in the sense of being free from any representational content, for instance, since it is precisely that which is represented that is also somehow creatively formed and structured in a way more or less unique to each film. As such, and unlike the affect associated with the mimetic cinematic representation of inherently highly expressive (i.e., profilmic) realities, this type of feeling content is wholly "made" by filmmakers when the work is made, as opposed to channeled (or "borrowed," as it were), and is only realized through requisite viewer attention. As Mitry holds, its instances are frequently governed by artistic intentions related to the creative interpretation of a subject, or some aspect of recognizable reality, that uses and *surpasses* cinematographic representation and, today, video-digital representation and its basic psychological effects, and where such interpretation includes an emotional or affective stance. Thus, it is the product or effect of participation with a film's artistic *presentation*, as opposed to only its dimension of representation and, a fortiori, situations thrown up by the story-world.

A principal source or object of this third basic form of local expression may be stylistic features and what I have described as a film's prominent "world-markers" in their more perceptually and affectively transient aspects. For instance, it may reside in the way that a given scene is staged, a shot framed, an object lit, or the tone of a voice-over narration. Or it may involve a film's selection and presentation of the aforementioned inherently expressive realities, if and when a film appropriates these to its own artistic ends, as recognized and appreciated by the viewer, who is moved accordingly. The full artistic and emotional effect of *Psycho*'s landmark shower scene, for example, is some complex, superbly orchestrated amalgam of sensory-affective, cognitive-diegetic, and formal-artistic expression.[36] This last may stem not only from more abstract properties of film form but from exemplifications of such properties that are productive of metaphors, allusions, or other external associations as these are grasped by viewers (and with which the images of Marion Crane's murder and aftermath are replete). Thus a film may provide "a richly symbolic

commentary on the modern world as a public swamp in which human feelings and passions are flushed down the drain," as Andrew Sarris observed about *Psycho*, referring to both the shower scene and the film's final image.[37] Through its maker's creative, formal, and artistic transformations of the preexisting and known, a film may "speak" in highly affective fashion, not only about the imagined or imaginary lives of *characters* in some "other" place and world on the diegetic plane but to something about *our* lives and experience as viewers, or life in general—and do so in highly affective, feeling-generating fashion.

For viewers attentive to it (and possessing the requisite extrawork knowledge and experience), the full and no doubt intended emotional power of Alex's (Malcolm McDowell's) assault on the writer and his wife in *A Clockwork Orange*, played out to the accompaniment of "Singin' in the Rain," derives not only from the visual, photocinematic depiction of brutal violence inflicted by one person on others, nor from the specific narrative context in which it occurs, nor from an identification with the characters who are the victims of the senseless attack. The emotional power of this sequence arises also, and emphatically, as a result of the familiar, comforting, and feel-good extrawork associations of the song—and the Hollywood musical of which it is a part—as unexpectedly and "perversely" paired with this represented action in allusive fashion. As manifesting a provocative, confrontational artistic choice on the part of the film and director, the resulting "cognitive dissonance" and affective tension or *frisson* translates (in the manner of Tan's A-emotion) into feelings about the film as a work and an experience (whether positive or negative). Although "Singin' in the Rain" is a diegetic feature of the fictional *world-in* the film, through the aegis of the viewer's affective as well as intellectual response to the constructed sound-image presentation (which it both allows for and encourages), it notably transcends this narrative-fictional reality, prompting reflection on the artistic *world-of* the film—its intentions, and its extranarrative thematic, satirical, allusive, and cinematically reflexive meanings.

To reiterate, whatever specific form it may take, what chiefly distinguishes this type of affective expression is that a particular feeling either is simultaneous with, or, in some cases *prompted by*, a recognition pertaining to something specific about the cinematic work as a work. While most frequently very closely conjoined with it, such feeling, it also bears repeating, may on occasion bypass the fictional world-in (and imaginative engagements with it) or, at least, not depend on it integrally. Nor is it to

be (solely) attributed to the iconicity of the cinematic medium, that is, as simply the affective result of visually reproduced objects, still or in motion, or its power to stimulate the senses and emotions through any other more direct means. Rather, it entails the recognition and experience of potentially any of a cinematic work's individual symbolic-aesthetic exemplifications (as previously described), together with what Deleuze aptly refers to as "attentive" as opposed to merely "habitual" recognition and engagement with a film work.[38]

While it may yet have the same general perceptual source or cognitive object as that of an instance of sensory-affective or cognitive-diegetic expression—for example, a deep-focus composition, a dramatic event, the movement of a character or the camera, the color scheme of an interior—formal-artistic expression is disclosed to a different manner or mode of attention, as if on another "wavelength"—an aesthetic one, in this case—of affective reception and awareness. Here, then, is one affective equivalent, and often consequence, of the aforementioned experiential duality characterizing cinematic presentation, wherein the viewer may attend to the film image both as a representational window on its represented subject and story and as a meaning- and intention-bearing construction in simultaneous, or alternating, fashion. As an affective component of the symbolic-aesthetic multiplicity, complexity, and density of artworks discussed previously, such expression is another hallmark of artistically motivated and successful films. And, in turn, their full significance and value as art depend on how skillfully (in all of the details and complexity of the general task at hand) this mode of affect is achieved.

Such formal-artistic expression, even though still "local" within a film world, is generally more durable than the other two types discussed, which tend in many cases to diminish in emotive power and are relatively less able to survive repeated viewings of a film. As viewers, we may often be less emotionally moved in relation to the characters and story (of which we know the end results) of *Psycho*, or almost any other film, after having seen it a number of times. Or, and perhaps especially, we may not be affectively jolted to nearly the same degree (if at all) by particular filmic effects, minus the powerful element of perceptual and dramatic novelty, shock, and surprise, when seeing a film again (and again). Simultaneously, however, and through the acquisition of all sorts of information related to a film and its making, for instance, we may become ever more aware and attentive to aspects of how a now-familiar story and plot are presented, a shot composed, or a line delivered. And, as a consequence,

we may become more sensitive to the relevant affects and emotions they may be intended to generate and *why*. That is, we become attuned to their meanings and functions in the context of the meaning and the felt and interpreted intentions of the cinematic work as a whole (including what Goodman refers to as the "cognitive function" of feeling in art as a route to knowledge about the world). All of this clearly crosses over into the realm of aesthetic experience and appreciation.

In sum, this tripartite classification of local filmic expression and affect is a tool of analysis, not a suggested recipe for artistic filmmaking. Nor, for that matter, is it always visible, as such, in the sensory, narrative, and artistic unity of specific films. The reality is that these types continually overlap and merge with one another, sometimes cooperating and sometimes not, to elicit the range of powerful emotions that, as all concede, characterizes most if not all fiction films. Thus, whatever feeling the final, close-up image-sequence of the face of Bob Hoskins, playing gangster-cum-businessman Harold Shand in John Mackenzie's *The Long Good Friday*, may instinctively or "naturally" prompt in being an iconic image of a human being whom we may immediately (perceptually) recognize to be in certain emotional states (as an instance of sensory-affective expression)—our response is also, one must suppose, inseparably mixed with feelings arising in relation to the understood narrative and dramatic situation of which the face and its expressions are a part (i.e., cognitive-diegetic expression). In this case the clearly inexorable, ironic-tragic situation of Shand, who has literally just fallen into the hands of IRA assassins, after having previously launched an unwinnable "gang war" on the organization (fig. 6.2). Such emotional projection on the part of viewers may well entail a feeling of "poetic justice," given Shand's situation, or an empathetic or sympathetic identification with the character (however violent and immoral his previous behavior). But this story-rooted emotional identification and projection is also likely combined, or concurrent with, the viewer's by-this-point developed feelings *toward the film work* of which this culminating close-up is a major part, in the form of a formal-artistic expression and exemplification tied to the film's meaning(s) and purposes as a work.

The Long Good Friday is particularly instructive in this latter respect, since the cinematic close-up is held for an unconventionally long period, far more than is required for the purposes of conveying basic narrative information and for a good deal longer than any other close-up in the film, as well as most close-ups in most narrative films.[39] This duration

FIGURE 6.2 Different forms of local film-world affect converge on the face in Mackenzie's *The Long Good Friday*.

emphasizes the close-up image's artistically expressive intent as tied to a particular cinematic technique. In terms of Bordwell's theory of film narration and viewing, the presence of the close-up and the feelings it generates here are readily perceived as the product of an "artistic motivation" on the part of the film and its maker(s) translating into an "aesthetic perception" on the part of the viewer. The latter provides its own "added" affective contribution to the sequence's experience (that is, in addition to what might be felt apart from it).[40] The viewer is in effect asked to appreciate and contemplate the alternately bemused, frightened, and resigned face of Hoskins/Shand, not *at the expense of* narrative or fictional comprehension and empathy (or antipathy) driven immersion, however, but, also and simultaneously, as a symbolic and artistic construction and intention. Indeed, here as elsewhere in cinema there is a certain creative fusion of expressive modes, possible in perhaps no other art, in which feeling is at once conveyed, heightened, and visually articulated to artistically meaningful ends.

CINEMATIC ENGAGEMENT AND IMMERSION: LOCAL SOURCES

The less literal (i.e., physical) of the two meanings of the word *immersion* pertains to a pronounced mental attention, concentration, or absorption

in relation to an object or event. While immersion in the world of a film is largely mental and virtual, as distinct from physical, it is as "real" for the viewer as many other conscious episodes of perceiving, feeling, imagining, or remembering. Moreover, film viewers may experience actual bodily effects before the screen, as much as entertain cognitive and emotional ones—for example, physical anxiety, warm glows, cold sweats, fright, intense pleasure, anger, disgust, and so forth. For these reasons, among others, while a host of synonymous terms may be used for describing absorptive cinematic experience, *immersion* (with its physical connotations) remains an apt term to capture the experiential sum of the perceptual, imaginative, and affective acts of a viewer "entering" into a film, with the range of (potential) consequences for both mind and body that ensue. As our discussion and the specific examples cited make clear, each local form of affect, but particularly the cognitive-diegetic and sensory-affective, can be seen to correspond to, and be partly responsible for, distinctive forms or aspects of cinematic immersion. Such instances of immersion are, in turn, equally "local," in the present sense of often being relatively temporary in terms of their psychological holds on viewers.

Granted a prominent place in contemporary affect-centered or "sensuous,"[41] film theory, what I have termed sensory-affective engagement involves the viewer's becoming notably absorbed in a film's perceptual and affective experience on a basis that is more immediate and primary than one reliant on any aspect of the fictional-representational and narrative dimension. With the now more or less continuous development of technical virtuosity in special effects and CGI, as well as 3-D viewing, a good portion of contemporary narrative cinema has been given over to (would-be) immersive, sensory spectacle, for which there is clearly a mass appetite. However, and as suggested by Tom Gunning's influential conception of the early "cinema of attractions," as rooted in the creation of a filmic spectacle that privileges "exhibitionism" over "voyeurism" (which puts the viewer in the place of witness to the lives and actions of characters in a contained diegetic space of drama), this is by no means only a contemporary phenomenon, necessarily associated with the latest digital technology or public demand.[42] Yet, and especially for a contemporary audience highly familiar with moving-image experiences of all kinds, such immersion in pure (or purer) spectacle may often be (as one may assume) local and transient in viewer consciousness. For it relies on a more immediate and largely present-tense mode of viewer attention, which is to

some degree in perceptual-cognitive competition with the strong pull of relatively less immediate and more reflective narrative construction, comprehension, and absorption (as also rooted in memory and anticipation), with which it oscillates.

A more specifically representation- or story-directed immersion in films is partly accounted for, and assumed in, the theories of film-viewer emotions discussed earlier and are to be found in numerous semiotic, psychoanalytic and narratological accounts of cinema focused on one or another of its aspects. Such psychological immersion in the fictional world-in a film operates through pronounced imaginative and empathetic or sympathetic relation to aspects of its represented reality, as distinct from explicit attention to the sensory and formal-artistic means by which this reality is constructed and exhibited (or a film's high-order meanings). Such a relationship to a film, bound to acts of imagination as more direct perception, may, like the proposed category of local expression, also appropriately be termed *cognitive-diegetic* (or, depending upon its objects, narrative-fictional) immersion.

In attempting to describe a particular mode of artistic experience that he terms experiencing a work "from within" (which has a strong "aspect of illusion") rather than "from without," R. K. Elliott writes of how a viewer of Pierre Bonnard's *Nude Before a Mirror* (1915) may experience the sight of the woman depicted (in this case the painter's wife) in the way that the painter has. In observing this domestic scene, the viewer may feel something of the painter's expressed tenderness toward his subject, "as if he has assumed not only the artist's visual field but his very glance, and is gazing upon the same world with the same heart and eyes."[43] For Elliot this type of attention, focused on the work's represented scene, entails possibly being simultaneously less focused on formal aspects of the painting as a constructed image (i.e., the "how" as opposed to only the "what" of the representation). Moreover, the feeling conveyed by, or pertaining to, the latter sort of "from without" attention may well be notably different in nature from that provided by an imaginative "from-within" engagement with representation (as founded on "an imaginative extension and modification of what is *actually seen*").

Elliott is right to maintain with respect to painting, among other arts, that while an immersive and emotional experience of this kind—wherein the work ceases to be "an object in the percipient's visual field" and becomes "itself the visual field . . . experienced *as if* the objects were

real" (163)—may occur at any juncture. But given its strongly individual-specific, or subjective, character and variability, it still most often and typically follows the work's own lead. Through its form, style, or genre, a work creates a cognizable stage, space, or "frame" for such an imaginative, and potentially more subjectively "intimate," entrance, identification, and participation with represented realities. In a film such engagement with represented objects and situations may be encouraged through composition and framing (as also in painting), through staging and dialogue (as in live theater), and through all sorts of narrative and plot devices (following the form of literature), as well as through musical and other auditory cues. But further, and unique to cinema, it may be fostered through camera movement and editing, and the particularly cinematic coupling of sound (including music) and image. Like local cinematic expression, such immersion in the represented *world-in* films is also often localized and temporary in nature, as Elliott argues with reference to art and literature in general.[44]

According to the familiar concepts of "aesthetic distance" and objectivity, such imaginative, representation-centered viewing (or reading or listening) amounting to immersion, has been sometimes seen as necessarily antithetical to the proper experience and appreciation of artworks qua artworks.[45] But far from challenging the potential aesthetic relevance of occurrences of highly imaginative and emotional engagement, via such "identification" with a character, object, or situation, the present account of film works and worlds readily acknowledges its contribution. Transposed to cinema, it is in full agreement with Elliott's claim (contra the "objectivist" conception of aesthetic experience and appreciation rooted in "psychic distance") that while "not *sufficient* from the aesthetic point of view,"[46] this sort of highly subjective, imagination-enabled engagement may still be of clear aesthetic and interpretative significance with respect to *some* film worlds, and parts of them, at *some* times. Certainly, many film worlds may encourage such an emotive, cognitive-diegetic pathway to immersion in their alternative reality as part of general artistic designs intended by their makers, even if, in other cases, such experiences on the part of viewers may have little to do with the filmmaker's intentions or what may be reasonably considered the artistic meaning and function of a film. Generally, the fact that viewers can and do become engaged in films in these ways (more or less exclusively) does not preclude other, sometimes equally (if not more) profound, and aesthetically focused, im-

mersive engagements with films and their worlds—ones, that is to say, that move notably beyond the represented world-in as an imaginary reality rather than being confined to it.

Both of these forms of cinematic immersion, sensory-affective and cognitive-diegetic, are important and interesting in their own right, as evidenced by the amount of attention they have received from contemporary film theorists and philosophers of film, as well as cinema historians focused on changing means of film exhibition and projection. Yet our greater concern from the perspective of a full aesthetic account of film worlds is with a more holistic, synthetic, often more persistent—yet still dynamic—immersion in film viewing. Owing to its sources and effects, it may be considered distinctly (or "first-order") artistic and aesthetic in nature. If a cinematic work of art as experienced, coupled with the world it brings into being, is an integrated symbolic and affective *whole*, it must on some level compel the attention and capture the imaginations of viewers as such. And cinematic immersion conceived as nothing less than film-world entry and aesthetic participation, as distinct from primarily perceptual immersion in audiovisual spectacle, or imaginative absorption in a cinematic story-world (or part of it) alone or exclusively, is closely connected to the last type of cinematic affect in our present scheme: global film-world expression, or the created and experienced "world-feeling" of films.

CINEAESTHETIC WORLD-FEELING AND IMMERSION

THE EXPERIENCE OF NARRATIVE FILMS OF MANY KINDS, TOGETHER with our discussion of basic types of film expression and immersion on the "local" scale of a cinematic work, opens the door for recognition of a more global aesthetic affect and immersion characteristic of film worlds. This is a property of the total durational experience of a film that, along with viewer attention, is also attributable to the artistic acts and intentions of filmmakers. As such, this global affective dimension is closely linked to artistic style and authorship as these pertain to the entirety of a cinematic work and its experience.

In seeking to identify and explain this phenomenon of an experiential constellation of film-work elements, we will find it necessary to shift from a predominantly analytic and cognitive approach, broadly speaking, to one that is more phenomenological and, in some senses, at least, "existential." Here we may take our lead from Mikel Dufrenne's detailed descriptions of the "expressed world" of the artwork as an aesthetic object of attention. A number of Dufrenne's central distinctions, categories, and conclusions help us to chart the relation between global film-world expression and viewer immersion, as well as to build further, necessary bridges between the sensory, symbolic (cognitive-semantic), and affective

dimensions of cinematic works and worlds. For reasons that will become clear, an adequate treatment of this topic also involves some consideration of cinematic temporality and rhythm in its various forms and heterodox presence.

CINEMA AND THE PHENOMENOLOGY OF AESTHETIC EXPRESSION

The Phenomenology of Aesthetic Experience (La phénoménologie de l'expérience esthétique) was first published in France in 1953.[1] The prominent philosopher and aesthetician Monroe C. Beardsley called this voluminous study "one of the two most outstanding works in phenomenological aesthetics" (alongside Roman Ingarden's *The Cognition of the Literary Work of Art*).[2] Despite the fact that more than a half-century has now intervened, there has been nothing in this field since to challenge its status as such. Eugene Kaelin points out that Dufrenne's study offers an alternative, in some respects Kantian-inspired, middle path between Merleau-Ponty's primarily perception-centered account of artworks and their experience, on the one hand, and Sartre's locating of the aesthetic in processes of cognitive imagination, on the other.[3] As immediately given in our sense experience *and* requiring acts of imaginative engagement—as well as always entailing a constant negotiation between perception and imagination—the experience of art, for Dufrenne, is defined primarily by a work's expressive and affective dimension. More specifically, it consists of the feelings generated by the nonmaterial worlds of aesthetic objects, which artworks render incarnate and shareable, presenting them to and for our conscious awareness.

Dufrenne draws a primary distinction between the work of art and the "aesthetic object." Whereas the artwork is a physical entity, an "empirical reality in the cultural world," the aesthetic object is the work as and when it is concretely experienced, wherein its full "sensuous" potential is actualized.[4] Through a consciousness-enabled removal from its quotidian perceptual environment, and from physical and measurable time and space, the aesthetic object emerges (from the artwork) as something *in* the world "but not *of* the world."[5] The figurative stage is thus set for the viewer's, reader's, or listener's immersive entrance into this profoundly "intentional reality" (in the phenomenological sense of an appearance existing within and for consciousness), and the different sorts

of perceptual and affective experience that the aesthetic object constitutes and promises. With respect to cinematic experience, this initial perceptual immersion Dufrenne describes may no doubt be aided by the screen size, environmental conditions, and rituals of a movie theater—now and at the time of his writing the ideal viewing situation in most instances. Yet, and as other past and present forms of film exhibition and viewing experience are sufficient to demonstrate—and as also applying to the subsequent, deeper aesthetic immersion to be described—large-screen, theatrical viewing is certainly not necessary for it.

In similarly attempting to reorient the concept of a certain, sui generis "aesthetic attitude," which is sometimes misleadingly portrayed as largely a matter of a detached, objective, and "disinterested" attention, Alan Goldman has written more recently that "when we are . . . fully engaged in appreciating a work, we often have the illusion of entering into another world. We lose ourselves in the aesthetic experience, in the world of the work. This is the truth behind the claim that the aesthetic attitude removes or detaches us from the world of our practical affairs. It is not that *we* are detached from the aesthetic object in appreciating it: very much the reverse is the case."[6] The common view that Goldman here rejects, with reference to the singular, "other" world of a work, is one that is also antithetical to Dufrenne's understanding of an aesthetic apprehension that is (in senses to be explained) "internal" to the aesthetic object and its world, as well as what I wish to argue in relation to the artistic worlds of cinema.

Dufrenne's first distinction between the artwork and aesthetic object, and his emphasis on the viewer's, reader's, or listener's initial and largely perceptual immersion into the nonphysical reality of the latter, is complemented by a crucial second one. Aesthetic objects and their associated worlds compel a more affective and complete immersive engagement because they are fundamentally dualistic. As we saw in chapter 1, in relation to the represented or denoted level of the cognitive contents of a film, this further distinction is one between the "represented" and "expressed" worlds of aesthetic objects. In some ways parallel to our present dichotomy between the *world-in* and *world-of* a film, Dufrenne stresses that along with its symbolic representations of recognizable objects, persons, actions, and so forth, in a representational work there is a constructed space and time within which all of these are situated and may be related coherently. This framework is at once novel and sufficiently

familiar enough to both function as a setting or context for the narrated story or drama and organize its basic perceptual contents (e.g., in any of the "ways of worldmaking" we have considered).

From an aesthetic, as well as a psychological and symbolic (or semiotic) perspective, a work's total representation is a kind of adjunct or extension of ordinary experience and the "real world." When, however, it is merged with the unique, created, and expressed dimension of the aesthetic object, in and through the work's experience as felt, a more complete and rounded, experiential reality is formed. Closely related with the artistic "style" that gives "body" to representation and expression in the aesthetic object, this reality is conceived as its total experienced "world."[7] The beholder (or reader) becomes immersed in this created and presented world not only through identification (and other forms of psychological engagement) with fictional realities, and the rest of what the work contains, but through the actual temporal and affective conditions and structures that govern an artwork's experience and may be seen as characteristic of aesthetic apprehension as such (allowing for certain variations among art forms and media).

Within his general account of aesthetic experience Dufrenne specifically extends the distinction between the represented and expressed dimensions, with all that it entails, to cinema. As was briefly discussed in chapter 1, he maintains that although "the vocation of the cinema that corresponds to its technical possibilities" is to "use all the resources of the image" to create the "illusion" that is its represented world, this is still, as in any art form, only a *means* to an expressive end.[8] In addition to anticipating Mitry's and Pasolini's core arguments (as well as some of Deleuze's) concerning artistic expression in cinema, Dufrenne's position is also in keeping with the aforementioned "functionalist" distinction between (1) what may be powerfully achieved in and by the film medium (or any moving-image media) in accordance with its special properties and capacities (e.g., cinematographic or digitized image ones)—for instance, the perceptual illusion of a three-dimensional space, more lifelike representations, a detailed fictional world—and (2) that which best defines its specifically aesthetic and formal uses, as multiple and variable as these may be. It is also along these lines that Dufrenne maintains that cinema as art "can enlarge our vision without having to deceive us."[9]

By way of only slight digression, and to bring this perspective up to date: just as in video-game creation, with which it is becoming increasing similar, in contemporary mainstream filmmaking computer-aided

processes can now conjure up the images not only of whole cities, landscapes, and armies but of entire historical worlds, dream worlds, alien worlds, and so forth, far more easily than ever before. They may achieve the sort of concentrated representational scope, detail, and multiplicity that prior to cinema was perhaps only to be found in some remarkable paintings and frescoes, such as Albrecht Altdorfer's *The Battle of Alexander at Issus* (1529) and Tiepolo's *Allegory of the Planets and Continents* (1753), and, after cinema's advent, only in the grandest of epics (e.g., *Cabiria, Intolerance, The Ten Commandments*). The fact that in highly popular films like *The Lord of the Rings* trilogy and *Avatar*, for instance, the screen is often full of more represented entities and events (given an added illusionism, in some cases, courtesy of the 3-D format) than can be consciously apprehended and appreciated makes the above distinction, and potential disjunction, between representations and sensory spectacle, on one hand, and expressive and aesthetic depth, on the other, only more salient. By the same token, a lack of any necessary correspondence between the extent and detail of a film's "represented world" and its aesthetic expressiveness (and meaning related to it) only makes the acknowledged artistic achievements of filmmakers who have worked in an "epic" register and format (i.e., widescreen) all that more impressive and valuable. The same holds true for any more creative and artistically significant use of CGI, 3-D technology, and HD picture resolution, since, and as now often commented upon, basic features of these image technologies may work against or overwhelm certain more subtle formal and aesthetic meanings and affects. In general terms it must be remembered that although they of course significantly overlap, cinema's *technical* developments, including the seemingly inevitable progress toward ever more fluid, convincing, and lifelike (in some ways, at least) simulations of direct visual and aural perceptions, is clearly distinct from any aesthetic evolution or development of narrative cinema.[10]

However it may manifest itself in specific works, as a primary goal (or, at least, consequence) of artistic creativity, Dufrenne associates aesthetic expression with an affective depth that, in turn, gives representation a sense of life and immanent necessity. Borrowing directly from Kant, he refers to this as the "inner finality" of the aesthetic object, which is *like* that which a "living being expresses." As fused in its total expressive world, representation and aesthetic affect are insoluble. Artworks manifest "a certain quality which words cannot translate but which communicates

itself in arousing a feeling. This quality proper to the work—to the works of a single creator or to a single style—is a world atmosphere."[11]

Many of the central features of the marriage of expression and immersion that are described in *The Phenomenology of Aesthetic Experience* with recourse to the idea of a singular, expressed "world-atmosphere" of a work (in any form) are, as I will attempt to make clear, particularly pronounced in the experience of a cinematic work and world. As I will explain further, in the case of film-worlds this global atmosphere of feeling of a special kind can be seen as an interrelation and integration of the three sorts of local affects described earlier. But it is also, and more generally, the affective sum total of a film's audiovisual and fictional representation, any number of symbolic-artistic exemplifications, and the dynamic temporal structure of a cinematic work. As one of the most significant and defining world-markers of films, this affect (partly analogous to what Mitry describes as "poetic feeling" in cinema)[12] serves to distinguish one film work and world from another in a profoundly qualitative way.

Some contemporary film theorists and philosophers of film have recognized the need to better account for this sort of global, created affect. With reference to Lynch's *Mulholland Drive*, among other films, Robert Sinnerbrink has argued recently that the overall "mood" that a film conveys, for which he uses the German term *Stimmung*, is generally missing from the affective map of films and their worlds offered by many current theorists who favor analytic and cognitive approaches (for some of the reasons I discussed in the previous chapter).[13] As if in response, Plantinga, one of the theorists in question, has recently proposed a distinction between the "human moods" of characters represented or expressed in a film and the variable "art moods" associated with a film work as a whole or with a part of it.[14] Plantinga's concept of art mood falls short, however, of the total affective whole of a film as an artwork, which includes a pronounced synthesis between it and character mood (or feeling) as tied to diegetic fiction.

While surely a significant part of it, neither "mood" (in these senses) nor "tone"—as when a critic suggests that one or more sequences changes the "entire tone" of a film—are a sufficient description of the affective whole in question, which also exceeds even what "atmosphere" may generally denote. Although this total expression can go under many names and be theorized from a number of different perspectives, it is the existential-phenomenological framework of Dufrenne's account of

aesthetic expression, making use of Kant's understanding of the "organic" unity of the artwork, and also dovetailing with some of the more convincing aspects of Mitry's theory of cinematic expression, that would appear to provide the most fruitful and comprehensive starting point for a general model of this experiential aspect of cinematic works.

GLOBAL FILM-WORLD EXPRESSION

A film has many different affective elements, just as it has many different represented, formal, and artistically exemplified ones. But in the same way that it has one single represented world, comprising all of its specific denotations and implied references and associations, it may be seen to possess a complex and composite but unitary, and aesthetically unified, feeling (or feeling constellation). As Cassirer recognized with respect to every artwork's holistic affect, this structure of feeling resists being identified with any single, readily articulated emotion, since quite often we "cannot subsume it under any traditional psychological class concept."[15] Such global affective presence is undoubtedly reliant and perhaps logically supervenient upon (in the contemporary philosophical sense) some of a film's episodes of local expression, as joined with other aesthetic and symbolic elements.[16] Yet it is not merely an aggregate but an emergent property, in that it does not consist of and cannot be identified with any collection of such individual, expressive features. Far from being confined to a particular feeling or emotion (or idea) conveyed by a given represented object or event, the appearance or action of a character, a musical cue, or a slow panning shot, the aesthetic expression in question belongs to any given film as a whole. For viewers sensitive to its growing presence, it may come to be associated with and to pervade virtually all of a film's literal and fictional representations, yet it "does not belong to them in their own right, since it is not they that bring it about."[17]

Global aesthetic expression is, in other words, strongly *cumulative*, often coming to awareness and increasing in intensity for the viewer as a film progresses—and more and more, in consequence, serving as an affective filter that colors and informs the representational contents of images and the human (or humanlike) dramas they convey. Yet it may also reveal itself at privileged moments, being microcosmically present in something approximating its "final" (i.e., total) work-constituted nature. Thus, for example, something of the particular constellation of feeling

forming the global created affect of Tarkovsky's *Stalker* may be seen as contained *in nuce* in the final, mysterious shot of the Stalker's crippled daughter, with its noumenal intensity and sense of the spiritual in the everyday. Likewise, something of the particular and total tragic-romantic expression of Hitchcock's *Vertigo* is conveyed to us in Scottie's (Jimmy Stewart) surreal anxiety dream.

At the same time, such global aesthetic expression also works as a principle of *synthesis*, integrating distinct and disparate formal and referential elements and expressions: as Dufrenne makes the point, it "changes and yet remains the same, sustaining a kind of organic development which does not change in its essence" (187). Thus, in films that are highly fragmented on the level of representation and story or are marked by numerous and varied local affects and emotion-producing images and sounds (such as Lynch's *Inland Empire*, Shane Carruth's *Upstream Color*, and Paolo Sorrentino's *The Great Beauty*, to cite a few notable, fairly recent examples), this expression may also provide a kind of expressive glue, in the form of a "common quality of feeling" that somehow reconciles contrasting or incongruous spaces, times, and events on an affective plane, as well as disparate tones, moods, and other feeling contents (some of which, if isolated from the whole, would be found to be discordant or in seeming contradiction [187]). As such an integration, the affective unity-in-difference in question is also likely reflected to some degree in the familiar viewer experience of the powerful, indeed sometimes overwhelming, copresence of many "mixed emotions" when a film ends, as forming an affective presence that admits of no single existing name, label, or description.

A brief consideration of Claire Denis's *Trouble Every Day* (fig. 7.1) may help to more concretely illustrate these general, related points. Denis's film has no shortage of visceral shocks and provoked "bodily" sensations and is rife with *sensory-affective* images and sounds: including what is seen to happen to human bodies and their remains within its story of a mysterious syndrome frequently turning sexual desire into fatal orgiastic violence. *Trouble Every Day* also furnishes plenty of opportunity for character- and story-based identifications and engagement, as tied to what I have called *cognitive-diegetic* expression (emotion). Yet, within a still recognizably horror-film framework, featuring the gruesome, graphic violence (or its aftermath) that is now seemingly de rigueur in the genre, these features are, overall, secondary in importance to what the film most powerfully foregrounds in affective and aesthetic terms: a

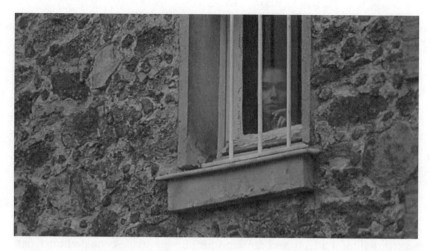

FIGURE 7.1 Cinematic world-feeling as a global, irreducible affective atmosphere in Denis's *Trouble Every Day*.

world-feeling in the form of an overriding mesmeric and uncanny atmosphere that might be described as constituting a mix of dread, fascination, eroticism, revulsion, and aspects of the surreal for which there is (of course) no single adjective, and of an immersion that is concomitant with these. Generally attempting to describe this affective force field of the film, Martine Beugnet, for instance, refers variously to its "pregnant atmosphere of anxiety," its "unusual mix of genres and atmospheres," and its "equivocal, melancholy tone."[18] While the creation of an unsettling atmosphere is a staple of horror films and thrillers, and, as Beugnet suggests, some generic elements surely contribute to such global expression of *Trouble Every Day*, the film conspicuously transcends any generalizable affect associated with standard generic classifications and conventions.

It may seem easier to describe *any* human experiential world in terms of observable, individuated, concrete, and physical-perceptual elements of it, as things that may be actually pointed to, as opposed to what are (in the first instance, at least) highly subjective and nebulous phenomena such as feeling, mood, or tone. So, too, it is natural to try to seek and equate any total affective expression in films with more localized, individually identifiable features of them. These include the objects or causes of discrete episodes of each form of *local* affective expression we have considered, particularly those of the *formal-artistic* sort, whose sources are (most often) readily observable individual formal and stylistic features of films. In

a nonspecifically cinematic context, Dufrenne aptly calls such individuated, affect-producing features of an aesthetic object its many and varied "expressive traits," which may pertain, in his examples, to "particular visual shapes, details of the mode of writing, or melodic themes."[19]

Certainly, in looking for the more specific causes of *Trouble Every Day*'s total expressive atmosphere or world-feeling (beyond its story events and situations in themselves), we may with good reason point to Agnes Godard's impressionistic, often defocused, cinematography; the film's cryptic and laconic dialogue; its oblique and fragmentary framings; the rhythm of the cutting; the accomplished ambient jazz-rock soundtrack (by the band Tindersticks); or the trancelike performances of Vincent Gallo, Beatrice Dalle, and Alex Decas, playing characters seemingly controlled in their actions by impersonal forces (biological, chemical, geopolitical, metaphysical) over which they have (almost) no capacities for resistance.[20] However, as an indecomposable, experiential unity, this strongly holistic expression eludes, almost defies, any definitive list of such contributing factors. Not only is their identification and analysis insufficient to fully account for this affective atmosphere, but, in terms of actual viewer experience, any such attempted causal attributions likely come *after* one has already "discovered" this world-feeling in the private theater of consciousness. In other words, they may well belong to a posteriori critical discourse, as well as being most frequently somewhat pale abstractions from the irreducible, experiential whole.[21]

Explicitly picking up on Dufrenne's general observations and looking at the matter from the filmmaker's, as opposed to the viewer's, position, Mitry argues that this area of cinematic art is squarely in the realm of creative intuition, where there are few if any prior rules and standards for anticipating and calibrating the conveyed temporal and rhythmic feeling of a shot or sequence—or, by extension, of the film in its entirety—given the "many constantly variable factors" involved. It is, rather, and as he continues, a matter of what "feels right" to filmmakers (particularly, in his view, at the editing stage of a film).[22] Through some seemingly magical amalgam of intuition, imagination, artistic intelligence, technical skill, and experience on the part of the filmmaker and his or her collaborators, ultimately in interaction with the viewer's capacities for feeling, which are to some extent anticipated, a global affective atmosphere is realized in many films. Although intangible and not given directly to perception (alone), it is as much an artistic feature possessed by a cinematic work

(and "objective" in this sense) as any other intentional deposit, such as a general theme or the particular symbolic association made by an image. And yet, like the proverbial smoke through a key hole, or a God whose "center is everywhere and circumference is nowhere,"[23] its complex artistic composition and its palpable yet ineffable character means that it eludes any more comprehensive, nonreductive analysis. It thus remains a rationally opaque and elusive *je ne sais quoi* of the most compelling of narrative cinematic works.

As responsible for a good deal of the experienced difference between one film world and every other, the singularity of this aesthetic world-feeling is beyond the uniqueness that every film possesses as a formal and symbolic (referential) construction and as a perceptually distinct and original object or event. For whereas these distinguishing attributes of a work are a matter of observable and cognizable facts and sensory apprehension—even if they often require substantial interpretation and understanding of the "given" data of moving images—global cinematic expression is, as I have already argued, a more directly *felt* than simply perceived or known presence. At the same time, however, just as all created worlds are, in Goodman's sense, *versions*, the singular cinematic world-feeling of any film (including *Trouble Every Day*, for example) may still be felt as *similar to* the total aesthetic expression of any number of other films, plays, novels, paintings, and pieces of music—as well as certain other nonartistic life experiences. Highly variable in terms of strength, depth, interest, and felt originality, in some films (in fact, perhaps the majority) if such global expression exists, it may be largely buried under, or eclipsed by, more temporary and superficial stimulations and local affects and emotions (sometimes in the form of clichés) to the asymptotic point of virtual absence.

As our previous discussions are more than sufficient to indicate, while important to film art in all the ways I have mentioned, I am not at all suggesting, in the manner of some familiar "expression" theories of art, that this global, *cineaesthetic* world-feeling (as it might also be appropriately termed) is the *only*, or always the most significant, aesthetic aspect or feature of a cinematic work-world. As experienced, it is not only copresent but typically in complex interaction with many perceptual and symbolic elements that are capable of bearing aesthetic properties or qualities, including both those that are perceptually given and relational, or imputed (i.e., dependent for their recognition on the making of culturally informed associations). These all have an a priori equal claim to artistic

significance and value. Moreover, such a global expression, as present and recognized, and frequently associated with a director's style (in ways that I will shortly address) is not necessarily artistically profound and valuable in itself. Rather, as I have already mentioned, it is rightly judged, as it is experienced, in the context of other (nonaffective) aspects, meanings, and values of a cinematic work. Thus while the nature and conveyance of such affect is seemingly a highly significant (if less systematic) basis on which a cinematic work may be interpreted, valued, and judged as art (and in critical practice often is, if not, however, under the label of "world-feeling" per se), it is hardly ever the sole one.[24] And although it may be more immediately felt and known than other artistic or aesthetic qualities of a film, like them, and as distinct from narrative and sensory aspects or properties taken in isolation, its depth and affective intensity may dramatically increase the more one sees, understands, and appreciates a film.

REVISITING CINEMATIC TEMPORALITY

Although the global, cineaesthetic world-feeling of many films may elude precise description and analysis, we may still wish to inquire about the general dynamics that characterize this special sort of affect and engagement in relation to significant medial, formal, and temporal properties of films. Its recognition, in other words, invites the question of how it is realized, at least in general terms, together with its connection to viewer immersion, in the strong, world-entering sense explained in the preceding chapter. In following the broad conceptual arc of Dufrenne's phenomenology of aesthetic experience, and its philosophical influences (most notably Kant), these dynamics and relations are predicated on the multifaceted temporality of films, as integral to the achievement of such work-embracing expression. A brief revisiting of the oft-discussed topic of time in films is equally necessitated by the general distinction between the fictional world-in and the artistically informed world-of a cinematic work (as still relevant in this affective context), insofar as each of these has its own associated, temporal axis that is also a prominent part of a film's aesthetic experience.

Narrative fictional films are both the repositories and products of three basic forms of time: (1) *actual* or *physical*, (2) *represented*, and (3) what may be termed, alternatively, *lived, experiential, felt,* or *expressed* time (with all

of these latter designations deemed equivalent in our present context). Whereas the represented time of a narrative film corresponds to the time of the aesthetic object's "represented world" as Dufrenne conceives it, and the world-in a film, as I have described it, the lived and felt time of a film is, in its aesthetic aspect, akin to what Dufrenne refers to as the "expressed time" of the aesthetic object's "expressed world."[25] The interrelations among these distinct forms of time (which, to a more limited extent, have spatial corollaries) are crucial to film worlds as experienced, and the ability to manipulate them successfully is central to artistic filmmaking.[26]

To briefly elaborate on this classification: the actual time of a film is the (externally) measurable clock time of its unfolding, as determined by the length of the reels containing the projected film or the information storage equivalent in the case of films created or projected digitally. By custom dating back to early theatrical exhibition practice, this time most often consists of around one and a half to two hours for the narrative feature film. As in a novel or play, represented time, in contrast, is that time directly or indirectly indicated by a film's fictional narrative and action, and it includes, principally, the chronology of represented events. In our present terms it is the timeline of the fictional world-in, regardless of the many ways it may be creatively manipulated and thus shown to differ from the strict and irrevocable linearity of temporal consciousness in our real (or, at least, our waking) lives.

If actual running time is thoroughly objective (as belonging to the causal order of nature or, at least, our means of measuring it), represented story time is perhaps best regarded as a kind of copy or imitation of it. At a minimum it is faithful enough to undergird the actions of characters and allow for the progressive development of action and story. As is true of a play or a novel, story time is reliant on the viewer's cognitive awareness and construction and is actualized only in and through a recognition of the temporal markers and durations that are portrayed: sometimes quite explicitly (in accordance with certain cinematic conventions and narrative designs) but sometimes only implicitly or with purposive vagueness. In some cases viewers may not fully grasp a film work's represented time on a first, second, or even third viewing, owing to its complexity or ambiguity, whereas in other cases this dimension is foregrounded to the degree that story and actual running time clearly coincide. In all instances, however, and no matter how roughly specified, this basic form of cinematic time, as common to all fictional narratives, is still fixed, the same for all

viewers who comprehend it, in the created, finished form of a work. (The total represented duration of the fictional events of *La notte*, *High Noon*, and *Do the Right Thing*, for instance, is always approximately twenty-four hours.)

Yet beyond the objective (running) time of every film, and the semi- (or quasi-)objective represented, fictional time that belongs in essence to all narrative forms, there is also a distinctive experientially grounded duration attached to cinematic works. Apart from its 119 minutes from opening image to closing credits, or the many decades of the late nineteenth century and early twentieth that its story spans, *Citizen Kane* possesses a *felt time*, which may vary from viewer to viewer, and from one experience of it to the next, but that in spite of this variability is identifiable with Welles's film. This third basic form of cinematic temporality owes much to the distinctively human, psychological form or mode of time that is not measured or quantified in any way. It is, rather, a qualitative succession that is simply "lived," as described famously by such thinkers as Henri Bergson, Edmund Husserl, Eugène Minkowski,[27] and, more recently, in relation to cinema, by Deleuze (who draws on Bergson's concept of *durée* in explicating it). In a narrative film, however, such unmeasured temporality is clearly never entirely independent of either of the other time dimensions described, both of which contribute substantially to its realization.

Although a part or dimension of a film world as consciously created, often with very deliberate, artistic aims in mind, like global cineaesthetic feeling, the lived—or, perhaps even better, "living"—duration of a cinematic work exists only insofar as it is actually felt by viewers. Descriptions of the phenomenon, including this one, merely succeed in gesturing in its direction. Just as all cinema involves (and requires) a concentration and distillation of ordinary, chronometric time on a representational level, like music it is also an experiential concentration of lived, affective time, introducing a level of palpable expression into a film world. Yet even if internal to the psyche—and subjective, by definition, in contrast to cinema's "objective" pole of basic and iconic representation—there can be, and often is, substantial transsubjective agreement among viewers, critics, and theorists about its primary qualities in a given work—such as, for instance, the felt lassitude of *L'avventura*, the breathless rush of *Touch of Evil*, the heavy and circular stasis of *Werckmeister Harmonies*. Additionally, there may be recognition and relative consensus concerning how aspects

of this work-created temporality are related to the whole range of a film's literal and figurative representations, themes, and meanings.

The triad of forms of time in or of a cinematic work may be thought of as three concentric circles. Their arrangement, however, in terms of which is figuratively contained within which (as one way to attempt to describe the empirical reality of the situation), differs according to the two most basic perspectives from which a film (or any artwork) can be described. From an external perspective, apart from one's actual perceptual and imaginative engagement and immersion, the running time of a film is the outermost circle. It contains represented (story) time and affective time, both of which begin and end with the film-viewing event (except, of course, to the extent they may be preserved in memory). In first-person experiential and affective terms, in contrast, this relation may be reversed. It is the expressed, lived time of a film world that often *seems* to contain both represented time and objective, clock time within its affective field, taking priority in our conscious awareness over each. Thus we may, for instance, glance at our watches during a film's screening precisely in order to check the extent of the discrepancy between our impression of its felt time and the actual number of minutes that have elapsed. Or, we may find it difficult to believe that two films whose felt time has diverged so sharply are actually the same length; or, again, we may remark on how so many fictional actions and events could have been packed into approximately those two hours, which have seemed to our conscious attention so much shorter or longer. (These familiar phenomena are clearly distinct from imagination-assisted story time, which may be minutes, days, or millennia.) Such experiential realities inform the creative pacing of films, as a major concern of directors and editors, and much creative (as opposed to merely functional) film editing hinges on how differences measured in seconds may radically alter the perceptual and affective experience and meaning of a shot or sequence. All of these considerations point to the existence of felt cinematic duration, which like any other inherent feature of cinema may be employed in variously creative and artistic ways. They also speak to how the differences and tensions between the immutable and inexorable actual (clock) time of a cinematic work as a created and physically bounded object, and its duration as experienced, in the perpetual present tense of its unfolding, may be crucial to its aesthetic experience.

Given these basic forms of time, there are also three distinct sets of recurrent relations among them. Actual work time and represented story

FIGURE 7.2 Actual and represented time self-reflexively in sync in the opening of Welles's *Touch of Evil.*

time may converge and diverge in a great many ways, as, for example, in the case of entire films, or sequences, presented in so-called real time. In some film worlds this relation takes the form of a significant artistic exemplification in itself. In the celebrated long-take, moving-camera sequence that opens *Touch of Evil*, a bravura foregrounding of the relation between diegetic, or *world-in*, time and actual cinematic (*world-of*) time is achieved in and through a dramatic action (and subsequent plot point). In a close-up image a timer affixed to a bomb (about to be attached to a car) is held before the camera and set before the viewer's eyes to three and a half minutes (fig. 7.2). This image serves not only to anticipate the amount of time until the imminent explosion but (simultaneously) to highlight the duration of the remarkable crane shot that leads up to it, with the explosion appearing to "trigger" the film's first edited transition.

The relation between represented and felt time may be an equally complex and aesthetically significant temporal interaction within film worlds. It may involve, for instance, the relative divergence or continuity (but always potential difference) between one or more *character's* temporal experience of represented events and the viewer's perceptual apprehension of their duration. In Resnais's *Last Year at Marienbad* and *Muriel* this conjunction is exemplified through complex point-of-view and flashback constructions (auditory as well as visual), which create a pronounced interaction between a character's and viewer's "time consciousness" (in Husserl's phrase). However it is articulated, cinematic art allows for the

lived time of the viewer's experience of a film world to be brought into analogical relation (more or less direct) with the experience of time on the part of characters, as it is represented and expressed. It is thus one (if only one) prominent route of aesthetic immersion by way of the represented and fictional world-in a work, which some films open up to their audiences via processes of perceptual and imaginative identifications with represented characters and situations.

With these relations between forms of cinematic time in mind, but to now return to the total expressed world-feeling of a cinematic work, as our primary concern, the latter is closely allied to a film's "lived" or felt time as here described. *Both* constitute an experiential, qualitative "unity-in-multiplicity," to borrow Dufrenne's characterization of the affective "world atmosphere" of the aesthetic object,[28] which intentionally recalls Bergson's classic description of the nature of lived time, or *durée*. Dufrenne is correct to emphasize, however, that such a global affective property of an artwork (as an aesthetic object), as a presence that grows or builds in consciousness, is not simply *like* lived, temporal duration but is conveyed *in* and *through* it: "it is above all time, in its pre-objective form, which the aesthetic object manifests in its expression."[29] In cinema, as in many arts, one of the major created and experiential links between lived time and this total affective expression is rhythm, always comprising, as Mitry observes, "relationships of intensity contained within relationships of duration."[30]

RHYTHM, LIVED TIME, AND AESTHETIC AFFECT

People tend to think that my preoccupation is with the simple plastic effects of the cinema. But to me they all come out of an *interior rhythm*, which is like the shape of music or the shape of poetry.
—Orson Welles

At its most fundamental level, rhythm is the perceived or felt order and pattern of a succession of discrete sense impressions, most often characterized by repetition and separated by intervals of varying lengths. But as Mitry, who writes at length and with acute perception on rhythm in cinema, maintains, it is also a matter of "time evolving in a succession of alternating and interrelated durations" amounting to an "effective distinction between contrasting times."[31] In this sense (at least) rhythm opposes

itself to clock time, precisely because the latter either has no rhythm or, amounting to much the same thing, its pattern never varies, bespeaking of mechanism in contrast to that which is organic and living.

The phenomenon of losing oneself in music, in a beat, is often viewed, perhaps rightly, as the paradigm case of immersive, absorptive experience. But this is by no means the only sort of affective and psychological immersion associated with the rhythmic character of a great many activities. A hallmark of being absorbed in a thought, a book, a conversation, or a daydream is the familiar sense of losing track of objective time. We find ourselves transported away from the homogeneous progression of seconds, minutes, and hours, and the many worlds of practical action that our temporal measuring devices both structure and prompt, to some more natural or aboriginal temporal condition, with another sort of unifying principle. Here we join with the affective rhythms of human actions and naturally occurring events, our sensory awareness of which opens up other cognitive, imaginative, and emotional spaces than those we may regularly inhabit. Of course, not all such common experiences of rhythmic transport are aesthetic, occurring in relation to art. Yet as part and parcel of the experience of artworks and their worlds—and especially, perhaps, cinematic ones—such dynamics of rhythmic immersion work in an often more powerful, concentrated, and dramatic way. In the case of a cinematic work, lived time and affective rhythm help to provide for immersive engagement on the part of the film viewer, but, in a double movement, these are also its symptoms and consequences.

These and similar considerations lead Dufrenne to argue that rhythm is not only one formal or structural property of artworks (as aesthetic objects) among others; rather, as tied to lived time, expressive rhythm is concomitant with the aesthetic object as apprehended. Like the work's total affective expression, rhythm, as the "movement that animates" representations, is conceived as permeating every other aspect or element of the work. Rhythm not only contributes to an artwork's world in the affective dimension; it "espouses and expresses the very being of it" as an aesthetic object that compels our attention.[32] These dynamics may be held to apply to our encounters in consciousness with physically static works like paintings and sculptures, as well as to drama, film, and, of course, music. Yet clearly, films, like musical works, not only seem but actually do (physically) extend and change in time; thus, they possess intrinsic rhythmic properties (visual, verbal, musical) that are powerfully copresent with felt

and figuratively represented ones. In addition to its (potential) aesthetic nature and value in narrative cinema, it is also not difficult to see how the prevalence, density, and plurality of different interlocking forms of rhythm, and the resulting affective heterogeneity, all contribute to the lived time of films, as well as to a deep affinity between cinema and non-cinematic or everyday perceptual and imaginative experience.

Rhythm is manifested in a bewildering variety of ways in films, and in relation to its incorporation cinema fully deserves the title of *Gesamt-kunstwerk*, or total art form. Burch argues that given its all-embracing and multifaceted nature—marked by an "enormous complexity" far exceeding that found in music—together with the interpenetration of space and time in cinema, a film's rhythm might just as well be termed its "cinematic structure" and vice versa.[33] Moreover, if narrative and non-narrative films alike have a single, shared artistic "secret," it is likely a rhythmic one. This, at least, is the view of numerous theorists, critics, and filmmakers. Merleau-Ponty, for instance, has associated the specifically artistic use of cinema with the articulation of "a particular overall cine-matographic rhythm," born of shot choice, order, and duration, and Mitry has pointed to an "organization of time, i.e., a *rhythm* that becomes apparent only at the moment the film begins to fulfill its aesthetic function."[34] So, also, many filmmakers—including some of the most prominent and perceptive writers and theorists among them (e.g., Eisenstein, Vertov [in relation to his theory of "intervals"], Pudovkin, Bresson, Godard, Straub, Kluge, and Tarkovsky)—have written and spoken of the rhythmic essence of cinema as an art form. Moreover, in some cases they have stressed the profound relation between a film's rhythm(s) and features of its affective dimension and the created worlds of films, specifically.

Memorably describing filmmaking as "sculpting in time," Tarkovsky posits rhythm, and what he calls "time pressures" internal to shots or sequences, as the source of an expressive depth in films residing beneath their perceptual surface.[35] He largely ascribes the root source of the affective, cinematic rhythm of a film to that which is internal to the image and which results from the "natural" movement and duration of the objects and actions filmed (including human bodies and wider natural phenomena such as wind, rain, flowing water, and fire, with which his own films are replete). Here, such natural motion and duration is both supported and channeled but also transformed by the movement of the camera, for example, as distinct from movement imposed on the image-event from without by sequencing and editing. Nonetheless, since Tarkovsky sees

editing as following the lead of this "internal" expressive movement as grasped and transmitted more or less intact by filmmakers, he argues that "you will always recognize the editing of Bergman, Bresson, Kurosawa or Antonioni; none of them could be ever confused with anyone else, because each one's perception of time . . . is always the same."[36] Aside from this last point (to which we will return) Deleuze, citing Tarkovsky's *Sculpting in Time* as a precedent, also places a great deal of stress on affective figurations born of the relation between the living body within the frame and the presentation of lived time around its actions and postures, as found (according to his well-known theory) in the postclassical, "time-image" films of Godard and Ackerman, Cassavetes and Philippe Garrel, among others.[37]

It seems quite clear, however, that as a general rule in-frame movement (attached to filmed objects, whatever they may be) provides for only a restricted concept of filmmaker-constructed, and aesthetically actualized and powerful, rhythm in cinema and its relation to affect. Not least, since its presentation transcends the "classical" film theory opposition between montage editing and the long-take sequence shot (as Deleuze also acknowledges).[38] Many other factors contribute to the rhythms achieved by and through the multiple temporalities of a film world, including the durational and affective consequences of editing and of graphic rhythms generated by light, color, shadow, and visual depth (or its lack); in addition, of course, there are the rhythmic properties of the soundtrack, not only music but sound effects and the often distinctive speech patterns of actors. Encompassing all of these, Eisenstein describes the total formal rhythm of a film as a matter of a "synthesis of two counterpoints—the spatial counterpoint of graphic art, and the temporal counterpoint of music."[39] In line with the broad distinction I suggested earlier between rhythmic "lived" (felt) time and a "rhythmless" clock time, he also contrasts the dynamic and irregular rhythm of both life processes and great art with that of lifeless and mechanical "metrics."[40] Taking it almost for granted that every would-be artistic film must possess its own unique "rhythmic formula," the Russian theorist-director claims that "it is quite obvious that the same sequence of movements, with the addition of different combinations of duration, will produce quite different expressive effects."[41]

In the early 1980s Godard gave a number of provocative interviews coinciding with the release of his *Sauve qui peut*, the English title of which, and the director's preferred one—*Slow Motion*—indicates the technique

that he turns to in order to explore the relation between rhythm, represented story time, and a more purely affective time, by manipulating the standard twenty-four-frames-per-second speed of films as shot and projected. Without citing Eisenstein directly, he echoes the Soviet pioneer, critiquing what he regards as the overly regular metrical dynamics of most cinema as lifeless and lacking dialectical energy. Commensurate with Cassirer's insight that affect in art is as much a matter of "motion" as "emotion,"[42] for Godard "different speeds" captured in a film necessarily bring with them different artistic moods and tones, in a constant affective flux.[43] Like Dufrenne, Godard associates felt rhythms not only with the experiential depth of a film ("through rhythms movies represent so-called life") but, correspondingly, with the gateway to distinctive artistic "worlds," and the affective qualities of them, which both result from and effect a transformation and animation of the profilmic. Rhythm, he maintains, endows that which a film represents with a new significance, one that is a matter of what the filmmaker more thoroughly creates rather than finds or simply allows the camera to record. He notes that in much contemporary filmmaking "rhythms have stayed the same but I think that there are infinite worlds. Movies do not 'land' on them. This is what is difficult and what interests me . . . because when one stops the image in a movement, one perceives a change. . . . One perceives a whole lot of other worlds."[44]

Both Godard's and Eisenstein's observations dovetail with Tarkovsky's claim that through a unified structure of "varying rhythmic pressures," one that is felt as well as visually or aurally perceived, a film may achieve an expressive depth that is characteristic of great art in many forms and media. With specific reference to the singular worlds of films and their makers, Tarkovsky argues that "it is above all through a sense of time, through rhythm, that the director reveals his individuality." Indeed, he conceives his own primary aesthetic task as trying to create his own unique "flow of time" and convey such temporal succession.[45] While both created and, in a sense, discovered in the course of a film's making, for Tarkovsky as well as for Eisenstein (and Welles, as quoted above), such total affective rhythm in its artistic manifestation cannot be imposed on a film's form via wholly external principles, preestablished conventions, or any technical means alone. Rather, it is a viewer-enabled, relational and "organic" property of a cinematic work as presented in its entirety and resulting from a filmmaker's often highly intuitive creative actions and intentions.

INTERNAL TEMPORALITY AND SUBJECTIVITY
IN THE FILM-WORLD EXPERIENCE

Dufrenne's phenomenology of aesthetic experience helps provide some further theoretical underpinning to all of these overlapping insights on the part of critics, theorists, and some of the greatest filmmakers concerning the interrelations among time, rhythm, and a successful or genuine artistic expression that emanates from the "interiority" of a cinematic work and its singular "world." The expression in question may, moreover, be credited with providing the recognized existence and experience of such a world (as a world) in the first place. In Dufrenne's phenomenological model the rhythmic movement of all aesthetic objects, but particularly temporal ones, joins with the movement of the viewer's combined perception and feeling of it, since "the duration of the aesthetic object can be perceived only if it is integrated into our own duration."[46] Given that the aesthetic object possesses an "expressed" (affective) time and space *of its own*, the linking up of these temporal streams has important consequences.

As we have just seen, in Tarkovsky's account, in the experience of a film the filmmaker's own expressed (sense of) time joins with, and becomes part of, the viewer's lived and felt duration. The filmmaker's subjectivity thus meets and engages with that of the viewer, as mediated (as it must be) by the work. Tarkovsky portrays this "global" interaction as an immersive "world dialogue," as it were, of a special, affective and aesthetic kind: "the person watching either falls into your rhythm (your world), and becomes your ally, or else he does not, in which case no contact is made. And so some people become your 'own,' and others remain strangers."[47] In Dufrenne's version of this suggested dynamic the realization of the artwork's expression, and "world," in the viewer's consciousness (as a durational phenomenon) is tied to the fact that time is "spatialized" and space "temporalized" in the aesthetic object.[48] In addition to serving as a fit description of the experience and systematization of rhythm in general—as a primarily temporal phenomenon that is perceived and measured spatially—this claim of Dufrenne's has special relevance to cinema, an art in which space and time profoundly unite and interpenetrate, and no more so than in the conjunction of cinematography and editing. Indeed, the French philosopher's formulation is almost identical with Panofsky's earlier observation (one fully in keeping with the direct and

pronounced influence of Cassirer's Kantianism on Panofsky's thought) that the greatest, and distinctly artistic, "possibilities" of films lie in their "*dynamization* of space, and, accordingly, *spatialization* of time."[49] French theorist Edgar Morin also argues along similar lines.[50]

In Dufrenne's phenomenology of art, such intimate interrelation of time and space (time spatialized, space temporalized) is seen to give the artwork, as experienced, the character of a "quasi-subject." Adapting certain of Kant's arguments in *The Critique of Pure Reason* in the pursuit of what might be best described as a philosophical metaphor for aesthetic experience, Dufrenne sees this dynamic as akin to the experiential field of consciousness itself. Whereas space is given a temporal dimension through a cognitive subject's successive perceptions of it (as something that persists), time is endowed with a spatial (i.e., external and empirical) presence, as that which is common to all observable changes and may be measured through standard movements.

Succinctly, lived time is a form of Kantian "inner sense" that is located (if that is the right word) in the *nonspatial interiority* of the conscious mind.[51] It is only a sense of time that provides for a unified *I*, and that sense of self to which the *I* is thereby related, as a persistent register of experiences, at any given moment of conscious awareness. Space, in contrast, as the a priori form of "outer sense," is divorced from the self and is the ground for the determination of an objective reality. However, given the suggested "phenomenological solidarity of time and space,"[52] each implies the existence of the other: time gives us a self, and space gives us a world. And just as a self implies a world and a world a self (as Merleau-Ponty also stresses), lived time implies space and space lived time. Not only do time and space interpenetrate in conscious experience, but this interpenetration *is* conscious experience, in the sense of allowing for its possibility and content.[53] In this way space, as composed of and composing the external objects of consciousness, is animated by experiential time and is literally put into an internal, mental kind of movement.

Now, the aesthetic relevance of this fundamental dynamic lies in the way it is mirrored in an artwork as experienced: *its* objective, spatial, "represented world" is metaphorically akin to the external reality that our outer senses help the mind to construct. In contrast, the "expressed world"—that is, world-feeling or "atmosphere"—of the aesthetic object as conveyed through lived time is, for Dufrenne, like the "inner" time sense of consciousness serving to establish the self-identity of the subject.

Just as in our actual, first-person experience, however—where the self possesses both a represented external reality and an internal, strongly affective, but largely inarticulate one—so, too, within the *aesthetic object* are the represented and expressed held in reciprocal, mutually determining relations.

Dufrenne, who has been followed here by some contemporary phenomenological theorists of film, regards this kinship as a justification for conceiving the artwork (as experienced) as a "quasi-subject" with a kind of animate "interiority," provided by the interdependent relationships between representation and expression, time and space.[54] In other words, a work is "related" *to itself*, as something like a conscious subject's relation to the *I* that changes in time yet remains experientially unified. Like consciousness, the aesthetic object is simultaneously "a relation to the self and a relation to a world," which, since the self coconstitutes a world, is also a self-relation.[55] Thus, and finally, the crux of this layered argument is that the relation between the spatiotemporal and experiential structure of consciousness, on the one hand, and of the aesthetic object, on the other, is not *only* a formal or structural *analogy*, since the aesthetic object itself is actualized in the beholder's consciousness (in which it is contained). We, as a cinematic work's viewers, may thus be seen to fulfill the work's expression through feeling it in time, whereby our subjective temporal field (or inner "world") joins with *its* "inner" expressed world.

Of more significance in this context than the ersatz characterization of an aesthetic object as a quasi subject—today the most frequently cited idea of Dufrenne's *Phenomenology*—is, I wish to claim, the fundamental triadic relation it identifies—that is, the relation structure of a work's felt duration, its qualitative affectivity as experienced, and the lived time of the beholder, which together form a dynamic but persisting unity. This unity may be seen as the bedrock of global *cineaesthetic* expression (cinematic world-feeling), as well as immersion.

Dufrenne's argument has a clear ring of aesthetic idealism. Crucially, however, what chiefly prevents this dynamic of expression from collapsing into a solipsistic relation between the self and the self—in which the objective presence and experienced alterity of *the work*, as a created and intended object, is lost in the form of its mental apprehension—is that the affective expression actualized in aesthetic experience is the expression not of a *quasi* subject but of an *actual* subject: namely, the artist, who is not somehow left out of account but is felt (and known) to be present

by "proxy" in his or her created world. Indeed, the unity of the aesthetic object's affective dimension in this view springs from the unity of a *Welt-anschauung*, a "way of being in the world which reveals itself in a personality," that is, the personality of the artist.[56] This holds insofar, it must be added, that the personality in question is in fact seen to be expressed by the *work specifically*, and withstanding any other public or private manifestation of it.

If, following Dufrenne, and as both Pasolini and Mitry also contend, the artistic filmmaker endows the communicative symbolic structure of a narrative film with a singular aesthetic expression as a result of his or her creative vision and stylistic choices—resulting in a "formal" *interpretation* of both a specific (represented) subject and of "reality" through this subject's cinematic treatment—then at least part of this effort can be seen to eventuate in the global affective expression of a film. In other words, it is manifested as a unified and unifying feeling of a film in which the filmmaker as creator is in a genuine (if not actual) sense "present." Such a cinematic version of authorial presence may be seen as one major experiential (or "phenomenological") reality underlying the common practice of associating or identifying the affective expression of an artwork and its created "world" with the biographical artist: for example, in references to the expressed, and expressive, worlds of Goya and Hopper, Mozart and Coltrane, Renoir and Bergman,[57] and the characteristic "feeling" of each. As a corollary of the association of the aesthetic object's "internal" expression with something of the inner life of an individual (the artist) as *externalized* and *objectified* in artistic form, Dufrenne suggestively regards the nonspatial, nonlocalized, rhythmic "interiority" of a work as akin to its individual "soul" (or *animus* in Latin, referring to both life and self-movement). Constituting its expressed "world-atmosphere" of feeling, this is implicitly contrasted with the representational dimension of the aesthetic object alone (as its "body").[58]

GLOBAL CINEAESTHETIC EXPRESSION (WORLD-FEELING), STYLE, AND FILM-WORLD CREATORS

A personal artistic style, in the view I have been explicating, is the intangible force that fuses artistically formed representation and expression in the full unity of a known and felt world—a world that, in this case, is an object-experience with a particular internal (affective) coherence that is intuited by the viewer as the film unfolds in lived, rhythmic time. As

was the case with Goodman's theory of style and artistic worlds rooted in symbolic-artistic reference (e.g., exemplification), it is beyond the scope of this chapter (and book) to defend this expression and creator-centered concept of style in toto. Yet Dufrenne is far from alone in making a connection between (1) a total, singular artistic expression or affect emanating from the experienced spatiotemporal "interior" of an artwork, including a film, and (2) the artist or, here, artistic filmmaker as its cause or source. Nor is he alone in using the particular terms that he does to describe this expression—namely, *world, worldview, soul, interiority, personality.*

In fact, the linking of style with all that which is sometimes referred to as a singular personal vision or outlook (as manifested through artistic expression and stylization) has a clear affinity with some prominent articulations of auteurist film theory and criticism and other creator-focused conceptions of cinematic art. Mitry holds that "for the filmmaker, inasmuch as his work is the manifest expression of his thoughts, his subjectivity, his way of seeing or feeling, the film becomes a means of perpetuating (or at least of fixing for his own consciousness) a unique moment of his self."[59] Carroll argues more soberly that by way of "personality," which he describes as an individual's "ways of being" translating into a "view of the world," there is a "deep connection" between the idea of an artistic style and of a work's affective expression. He further maintains that recognition and exploration of this tripartite conjunction (of style, expression, and personality) is the particular "theoretical strength" of auteurist approaches to cinematic art.[60]

Ideas such as these are also at the core of Andrew Sarris's highly influential "Notes on Auteur Theory in 1962," which defended and attempted to systematize the French *politiques des auteurs* developed earlier in the pages of *Cahiers du cinéma.* Sarris offers three basic and closely interrelated "premises" of a cogent auteurism, corresponding to three different "levels" of a film. The first premise pertains to "technique," that is, that a genuine cinematic auteur is a "technically competent" director. The second premise pertains to "style"; that is, a director is a genuine auteur if his or her body of work exhibits shared, significant, and identifiable features. These serve as a creative "signature" that, in turn, allows for the "distinguishable personality of a director," as reflected in his or her films, to be held up as a "criterion of value."[61]

However, it is Sarris's third and "ultimate premise" concerning artistic expression in cinema, as also closely connected to and underpinning an individual style and an expressed personality, that is still more directly

related to the approach and views we have been examining. In a substantial addition on his part to *Cahiers'* auteur criticism, such expression is seen as inseparably wedded to what he calls a film's "*interior* meaning" as the "ultimate glory of cinema as art." Sarris argues circumspectly (with some good cause) that this "meaning" is "not quite the vision of the world a director projects nor quite his attitude towards life," however much these may play a part in it. Rather, concerning this "ambiguous" and unique significance, which in the creation of a film comes to be "imbedded in the stuff of cinema," and directly along the lines of Dufrenne's conception of the expressed world of aesthetic objects, he writes: "Dare I come out and say that what I think it to be is an *élan* of the soul? Lest I seem unduly mystical, let me hasten to add that all I mean by 'soul' is that intangible difference between one personality and another."[62] For Bordwell, critically appraising Sarris's views, "interior meaning" is "best understood as an expressive quality that arises from differences we can recognize among directorial personalities. And while this expressive quality may pervade an entire work, as nostalgic melancholy suffuses Ophüls's films, it is just as likely to show up in privileged moments."[63]

I take Sarris to be suggesting that what "shows up" in particular moments may be a recognition, more pronounced, of what does often "pervade" a film work as a whole (at least an artistically good or great one)—that is, global cineaesthetic expression or world-feeling. Yet, as I have mentioned, it may come to the fore with varying degrees of affective and cognitive intensity and viewer awareness during its experience. Moreover like Dufrenne, in terms of all aesthetic objects, and Tarkovsky, with reference to the expressed personality and "world" of the filmmaker (encompassing his or her "innate perception of life")[64] as this is reflected in a singular rhythmic duration and its affect, Sarris also associates this irreducible, felt as much as perceived, difference between one film and filmmaker and another with rhythm. (Writing with reference to Renoir's *La règle du jeu*, he suggests, for instance, that it is sometimes "expressed by no more than a beat's hesitation in the rhythm of a film.")[65]

This experiential and expressive account of artistic style in cinema, forwarded in notably overlapping terms by Sarris and Tarkovsky (as if following Dufrenne's broader thesis), should be seen to supplement rather than to contradict the more perception-based, affectively detached, and analytic account of artistic style featured in Goodman's theory of world-making. The same may be said with respect to other equally "impersonal"

and deromanticized ("expression free," one might say) conceptions of cinematic authorship, including, for instance, Peter Wollen's influential structuralist account of the "author-function" in cinema.[66] Of course, to the extent that cinematic authorship (and style) is seen as problematized by the collaborative nature of filmmaking and by the significance of films clearly exceeding any implantation of actual intentions on the part of the director, as well as what might be taken as a "worldview" expressed in it, it is the latter, impersonal or "objective," notion of style that may seem especially apt in relation to cinematic worlds. Nonetheless, such approaches are clearly deficient in phenomenological and affective terms, with respect to their inability to account for the inherently and defiantly "personal" dimension of so many great film works and their worlds, not only as intellectually recognized and critically discussed but also as profoundly felt.

Indeed, even in the face of all attempts to sever the individual consciousness and actions of its principal maker from the work created, an affective expression on the part of the film director clings to the specially constructed world of a film. And it is notoriously difficult to shake off while still doing justice to a cinematic work's artistic accomplishments. Nor does the cinematic version of the so-called death of the author sit well with attempts, such as the present one, to theorize films as singular, unified, cognitive-affective, and artistic wholes. The fact that some or many film and other moving-image entertainments may be regarded, without loss, as collaborative productions in which there is little or no pronounced aesthetic expression and affect (or, for that matter, stylistic innovation and extranarrative significance) that is readily associable with a particular filmmaker is insufficient to support the thesis that cinema *as an art form* is characterized by a relative lack of personal authorship. Nor does it support the view that narrative films lack what such authorship may entail with respect to the feeling dimension of a cinematic work as analogous, in some respects, to that of a poem, symphony, or even architectural work (e.g. Gaudi's highly expressive buildings).

The unique, irreducible expression of a cinematic work-world appears to be not only analogous to an individual personality, as likewise functioning as a complex but irreducible constellation of features, but *is* one formal-expressive instantiation of the artist's at least *creative* personality or self (to be distinguished from the empirical or biographical one). A singular film world bears the marks, however indirectly (or by "proxy"), of an

equally unique, individual perspective and intentionality. In other words, it is a more or less direct reflection of that actual human agent who makes hundreds, if not thousands, of interrelated decisions in the making of a film, all of which may somehow contribute to its artistic features, affective and otherwise, and its significance. If a film director is aptly defined as "one who is asked questions," as Truffaut's voice-over in *Day for Night* suggests, then perhaps not all, but surely much, of a finished film work and its world, as presented and experienced, is the result of the "answers" given. In more general terms, Bordwell asks the appropriate rhetorical question: "who is to deny that a director's habitual ways of orchestrating the diverse materials of the medium do not reflect something of the director's personality?"[67] Similarly, in a robust defense of the view that artworks (and not just people) may be properly said to express feelings, attitudes, and moods, which also argues for a strong link between expression and intentionality, Guy Sircello points to what he terms the actual "artistic acts" of creators as these are concretely manifested by works. These artistic acts ensure that at least some of what a work expresses is properly attributable *both* to the work (as a perceptual object) and to the artist, via how, exactly, a particular painter *paints*, a certain poet *treats* a given subject, a novelist *portrays* a character, and so on, with the expression in question coming as the direct result of these activities. It is to be understood, however, that the acts in question are "not identifiable or describable independently of the works 'in' which they are done."[68]

Although the problems surrounding the relation of artistic style and expression to such a fairly robust conception of authorship are complex, the general position advocated here (as transferred in its application to filmmaking) is indicated by philosopher Peter Lamarque, who writes, "If style is thought of as *a way of doing something*, rather than merely as a set of formal features, then it seems to be closely related to the expression of personality."[69] Such a (tentative) conclusion is no more surprising, or implausible, than our commonly held belief that a great many of our real-life decisions, actions, and projects are external and public manifestations, reflections, or symbols of aspects of the entire person whose decisions, actions, or projects they are. These, it should be added, almost always possess an affective character. In fact, from certain perspectives in psychological theory there is no clear distinction to be made: a personality consists in *just* those recurrent traits, attitudes, and dispositions of an individual that somehow find public expression and communication—of which art, including narrative film art, is one substantial form.

Defending single authorship in cinema against a number of philosophical objections to it, Paisley Livingston argues that film directors, like authors or creators of any artworks, have, first, *expressive intentions* and, second, control over *the whole* of a work. These are, in fact, his two proposed criteria for artistic authorship in any form or medium.[70] Aptly fulfilling these criteria, global cineaesthetic expression (or world-feeling), as precisely encompassing the whole of a film work in all the ways discussed here, may also be seen as largely the product of filmmakers' intentions (whether these are direct and conscious, or indirect or "second-order"), no less so than its multilayered representations and chosen world-making strategies, together with the specific formal structures chosen to exhibit and convey them. Mitry remarks that "when a film displays an aesthetic principle and reveals a personality, it is not difficult to observe that this personality *always* comes from the director."[71] While a great deal of emphasis must be put on the *when* in this observation, it seems a generally valid one. Of course, as the advocates of the thesis of multi- or nonauthorship in cinema wish to remind us, through his or her own creativity and style something of the personality of a cinematographer or composer or screenwriter or actor is also expressed, or otherwise present, in a film. Although more than plausible, this observation is largely irrelevant in our present context since these other reflections (or "indicia") of authorship are further and quite rightly associated with the *cinematography* or the *dialogue* or the *music* or the *acting*, specifically, but not with the film work as a whole, to which cineaesthetic world-feeling as artistic expression belongs (together with much else of artistic interest and experience in relation to a film in symbolic, thematic, and formal terms).

In juxtaposing central aspects of some past and present, expression-centered formulations of cinematic authorship with a conception of a film's total, durational world-feeling, as an affective and aesthetic expression ultimately emanating from a single personality through the objective mediation of a created world, an important qualification must be added. As Sarris implicitly acknowledges, any truly defensible auteurism must begin by recognizing that the "distinguishable personality" and "worldview" that a film is seen to embody and express is not to be equated, tout court, with the empirical personality or worldview of a certain historical individual (the film director), as apparent or discoverable independently—that is, *outside* of the work or works under consideration. For even if the filmmaker's (or other artistic world-creator's) subjectivity is clearly "behind" a film world's total expression, in terms of at least partly

conscious, well-formed intentions (or a transmission of "signature" features into a work via some other means), this does not mean that the viewer can ever "get behind" the work-world to access even this much of originating subjectivity *in any other form* (as Sircello rightly observes).[72] Nor, for that matter would the subjectivity, if so accessed, necessarily correspond with that expressed by, and through, the work.

With these considerations in mind, insofar as aesthetic expression is a manifestation of the artist's subjectivity, both Dufrenne and Merleau-Ponty maintain with good reason that the expression in question is ultimately better conceived in a more holistic and relational, as opposed to a predominantly psychological and biographical, sense—that is, as a reflection and product of the artist's "being-in-the-world" as manifested in art. As in Heidegger's conception of *Dasein*, this formulation captures the idea that although this "being" is an irreducible "unity of subjectivity," like the "expressed world" (Dufrenne) of the aesthetic object of which it is both a result and an extension, it is still also tied to those larger formative or mediating cultural and historical realities from which neither the artistic self (as a self) nor the aesthetic object (as experienced) is entirely emancipated. The true relation here is a kind of symbiotic or mutually informing one, which is difficult to express in short compass but has been articulated, perhaps as well as it can be, by Merleau-Ponty, in the essay "Cézanne's Doubt," where he writes that "although it is certain that a man's life does not *explain* his work, it is equally certain that the two are connected. The truth is that *this work to be done called for this life*."[73]

Despite the difficulties and limitations of more author-centered accounts of film art and (creative) expression discussed and debated for what is now more than fifty years—as well as even more long-standing critiques of creator-focused theories and proposed definitions of art in general—the constellation of artistically relevant, "globally" expressive causes and effects I am attempting to describe has not only a certain phenomenological but inductive validity; that is, it finds apparent support in comparisons among films. Although the cineaesthetic world-feelings of *Inland Empire* or *Solaris*, for instance, are singular affective realities, they are likely closer to that of Lynch's and Tarkovsky's *other films* than to *any other* director's works. If we may trust our informed intuitions here as viewers, many films are rightly regarded as versions or variations on the same authorial expression. This translates into the existence not only of a number of affectively, as well as formally and thematically, similar Lynch

or Tarkovsky film worlds, but of a cinematic "universe" of a filmmaker, as one that his or her individual films come to make visible and exemplify. Thus, as well as being similar in terms of the presence of the same or similar characters, locations, themes, allusions, genres, techniques, and stylistic templates—all of which may, of course, also form patterns and viewer experiences that reflect both an individual cinematic style and an artistic personality—we may further envision such a creator universe as comprising films bound together by characteristic world-feelings created and conveyed by them. Like that of a painter or novelist, a filmmaker's creative signature may reside in more diffuse, less directly representational but at the same time more intimate, tones, moods, durations, and atmospheres, every bit as much as a known penchant for (say) jump cuts, wide-angle lenses, circular narratives, or existential themes. Moreover, in experiencing several films by the same director, we may hope to become more receptive to the *differences* among the films constituting a body of work in this major, affective-expressive respect.

Acknowledging such proprietary or "creator-owned" film-world expression (or feeling) does not necessarily challenge the affective and experiential singularity and alterity of an individual film work and world. Bazin, for instance, was keen to preserve and defend this inviolable singularity of a film's own "world" against the radical auteurism espoused by the younger *Cahiers du cinéma* critics (and future directors) in the late 1950s. For Bazin (and some subsequent theorists) auteurism, even in moderate forms, is always in danger of lapsing into an "aesthetic personality cult."[74] It risks regarding a director's body of work as a homogeneous, overdetermined entity, omnivorously absorbing and absolving significant generic, stylistic, and experiential differences among films. Yet recognizing and appreciating an affective and affecting "Lynch world" or "Tarkovsky world" is, of course, predicated on first experiencing and coming to know and appreciate the aesthetic world-feeling of, for example, *Blue Velvet* and *Lost Highway*, *Andrei Rublev* and *The Sacrifice*, individually. The attribution of all such *creator worlds* (and their distinctive affective designs), no matter how immediate and obvious their existence may sometimes seem, is still an interpretive, critical, or second-order extrapolation from individual works. To evoke Michel Chion's description (for his own film-critical and theoretical enterprise), such a frame of reference, centering on the identification of recurrent, expressive properties, instead serves to "bring the *politique of auteurs* into a dialectical relationship with the *politique of the*

work."[75] Like the exemplified features of artworks in general, the global affective atmosphere established by a cinematic work is and can only be a *sample* of itself, something of and for which the work itself is the concrete manifestation and symbol (in a certain sense).

In fact, the relevance of samples, descriptions, and the related concept of artistic exemplification in this context shows that even here, with respect to an irreducible and "subjective" affective expression conveyed by a film world as a whole, we have not totally escaped, or moved beyond, all relevant symbolization. As we saw in chapter 5, exemplification as a referential process is a matter of a work's foregrounding one property or sensible aspect of itself—whether simple or complex, perceptually given or symbolically mediated—relative to (some) others possessed. Although a global, relational property of the film world as experiential object or event for viewers, *cineaesthetic* world-feeling is still selected, featured, and, in effect, offered up for experience by the work. And, like other exemplifications throughout art, it elicits and inspires viewers, critics, and theorists to attach relevant semantic *labels* to this holistic phenomenon, in the hope of capturing at least some better sense of (what is, after all) a primarily nondiscursive, artistic, and affective presence. However, turning again to our actual, critical practice (and following Dufrenne's lead on this point), in addition to applying such adjectives as *lyrical, tragic, grotesque,* and many others to local, as well as more global, instances of cinematic expression, it is both revealing and appropriate that the labels in question are frequently ad hominem. That is, we speak of the "atmosphere" or "tone" or "mood" of *Kurosawa* or *Antonioni* or *Murnau* versus that of *Ozu* or *Fellini* or *Lang;* or, again, we speak simply of the feeling of a "Kurosawa world" or an "Antonioni world."[76] Thus, as akin to Langer's stated view that the artwork *as a whole* is an externally objectified manifestation and symbol of irreducible subjective "feeling" finding artistic objectification, the global, aesthetic world-feeling of a film can be seen as a kind of "meta-exemplification" tied to its creator's attitudes as well as cognitive intentions.

CINEAESTHETIC IMMERSION

Since the world-feeling of a film is by nature a nonempirical, intentional property, brought into being in a relation between features of the work and the empathetic or other feeling capacities of viewers, its relation to

immersion is a close and, as might be said, intimate one. The attentive viewer moves into the affective and temporal "interiority" of a film as experienced, seemingly beyond or below its perceptual surface, in order to be in position to both apprehend this form of cumulative expression and yield to its persuasion—in the sense that we associate feeling and affectivity with a depth going "beyond appearances." What Sarris terms ineffable "interior meaning" and Dufrenne describes as an irreducible affective and aesthetic world-atmosphere are present, or disclosed, only for viewers who are in certain senses receptive to the film world as an artistic *event* (as I will elaborate on in the next chapter), which may also be conceived as virtually entering into the cinematic work's world. In other words, if the aesthetic experience of film typically involves a series of local affective and imagined entrances and exits into various represented, implied, and imagined "spaces" (including fictional-narrative ones), there is also, as overlapping and building on it, a more general, and often more profound, form of psychological immersion, and (to some degree) "surrender," for which cineaesthetic world-feeling is a primary vehicle.

Like other experiential worlds, but in a highly concentrated fashion, the world of a cinematic work concretely "feels like something" one is actively involved with, participating in, and absorbed by. (In attempting to further account for this basic human sensitivity to the composite and irreducible feelings and atmospheres of individual worlds, both within and without the realm of art, Dufrenne speculates about the existence of an "affective *a priori*," something like the innate, or a priori, mental categories that Kant famously posits.)[77] Correspondingly, and as is true of other enclosed worlds of experience, to be affected by a film world's total created expression entails *already being within* the particular experiential fold or arena that it creates through the artistic use of a given moving-image media. The concept of immersion is here taken to involve and require entry into the full aesthetic reality of a film as temporarily substituting a perceptual and imaginative participation with represented characters, environments, and situations—and a singular atmosphere of feeling in, through, and around them—for the viewer's ordinary perceptual environment and feeling-world(s). Generally speaking, however, and contrary to some representation-focused and illusion- and "make-believe"-centered accounts of film viewing and immersion, the relevant aesthetic immersion in a film during its experience, together with its difference in kind from an imagination-based (and what I have called cognitive-diegetic)

engagement and immersion in a fictional narrative or story-world (in-and-for-itself), is aptly described by Dufrenne as "the acquisition of an intimacy with what the object expresses. It is no longer a question of pretending that Hamlet is real so that we may become interested in his adventures. Instead, we make ourselves present to Hamlet's world so that it may touch us and flow into us" (406). Thus, a significant part of a film's aesthetic experience can be seen as a matter of a "sympathetic reflection which strives to grasp the work from the inside" (i.e., of its experience as a work) as he also advises, wherein such reflection occurs at the "instigation of feeling" (423) as opposed to being only intellectually grasped or recognized from a distance, as it were. Like its local cognitive-diegetic and sensory-affective analogues, *cineaesthetic* immersion is especially encouraged and foregrounded in some film worlds, just as it may be deemphasized, discouraged, and thwarted in others (a fact that perhaps misleads some theorists in regard to its film-artistic significance).

Just as with respect to the primarily sensory "bombardment" or seduction of which cinema is obviously capable, the aesthetic immersion (and "surrender") in question, it must be emphasized, is also not necessarily equivalent to some kind of mesmeric, hypnotic fascination before the screen. This is true even if, with respect to some celebrated works by celebrated directors like Dreyer, Herzog, and Tarr, such reaction and engagement may doubtlessly be one common, appropriate, and intended response to a given cinematic work-world and a fair description of the core of its perceptual and affective experience. If such immersion is not rooted in any form of cognitive illusion (in itself), however, then neither is it a matter of work-conveyed feeling alone. Aesthetic immersion in the world of a cinematic work, like that of a novel or a theatrical performance, is also tied to thinking through and working out issues, questions, puzzles, or problems that it poses to the viewer on narrative, reflexive, conceptual, or even "philosophical" levels of address. Such cognitive, reflective engagement may precede or accompany the taking up of a stance or attitude that is more "internal" to the work and submits to its temporal development: here it comes to be accompanied by the intimacy, depth, and subjectivity of an affective response.[78] This is tantamount to saying that to mentally and emotionally enter the world of a film in aesthetic fashion, one may first have to become acquainted with it and, in that concrete sense, to "know" it.

Concerning the relation between aesthetic feeling and reflective thought in the experience of a film, Mitry rightly argues that the "aesthetic attitude in the cinema" is a matter of "participation" or "*active* contemplation" rather than contemplation alone, given that no other art is so fully capable of synthesizing the "two languages . . . of reason and emotion, reaching the one through the other in an interdependence of whose reciprocity remains constant."[79] With respect to the counterintuitive cause-and-effect intricacies of time travel (*La jetée, Primer*), the morality of terrorism and counterterrorism (*The Battle of Algiers*), the associative cultural relations among Marilyn Monroe, Joseph McCarthy, and the atomic bomb (*Insignificance*), and many other complex and thought-provoking issues and realities, narrative films may make considerable demands on the viewer's intellect, as required to function in real time. Yet no matter how abstract, conceptual, or purely formal the features of a given film world are, aesthetic reflection on them during a film's experience is often marked by an affective charge or valence, and hence a meaning for the viewer from which the perceiving and feeling *I* cannot be (entirely) excluded.

As implied here, what may be termed *cineaesthetic* immersion is inherently both self- and work-reflexive. It necessarily involves some attention to, and reflection on, a film as a created work, but it also includes, quite often, reflection on one's own dynamic and changing *experience of it*. What Elliott writes of aesthetic immersion in the world of a poem holds also for film, namely that it entails "an awareness of certain qualities of an objective content" but combined with a "reflexive awareness of certain aspects of the *experience as such*."[80] This is at least one differentia of film and dream experience. Unlike being metaphorically lost in a dream, or a daydream, aesthetic immersion in a film world carries along some sense that everything one feels and thinks occurs in the context and confines of an aesthetic experience that is not only uniquely occasioned by the work but is also a direct consequence of its artistic forms and purposes (however these are attributed) and our responses, as viewers, to them. (This is where the affective and aesthetic experience provided by a cinematic work-world overlaps with the hermeneutic event of understanding and truth its viewing also entails, in ways to be addressed in the next chapter.) Thus the "surrendering oneself" that has been mentioned should be thought of not as passive acceptance but rather as an active, ongoing negotiation

between the self and a created film world as an aesthetic object (as bound to its interpretation, understanding, and truth), in the form, that is, of a kind of experimentation, including in the feeling dimension, that is also an exploration.

In this context we come back yet again to one of the principal themes of our account—namely that for viewers the appreciation of cinematic art requires more or less simultaneous attention to a film as (a) an audiovisual, sensory presentation; (b) a narrative-fictional, imagination-enabled reality; and (c) a specially created, symbolically constructed, and artistically intended work. All three forms of attention constitute a film world in aesthetic and experiential terms and realize a unique, total (or "global") feeling or affective atmosphere and an often pronounced immersion as intimately related to it. And however relatively resistant to precise analysis the feeling-constellation and immersion in question may be, they cannot be removed from, or neglected in, any adequate, let alone would-be more comprehensive, theorization of narrative cinema as art.

The basic character of film worlds as symbolic constructions (or, if one prefers, intentional communicative objects) entails that the viewer's deepest aesthetic relation to a film—as taking the form of participatory immersion—is not passive but *responsive*. And, with reference to one prominent way in which all aesthetic experience has been traditionally theorized, although neither practical nor involving major actions of the body, it is certainly never "disinterested" (affectively or otherwise). Yet, and as we will now turn to reflect on further in the final chapter, as well as to experience and feel, the artistic event of a film world is also a quest to learn and understand. Paralleling and overlapping the immersion in film viewing we have discussed, this understanding occurs in an equally global sense and on an equally global film-world scale, that is, with respect to the total meaning and presence of a cinematic work (as it may be ascertained). Crucially, it involves both a mental and *cultural* situating of a film world, as this artistic (and narrative) totality, in relation to *other worlds*—real and imagined, cinematic and noncinematic, narrative and nonnarrative.

PART IV
WORLDS OF TRUTH

TOWARD AN EXISTENTIAL HERMENEUTICS OF FILM WORLDS

OUR INQUIRY INTO THE CREATED AND EXPERIENCED WORLDS OF cinema has shown that in seeking to grasp the distinctively artistic dimensions of narrative films, as taking the form(s) of such worlds, it is insufficient to approach them in the same manner as objects of our ordinary, unmediated acts of sense perception and attention. Regardless of how much medium-enabled (or amplified) continuity with the sights and sounds of the "real world" films may involve (and what Gregory Currie refers to as the "likeness thesis" with respect to conceiving this continuity),[1] they also transcend and diverge from what is known and most familiar in our firsthand, extracinematic, and nonartistically mediated experience. In so doing, they do not so much simulate or mime our perceptual and emotional capacities as open up new avenues of and for their exercise. At the same time, in still adopting a broadly referential approach to cinema, rooted in symbols and signs, I have appealed to a tradition of reflection that regards all art as a fundamental and partly autonomous mode of symbolic representation and expression. Building on certain frameworks of ideas in the general philosophy of art, and relevant film theory, we have seen that a more promising theoretical approach may be founded in the

conception of cinematic works as purposefully created symbolic and af-fective "worlds of their own."

As is only to be expected, however, many questions remain (and not only those that arise in the necessary task of filling in a wealth of details). If film worlds are literally and figuratively bounded realities, to be de-fined largely by their alterity with respect to everything that falls outside of their singular symbolic and affective confines, it may be difficult to see what prevents their being forever closed off to one another and to common experience like Leibniz's "windowless" monads, as those wholly self-enclosed, self-perceiving entities that the seventeenth-century philos-opher famously argues are the fundamental constituents of the universe. How can we best characterize the nature of the close relation between a given film world and all the other worlds (collectively constituting much of our cultural experience) that, as we have seen, provide the materials for its construction? And, following from this, how can we preserve in theory the logical, symbolic, and aesthetic distance between a film's artis-tic elements and features, on the one hand, and all the various realities from which (as transformed) they derive and remain connected (i.e., are still recognizable for what they are), on the other? In still broader terms, apart from its being *consistent* and *coherent* with and for itself, as a "het-erocosmic" reality, can we also maintain that the singular world of a cin-ematic work possesses some more generally applicable and apprehended *truth* beyond its own sensory and imaginary confines? Finally, what is the ground on which we stand in negotiating between the "polarity of familiarity and strangeness" with respect to a film (as Hans-Georg Ga-damer has described the preeminent character of the work of art),[2] with the result that its created world can be meaningfully integrated into, and become a part of, *our worlds*, as viewers and persons, in lasting ways?

Well beyond cinema, but by no means lacking relevance to it, these are the very sorts of questions that philosophical hermeneutics is devoted to exploring with respect to the meanings and truth-values of texts and representational artworks, and the possibilities for their intersubjective interpretation through historical time and across cultural divides. In-cluding the writings of such prominent thinkers as Gadamer, Ricœur, and, more recently, Charles Taylor and Gianni Vattimo, this tradition of thought offers many relevant insights into the being and understanding of cinematic works and worlds in certain ways that have remained largely unexplored in the theory and philosophy of film.[3]

In its extension to art, philosophical hermeneutics is not concerned with the modeled human subject as a universal and ahistorical consciousness, as traditionally posited in frameworks of empirico-scientific naturalism and phenomenology, alike. Hermeneutics is, instead, occupied with the subject (the interpreting viewer or reader) as "radically" historically and culturally situated and as being shaped by, as much as shaping, the common, symbolic frameworks of thought and action.[4] This subject encounters art not only in the self-enclosed, phenomenological space and time of a work's own creation, under the causal conditions of its medium, but as within the larger totality of a specific cultural and historical formation of experiences, ideas, beliefs, and so-called prejudices. Whereas phenomenological aesthetics seeks to capture the reciprocal, unified, and unifying interaction between subject and work on the (more) concrete plane of *perception* and *affect* (and its continual flux), the hermeneutic method, in its existentially attuned aspects, and as brought to bear on artworks, attempts to chart and better understand the equally dynamic self- and work-constitutive process of *understanding*. This pursuit includes, ultimately, the kind of truth that art reveals in its own ways since, as Gadamer holds, quite rightly, a work of art is not only an "expression of life" but is, or must be, "taken seriously in its claim to truth."[5]

The insights afforded by this hermeneutic perspective are every bit as applicable to narrative films, with reference to their artistic aspirations and accomplishments, as to literature, drama, or painting. Mitry writes that "the cinema is *not just an art*, a culture, but a means to knowledge, i.e., not just a technique for disseminating facts but one capable of opening thought onto new horizons."[6] For all the reasons already given and more to be enumerated, however, this truth-telling function is *precisely* that which great cinematic *art* already discharges, not as an occasional means but as its perennial end. Clearly, to better recognize how this occurs, we must steadfastly reject the age-old, rationalist legacy Mitry here upholds, and its association of what is or can constitute knowledge, "thought," and truth with something fundamentally beyond the capacity of art.

From the hermeneutic (and to a degree Heideggerian) perspective to which we now turn, a film world may be conceived of as a transsubjective *event* of artistic and cinematic truth. On multiple levels it is this very event character that serves to reconcile the positions of the viewing subject (as a genuine self) and the object (as the completed and physically instantiated cinematic work). It also brings together, in the same field of awareness,

a film world's transformative creation (including its interpretations of aspects of all that is referred to as the profilmic) and the typically highly immersive character of viewer experience. This hermeneutic approach thus complements and helps to further reconcile on a higher dialectical level, as it were, the cognitive-symbolic and phenomenological interpretations that we have traced and made use of in our views of cinematic art as profoundly symbolic (in its representations) and as affectively and intentionally expressive in multiple experiential ways. It does so by means of what the Heidegger scholar and translator Albert Hofstadter has termed, with respect to a similarly motivated theory of art, the "joint revelation of self and world."[7] In such a synthesis we are able to see these dimensions of the narrative film in a more holistic, integrated way, as mirroring the equally complex, internal constitutions of their creators and audiences.

PARTICIPATION, TRADITION, AND THE ARTWORK WORLD AS TRANSFORMATIVE EVENT

The hermeneutic conception of the encounter with a text or artwork regards it as an ongoing process of seeking understanding on the model of an open-ended conversation and dialogue. However, and relatively less discussed, Gadamer also draws a comparison between the participatory engagement with a work and the social-cultural phenomenon of *play* and *game*. He does so, however, in something more than the imaginary, "make-believe" sense that Kendall Walton, E. H. Gombrich, and others appeal to in discussing the experience of representational artworks as a form of imaginative play. Central to Gadamer's argument is that the process of what happens "in between" the experiencing (or playing) self and the artwork (or game) is at the heart of both art and play (*TM*, 109).

Despite a lack of "real-life" consequences, play is often taken quite seriously. Although creative and allowing improvisation to various degrees, it is also a rule-governed activity, with an ethos and a proverbial "life of its own." One gives oneself up (so to speak) to the game, to its norms, permitted movements or actions, spatial and temporal boundaries, and so forth, in a similar way to which one submits to the artwork. Yet unlike most play, which Gadamer, following pioneering Dutch anthropologist John Huizinga, regards as an ultimately in- and for-itself human social behavior lying at the foundation of many cultural pursuits, participation with a work has an overriding goal: to understand it for what, and all, that

it is. Moreover, whereas no audience is required for ordinary play, such as children's make-believe, or for more elaborate, structured games (e.g., chess, bridge, soccer)—with the result that the game may often be a reality for the players alone—the artwork is fundamentally an "event of being that occurs in presentation," that is, for an audience.[8] While this much seems obvious for theatrical performances throughout history, Gadamer extends the performative and presentational aspects of spectatorship to all artworks. He traces their implications for artistic experience as taking the form of occasional historical occurrences, as well as for the interpretation and understanding of works.

Central to Gadamer's thought is the combination of, first, the artwork's occasional (self-)presentation (as in theatrical or musical performance) and, second, its ontological stability and repeatability, that is, its existing to be seen or heard by an audience on multiple occasions (in the form of unique historical events of performance) while at the same time remaining self-identical. Gadamer regards these conjoined characteristics of a work as its *Gebilde*, or basic "structure" as a form of experience, as well as expression and truth. Given their peculiar mode of being, much like games, with their bounded boards and playing fields, but even more emphatically, artworks, as creating and presenting virtual realities, carve out their own experiential, cognitive, and cultural "space" as removed from the quotidian environment of practical use objects and transparent behaviors. What they lack, however, is all or most of the *physical* interactions with objects and people in real space and time that characterize many forms of play and games, as well as causal and purposeful activity in the worlds of objects and social intercourse. For these reasons, and similar to what Dufrenne suggests with respect to a work as an "aesthetic object" of attention "in" but not "of" the world, the physical work of art when and as experienced is "raised to its ideality" in the form of an appearance (*TM* 109). The work functions, that is, on a different plane from physical-practical life and intentions.

The nature of the encounter with an artwork as a temporal and historical "event" rooted in "play," and idealized self-presentation (or "structure"), as together forming the dual "being of the aesthetic," is also, in this view, the source of its creating and disclosing nothing less than a meaningful, nonmaterial *world* of its own (*TM* 112). The work exists as "another, closed world," wherein "what unfolds before us is so much lifted out of the ongoing course of the ordinary world and . . . enclosed in its

own autonomous circle of meaning" (*TM* 112, 128). Accordingly, Gadamer maintains that in comparison with an artwork's world—as an enclosing context and interpretative encounter amid the quotidian—extrawork reality, as always *thrown into relief by it*, is defined as that which is "untransformed," whereas art (in the form of the individual work) is a "raising up (*Aufhebung*) of this reality into its truth" (*TM* 113). We have seen that with respect to cinematic art as world-making, and as the source of immersive experience, such autonomy of "world" presence and meaning that films possess is indeed one equally the consequence of their transformational character, which is here identified with distinctly artistic truth.

Related to its further recognition of the transformation of the experiencing *self* in the presence of the artwork and world seeking to be figuratively entered and understood, central to Gadamer's hermeneutics of art is a distinction between two forms of experience. The dichotomy in question is reflected in the differences between the corresponding senses of the German words *Erlebnis* and *Erfahrung*. Whereas the former term tends to connote a brief, transient, and superficial encounter, allowing for a passing experience soon forgotten, the latter is often used to refer to a deeper, more meaningful, "life experience." In other words, *Erfahrung* pertains to an event in the world with lasting consequences for the self that has witnessed or undergone it. We do not generally credit the particular "worlds" of most games and their experiences with being able to fundamentally change how we look at experience or understand ourselves. Art, however, is fully capable of providing such a more meaningful, self-contained, and unified experience—*Erfahrung*—as leading to self-knowledge and knowledge of the world, in the form of an "encounter with something that asserts itself as truth" (*TM* 489). To appeal to a relevant interpersonal analogy, the art object is met within the context of a temporally extended and cumulative event of understanding, no less than in any serious, extended conversation, as opposed to engaging in a more superficial or perfunctory verbal exchange.

For Gadamer the experienced and interpreted world of the artwork is "closed within itself" in the sense of evidencing many pronounced differences from what remains outside it and existed before it. Yet (and as the hermeneutic enterprise depends upon) it is at the same time "open" to the beholder, if not always transparently so (*TM* 109). It is, after all, a communication intended wholly *for* an audience and its individual members (even if generalized), who become, in effect, part of the work-world as an

artistic and historical event that may, in principle, be understood—even if never completely or definitively or on a single occasion of a work's encounter. Like any genuine communication, this is an encounter that not only informs but transforms the experiencing and interpreting subject to various degrees. As such, it may be seen as a kind of corollary and reflection of the transformational (as opposed to the merely reflective or reproductive) character of a work, including a narrative film, vis-à-vis whatever it represents.

In a cinematic context this conception of the substantial transformative and *aletheic* potential of artworks (which I will explain further below), indebted to the influence of Heidegger's later philosophy, can be understood as applicable not only to a film's formal transformation of preexisting materials into individual symbolic and aesthetic elements but also to a number of related, higher-order transformations. These include an "ontological" one, whereby filmed objects, places, and people together take on an interrelated fictional existence, and a story-world comes into being, as well as, in some cases, the transformation Cavell describes, wherein an actor becomes an idealized and abstracted cinematic persona (a "star").[9] There is also an "authorial" transformation at work, whereby a filmmaker is regarded as the creator of a meaningful and expressive world that will subsequently stand for him or her as a cinematic artist (as discussed in the previous chapter). From an experiential perspective such transformations, as joined by a host of other perceptual and formal ones, are also accompanied by, and all encompassed within, a multifold "existential" alteration of the viewing self as a result of participation in the artistic and cultural-historical experience of a film-created world. Nor, in relation to cinema, does this lack pronounced social and cultural, in addition to individual, relevance. This is because the work-occasioned time-space of audience immersion and transport is not wholly private or subjective, existing only on the psychological plane. Rather, it also has a manner of existence within the larger, intersubjectively shared space and time of an artistic, and here cinematic, *tradition* of creation and reception. This tradition changes and develops, as do viewers as concrete individuals, with the result that, although the *world-in* and *world-of* a film remain self-identical, throughout both historical and individual life time, our *relations* to these alter and mutate, more or less dramatically or subtly. (Here lies much of the historicity of representational and expressive symbolism.) Tradition, or *Überlieferung*, in this relevant sense is "not simply a permanent

precondition; rather, we produce it ourselves in as much as we under-
stand, participate in the evolution of tradition, and hence further deter-
mine ourselves."[10]

I have already argued for the importance of tradition in cinematic
world-making, especially given that however seemingly novel, indepen-
dent, and original its creative activity may appear, and indeed be, it always
also involves "remaking" in the more abstract sense of bringing together,
(re-)organizing, and reformulating many pieces of other, culturally con-
structed worlds, including preexistent film and art worlds (as already
surrounded by their interpretations). Over time, and through cinematic
practice and institutional support, the resulting symbolic and artistic
structures have, in turn, become the stuff of particular film styles, move-
ments, and genres. Whether or not a given instance of actual filmmaking
is accompanied by a more critical awareness of the underlying, dialecti-
cal process (to any pronounced degree), every filmmaker who picks up a
camera also takes up a stance in relation to relevant aspects of cinematic
tradition, adhering to some, discarding others, attempting to reinvent
still more.

As Gadamer's broad-based reflections bring to our attention, however,
cinematic tradition is not just the storehouse of materials of cinematic
world-making and the toolbox of effective ways to put them together. It
is also the dynamic arena of the evolving nature of cinema and of inter-
action between viewers and films, which is in itself a more extensive,
if more loosely bounded, cultural and institutional "world." At its core,
cinematic tradition is the overarching and enabling nonphysical reposi-
tory of all relevant practical and theoretical knowledge that is always in
principle accessible, even if it cannot be fully grasped or retained in its
entirety by any one director, viewer, critic, or theorist. As such it is the
open field of the possibility of cinematic art, both the matrix from which
every film world emerges and that which gives its experience genuine
meaning and value.

Tradition enables and shapes the reception and understanding of a
film. But just as a cinematic work creates a new "version" and way of
thinking and feeling about whatever familiar phenomena it addresses
and represents—in the form of a novel world (or world-version)—it may
also throw a new and singular light on all previous cinema, altering our
views of what it has been and what it may yet become. Here we are speak-

ing not only of the theorization of cinema in general, and of the forma-
tion and maintenance of canons, for instance, but of understanding and
appreciating the individual works and worlds of which they consist (in
light of implicit comparisons with many others). For these reasons, what
Joseph Margolis writes of the painted worlds of Paul Klee is equally true
of the cinematic worlds of Welles, Fellini, or Almodovar (for instance):
"We are obliged to construct (within our sense of the tradition of receiv-
ing art) what we judge to be a fair way of entering the (Intentional) 'world'
of any particular Klee. . . . But the deeper point is that *how* we enter Klee's
'world' is a function of how we ourselves have been formed and altered
by the on-going history of painting we suppose we are able to master, well
after the original Klee was produced."[11]

In other words, and as contemporary hermeneutic philosopher Charles
Taylor, for example, also stresses, the experiencing and understanding
self is *no less than the work* also situated within, and partly a product of, a
continuously evolving tradition, in the form of shared historical, cultural,
and linguistic experience generally, in which we come not only to describe
but quite literally to define and know ourselves and our worlds.[12] Involv-
ing relevant claims of the past on the present and their evaluation, it is
such accumulated, enveloping context that makes an artwork's (or virtu-
ally any cultural artifact's) genuine understanding possible. As explicated
in *Truth and Method*, one of the landmarks of late twentieth-century Euro-
pean thought, the general process involved is Gadamer's famous "fusion
of horizons" (*TM* 305–7, 374–75), cultural and historical, in which, as Da-
vid E. Linge has explained, the "limited horizons of text and interpreter"
(as conditioned by the specific historical and cultural position of each)
are synthesized into a new and "comprehensive" one.[13] Taking this form,
the full comprehension of the intentions deposited in a given cultural
artifact always involves "both the alien that we strive to understand and
the familiar world that we already understand"[14] and their successful rec-
onciliation or accommodation. In other words, adequate interpretation
of any artwork or text is informed by knowledge of the historical world
from which the work comes and the artistic tradition of which it is a part
as both are negotiated, reconciled, or fused with the interpreter's under-
standing of his or her self and world, on the one hand, and the actual tem-
poral experience of the work and *its* presented world as an in-itself reality
prompting self-reflection, on the other. This dynamic relation between

such contextual knowledge or preunderstanding and self-awareness (responsive to the demands of the work in its sensory and representational concreteness) marks all genuine artistic appreciation and understanding.

For all these reasons, in the view shared by Gadamer, Ricœur, and other thinkers partial to the hermeneutic outlook, at its most genuine and complete, the interpretation of a text or work, as resulting in its genuine, if never complete, understanding, is not a detached, impersonal activity in which the interpreting subject has no actual stake in the meaning and expression that is conveyed and discerned. Instead, interpretation is a more complete interaction that has the power to alter the subject in the process. Some such alterations may be small and go relatively unnoticed, but others may be quite profound, even life-changing. In all cases there is an acquisition by the work-encountering self, through the mutual reshaping and redefining of "subject" and "object" in the artistic experience—even if, it should be added, and as also differentiating the hermeneutic conception from other theoretical models of interpretation (e.g., Derridean deconstruction), in this meaningful exchange and negotiation the work, as the product of artistic intentions and supraindividual artistic tradition, always has the upper hand and the final word, as it were.

Cinema and the Hermeneutic Circle

These important yet obviously highly general ideas and suggestions gain greater concreteness and (more) explicit relevance to cinema with reference to the related concept of the "hermeneutic circle," which both the real-time and postexperience interpretation of any film may be seen to involve. Given the fact that "nothing that needs interpretation can be understood at once" (TM 191–92), the circle in question refers to the alternating movement of attention from each temporal or spatial part to the whole, and back to the part, in an iterative process of grasping a work's meaning (whatever specific form the parts may take and however the whole in question is classified). The process entails a negotiation between meanings that are *anticipated*, and projected onto the whole on the basis of what we believe (at any given point in the work's experience) to be our grasp of its parts, and those that are found or not found, corroborated or dismissed. Here the primary task of the reader or viewer is thus, in Gadamer's words, to "expand the unity of the understood meaning cen-

trifugally," wherein the "harmony of all the details with the whole is the criterion for correct understanding."[15]

In the case of films, and unlike still photographs or paintings, this iterative movement of greater comprehension is a matter of part-whole relations perceived and interpreted in not one but two temporal modes, namely, in the intersection of the actual progression of a film and the naturally conditioned "subjective" time of the specific pattern of our successive acts of attention. Whenever we watch a film attentively and, thereby, actualize and complete it in and through our conscious assimilation of its percepts and symbols, we are in the midst of a productive, dialectical tension between the "now" (and the spatial-temporal *part* of the cinematic whole it represents), on the one hand, and a unity of past and present (the viewer's and the work's) that is always *in process*, coming-to-be, on the other.

While watching a film, we may at any one moment be inevitably drawn to sensory spectacle, dramatic situations, arresting compositions, virtuoso performances, and the personalities and appearances of star actors and actresses, as well as moved to and fro by the power of local affective expression—be it any of the *sensory-affective, cognitive-diegetic,* or *formal-artistic* varieties that we have identified. However, as inveterate, human seekers after meaning and order of many and various kinds, we are also and equally compelled to consider how these psychologically mediated parts of many kinds "all fit together," certain in our tacit conviction that they contribute to a greater cinematic and artistic whole, with its own cognitive-expressive significance and coherence. Unlike what may or may not be true of empirical experience generally or the universe-at-large, in this case, at least, our belief and faith are clearly justified by the fact (or reasonable belief) that the parts have been meant by some *purposive intelligence* to be so meaningfully arranged and related.

More specifically, the constant mediation between cinematic part and whole takes many forms, some more basic than others in film experience (and as anticipated by filmmakers). These include, for instance, the relations of opposition and resolution (on some level) between the *shot* and the *sequence,* the form and contents of *onscreen* and *offscreen space,* the synthetic combination of the *perceptually present* image or sound and the *memorial one,* and the *narrative event* and the larger (simultaneously apprehended and constructed) *fictional reality* or story-world in which it

occurs. The part-whole reconciliation necessary to grasp the cinematic work and its meaning as a synthetic unity may be deferred or detoured for valid aesthetic or artistic reasons, such as those determined by the form and style of the work, for instance. But it may also be sidetracked for more prosaic reasons, such as when our attention and concentration wanes, and we mentally "wander away" from a film and its demands. Yet the work, insofar as it is made to be understood (in a nonreductive sense) and experienced as an intention-bearing unity, always draws us back to the task at hand—to interpret it "personally" and in a dialogical sense. Since whether by way of a scratched, celluloid print with less than ideal sound or via the present-day marvels of Blu-ray presentation and the latest iteration of Dolby surround sound, a given cinematic work offers and presents so much more than only a replication of, or substitute for, sensory and affective experience in and "for its own sake," as an occasion of *Erlebnis* (as distinct from *Erfahrung*).

As the above implies, the circle of understanding is not confined to the work, to what it has to say, show, or otherwise disclose to us in an impersonal and unidirectional fashion. Hermeneutic inquiry into the meaning of an artwork is always also marked, in Gadamer's words, by the attempt to achieve a "continuity of self-understanding . . . despite the demands of the absorbing presence of the momentary aesthetic impression" (*TM* 96). As he, together with Ricœur and Vattimo, argues, the continuity referred to here is one that is insufficiently recognized and accounted for within subjectivist and "sensationalist" accounts of art in the romantic tradition (as rooted in the momentary flux of *Erlebnis*). Instead, they must be philosophically recovered in a transsubjective hermeneutics of art (as rooted in *Erfahrung*) as distinct from "aesthetics," as associated with these romantic and idealist-subjectivist views.

Gadamer is right to stress that understanding a work as a whole also embraces and includes an integration of it with the individual viewer's culturally mediated life experience, knowledge, and identity—all of which an artistically serious film's experience may serve to focus like a prism while simultaneously modifying. Potentially, all cinematic worlds, and certainly great ones, provide a reflective platform for a *self-encounter* wherein the viewer is met not only with many forms of association and exemplifying moving images and sounds but also, however indirectly in some cases, with his or her *own* world(s) and the parts he or she plays within them.[16] It must be stressed that although we have arrived at the subject of these

dynamics and their implications in relation to film works and worlds vis-à-vis hermeneutics, they are a concern for any general understanding of art—cinematic or otherwise—given that, as one philosopher has written, such understanding must always include inquiry into "descriptions of what happens to the self in aesthetic experience" and, more precisely, the familiar (if relatively underanalyzed) process by which the self is seemingly "lost" and "regained" in the encounter with an artwork.[17]

In a cinematic context, then, the hermeneutic circle is usefully regarded as representing a negotiation and attempted synthesis involving three distinct dualities: (a) the temporal whole of the work versus its constituent parts, with respect to both film form and content; (b) the viewing self who encounters the cinematic work, and is changed by it, versus the self that one *was*, prior to this encounter and what it discloses; and (c) the film as a singular, self-enclosed, perceptual, and affective reality versus the larger cinematic, artistic, and cultural-historical traditions and contexts in which it is inextricably embedded and that contribute equally to its world-like nature (including being made, experienced, and interpreted as a particular, externally objectified *version* of the way things are or might be). In the film event these dialectical oppositions are fundamentally present to one another, each presupposing the dynamic operations of the others.

FILM INTERPRETATION AS HERMENEUTIC UNDERSTANDING

In the framework of ideas we have been considering, interpretation is always constrained and channeled by the precedents of tradition and the standards and principles these put into play for constant reevaluation and debate, again on the model of dialogue, as genuine and successful, intersubjective communication. It is the inviolable presence of the cinematic work, as fixed in its medium and "incarnate" (to which nothing more can be added or anything taken away), that anchors this process in an "objective," publicly accessible, and empirical reality, transcending the perceptions and imaginative contributions of individual viewers. While such permanency does not guarantee or fix a corresponding objectivity in artistic interpretation, as some critics, theorists, and philosophers might wish, it controls it within rationally manageable bounds.

Following from these considerations, there are not *different Citizen Kane* worlds for every viewer who experiences and interprets Welles's

1941 classic, nor for any one viewer's experiences of it at different points in biographical time and place. Rather, separate experiences and different interpretations of a film's work-world constitute so many *events* that, like many natural ones, have a common source that causes or allows them to form patterns and overlap with one another, concentrating within a certain range. From the hermeneutic view, film interpretation inevitably involves negotiation based on the finding and articulation of such "common ground," which is an expanding, historically variable but bounded field of significance. Such a concept of interpretation, which may just as well, and perhaps better, be termed genuine *understanding*, with reference to virtually any cultural object, is rather obviously different from and grander in scope than what may customarily fall under the heading of "interpreting" *Les enfants du paradis* or *Taxi Driver* within the discourse of film studies. Its full explication requires consideration of the notion of the revealed and interpreted *truth* of a film work and world—as the main goal and object of such understanding and a topic we will consider next. Prior to this, however, at least a few related, clarifying points may be made.

First, the interpretation (or understanding) in question, as forming an iterative succession of related interpretive acts, with each new act informing all previous ones, is, in one aspect, at least, nothing more—and nothing less—than a fully engaged encounter with a film work as a whole. This includes its viewing, of course, but also extends reflectively beyond it. In paraphrasing Ricœur's analogous concept of textual "comprehension" (as encompassing more than narrative comprehension), Andrew writes that this is "synthetic in that it listens to the wholeness of the text," as well as responsive to the ways in which the work "lives in the web of its interpretations, in their history, and in the projected meanings to which they point."[18] Such an orientation toward a film is fundamentally open to what it "says" to the viewer at the time of encounter. As such, and second, interpretation in this primary sense should not be confused or conflated with the activity of *analysis*, even though these two may be coincident and, at times, mutually supportive. Considerably more narrow, pragmatic, and encapsulated, analysis (whatever conceptual and systematic rigor it may possess—or lack) is bound to a particular method and typically focused on one a priori selected general aspect of a film—for example, its narrative structure or its thematic significance or its place in the historical evolution of cinematic form—to the often necessary exclusion of many

others. Bordwell's well-known claim that the interpretation or "reading" of a film is necessarily a *postexperience* activity, entirely distinct from the "synoptic" real-time process of narrative film "viewing" (and story comprehension),[19] certainly holds for *analysis* but not for interpretation in our present sense. As leading to the sort of unpredictable understanding Gadamer attributes to engagements with artworks (and their worlds), and with which I am most concerned in relation to film worlds, interpretation always and necessarily begins *during* a film's experience but need not cease with the final credits. It may be endlessly renewed, repeated in every subsequent encounter, and incorporated in all intervening reflections.

Whether one has seen it once or ten times, the interpretation of a (seemingly) meritorious cinematic work and its world is never final but is continuously revised and supplemented by new events, new experiences, new ways of knowing. (This open-ended process, which as such is distinct from an analysis, mirrors the activities of film-world creation, involving an extended process of symbolic and aesthetic remaking and rethinking.) To be sure, such a process as conceived in these terms in relation to narrative cinema is a model that some may, for any number of reasons, consider idealistic given its many actual conditions, both psychological and institutional. But it is no more or less suspect, on that account, than the prospects for "open" critical discussion in literature and the arts generally.

The interpretation and understanding at issue must also be distinguished from many critical-theoretical "readings" of films (including but not limited to so-called symptomatic readings, focused on the ideological dimensions of works) that academic skeptics (including Bordwell) have now for a number of decades submitted to a good deal of critical scrutiny.[20] Such readings often look for, and find, in particular films confirmation of an already well-established theoretical supposition existing for, and adopted by, the theorist or critic before the cinematic work or its encounter. They risk being closed to both the singularity and multivalence of a film as an artwork, in the pursuit of features that fit the established protocols of the view in question. No doubt, such an approach may unduly reduce a film work and world to an antecedent doctrine's own shape and size, so to speak, as distinct from enabling "the expansion of the reader to the size of the text and to its specific shape," as Andrew maintains (again with reference to Ricœur's conception of a text's full comprehension).[21]

Yet unlike what may be true of some exercises in film analysis, and the goal (at least) of such programmatic readings, in this existential-hermeneutic frame of reference interpretation is not a matter of attaining certainty as opposed to ambiguity, or indeterminacy, as if films transmitted certain message-bearing signals that, in the jargon of contemporary communications theory, have only to be discriminated from a background of disorderly "noise" in order to be "received." Rather, it is founded on the acceptance of the "productive" ambiguity of a work as admitting a plurality of plausible or reasonable but not necessarily equally valid interpretations. This is certainly not an "irrational" process, partly just because it *is only* a process, without any certain or necessary terminal point. And, again, if truly work-centered and governed, in terms of its dialectical reference points, there is little real danger that it will, on the one hand, lapse into subjective impressionism, incapable of gaining substantial ratification and agreement, or, on the other hand, become little more than a platform for unrelated opinions or the advancement of some general, theoretical program that the medium may be enlisted to support in reductive fashion.

Although interpretative understanding begins when a film viewing begins (and continues with each and every viewing) and is, as I have suggested, manifested in the ongoing interior, so-called intrasubjective dialogue that the viewer shares with it, in its *post–film experience* phase, as now also public and addressed to others (e.g., intersubjectively discussing or writing about films), this understanding evolves into a far more comprehensive (and comprehending) process. Yet it is still one that is, in terms of its results, highly revisable. As is the case during a film, but now from a more privileged position (the entirety of the work having been experienced and known), the hermeneutic task of the would-be understanding viewer (or critic or theorist) is to attempt to reconcile a film work's nature, as a created and intended symbolic-artistic object (in all the ways that have been described), with those realities that it represents and refers to, as often supplemented by relevant, extrawork knowledge. Both of these poles of the referential process—that is, the cinematic-artistic "symbol" and the symbolized—are in turn reflected upon through the lens of a film's actual (including affective) experience.

Goodman and Elgin make the relevant observation, in a similar context, that all the "presystematic judgments" that are a constant feature of our direct experiences of artworks serve as "touchstones" for all subse-

quent, more reflective and synoptic, understandings.[22] Since a film, as a temporal work, reveals itself at its own pace (to which the viewer has no choice but to submit) and relies on the workings of our individually limited memory capacities, it even more especially necessitates that our initial interpretations and judgments, at whatever level of sophistication they may occur, are always in part a reflection on what we have thought and felt most distinctly or strongly during the film event. In other words, despite the subjective conditions that some theorists of interpretation have been reluctant to acknowledge (and that have been anathema to others), our own personal dialogue of comprehension with a film—and, through its mediation, with our constantly self-aware thought and feeling during the viewing experience—feeds and evolves into all subsequent, more carefully composed, critical discourse surrounding it, whether spoken or written, informal or formally institutionalized.

In sum, involving (a) interpretative understanding, in this sense, together with (b) the governing presence of cinematic tradition (here including that of film criticism and theory, as well as practice), and (c) a work's character as "idealized" self-presentation, a film world is an *event* not only in the obvious sense that its full manner of existence depends on occasional realizations in physical space and time—that is, whenever it is projected or otherwise screened or played in a way accessible to our sight and hearing. Instead, in its nature as a historical, transformational, and "comprehending" process, it is also, and especially, an event in the hermeneutic conception here offered. On the viewing side of the relation, this event and process is also one of self-knowledge (and, perhaps, self-growth). Moreover, since the activity here considered contains and unifies potentially multiple, individual viewings often separated in historical and biographical time and cultural space, its results as expressed and preserved in discourse continually modify, deepen, and expand a film work's associated *world* (as, ultimately, the event in question).

Much of the above is predicated on the fact that the artistic event of a film is always (also) a conveyance, in some manner and degree, of intersubjective truth about human and cultural realities existing apart from and outside of its own singular perceptual and affective confines. Such truth-revealing potential transcends a film's affective expression, the pre- and profilmic reality of its perceptual and represented contents, and its narrative-fictional construction, together with its individual symbolic and artistic exemplifications, even while all of these familiar dimensions

typically work together to actualize it. Beyond what may (only) be determined through the detailed consideration of specific films, however, what more may actually be said in general terms about a film world's "truth," both as an object of interpretative attention and understanding and, simultaneously, as an occasion of artistic-cinematic revelation, or disclosure?

TRUTH AND FILM WORLDS

In a nostalgic article entitled "What Do Critics Dream About?" Truffaut writes that as a working film critic he always believed that "a successful film had simultaneously to express an idea of the world and an idea of cinema; *La règle du jeu* and *Citizen Kane* correspond to this definition perfectly."[23] Expanding on Truffaut's critical maxim, more profound than its brevity may indicate at first blush, film worlds may be seen to convey two basic forms of truth. The first, roughly corresponding to Truffaut's "idea" of, or about, "the world," might be called *existential* or *experiential* truth. This is a revealed truth *of* life as much as *to* life. However, as we have seen in our brief references to a number of films, including Truffaut's own *Day for Night*, film worlds may also convey a more narrowly focused sort of truth. Akin to Truffaut's "idea about cinema," this truth concerns the ongoing, self-sustaining practice of cinematic art as one cultural form of expression among others, of which every cinematic work is a (potential) instructive and illuminating sample. As grounded in an enabling tradition now approximately 125 years old, we may, for short, refer to this latter as *cinematic* truth. Manifested in a film world in its own ways, and with varying degrees of interest and insight, such truth is (as Goodman and Elgin might say) characteristically exemplificational. It is a truth *about* cinema, specifically, that operates through reference to what a cinematic work *is*, as a work, as opposed to (only) what it represents; and rather than more narrowly targeted and localized self-reference or self-reflexivity, such truth is "global" in significance, with reference to the work as a whole.[24]

Existential Truth

The existential truth conveyed in and through a given film world is a strongly culturally and historically emergent one. In addition to addressing itself to specific areas of human concern and experience (potentially

any area), it is in itself *experiential*. Moreover, as we have already seen, it is dialogical and reciprocal, both found and made, not least in the respect that it is capable of making a contribution to the complex, personal reality that we call self-knowledge. Such capture by cinematic works of art of that which is phenomenally most real or authentic is clearly not a matter of veridical or mimetic representation alone. That is, it is not an informational "what" knowable apart from the sensory and aesthetic "how," as in a series of semantic (or quasi-semantic) messages that could just as well be communicated in some other didactic medium and form. Nor is the existential truth of film worlds equivalent to a factual, or objective, presentation of some range or aspect of lifeworld or historical events, wherein truthful representation is equated with realism of style or treatment. Indeed, as Sartre argued in defending Tarkovsky's *Ivan's Childhood* as true to the lived experience of war (against some socialist critics at the time of the film's release), in narrative cinema (as in all art) factual accuracy, and a will toward the objectivity of neutral reportage, may impede the conveyance of more valuable and enriching truth, as much as subserve or guarantee it.[25] Nor, again, despite some of the best known remarks of authors in the theoretical tradition of film realism, does such film-world truth in our present sense emanate *directly* from inherent properties of the medium—that is, when these are sufficiently "respected" and put to work. This includes the cinematographic truth often seen to result from the (suggested) objectivity (or "honesty") of the film camera, which simply records all before it in a mechanical fashion free from direct human mediation and, as a result, provides an "automatic" and factual view of the "real world" otherwise inaccessible.[26]

Although it is of course enabled and profoundly channeled through an audiovisual, photographic medium—and to varying degrees is shaped by its "ontological" features—following from all that we have established concerning cinematic art thus far, the truth in question is, instead, to be approached in terms of what films may reveal about their particular subjects (of representation) as these are mediated and concretized through narrative fiction, and other cognitive strategies and figurations, together with (and through) a distinct artistic and cinematic style founded on relevant and highly mediated (symbolic) exemplifications and attendant expression. In the case of *Ivan's Childhood*, and via Sartre's perceptive interpretation, it is precisely in deviating from any sort of factual reporting and literal or mimetic depiction of events occurring on the Russian

front during one of the darkest periods of World War II—as might be found in any competent historian's account or presented in an educational documentary—that the film is able to so powerfully convey the fundamentally surreal or oneiric nature of war as also (always) a subjective, impressionistic, and senseless reality for those at the center of it (and certainly for children, such as the film's central character). And, moreover, it is able to do so in a profoundly affective, as much as perceptual and imaginary, way whereby work-generated feeling serves a "referential" function. As Sartre implies, this much is achieved through a creatively forged, rather than a simply found or ready-made, affiliation between a film's subject and a particular cinematic style and form, together with a particular view of empirical reality following from and expressed by it. In this specific instance it involves the sympathetic, mutually supportive relation between the subject matter and the film's presentation of its young protagonist's "mindscreen," constantly shifting between registers of reality, fantasy, and dream without, that is, the film presenting or signaling these modes of experience, and the transitions from one to the other, in any clear or conventional cinematic way. In looking at his post–*Ivan's Childhood* films, we can (now) see that the presentation in question is not only a defining stylistic *world-marker* of the film but a hallmark of Tarkovsky's cinema (one also found with notable variations in *Andrei Rublev*, *Mirror*, and *The Sacrifice*).

There is no certain route of access to a film world's existential truth content, which may have various direct and indirect relations with fictional narrative (and the jointly represented and imagined *world-in*), together with a film's artistic transformations, structures, and intentions, as these are experienced and interpreted. The truth in question may be communicated in and through the very detail, grain, nuance, and tone of any or all of these. What must be stressed is that like a film work's various symbolically exemplified features, rather than transparently "seen-in" or semantically "read-off" it, as in our more ordinary acts of comprehension, the truth latently present in a film world does not reside exclusively in what it (more) literally or explicitly shows or says. Rather, it most typically comes to light through repeated viewings and efforts of interpretation necessarily directed at a cinematic work and world in the entirety of its sometimes more opaque artistic function and meaning.

In all these ways such truth is most aptly characterized as an event of "disclosure" or "revelation" occasioned by a cinematic work, which,

according to Heidegger and Gadamer, as two of the leading exponents of this concept of art, is, as we have seen, always an occurrence within time and history through which a new aspect of the authentic "being" of things (or "the being of beings") is disclosed. Art, according to these philosophers, "is the becoming and happening" of a truth that is profoundly different from that which permits certain discursive assertions to be counted as items of fact or knowledge.[27] It is in this sense that Heidegger, in famously rejecting an age-old Western rationalist and propositional conception of truth (inherited from classical Greece), speaks instead (in poetic-theoretical fashion) of a "showing forth," an "unconcealedness," and a "bringing into the open" of a new reality on the part of artworks. It is as if in encountering them, one enters a clearing (*Lichtung*) in the otherwise trackless forest, which enables one to see the surroundings for the first time and to gain a necessary orientation and perspective.[28] This fundamental notion as to the meaning of what "is true," as gleaned from the pre-Platonic, original meaning of *aletheia*, concerns a specific and existent reality that only the work may succeed in making fully apparent.

In his profound, if also frequently obscure and difficult, essay "The Origin of the Work of Art," Heidegger argues that "the setting-into-work of truth thrusts up the unfamiliar and extraordinary and at the same time thrusts down the ordinary and what we believe to be such. The truth that discloses itself in the work can never be proved or derived from what went before. What went before is refuted in its exclusive reality by the work. What art founds can therefore never be compensated and made up for by what is already present and available" (75). What a cinematic work is truthful *to* does not entirely preexist its experience—because only through its creation, appearance, and individual engagement may one become fully aware of that which it reveals and expresses, as well as of the unique constellation of external realities with respect to which it draws away the veil of ignorance, so to speak.[29] The work's appearance in the world of objects is simultaneous with the appearance of *its* world as a novel one, something over and above antecedently familiar realities, including all those it incorporates to its own ends.

Thus if cinematic art may convey what is true, it does so through an intervention in, and transformation of, what we ordinarily perceive, think, and believe. This activity does not involve a loss or diminution of primary reality, as Plato has notoriously held in his opinion of art as *mimesis*, or mere imitation, which, as Cassirer has written, inevitably condemns art

to cognitive failure.[30] To the contrary, a primary virtue of the hermeneutic approach sketched here is that it enables us to finally move beyond this conception, with respect to films and their experiences, and many of our intuitions concerning their greatest values. In its skilled and insightful presentation—which is also a *re-presentation*—of appearances to disclose that which is otherwise "hidden," obscured, or overlooked, a cinematic work is not like a mirror of an already illuminated reality—as if a set lit for a camera—but, more appositely, a searchlight in the dark, revealing much that we did not even suspect was present before its beam contacted it.

Since, as we now have traced in some detail, cinema effects a pronounced transformation of quotidian, lifeworld objects and actions as previously experienced and known as central to its artistic functions and value, the cinematic-artistic "event of truth" may continue to be regarded as a "defamiliarization." Yet the oft-noted process must be seen to occur in a more "global" and holistic sense than in Viktor Shklovsky's (original) invocation of the term (in his essay "Art as Technique") as pertaining primarily to an artwork's deliberate disruption and frustration of "automatic" perceptual processes (leading to knowledge and action), occuring in our ordinary (lifeworld) activities, through the interposition of particular "formal" or structural devices as the methods of such disruption. In Bordwell's and Thompson's more or less direct extension of Shklovsky's concept of defamiliarisation to narrative cinema, they take it to apply to a film's disruption or rendering moot of the common perceptual-cognitive schemata (or strategies) that viewers employ to construct a coherent narrative and story-world from the perceptual information a film provides. They associate such an interest and activity on the part of a narrative film—drawing attention to what might otherwise go unnoticed in its experience, as concerning its form and structure—with (what is in their view) the distinctly "aesthetic" aspect of narrative cinema in its more creative and original manifestations.[31]

However, just as there is more to art-making and reception in general than either perceptually accessible form (even as this is broadly construed to include many aspects of style) and story comprehension and construction (in the case of narrative art), films also connect with other, and perhaps deeper, sources of *Erfahrung*. In bringing the now-familiar concept into line with the existential-hermeneutic perspective (and its critical modification of *mimesis* in art), defamiliarization must also embrace and

encompass not just formal and structural processes and elements but the full range of a cinematic work's representational and symbolic "contents," with all that these carry in its train, and which we have found necessary to characterize in terms of the more expansive notion of an artistic *world-version* of objects and experiences. In other words, and also in keeping with the broad arc of Heidegger's well-known discussions of the truth in and of painting and architecture, the "aesthetic" in cinema as a feature and goal of individual works is not only a matter of the work prompting (greater) reflection on its own—and the viewer's—perceptual and representational *processes* in constructing the film's version of X subject for attention (e.g., a city, an individual's life, the French Revolution). It also and equally prompts reflection on *the resulting product*—that is, the presented version of X in question—in all the sensory presence of which the medium is capable. That is, the object of representation is now *given*, as it were, in and through the cinematic work both as an in-itself ("ideal") reality and in conjunction and comparison with that which is known and felt about it in "real life" (i.e., outside of the work), before, during, and after the encounter (and also together, it should be added, with how it may be known as presented in *other* works as other and different artistic versions). Related to the dynamic Mitry and Dufrenne stress with respect to the relation between cinematic representation and artistic expression in film, this can also be put in perhaps more familiar semiotic terms: aesthetic perception and experience are a matter of (greater than normal) attention being paid not only to the artistic "signifier" but also to the "signified" in the (potentially) full range of its artistically communicated presence and its work-specific, semantic attributions. With these points in mind we may now continue to flesh out and perhaps make more plausible these major aspects of Heidegger's and Gadamer's central theme concerning art and truth in their application to cinema, as well as indicate the relation of such an existential hermeneutics of art to the other theoretical and philosophical perspectives and concepts (including that of symbolic exemplification) that I earlier attempted to bring to bear on film works and worlds.

DISCLOSURE, PROJECTION, AND PRESERVATION

One effect of the journey through cultural and historical space and time a film world provides is that aspects of our lifeworlds appear new and strange, as if our taken-for-granted acquaintance with them has all along

FIGURE 8.1 Allen's *Manhattan* as one of many cinematic and artistic world-versions of New York City.

been incomplete or mistaken. For instance, neurosis is not the same after the creation and experience of *Through a Glass Darkly*, color after *Black Narcissus*, or modern travel after a number of Wenders's films. Nor is Rome the same after *La dolce vita*, or Los Angeles and its environs (including Hollywood) after *Mulholland Drive*. Fellini's and Lynch's film worlds are not capable of altering the physical environment of these cities, of course. But they reveal new perceptual, aesthetic, cultural, mythical, and historical facets or dimensions of these places that would in a significant sense not have been revealed had these specially created worlds not existed. Although one cannot literally walk the streets of Woody Allen's or Martin Scorsese's Manhattan, as these are the thoroughfares of virtual as distinct from physically embodied and causally supported worlds (for all that this distinction entails), in visiting and exploring Manhattan one can, nonetheless, recognize these filmmakers' Manhattan-set worlds as palpably present (fig. 8.1). In and through their works Allen and Scorsese (and their collaborators) do not so much present a certain city and its inhabitants as they existed *before* being mediated and transformed within a cinematic world structure but in the very process of being so transformed, street by street, as it were. We may think of film worlds as superimpositions. Like new templates placed over (older) experiential realities, they shape, organize, and render coherent and navigable our more immediate sense experiences—preceding and conditioning the discovery of a truth they both embody and convey.

Our critical, evaluative judgments of the truth-to-experience of films, however rudimentary or sophisticated, always pertain to their transformations of preexisting realities, as so many constituent, film-world materials—given, that is to say, what we take to be our firsthand knowledge and familiarity with them. (This is no less true, it should be added, with respect to films in the mode of cinema verité or its spirit, for instance, where all such transformations are ostensibly at their minimum.) I have argued that a cinematic work's affective dimension may be divided between, first, what belongs to the extrawork psychological and affective nature of its selected (profilmic) materials—for example, objects, faces, events (the selection of which itself is a creative, intentional, world-shaping act)—and, second, feeling conveyed by virtue of the unique symbolic and aesthetic articulations created with and through these materials, in the manner of formally shaped and presented referential elements and structures, including narrative-fictional ones. With respect to meaning, as well as feeling, these two factors and their proportions are often at the forefront of interpretative attention and understanding—as when we say, for example, that the cinematography or editing of a film is not suited to its location or subject matter or the human behavior represented. For not only is this characteristically cinematic dialectic of the "naturally" or "mechanically" reproduced and the creatively and formally shaped or altered (and hence interpreted) a powerful magnet for viewer engagement, but also, and equally, it is a criterion for artistic and aesthetic interest and value. As Mitry, among others, suggests, and as previously discussed (also with reference to Goodman's cognitive philosophy of art), assuming it is aesthetically attentive, both viewer experience (in the cognitively robust sense here argued) and postviewing critical discussion always demand assessing and negotiating the relation between some known and recognized *extrafilmic* reality and a film's (and filmmaker's) interpretation and transformation of it in the form of a singular cinematic and artistic *version*. During a film's experience this "higher-level," culturally informed aesthetic comprehension (and its back-and-forth mental movement between what is inside and outside of the work), occurs, it must be added, in addition to, simultaneous with, and often closely intersecting basic narrative comprehension and its processes.

We may come to the worlds of *Manhattan* or *After Hours* or *Eyes Wide Shut* knowing New York City very well, as perhaps present or former residents or frequent visitors. In such cases a more complete apprecia-

tion of these cinematic "New Yorks" may well require (at certain points in their experience) temporarily relinquishing some of our conceptions, past experiences, and expectations of the great metropolis in order to more openly and productively engage with a very different place on-screen: that is, one of a more closely bounded, intentionally and symbolically concentrated sort. Whatever our own, personally experienced, and practical knowledge–determined and –dependent "New York" is (or was) *prior to* encountering a cinematic version of it, if the work is interesting and successful, our various conceptions, attitudes, feelings, and so forth will be (permanently) altered in some degree as a result of its experience. And yet, not only can prior awareness of the physically actual city *also add* to our appreciation of each of a great many different moving-image and sound-enabled "New Yorks," but grasping the filmmaker's particular artistic vision and version of this complex reality might require and presume such firsthand experience and quite self-consciously build on it.

The reader will be able to supply numerous examples of his or her own here, but the key point is that whatever we know or believe about New York prior to viewing a film set there, or otherwise representing it, is always and fundamentally *put into play* in the event of the work and our participatory dialogue with it. In the perceptual-cognitive and affective crucible of a film's experience, the relevance (and value) of such knowledge and belief is always tested, as it were. Obviously, what applies in this example applies in some measure to any specific, familiar, profilmic (or extrafilmic) reality that a film world simultaneously represents, presents, and transforms—be it such a vast, complex, and physically instantiated one, like a major city, or perhaps a single, biographical individual treated fictionally, or even an abstract idea or system of accepted beliefs.

In these ways perhaps the most relevant feature of film worlds as conduits of artistically conveyed truth to experience is a dialectical one: it consists in the opposite tendencies of filmmaking and viewing wherein one process is the reverse of the other. Although creative filmmaking involves the construction of an indecomposable and artistic-symbolic *unity* (in physical, perceptual, and meaning-bearing terms), a finished work subsequently, and as experienced, not only also permits but requires and compels, on a mental plane, a kind of individually self-centered "deconstruction" of this unity in order to attain a new and higher synthesis. To explicate this fully: the filmmaker borrows his or her materials from our

worlds of experience in order to fashion a new world apart. Yet (a) in order to recognize this as (also) a creative *version*, and artistic *interpretation*, of experience and its objects, and (b) for the purpose of grasping the extent and nature of the transformations in question, and the possible purposes and meanings of them (in relation to the cinematic and artistic whole), the viewer must—at least initially—parse out and mentally *return these* realities-cum-world-making materials to the "places" from which they came. Such knowledge-based recognition, comparison, and comprehension is a major aspect of judging a film's artistic success and interest. Moreover, rather than a challenge to it, it is the ultimate foundation of a cinematic work-world's most significant alterity and singularity, in artistic terms. In addition to a reemphasis of relevant insights found in Mitry's film theory in these respects (as well as in Goodman's aesthetics), here we may also find the film-theoretical application of Gadamer's thesis that "only the support of familiar and common understanding makes possible the venture into the alien, the lifting up of something out of the alien, and thus the broadening and enrichment of our own experience of the world."[32] As a more concrete version of the basic, active relation of representation itself, every cinematic work-world involves a three-way "conversation" between certain extrawork realities, their artistic presentation as mediated by the intentions and creativity of filmmakers, and the viewer, not only as perceiving and imagining subject but also as a cultural and historically situated "self."

Goodman adopts a differently oriented but recognizably similar position in his cognitive philosophy of art, centered on the concepts of artistic "projectibility" (an obviously apposite term in a cinematic context) and what he calls "rightness" or fidelity to experience, as a suggested more relativist alternative to *truth*. He writes that "what a Manet or Monet or Cézanne does to our subsequent seeing of the world is as pertinent to their appraisal as is any direct confrontation. How our looking at pictures and our listening to music inform what we encounter later and elsewhere is integral to them as cognitive."[33] In line with Goodman's further explication of this key notion of retrospective "projection" in largely perceptual and formal terms, in a cinematic context it would seem to mainly apply to what film worlds look and sound like. Certainly we may perceive light and shadow in new ways as a result of seeing the most accomplished film noir lighting, experience three-dimensional space differently by virtue of its two-dimensional presentation in a German expressionist or Soviet

montage film, or see aspects of color differently as a result of the creative use of Technicolor or lens filters. And the power of film art, in the form of specific works, to alter the visible and audible world around us by changing how we more literally see and hear it, should, of course, not be understated (or left unanalyzed).

Yet, as I noted earlier with respect to "defamiliarization," since a film may in one way or another *exemplify* any kind of property by way of reference that passes through itself (i.e., its own nature as a work), the realities it helps to reveal or clarify through the viewer's "projection" of it onto, and over, extrawork (and noncinematic) experience are not confined to purely perceptual ones. They are, rather, as potentially unlimited in kind and scope as intellect and imagination themselves and are constrained only by the medium. Thus, *Blow-Up* leads us to awareness of certain truths about perception, images, and art; *Blade Runner* plumbs the mysteries of personal identity; and *Adaptation* prompts reflection on the vicissitudes of Hollywood screenwriting and the nature of film narrative. As I have argued, in each such instance the formal, presentational vehicle of such insight and enhanced understanding everywhere interpenetrates and shapes such semantic and ideational content as may be abstracted from a cinematic work. In this aspect the truth-telling process is, moreover, again a circular or recursive one: the more a cinematic work-world can be interestingly and revealingly projected onto external domains of experience, the more we learn, and continue to learn, about it and its reservoirs of meaning.[34]

In the highly figurative terms of his later philosophy, Heidegger refers to a similar process of an artwork's "preservation." Those who grasp what the work reveals and "stay within" the event of truth it embodies (that is, remain attentive to and "respectful" of it) are its "preservers." Such preservation is always relative and variable, dictated to some extent by the terms of individual works and what they "demand" of us (as audience). Moreover, the full and "proper way" to preserve a work is, as Heidegger suggests, "co-created and prescribed only and exclusively by the work." In much the same way, we might add, common, prior standards of what is "realistic" or "natural" or "credible" or "right" as applied to films are to some notable extent challenged and tested by recognition of the specific nature and intended artistic aims of a given cinematic work and world. As Heidegger further maintains, and as is relevant to the worlds of films as much as any other artistically created and experienced worlds, such

"preservation" occurs at different levels of knowledge with always differing degrees of scope, constancy, and lucidity.[35] Of course, film critics and theorists have a large role to play in both of these "projecting" and "preserving" processes, *one* aspect of each being the labeling, bringing to attention, and interpretation of what I have termed (and discussed as) a film world's exemplified symbolic-aesthetic elements and world-markers, as the most significant among these.

Finally, under the present heading of film-disclosed truth "about the world," beyond the dimensions of perceptual form and symbolic and referential content (with reference to a single film or the entire body of work of a filmmaker), such frequently retrospective, epistemic world "projection" and "preservation" also pertains to the affective-expressive dimension (as is implicit in both Goodman's and Heidegger's accounts). As we have seen in the application of Dufrenne's general aesthetics of feeling, the global affective expression, or world-feeling, of a film may serve to draw it closer to the powerfully felt reality of many other worlds, and experiences constituting them, ones that may come to greater awareness and appreciation by way of it. Likewise, and more generally, the affect and emotions that a film world generates (and that, as we have seen, are of structurally and psychologically distinct types) may allow for perceptual and representational, artistically mediated truth to come into sharper focus and heightened attention, and to acquire personal relevance. Indeed, this feeling-led recognition and access to what may be otherwise closed off and invisible to our faculties of cognition alone is already assumed in the conception of the inherent expressivity of the symbols of art, and there is no sound, convincing reason to summarily withhold it from cinema.

Cinematic Truth (as Exemplified)

To return to Truffaut's observation that I have taken as the starting point for a consideration of film-world truth as distinctly artistic truth: if what has been said thus far pertains to a film's "idea of the world," how may we best understand the French critic-director's further claim that every successful film must present an "idea of cinema"? The leading edge of his remark is to remind us that every cinematic work of art is already a *concrete example* of what cinematic art is, and can aspire to be, as an instantiation and further development of the traditions to which it belongs. For this reason the truth that each film world exemplifies is also therefore a truth

about the importance and constitutive role of cinematic tradition, one that often precedes all other forms of self-acknowledgment and explicit, representational self-reference. The meaningful self-display in question is, in other words, a more basic, primary "exemplification" (or serving as a *sample-of*) than that which we have discussed in relation to a film's individual *self-reflexive* features, which are most often more episodic and narrowly focused or specific in terms of subject—for example, showing or referring to some particular aspect of filmmaking or film viewing and thus commenting upon it.

Work-exemplified truth of this second kind is by no means confined to modern and contemporary cinema or to films that are mainly or directly "about film" in fictional and narrative fashion. Yet, and to draw an analogy with the practice and theory of painting, neither is such truth always and only manifest in the conspicuous, *form-centered* way that Clement Greenberg famously tied to a definition of distinctly modern painting (from Cézanne to abstract expressionism) as always first and foremost "about" painting (a tendency that philosopher and art theorist Arthur C. Danto—with reference to Truffaut's films, in fact—directly compares with the pronounced "self-consciousness" of modern art cinema).[36] Nor, however, is the revealed, cinema-related truth in question exhausted by a more *representation-centered*, sometimes (self-)critical or probing, concern on the part of a film with cinema's nature, history, or institutional settings more along the lines of the self-referential character of "postmodern" pop and postpop art. To the contrary, this potential truth about cinema that Truffaut intimates, and I am expanding on, is something wider than the pronounced tendency toward the (self-)reflexive in both modern (or modernist) and contemporary (e.g., postmodern) cinematic guises that Danto, Deleuze, Robert Stam, and many other writers have usefully identified and compared with its manifestation in other arts, although it may, nonetheless, be seen to encompass and, in effect, license specific forms of reflexivity.

For beyond (self-)reflexivity as an artistic strategy and technique, the truth in question may also be seen as related to Kant's concept of the *exemplariness* of an artwork, as inextricably bound to a judgment concerning its merits. This idea refers, specifically, to the work's being judged as able and worthy of serving as a "model" or standard for future artistic creation and the founding of (new) stylistic traditions. The quality and capacity in question is regarded as a necessary "check" on *originality*, as Kant's other

criterion for a work's manifestation of artistic "genius."[37] Such exemplariness assumes a work's being recognized (by artists, as well as critics) as a creative and valuable artistic address of, and reflection on, the practices and past works of the art form in question, whatever specific form such address and reflection may take in individual works (e.g., whether relatively more form- or representation-centered).

We have already met with particular instances of such truth (and "exemplariness") in several places throughout this study. I refer here to some of the cited film works and worlds that exemplify through aspects of their form, narrative, and themes something true and significant about cinematic art (in light of recognition of their created and experienced worlds as symbolic and aesthetic realities). Works of film theory are typically full of such paradigmatic examples, and to that extent they implicitly admit such "cinematic" truth. Thus, not only may films serve as examples, models, and precedents for subsequent innovative and artistically significant filmmaking practices (as Kant's idea of artistic exemplariness entails), but, and more in line with a Hegelian and post-Hegelian conception of the (historically increasing) closeness of art and philosophical and critical reflection on art, they can stimulate and assist our critical thinking and theorizing concerning cinema's possibilities and limits as art. Pending further exploration and analysis, it seems reasonable (and not entirely circular) to believe that the ability of *some* films to valuably contribute to the formulation of a general theory of film art (whether it be the present one or some other) is testament to each presenting and disclosing some quantum of cinema-related truth in a compelling way.

As it seems hardly necessary to point out, many films do not exploit their own nature in this direction to the same extent or with the same significance and insight. Additionally, in some specific filmmaking modes and styles, as in some individual works, such "cinematic truth" may well be more prominent or trumpeted in some ways than it is in others and, in consequence, may be relatively more on the sensory and perceptual surface. More typically, however, and no less so than each film world's content of the existential truth we have described, this more specific, cinema-directed form of the true as that which is "brought out into the open," in Heidegger's sense, is often far from transparent, or always in plain view of casual observation or untutored experience, in any ordinary senses. As is the case with virtually all artistically exemplified and stylistic features (and world-markers), its appreciation may require efforts

of active, engaged interpretation and critical reflection, coupled with the prior possession on the part of the individual viewer of filmic and cultural literacy. Moreover, the general claim and conception that artistically and cinematically conveyed truth, whether "existential" or "cinematic" as here described, is revealed (e.g., in contrast to being discursively formulated) in the first instance, does not mean, or entail, that it is revealed to *all* viewers, on *every* occasion of a work's experience.

The complete picture (which can only be sketched here) is thus one of truth in a work of cinematic art ("existential") that potentially concerns any aspect of human experience and primarily works through and with symbolized "content" and subject matter but also transcends them—since it is ultimately inseparable from a film's global, presentational "form" and artistic world-version (i.e., of that which it represents). But there is also another sort of truth, concerning cinema itself, which is more akin to the exhibition of a *paradigm case* or *example* (to evoke a philosophical notion associated with the later reflections of Wittgenstein) and that, while often enlisting the aid of what a given film represents literally, fictionally, or figuratively, is also more "form" and self-centered (in other words, at a relatively lesser symbolic remove from its perceptual and formal presence). This aspect of aletheic "disclosure" pertains to what a cinematic work "says" about cinema (and cinematic art) as a practice and concept, while also providing an implicit version and interpretation of it. No less than in its outward facing representations, however, as I have maintained throughout the preceding chapters, the only vehicle for such self-reflection of a narrative film work is all the formal transformations of its chosen materials that it effects through both the film medium (or media) and the processes of narrative fiction. Taken together, these dual-facing, genuinely aletheic potentials of an encounter with a film world thus pose a significant challenge, at the highest levels of a work's cognitive and expressive value, to any overly simplistic or reductive use by theorists and critics of a form-and-content dichotomy.

FILM-WORLD TRUTH AND CRITICISM: SOME OBSERVATIONS ON ARTISTIC VALUE

In offering a world-centered framework for the theorization of films as artworks, I have taken a largely descriptive rather than normative or film-critical stance. While I have cited many films that are indisputably sig-

nificant in artistic terms, my inquiry has (with some exceptions) been concerned with the matter of what cinematic works and their worlds *are* as artistically intended objects and events, in contrast to what makes some films and worlds better (often far better) as art than others. However, in bringing to a satisfactory completion this discussion of the two forms of revealed and interpreted truth to which films as art may be conceived to aspire, and sometimes, at least, to attain—and also by way of necessary conclusion on this obviously large and ramified subject—a few consequent observations as to their specific relevance to the aesthetic valuation of narrative films are in order.

If, as I have claimed, every cinematic work-world is singular in its multifaceted totality (and even, perhaps, rationally incommensurable with others in some significant respects) and, further, that there is no one set of universal, fixed standards for critical judgment, or certain way to transition from film theory to "metacriticism," none of this should be taken (or need be taken) to imply that all films are of equal artistic value. Critical standards pertaining to the twin forms of film truth exist, even if these are culturally and historically relative and, perhaps less obviously, also highly relative to each given world (or world-system) in some respects (i.e., in the sense that some films require us to revise or enlarge our criteria and will continue to do so). All films, as symbolic constructs, organize realities in particular ways through the kinds of general processes that I have traced. But, this does not mean that they do so *well* or that the end result is particularly interesting, novel, or illuminating.[38] As Goodman astutely observes on the subject of the endlessly renewed process of more interesting and enlightening cultural and artistic world-making, "while readiness to recognize alternative worlds may be liberating, and suggestive of new avenues of exploration, a willingness to welcome all worlds builds none."[39]

To fully grasp the created worlds of films, as I have argued, it is first of all necessary to appreciate their artistic and cinematic transformations of that which is antecedently known, commonplace, and familiar. This is precisely where the two forms of filmic truth—existential and cinematic—meet each other and potentially effect a synthesis. Truffaut is right to suggest, in terms of what a good or great film must do, that such an "aletheic" conjunction is, and should continue to be, a principal criterion for a film's inclusion in any canon of narrative cinematic art. The best cinematic works, narrative and nonnarrative alike, not only express

truths about experience or "the world" and cinema together and simultaneously, but what is so expressed in each such case is (almost invariably found to be) interesting, profound, and revealing, as opposed to superficial, clichéd, and trivial. (To pick but one example: apart from any specific stylistic, narrative, and screenwriting considerations alone, this arguably marks the most fundamental difference in terms of artistic success and interest between Wenders's *Alice in the Cities, Kings of the Road,* and *Wings of Desire,* which are generally and rightly considered masterpieces of postwar European cinema, and his later *The End of Violence, The Million Dollar Hotel,* and *Land of Plenty,* which are generally considered artistic failures.)

More generally, these forms of truth may be considered among the chief objectives of film art—in some plausible sense of this notion such as the realization of the best-informed intentions on the part of filmmakers—and among the broad teleological goals of cinematic worldmaking, dissemination, and valid interpretation. If this much is accepted, there are normatively "true" and "false" film worlds, based on their possession or lack of a range of representations, exemplifications, and expressions of whatever extrawork realities the film addresses in terms of a subject. It matters little whether we speak here of post–World War I Vienna or swinging-1960s London, of childhood or the psychology of love, of the French Revolution or the troubles of Northern Ireland, or, indeed, of cinema itself. The issue is whether a cinematic work of art helps us to recognize (and "re-cognize") something new and significant—and feel something significant and perhaps emotionally atypical or unique and awareness-heightening—about it. Or, in contrast, does the work serve only as a mimetic conduit, confirming what is already common belief, attitude, or knowledge? Or, worse still, does it distort, obscure, or fail to do adequate justice to that which it incorporates or to which it refers? Since it is centered on the artistic creation and interpretation of a film, the "falsity" in question, however, like the potential for truth, is not an "extra-aesthetic" interpreted feature (e.g., connected to an inferred, didactic theme or "message") but lies near the heart of what I have explicated as a film's full aesthetic dimension.

If Truffaut's own *400 Blows* and *Jules and Jim* have claims to the status of important cinematic works of art, it is because, like *Citizen Kane* and *La règle de jeu* (as the two films that he singles out for attention in the respects I have been considering), they admirably fulfill these dual criteria. In these films both forms of truth—existential and cinematic—

are present in a pronounced way, sometimes in mutually illuminating (if dialectical) relation, and the "content" of each is deemed particularly valuable and compelling. In this sense the apprehended presence of such illuminating and compelling "ideas" (to return to Truffaut's suggestion, with which I began), or, at least, meaningful suggestions, concerning both "life" and "cinema," must be seen to testify to artistic accomplishment and value. The accompanying caveat, however, is that "ideas" here does not in any sense exclude the display of skill in the use and handling of formal and sensory properties, which, after all, are among the vehicles of transmission.

The forms of truth that successful cinematic works convey are the direct result of discovering or making cinematic and artistic forms that are both interesting and enlightening in themselves and then locating them within a seemingly right (or at least highly appropriate) vehicle for their narrative, thematic, and conceptual content. In this context Mitry has rightly observed that "though the work of art may take it upon itself to express valid truths, the problem exists in creating a form both necessary and suitable for giving the chosen idea its completed meaning, enabling it to become fulfilled in an original signification."[40] The concept of a film world that I have elucidated is consistent with Burch's contention that in cinema "a subject can engender form and that to choose a subject is to make an aesthetic choice."[41] That this may often seem not to be the case is more a reflection of the lack of aesthetic accomplishment or interest on the part of some films (and their makers) than any formalist proof that subject and form are, or should remain (somehow) functionally independent, even in a narrative film context. As Burch also argues, any subject a filmmaker chooses to address should ideally provide, in some way, an opportunity for a cinematic and wider artistic exploration of form, just as a film's form should ideally be related, or relatable, on various levels, to content and subject matter.[42] If narrative cinematic works of art are to be held to the general evaluative critical standards we customarily apply to novels, paintings, sculptures, and plays—and there appears no good reason not to—this is surely not too much to ask of them and of their creators.

My emphasis on this double and opposite-phased movement toward truth conveyed by and through an artistically successful film world is not to overlook the fact that even when present (in potential), it may not be fully manifest, or even discoverable by some audiences, in many cases. A

given cultural and artistic context, as well as all manner of (other) contingent historical and practical constraints, may have *not yet allowed* a film world's truth to be recognized and experienced. We could (if space permitted) discuss many cases in which extrawork factors concerning, for example, a film's audience, commercial interests and expectations, the lives of its makers, or a controversial or taboo subject matter have caused its artistically conveyed and embodied existential and cinematic truths and related values to go underappreciated for years or decades, if not to the present moment and thus have also prevented its potential artistic influence on subsequent films. Such historical vagaries that preclude due appreciation at particular times in film history are evident, for instance, in the wayward life-stories of now canonical films like *Vertigo*, recently surpassing *Citizen Kane* in the respected *Sight and Sound* critics' poll as the greatest film ever made, having opened to famously mixed and muted reviews in 1958 (before largely dropping off film and television screens for a number of years); Powell's scandal-inducing, near career-ending *Peeping Tom*; Kalatozov's extraordinary, "lost and found" *Soy Cuba* (sponsored by Soviet Russia and Castro's Cuban government, which later shelved it for political reasons); and still underappreciated narrative-experimental works like Lynch's *Twin Peaks: Fire Walk with Me*. Of course, to any such list to which the reader may wish to make his or her own additions, we should add the category of simply "undiscovered" film worlds of artistic merit and significance (with particular reference to the products of several lesser known and discussed national cinemas and traditions).

Classic films may stand the proverbial test of time, but none are timeless in the truths they disclose about experience and cinema. In this respect, as in others, they are subservient to the historicity of artistic perception, interpretation, and judgment. Although the history of cinema is still undeniably brief in comparison with the other arts—making its artistic accomplishments and milestones all that more impressive—what we may see and appreciate in and about a film world constructed today may not have been grasped thirty or sixty years ago and perhaps could not possibly have been. But also, and vice versa, there are likely some aspects, including aesthetically significant ones, of certain cinematic worlds that, owing to lack of requisite knowledge, experience, or interest, the contemporary viewer can no longer see, feel, and comprehend. If in itself not particularly original, the robust acknowledgment of the artistic truth of

films being bound to vicissitudes of history, circumstances, and taste is one of the principal benefits of conceiving of a cinematic work's created and presented world as a hermeneutic *event*—a dialogical process that begins but most certainly does not end with a film's (first) viewing. And if the human creators of cinematic works and worlds have their artistic careers, so, too, as previously suggested, do their creations have their "interpreted careers," in Margolis's phrase.[43] These, as well, are important parts of a film world's experience, and any specific attempt at informed interpretation also involves the viewer's active considerations of their past "lives," in the form of their previous receptions and interpretations, from the standpoint of the present situation (just as, that is, and in a more systematic way, this sort of awareness, whether it is made explicit or not, also informs their scholarly discussion and appraisal).

The present argument is not meant to suggest that the more profound, and thought- and creative action-inspiring, truth(s) in question are the only monuments of lasting cultural significance and value that are or should be in play with respect to the productive and informed criticism of cinematic works in artistic or aesthetic terms, nor their experience. One may wonder, for instance, where the phenomena of the aesthetic or other *pleasures* of cinema, of our sometimes simple enthrallment with the art of the moving image as a "for-itself" good, as it were, fit into this general approach. Yet this prominent aspect of viewer experience, as one reason among many why people watch films (of all kinds), does not seem to me to be in any way incompatible with what I have maintained about film worlds in terms of their artistic (i.e., aesthetically symbolic and affective) truth and value. Experiencing, coming to know, the revealed and interpreted truths of films is frequently satisfying, pleasurable, and intensely exciting, including in those ways that we might attempt to define (and defend) as uniquely aesthetic or responsive to art. And although other types of pleasure and delight in the wonders of cinematic media and their use (which will no doubt continue on their track of technical innovation) is often ancillary to it, it is by no means necessarily antithetical to the genuine knowledge that films, as artistic worlds, may provide. By the same token, however, viewers can take all manner of clearly nonaesthetic pleasures—voyeuristic, erotic, ironic, "guilty"—in watching films that they and others would not wish to regard as artistically or culturally significant. Surely pleasure on its own, even in that contemplative, "disinterested" form

Kant posits as at the root of the aesthetic and its connection to fine art, does not begin to exhaust our visits to film worlds in all their cognitive and affective richness, complexity, and heterogeneity.[44]

Although the truth and value of films as art is a "serious" matter in the ways that I have been arguing throughout, there is, of course, no correlation between this seriousness and a relative seriousness of tone, attitude, or genre. The comedy or musical film, as well as the drama, may reveal much that is previously hidden our unknown amid the appearances that surround us. Moreover, it may do so not only (and without contradiction) in thoroughly entertaining ways but in a formally and expressively innovative fashion that expands the artistic range and scope of narrative cinema. An artistically interesting and truth-conveying film world may, it would appear, address itself to any subject and aspect of life (including apparently common or even trivial ones) and adopt any perspective, attitude, or tone in so doing. Given some common expectations, and past and current critical prejudices, however, it is perhaps especially important to take note of Jacques Demy's observation—aptly capturing not only the great artistic achievements of many of the best film comedies but also his own major and frequently overlooked contribution to cinematic art—that "lite films about serious subjects" may be more artistically profound and valuable than "serious films about lite subjects."[45]

In this chapter we have begun to explore a hermeneutics of cinematic art commensurate with the proposed concept of film worlds. A more adequate treatment would involve much more detailed consideration of particular films and their interpretations (over time). I hope enough has been said, however, to show that the "objective" reality of a cinematic work-world, as a symbolic-aesthetic object, and its most "subjective" one, as an unfolding affective-immersive experience in lived time, are united in both the reality and the concept of the cinematic *event*, as at once a life experience and reflection of the larger, contextual realities of culture and cinematic tradition. If anywhere, here is the meeting and reconciliation of subject and object, work and viewer, the times, places, and activities of a film's creation and its experience and interpretation. In terms of its theorization and description, recognizing artistic truth in narrative cinema (which is, of course, never a whole or final truth) necessarily involves consideration of the ways in which a cinematic work is a representationally and narratively conveyed fictional reality and story, as well as a formally embodied, symbolically constituted object that provides a highly

personal, subjective aesthetic experience within each viewer's private consciousness. But it equally requires full recognition that in the most profound and ramified sense, it is also an intersubjective, historical, and cultural reality—an event of art.

In the foregoing chapters I have advanced the thesis that in its major aspect as a symbolic, affective, and aesthetic object and event, a narrative film creates and presents a world. The world-like character of a cinematic work is asserted not only in the (generally and theoretically accepted) sense of an imagination-posited place and time, where fictional characters exist and a certain story of their actions unfolds, but also the more holistic and (perhaps) philosophically deeper one that each film presents (or is, at least, capable of presenting) nothing less than its own artistic version of human experiential reality on integrated sensory, affective, and cognitive levels.

My goal has been to offer an alternative approach to the aesthetics of cinema. While I have proposed some original concepts, distinctions, and descriptions, this has also involved the introduction (or reintroduction) of a number of already existing and illuminating, if currently somewhat neglected, philosophical and theoretical perspectives on art and cinema into the contemporary discourse of film theory and philosophy. Indeed, and with respect, for example, to the expressive and emotional valences of films, their self-referential dimensions, and complex dynamics of cinematic experience as aesthetic experience, and the artistically conveyed truths of films, these represent perhaps more perspectives than can be adequately explained, or done justice to, in one volume. Informed by appropriate theoretical and philosophical sources, the exploration of these and other relevant subjects will, I hope, continue in other forms and contexts. Most of all, it will await further impetus from the extraordinary worlds brought into existence through the various media of the moving image.

Whatever its merits and defects may be, the model of an artistically intended and aesthetically experienced film as a specially constructed and experienced world is not a reductive one. It does not, in other words, whittle down narrative cinematic art to one or another partial aspect, magnified out of proportion, in the attempted application of a single, all-embracing, one-size-fits-all theoretical system or doctrine nor to an excessively narrow empirical research program. Of course theory is not the

same as history or description, but it must do justice, if it is to be pursued at all, to the multiplicity and complexity of the phenomena it attempts to organize and understand, which, in this case, is also naturally, historically, and culturally shaped and mediated to a profound degree. Above all, film theory (as also intersecting with the philosophy of film) must (still) seek to capture, however necessarily in a series of relatively pale abstractions, something of the full and actual sources and effects of narrative cinema's *artistic* spell. While much detail remains to be filled in, the proposed framework, like the fundamental approaches to art and art-making it draws on, at least leaves ample room to do so.

INTRODUCTION

1. Deleuze, *Cinema 2*, 68.
2. Bradley, quoted in Abrams, "From Addison to Kant," 163.
3. Bordwell writes: "We don't have to think of film as an art form. A historian can treat a movie as a document of its time and place . . . but most of the time we assume that cinema is an art of some sort" (Bordwell and Thompson, *Minding Movies*, 86).
4. Sarris, "Notes on the Auteur Theory," 562.
5. On the postmodern critique of aesthetics, more generally, see Schaeffer, *Art of the Modern Age*.
6. See Margolis, *Cultural Space of the Arts*.
7. Dyer, "Introduction to Film Studies," 4.
8. This is certainly not to pit the "cultural" against the "aesthetic," which, as Dyer rightly notes, is a false opposition (ibid., 9–10).
9. Bordwell and Thompson, *Minding Movies*, 95.
10. See Bordwell, "Contemporary Film Studies"; and Carroll, "Prospects for Film Theory."
11. Along with Bordwell's *Narration in the Fiction Film*, other works include Branigan, *Narrative Comprehension and Film*; Verstraten, *Film Narratology*; Chatman,

Coming to Terms; Wilson, *Narration in Light*; and Wilson, *Seeing Fictions in Films.*

12. See Thompson, "Concept of Cinematic Excess."

13. Wolf, *Building Imaginary Worlds*, 53.

14. Bordwell and Thompson, *Minding Movies*, 86, 92–93.

15. In these respects this is a very different view of what an aesthetic approach to narrative cinema may consist in from that which Murray Smith appears to suggest in his essay "Film."

16. For recent, similar perspectives in the contemporary analytical tradition see, e.g., Anderson, "Aesthetic Concepts of Art"; and Goldman, "The Aesthetic."

17. Goldman, "The Aesthetic," 265.

18. See Lewis's foreword in Mitry, *Aesthetics*, vii; and Andrew, *Major Film Theories*, 185–205.

19. Mitry, *Aesthetics*, 80.

20. See Andrew, *Major Film Theories*; and Andrew, *Concepts in Film Theory*. In an article appearing a few years before my 2008 piece "Towards a Theory of Film Worlds," and well after Andrew's discussions, Christopher S. Yates also addresses "cinematic worlds" with reference to Dufrenne's aesthetics, for example. His main focus, however, is on Heidegger's concept of "world-disclosure" and aspects of Stanley Cavell's philosophy of film as juxtaposed with the works of Terrence Malick (see "Phenomenological Aesthetic of Cinematic Worlds").

21. Goodman, *Ways of Worldmaking*, 70.

1. Worlds Within Worlds

1. Andrew suggests this distinction in relation to films but does not explicate it in the present terms (see *Concepts in Film Theory*, 40–47).

2. Wittgenstein, *Tractatus Logico-Philosophicus*, 25.

3. McKay and Nelson, "Propositional Attitude Reports" n.p. Propositions for these purposes may be generally understood as "public, language-independent, abstract entities with a structure that mirrors, to some degree, the syntactic structure of the natural language sentences that express them."

4. Some theorists have evoked so-called modal logic, that is, the logic of "possible worlds," in relation to fictional worlds of works, insofar as the latter are posited as at least logically possible realities but ones (as yet) empirically unrealized.

5. Bloom and Skolnick, "Intuitive Cosmology," 77.

6. See Ryan, *Narrative as Virtual Reality*, 89–139.

7. Herman, *Story Logic*, 4.

8. Walton, *Mimesis as Make-Believe*, 144–45; see also his "How Remote Are Fictional Worlds?"

9. Walton, *Mimesis as Make-Believe*, 57.

10. Carroll, *Engaging the Moving Image*, 201.

11. Goodman asserts that "there are no fictive worlds" (*Of Mind and Other Matters*, 125).

12. Margolis, *Cultural Space of the Arts*, 135.

13. Ibid., 137.

14. Walton, *Mimesis as Make-Believe*, 140.

15. Andrew, *Concepts in Film Theory*, 40.

16. Ibid.

17. Wolterstorff, *Works and Worlds of Art*, 198–99.

18. Abrams, "From Addison to Kant," 164; see also Wilson, "Comments on *Mimesis as Make-Believe*" (393) for a discussion of Abrams's work.

19. Abrams, "From Addison to Kant," 170.

20. See Tolkien, *Tolkien on Fairy-Stories*, 112; see also Wolf, *Building Imaginary Worlds*.

21. Gadamer, *Truth and Method*, 112.

22. Frampton, *Filmosophy*, 47.

23. Ibid., 6–7.

24. Frampton argues that although "filmmakers are film-creators," they are also "simple conduits for film-thinking" (ibid., 75).

25. See Sobchack, *The Address of the Eye*, 24.

26. See Livingston, *Art and Intention*, 62–90.

27. Wollen, *Signs and Meaning*, 116.

28. See Lamarque, *The Philosophy of Literature*, 197–202.

29. Wolf, *Building Imaginary Worlds*, 11, 29.

30. Perkins, "Where Is the World?" 22.

31. Metz, *Film Language*, 98; also quoted in Winters, "The Non-diegetic Fallacy," 228.

32. Burch, *To the Distant Observer*, 18–19. As Winters has pointed out, this differs from other influential theoretical conceptions of the diegetic (forwarded by Gérard Genette and Claudia Gorbman, among others) pertaining to cinematic narration exclusively or to a distinct level of it (see "The Non-diegetic Fallacy," 225–27).

33. See Mitry, *Aesthetics*, 72.

34. See Winters, "The Non-diegetic Fallacy"; and Stilwell, "Fantastical Gap."

35. Winters, "The Non-diegetic Fallacy," 225.

36. See, e.g., Bordwell's persuasive critique in *Narration in the Fiction Film*, 16–26.

37. See also Cecchi, "Diegetic versus Nondiegetic."

38. See Winters, "The Non-diegetic Fallacy," 224; and Cecchi, "Diegetic versus Nondiegetic."

39. See Winters, "The Non-diegetic Fallacy," 224, 228; and my "Spaces, Gaps and Levels."

40. Stilwell, "Fantastical Gap," 184; see also Winters, "The Non-diegetic Fallacy," 224.

41. Perkins, "Where Is the World?" 36.

42. Metz, *Film Language*, 108–9, 111, 212–15.

43. Ibid., 76–80, 97–98.

44. See ibid., 98. In addition to citing Dufrenne in *Film Language*, Metz also credits him with the suggestion of publishing the book (see xii).

45. Dufrenne, *Phenomenology*, 176.

46. Ibid., 175.

47. Metz, *Film Language*, 10.

48. Dufrenne, *Phenomenology*, 167.

49. See notably Wollen, *Signs and Meaning*, 153; and Harman, "Semiotics and the Cinema," 90–93.

50. Burch, *Life to Those Shadows*; Bordwell, Staiger, and Thomson, *Classical Hollywood Cinema*, 24.

51. See Kawin, *Mindscreen*; and Orr, *Contemporary Cinema*.

2. THE FRAMEWORK OF WORLDS

1. *Sherlock Jr.*, *Céline et Julie vont en bateau*, *Videodrome*, *The Purple Rose of Cairo*, and *Inland Empire* are among notable films that explore this fantasy.

2. *Oxford English Dictionary* (hereafter *OED*), 2nd ed., s.v. "world."

3. See Heidegger, "Origin of the Work," 34, 42–44; and Gadamer, *Truth and Method*, 443.

4. *OED*, s.v. "world." In a lecture (published in *The Empirical Stance*) Bas C. Van Fraassen also surveys the dictionary meanings of the word *world*, and their respective histories, for the purpose of showing that, despite grammatical appearances, the term does not refer to any single object or entity.

5. See, e.g., Schutz, "On Multiple Realities."

6. See Margolis, "Deviant Ontology of Artworks."

7. See Goodman, *Ways of Worldmaking*, 4.

8. See Sebeok, *Signs*, 3.

9. See Wollen, *Signs and Meaning*, 141.

10. See also Buckland, *Cognitive Semiotics of Film* as another instance of a somewhat hybrid position in this respect.

11. See, e.g., Underhill, *Creating Worldviews*, 19–21, 63–64.

12. On this topic see Taylor, *Philosophical Arguments*.

13. Ibid., 101.

14. See Ellis, *Language, Thought, and Logic*, 1–44.

15. Friedman, *Parting of the Ways*, 88; see also Rockmore, *In Kant's Wake*, 17.

16. See, e.g., Dupré, "Cassirer's Symbolic Theory"; and Verne, "Cassirer's Concept."

17. Hamlin and Krois, *Symbolic Forms*, xv.

18. Cassirer, *Language and Myth*, 8.

19. See ibid., 98, for instance, as well as his *An Essay on Man*; and Verne, "Cassirer's Concept," 21.

20. See Verne, "Cassirer's Concept," 22–24.

21. See Cassirer, *An Essay on Man*, 141.

22. Langer, *Feeling and Form*, 410.

23. See Langer, *Philosophy in a New Key*, 97–99.

24. Ibid., 93–94.

25. See Langer, *Problems of Art*, 124–27.

26. Langer's suggested strong, overall identification between the film camera and the viewer (as witness to represented events) as a *general property* of all cinema, as opposed to a feature of specific works or film styles, is problematic, for instance, as are at least some of her analogies between cinema and dream experience.

27. Carroll, *Philosophical Problems*, 262; and Carroll, *Engaging the Moving Image*, 1–9.

28. See Goodman, *Ways of Worldmaking*, 1–2.

29. See Ricœur, "*Ways of Worldmaking* (Nelson Goodman)," 107.

30. Goodman, *Ways of Worldmaking*, 5; *Languages of Art*, xi.

31. Goodman, *Ways of Worldmaking*, 3.

32. Ibid., 11.

33. See, e.g., Brown, "Greenaway's Contract."

34. Pascoe, *Peter Greenaway*, 21.

3. Filmmaking as Symbolic Transformation

1. Panofsky, "Style and Medium," 365. See also Cavell, *The World Viewed*, 16.

2. Pudovkin, *Film Technique*, 24.

3. Rohmer, quoted in Bazin, *Orson Welles*, 120.

4. Wilson also suggests as much in *Narration in Light*, 140.

5. Burch, *Theory of Film Practice*, xix.

6. Holmes and Ingram, *François Truffaut*, 180.

7. In the published screenplay of the film Truffaut discusses this attitude as displayed by the character of Ferrand (see Truffaut, *Day for Night*, 12).

8. Holmes and Ingram, *François Truffaut*, 181.

9. Burch, *Theory of Film Practice*, 120.

10. Mast, "What Isn't Cinema," 386.

11. Langer, *Feeling and Form*, 412.

12. This is the title of Danto's 1981 philosophical study of art, drawing examples from pop art practice.

13. See, e.g., Deleuze, *Cinema 1*, 56–57. In later writings Mitry endorsed Deleuze's views as being close to his own much earlier published ones (see Mitry, *Semiotics*, 22–23).

14. See Greene, *Pier Paolo Pasolini*, 92–126.

15. Mitry, *Aesthetics*, 54.

16. See Andrew, *The Major Film Theories*, 185–211; and Lewis, *Jean Mitry*, 6–7.

17. Mitry, *Aesthetics*, 88, 80.

18. See ibid., 343.

19. Lewis, *Jean Mitry*, 64. Lewis has also discussed similarities between both Mitry's and Dufrenne's "antistructuralist" views of the artistic symbol and Langer's, Ricœur's, and Merleau-Ponty's, all seen to be part of a similar "family" tradition in this respect, one roughly analogous to that which I have traced further back in time (see ibid., 7, 55, 64).

20. Patar in Mitry, *Aesthetics*, xv.

21. Mitry, *Aesthetics*, 15 (subsequent references to this source are cited parenthetically in the text proper).

22. Dufrenne, *Phenomenology of Aesthetic Experience*, 325.

23. Mitry's stated views bear some resemblance to V. F. Perkins's arguments in *Film as Film*, which also seeks to reconcile (while amending) central insights of classical realist and formalist film theory.

24. See Mitry, *Aesthetics*, 355.

25. Greene, *Pier Paolo Pasolini*, 92.

26. Pasolini's sometimes unorthodox and ambiguous application of linguistic terminology to cinema, in analogies drawn between film and language, attracted criticism from both semiotic and nonsemiotic theorists. This also appears to have colored Mitry's reading of Pasolini in which the French theorist notably fails to recognize the affinity between Pasolini's account and his own symbol-centered views (see Mitry, *Semiotics*, 138–39).

27. For more on Pasolini's relevant views see Greene, *Pier Paolo Pasolini*; and Viviani, *A Certain Realism*.

28. Eisenstein, *Film Form*, 130; see also Lewis, *Jean Mitry*, 23–27.

29. Pasolini, "The 'Cinema of Poetry,'" 168.

30. See Greene, *Pier Paolo Pasolini*, 113.

31. Ibid., 98; Greene quotes Deleuze on 109.

32. Pasolini, "The 'Cinema of Poetry,'" 171.

33. Ibid. (Pasolini's emphasis).

34. It is not that Mitry denies this semiotic "prehistory" so much as he deemphasizes it.

35. See Bordwell, Staiger, and Thompson, *Classical Hollywood Cinema*.

36. Pasolini, "The 'Cinema of Poetry,'" 169–71.

37. Metz, *Film Language*, 215n.

38. Ibid., 137–40, 215 (and note).

39. Pasolini, "The 'Cinema of Poetry,'" 170.

40. Ibid., 173.

41. From Pasolini's Marxist perspective, however, the aesthetic achievement in question is not always ideologically defensible: a case in point being the "poetic" cinema of Godard, Antonioni, and Bertolucci, which he sharply criticizes for its "bourgeois" artistic sensibility.

42. Metz, *Film Language*, 76.

43. See Heidegger, "Origin of the Work of Art," 45–49.

44. Pasolini, "The 'Cinema of Poetry,'" 171.

45. Billard, "Interview with Michelangelo Antonioni," 8.

46. Mitry, *Semiotics*, 171. Although for these reasons language is not an appropriate theoretical "model" for film, in Mitry's view it remains an appropriate "basic" point of comparison.

47. Deleuze, *Cinema 1*, 12.

48. See Panofsky, *Meaning in the Visual Arts*, 26–41.

4. WAYS OF CINEMATIC WORLD-MAKING

1. Goodman, *Ways of Worldmaking*, 4.

2. Ibid., 34.

3. According to Lamarque and Olsen, the concept of a world-version enables Goodman to deflect "the simple objection that worlds are just too vast or comprehensive to be the sorts of things [individual] humans can make. Making *parts* of worlds or making *changes* in worlds is more on the human scale" (*Truth, Fiction, and Literature*, 209).

4. Goodman, *Ways of Worldmaking*, 7–17.

5. Deleuze, *Cinema 1*, 16.

6. Mitry, *Aesthetics*, 88.

7. Bonitzer, "Deframings," 200.

8. Bazin, *What Is Cinema?* 1:165–66.

9. Mitry, *Aesthetics*, 45.

10. See Marks, *The Skin of the Film*, 172–77.

11. See my "Space, Theme and Movement."

12. Goodman, *Ways of Worldmaking*, 11.

13. Deleuze, *Cinema 1*, 108.

14. Kracauer, *Theory of Film*, 46.

15. See Goodman, *Ways of Worldmaking*, 13–14.

16. Chion, *Kubrick's Cinematic Odyssey*, 66.

17. Metz, *Film Language*, 115.

18. Deleuze, *Cinema 2*, 98–125.

19. See Kovács, *Screening Modernism*, 137–38.

20. Perkins, quoted in Bordwell, *Narration in the Fiction Film*, 282.

21. See Bordwell, *Narration in the Fiction Film*, 274–310.

22. On the subject of temporal and spatial divisions, intertitles, and reflexivity see Chion, *Kubrick's Cinema Odyssey*, 66–70.

23. See also Biro, *Turbulence and Flow in Film*, 203–29.

24. See Burch, *Theory of Film Practice*, 5–6.

25. Chion, *Kubrick's Cinema Odyssey*, 81.

26. Goodman, *Ways of Worldmaking*, 14.

27. Such viewer construction is one of the cornerstones of Bordwell's theory of film narration (as *fabula* construction), drawing as it does on approaches to perception and comprehension rooted in cognitive psychology (see Bordwell, *Narration in the Fiction Film*).

28. Goodman, *Ways of Worldmaking*, 14.

29. Bresson, *Notes on the Cinematographer*, 93–94, 104, 96.

30. See Thompson's analysis of what she calls the film's "sparse parametric style" (*Breaking the Glass Armor*, 289–317).

31. See Tarkovsky, *Sculpting in Time*.

32. Similarly, Deleuze refers to the "saturated" image-sets of some films and styles (marked by a "multiplication of independent data") in contrast to relatively "rarefied" ones (such as close-ups of single objects, or the depictions of "empty" places and spaces) (*Cinema 1*, 12).

33. Godard, *Godard on Godard*, 239.

34. Goodman, *Ways of Worldmaking*, 14.

35. See ibid., 16.

36. Bakhtin, *The Dialogical Imagination*, 68–82.

37. Along these lines, Goodman cites caricature in drawing as a prime example of distortion (see *Ways of Worldmaking*, 16).

38. Goodman regards "quotation" as a major aspect of world-making and devotes a chapter to its logical and epistemological nature in *Ways of Worldmaking*, 41–56.

39. From this perspective, and as Theodore Gracyk observes of Goodman's aesthetics, "artistic creativity must be measured by an artist's relationship to existing symbol systems" (Gracyk, *The Philosophy of Art*, 58).

40. See Goodman, *Ways of Worldmaking*, 17.

41. Ibid., 54.

42. Cavell, *The World Viewed*, 31.

43. Carroll, *Engaging the Moving Image*, 141.

5. Representation, Exemplification, and Reflexivity

1. It was subsequently extended and modified in later writings, including those with coauthor Catherine Z. Elgin.

2. Goodman, *Languages of Art*, 5.

3. See Metz, *Film Language*, 108–14.

4. Those philosophers and theorists who appeal to putative scientific support for a general perceptualism and so-called pictorial recognition theory, which de-emphasizes cultural mediation with respect to the perception of film images, include Noël Carroll, Gregory Currie, and Berys Gaut. See, e.g., Carroll, *Philosophy of Motion Pictures*; and Currie, "The Long Goodbye."

5. Goodman, *Languages of Art*, 16.

6. On this issue see Files, "Goodman's Rejection of Resemblance"; Lopes, *Understanding Pictures*, 55–76; and Lopes, "From *Languages of Art*." In the latter Lopes attempts to "salvage" Goodman's position on the conventional nature of pictorial representation by reinterpreting it.

7. See Robinson, "Goodman," 187; Lopes, *Understanding Pictures*; and Andrew, *Concepts in Film Theory*, 38–41.

8. Mitry, *Aesthetics*, 51, 72–88.

9. On this point, and with reference to all representational art, see Margolis, "Deviant Ontology of Artworks," 120–21; and Margolis, *Cultural Space of the Arts*.

10. See Goodman, *Languages of Art*, 253.

11. See, e.g., Arrell, "Exemplification Reconsidered"; Lopes, *Understanding Pictures*, 220–22; and Lopes, "From *Languages of Art*."

12. Goodman and Elgin, *Reconceptions in Philosophy*, 9.

13. See Goodman, *Languages of Art*, 53.

14. Goodman and Elgin, *Reconceptions in Philosophy*, 9.

15. Goodman, *Ways of Worldmaking*, 64–70.

16. Metz, *Film Language*, 77.

17. See Goodman and Elgin, *Reconceptions in Philosophy*, 69.

18. Goodman, *Languages of Art*, 253.

19. Van Fraassen, *Scientific Representation*, 17.

20. Goodman, *Ways of Worldmaking*, 65.

21. Ibid., 135–37.

22. For a balanced discussion of Goodman's account of exemplification see Gracyk, *Philosophy of Art*, 47–51.

23. In Goodman's own idiom, "Exemplification relates a symbol to a label that denotes it, and hence indirectly to the things (including the symbol itself) in the range of that label" (*Languages of Art*, 92).

24. See, e.g., Goodman, *Ways of Worldmaking*, 66–70; Margolis, "Art as Language"; and Beardsley, "*Languages of Art* and Art Criticism."

25. The latter phrase is often associated with the Lumière brothers' view of their invention and with Bazin's film theory.

26. See Goodman and Elgin, *Reconceptions in Philosophy*, 20.

27. See ibid., 40–41; and Goodman, *Languages of Art*, 85–95.

28. Goodman, *Languages of Art*, 248. For a criticism of this view see Carroll, *Philosophy of Art*, 95–104.

29. Goodman, *Of Mind and Other Matters*, 8.

30. Thompson, *Breaking the Glass Armor*, 10.

31. See, e.g., Whittock, *Metaphor and Film*; and Carroll, *Theorizing the Moving Image*, 212–23.

32. Goodman, *Languages of Art*, 80. Although far too vast a topic to be addressed here, unlike the theorists cited above, Goodman considers the movement in thought from concrete or possessed perceived properties of artworks to more abstract ones (via so-called "root" or "conceptual" metaphors) to be indispensable to the processes of interpretation and understanding.

33. See Whittock, *Metaphor and Film* for detailed discussion of metonym and synecdoche in cinema.

34. Goodman and Elgin, *Reconceptions in Philosophy*, 70.

35. Lopes, *Understanding Pictures*, 220.

36. See Goodman and Elgin, *Reconceptions in Philosophy*, 42–44.

37. See Langer, *Feeling and Form*, 412.

38. Julia Kristeva (who introduced the term into widespread use), Roland Barthes, and Gérard Genette regard intertextuality as an alternative to the discourse of "intersubjectivity," individual intentionality, and influence in literary studies; see Kristeva, *Desire in Language*, 66.

39. Goodman and Elgin, *Reconceptions in Philosophy*, 42.

40. See MacCabe, "Realism and the Cinema."

41. These include Deleuze, *Cinema 2*; Stam, *Reflexivity in Film and Literature*; Bordwell, *The Way Hollywood Tells It*; and Perkins, "Where Is the World?"

42. Goodman and Elgin, *Reconceptions in Philosophy*, 38.

43. Ibid., 36.

44. Sobchack, for instance, pursues an "anti-expressionistic" conception of reflexivity in film wherein it is explicitly identified with what she sees as the "perceptual" nature of the medium rather than its artistic uses (see *Address of the Eye*, 5, 20, 143).

45. Stam discusses cinema in relation to some of these traditions in *Reflexivity in Film and Literature*.

46. See Burgoyne, Flitterman-Lewis, and Stam, *Vocabularies in Film Semiotics*, 198–203.

47. I intend, in fact, to explore the nature of cinematic reflexivity as a form of symbolic exemplification and filmic world-making in a subsequent work.

48. See Greene et al., *Princeton Encyclopedia*, s.v. "objective correlative."

49. In fact, the dark wig Camille/Bardot wears is, according to Godard biographer Richard Brody, the same that Karina/Nana wore in some sequences in *Vivre sa vie* (see Brody, *Everything Is Cinema*, 163).

50. In this sequence Godard's own voice narrates portions of Poe's story "The Oval Portrait" over highly composed shots of Karina's character, Nana, and finishes with the line, "It's our story, a painter portraying his love."

51. For discussion of more examples of this dynamic in the film see Brody, *Everything Is Cinema*, 157–73.

52. Goodman, *Languages of Art*, 93–94.

53. On this and the dynamic oscillation between the "over-objective" and the "over-subjective" poles in Kubrick's cinema see Chion, *Kubrick's Cinema Odyssey*, 82–89.

54. Ebert, "Review of *El Topo*," n.p.

55. Goodman, *Ways of Worldmaking*, 68; see also Elgin, "Reorienting Aesthetics."

56. See Meskin, "Style," who cites on this basic point Gombrich, Panofsky, Walton, and Robinson.

57. See Carroll, *Engaging the Moving Image*, 127–64.

58. Goodman, *Ways of Worldmaking*, 34, 39.

59. Ricœur, "*Ways of Worldmaking* (Nelson Goodman)," 111.

60. Goodman, *Ways of Worldmaking*, 40.

61. Goodman distinguishes between "trivial" and "contingent" features of works and "constitutive" ones (*Ways of Worldmaking*, 34–37).

62. See Bordwell, *Making Meaning*.

63. Schaeffer, *Art of the Modern Age*, 304.

64. Goodman, *Ways of Worldmaking*, 39, 35–36.

65. See Bazin, *What Is Cinema?* 2:144; and Altman, "A Semantic/Syntactic Approach to Film Genre."

66. See Deleuze, *Cinema 1*; Deleuze, *Cinema 2*; and Jameson, *Postmodernism*. In another example of a relatively more general classification, James Walters has proposed a typology of represented worlds in films consisting of "imagined worlds," "potential worlds," and "other worlds" (more sharply divorced from "reality"). See Walters, *Alternate Worlds*, 157.

67. On the relation between Tarr's films and those of Antonioni, Jansco, Tarkovsky, and Bresson, see Kovacs, *Cinema of Béla Tarr*, esp. 15, 50–51, 60, 174; on Green's relation to Bresson see Brooke, "Robert Bresson."

68. See Carroll, *Engaging the Moving Image*, 127–47.

69. See Robinson, "Goodman," 192, 195–96.

6. FORMS OF FEELING

1. See Robinson, *Deeper Than Reason*, 231–32.

2. Carroll, *Engaging the Moving Image*, 145.

3. See Carroll, *Philosophy of Art*, 80.

4. See Croce, *The Essence of Aesthetic*; and Collingwood, *Principles of Art*.

5. See, e.g., Marks, *Skin of the Film*; Massumi, *Parables for the Virtual*; and Shaviro, *The Cinematic Body*.

6. See Massumi, *Parables for the Virtual*.

7. Plantinga, "Notes on Spectator Emotion," 378.

8. Tan, *Emotion*, 44.

9. Gaut, *Philosophy of Cinematic Art*, 244.

10. See, e.g., Smith, *Engaging Characters*; Plantinga and Smith, *Passionate Views*; Carroll, *Philosophy of Mass Art*, 245–90; and Carroll, *Engaging the Moving Image*, 59–87.

11. See Turvey, "Seeing Theory"; see also Allen, "Looking at Motion Pictures (Revised)"; and Wittgenstein, *Philosophical Investigations*, 193–208.

12. See Carroll, *Engaging the Moving Image*, 68–74; see also Gaut, who defends a version of the widely held character identification doctrine (*Philosophy of Cinematic Art*, 252–62).

13. Tan, *Emotion*, 52–56.

14. Ibid., 64–65, 81–84.

15. Plantinga, *Moving Viewers*, 74.

16. See Smith, "Imagining from the Inside," 412–30; and Elliott, "Aesthetic Theory."

17. See Plantinga, *Moving Viewers*, 74.

18. See, e.g., Carroll, *Engaging the Moving Image*, 44–45.

19. Plantinga, *Moving Viewers*, 68–71.

20. As a whole this typology mirrors, approximately, a general analysis forwarded in recent years by Jon Elster, according to whom emotional experience in the arts may be analyzed in terms of features or elements of works that are immediate and visceral, cognitive, and intrinsic or qualitative (see *Alchemies of the Mind*, 246).

21. See Prinz, *Gut Reactions*.

22. See Elster, *Alchemies of the Mind*, 255.

23. Carroll has discussed this sort of feeling in films; see, e.g., his *Engaging the Moving Image*, 33.

24. Metz, *Film Language*, 76.

25. Mitry, *Aesthetics*, 343. Mitry also refers to this as "a priori emotional response" to a film's representations.

26. In wider terms, of the three forms of affective expression in films identified, the sensory-affective would appear the most amenable to empirical, scientific study by a considerable distance.

27. A third, intermediary subcategory of sensory-affective expression may involve so-called haptic affectivity. This is seen to follow from the nature of what Marks and other writers term "haptic images" (here taking inspiration from Deleuze's analysis of Francis Bacon's paintings and other, older theoretical and art-historical sources). These lack any clear representation or denotation of objects (or objects-as-wholes) while still representing some parts or aspects of them. Lacking such clear representational purposes (or success), such images foreground the surfaces and textures of profilmic materials and are seen to activate less ocular and more "tactile" and synesthetic sensory capacities (see Marks, *Skin of the Film*).

28. Mitry discusses this subject with reference to Resnais's *Night and Fog* (see *Aesthetics*, 342).

29. Barthes, "An Introduction to the Structural Analysis of Narrative," 237.

30. See, e.g., Chatman, *Coming to Terms*.

31. Carroll, *Engaging the Moving Image*, 74.

32. Bordwell, *The Way Hollywood Tells It*, 121–37.

33. Perhaps inevitably, some films that prioritize this sort of affect have had thrill rides based upon them constructed at major theme parks or, as in the case of Disney's *Pirates of the Caribbean* franchise, have been directly inspired by such rides.

34. Cassirer, *An Essay on Man*, 141.

35. Mitry, *Aesthetics*, 337.

36. See Perkins's relevant analysis of the sequence and its symbolic and affective levels and objects in *Film as Film*, 107–15.

37. Sarris, quoted in Hoberman, "*Psycho* Is 50," n.p.

38. Deleuze, *Cinema 2*, 42–44.

39. Thompson points out that when a given cinematic "device" appears onscreen for a certain amount of time over and above that which is required to convey narrative information, this may cue the attention of some viewers to the it *as* an employed device with extranarrative "artistic" import. See Thompson, "Concept of Cinematic Excess," 518.

40. See Bordwell, *Narration in the Fiction Film*, 32–33, 36, 53.

41. Barker, *Tactile Eye*, 3.

42. Gunning, "The Cinema of Attractions," 64.

43. See Elliott, "Aesthetic Theory," 162–63.

44. In Elliott's words immersion may involve "only a part of a picture or a momentary sense of the real presence of the object represented" ("Aesthetic Theory," 163).

45. Elliott attributes this objectivist and strongly perception-centered, as distinct from imagination- and affect-centered, concept of aesthetic experience to the views of Monroe Beardsley, O. K. Bouwsma, George Dickie, and Joseph Margolis. See Elliott, "Aesthetic Theory," 154n.

46. Elliott, "Aesthetic Theory," 157.

7. CINEAESTHETIC WORLD-FEELING AND IMMERSION

1. Dufrenne's first major work was not available in English translation until some twenty years later.

2. Beardsley, quoted in Casey, foreword to Dufrenne, *Phenomenology*, xxi.

3. Kaelin, *An Existentialist Aesthetic*, 367.

4. Dufrenne, *Phenomenology*, 16. Casey points out in his introduction to the English translation that while *sensuous* is often synonymous with *perceptual* in Dufrenne's arguments, it also has a more distinct philosophical meaning via Kant's distinction between it and "understanding" (Casey, introduction, xlviii, note 3).

5. Dufrenne, *Phenomenology*, 148.

6. Goldman, "The Aesthetic," 266.

7. Dufrenne, *Phenomenology*, 185.

8. Ibid., 195.

9. Ibid., 174–75.

10. On this point see Deleuze, *Cinema 2*, 267.

11. Dufrenne, *Phenomenology*, 242–43, 185–90, 178.

12. Mitry, *Aesthetics*, 126.

13. Sinnerbrink also suggests that this mood is unique to every "cinematic world" ("Stimmung," 148).

14. See Plantinga, "Art Moods."

15. Cassirer, *An Essay on Man*, 150.

16. Dufrenne describes the world-feeling of the aesthetic object as being like a "supervening or impersonal principle" (*Phenomenology*, 168). In the relevant philosophical sense, "A set of properties A supervenes upon another set B just in case no two things can differ with respect to A-properties without also differing with

respect to their *B*-properties. In slogan form, 'there cannot be an *A*-difference without a *B*-difference'" (McLaughlin and Bennett, "Supervenience").

17. Dufrenne, *Phenomenology*, 168.

18. Beugnet, *Claire Denis*, 164–66.

19. Dufrenne, *Phenomenology*, 328.

20. Beugnet discusses each of these aspects of the film (see *Claire Denis*, 164–84).

21. See Dufrenne, *Phenomenology*, 328–29.

22. Mitry, *Aesthetics*, 126.

23. Although sometimes attributed to earlier philosophers, this formulation belongs to the twelfth-century theologian Alan of Lille.

24. Ibid., 16. Mitry makes this point in critiquing Croce's expression theory of art.

25. Dufrenne, *Phenomenology*, 182–85.

26. What I term *actual* time is equivalent to what Bordwell and Thompson call "screen duration," whereas *represented* time is compatible, in some respects, with their categories of "story duration" and "plot duration," both of the latter being equally a matter of what a film denotes (*Film Art*, 97–99). However, Bordwell and Thompson's schema has no equivalent for felt or *expressed* time as here described, nor is this part of Gaut's similar classification of time in cinema in his *Philosophy of Cinematic Art*.

27. See Sherover, *Human Experience of Time*.

28. Dufrenne, *Phenomenology*, 187.

29. Ibid., 184.

30. Mitry, *Aesthetics*, 125.

31. Ibid., 271 (see also 104).

32. Dufrenne, *Phenomenology*, 256, 258.

33. Burch, *Theory of Film Practice*, 67.

34. Merleau-Ponty, *The World of Perception*, 73; Merleau-Ponty, *Sense and Non-sense*, 57; and Mitry, *Aesthetics*, 90.

35. Tarkovsky, *Sculpting in Time*, 117.

36. Ibid., 121.

37. See Deleuze, *Cinema 2*, 42, 189–204.

38. See ibid., 42.

39. Eisenstein, "A Dialectical Approach," 109.

40. Ibid., 106.

41. Eisenstein, "Montage of Film Attractions," 54.

42. Cassirer, *An Essay on Man*, 149.

43. Godard, quoted in Oumano, *Film Forum*, 78.

44. Ibid., 174.

45. Tarkovsky, *Sculpting in Time*, 114, 120–21.

46. Dufrenne, *Phenomenology*, 282.

47. Tarkovsky, *Sculpting in Time*, 120.

48. Dufrenne, *Phenomenology*, 247.

49. Panofsky, "Style and Medium," 354.

50. See Morin, *The Cinema*, 63–64.

51. Dufrenne, *Phenomenology*, 243.

52. Ibid., 273.

53. For more on the reasons for this see ibid., 242–48.

54. Both Sobchack and Barker cite Dufrenne's concept of the work as "quasi sub-ject" in support of the notion that films are "embodied" entities (see Sobchack, *Address of the Eye*, 142; and Barker, *The Tactile Eye*, 11–12, 18, 148–49, 160). How-ever Sobchack, and to a lesser degree, Barker, problematically implies that Dufrenne's view is simply of a piece with Merleau-Ponty's phenomenology of visual perception as applied to art. This is, however, to divorce Dufrenne's arguments from their Kantian conceptual roots and to significantly underrep-resent their crucial *temporal* as well as spatial (i.e., visual) dynamics (the former being the subject of comparatively less attention on Merleau-Ponty's part).

55. Dufrenne, *Phenomenology*, 413. His suggestion here is made with reference to Kant's insight that time-consciousness entails the self being "affected by the self."

56. Ibid., 177, 413–14, 447–56.

57. See ibid., 450–56. Dufrenne argues that "the creator appears immanent in the work" owing to a "state of expression" that "can be related equally well to the work or to the creator" (222).

58. Ibid., 188–90.

59. Mitry, *Aesthetics*, 83.

60. Carroll, *Engaging the Moving Image*, 131.

61. Sarris, "Notes on the Auteur Theory," 562–63.

62. Ibid.

63. Bordwell, "Sarris and the Search for Style," 172.

64. Tarkovsky, *Sculpting in Time*, 121.

65. Sarris, "Notes on the Auteur Theory," 563.

66. In his *Signs and Meaning in the Cinema* Wollen associates a "Ford" or "Hitch-cock" world, for instance, with sets of systematic oppositions on the level of a film's latent thematic content as these are uncovered by theorists (94).

67. Bordwell, "Sarris and the Search for Style," 171.

68. Sircello, *Mind and Art*, 29.

69. Lamarque, *Philosophy of Literature*, 103.

70. See Livingston, "Cinematic Authorship"; see also Gaut, *Philosophy of Cinematic Art*, where Livingston's views are discussed in detail (118–24).

71. Mitry, *Aesthetics*, 10.

72. Gadamer also makes this point (see *Truth and Method*, 292).

73. Merleau-Ponty, *Sense and Non-sense*, 20.

74. Bazin, "On the politique des auteurs," 257; see also Wollen, *Signs and Meaning*, 53.

75. Chion, *Kubrick's Cinematic Odyssey*, 41.

76. Dufrenne writes that "to talk of the comic in Molière is thus to specify a singular world by giving it a name and contrasting it with other worlds which do not possess a precisely similar atmosphere" (*Phenomenology*, 450).

77. See ibid., 441–50.

78. Dufrenne acknowledges this copresence and interdependence of feeling and reflection (see ibid., 424).

79. Mitry, *Aesthetics*, 184, 28.

80. Elliott, "Aesthetic Theory," 158.

8. TOWARD AN EXISTENTIAL HERMENEUTICS OF FILM WORLDS

1. Currie, *Image and Mind*, 20.

2. Gadamer, *Truth and Method*, 295.

3. This is certainly true in comparison with other major movements and traditions in twentieth-century continental philosophy—e.g., semiotics and structuralism, existential phenomenology, and Bergson's life-philosophy.

4. For this reason (as well as its indebtedness to Heidegger's brand of existential phenomenology) Gadamer's hermeneutics and (that of subsequent philosophers building on it) may also be considered "existential" in orientation.

5. Gadamer, *Truth and Method*, 297.

6. Mitry, *Aesthetics*, 366 (my emphasis).

7. Hofstadter, *Truth and Art*, 23–36.

8. Gadamer, *Truth and Method*, 116 (subsequent references to this source are cited parenthetically in the text as *TM*).

9. See Cavell, *The World Viewed*, 28–29.

10. Gadamer, *Truth and Method*, 293. Thus the interpretation and understanding of a work is less a "subjective act" than a participation "in an event of tradition."

11. Margolis, *What, After All, Is a Work of Art?* 42.

12. See Taylor, *Philosophical Arguments*, 101–11. This is a selfhood that, as Cassirer also maintains, is very largely symbolically constructed out of historical materials at hand.

13. Linge, introduction to Gadamer's *Philosophical Hermeneutics*, xix.

14. Ibid., xii.

15. Gadamer, *Truth and Method*, 291. As Gadamer reflects, the "circle" itself is everexpanding, since "the concept of the whole is relative, and being integrated in ever larger contexts affects the understanding of the individual parts" (190).

16. See Gadamer, *Philosophical Hermeneutics*, 102.

17. Collinson, "Aesthetic Experience," 174–75.

18. Andrew, *Concepts in Film Theory*, 182.

19. Bordwell, *Narration in the Fiction Film*, 30. In Bordwell's film narratology the processes of narrative construction and comprehension belong to "viewing" in this sense.

20. See Bordwell, *Making Meaning*.

21. Andrew, *Concepts in Film Theory*, 182.

22. Goodman and Elgin, *Reconceptions in Philosophy*, 12.

23. Truffaut, "What Do Critics Dream About?" 6.

24. Clearly neither metaphorical nor noncognitive, "truth" as here conceived is not a matter of certain sorts of propositions or a logical "operator" on empirical facts.

25. Sartre, quoted in Dunne, *Tarkovsky*, 38–39.

26. As in Bazin's realism, such an automatically generated view or projection of the real world, as associated with cinema, is at the heart of Cavell's realist ontology of film (see Cavell, *The World Viewed*).

27. Heidegger, "Origin of the Work," 39, 71.

28. See ibid., 51–63.

29. See also Gadamer, *Philosophical Hermeneutics*, 224.

30. See Cassirer, *An Essay on Man*, 138–39.

31. See Bordwell, *Narration in the Fiction Film*, 32–33, 39; and Thompson, *Breaking the Glass Armor*.

32. Gadamer, *Philosophical Hermeneutics*, 15.

33. Goodman, *Languages of Art*, 260; on "projectibility" and "rightness" see Goodman and Elgin, *Reconceptions in Philosophy*, 22.

34. As Goodman puts the matter in more general terms, "not only do we discover the world through our symbols but we understand and reappraise our symbols progressively in the light of our growing experience" (*Languages of Art*, 260).

35. Heidegger, "Origin of the Work," 67.

36. See Greenberg, "The Avant-Garde and Kitsch," 9; see also Danto, "Moving Pictures."

37. See Kant, *Critique of the Power of Judgment*, 186–89.

38. This idea is tied to Goodman's view that "both the dynamics and the durability of aesthetic value are natural consequences of its cognitive character" (*Languages of Art*, 260).

39. Goodman, *Ways of Worldmaking*, 21.

40. Mitry, *Aesthetics*, 338.

41. Burch, *Theory of Film Practice*, 166.

42. Ibid., 141–42.

43. Margolis, *What, After All, Is a Work of Art?* 136.

44. See Schaeffer, *Art of the Modern Age*, 307.

45. *Le monde enchanté de Jacques Demy*, 52.

Abrams, M. H. "From Addison to Kant: Modern Aesthetics and the Exemplary Art." In *Doing Things with Texts*, edited by Michael Fischer, 159–87. New York: Norton, 1989.

Allen, Richard. "Looking at Motion Pictures (Revised)." *Film-Philosophy* 5, no. 25 (2001): www.film-philosophy.com/index.php/f-p/article/view/646/559.

Allen, Richard, and Murray Smith, eds. *Film Theory and Philosophy*. Oxford: Oxford University Press, 1997.

Altman, Rick. "A Semantic/Syntactic Approach to Film Genre." *Cinema Journal* 23, no. 3 (1984): 6–18.

Anderson, James C. "Aesthetic Concepts of Art." In *Theories of Art Today*, edited by Noël Carroll, 65–92. Madison: University of Wisconsin Press, 2000.

Andrew, Dudley. *Concepts in Film Theory*. Oxford: Oxford University Press, 1984.

——. *The Major Film Theories: An Introduction*. Oxford: Oxford University Press, 1976.

——. "The Unauthorized Auteur Today." In *Film Theory: An Anthology*, edited by Robert Stam and Toby Miller, 20–28. Oxford: Blackwell, 2000.

Arrell, Douglas. "Exemplification Reconsidered." *British Journal of Aesthetics* 30, no. 3 (1990): 233–43.

Bakhtin, M. M. *The Dialogical Imagination: Four Essays*. Edited by Michael Holquist. Translated by Caryl Emerson and Michael Holquist. Austin: University of Texas Press, 1981.

Barker, Jennifer. *The Tactile Eye: Touch and Cinematic Experience*. Berkeley: University of California Press, 2009.

Barthes, Roland. "An Introduction to the Structural Analysis of Narrative." *New Literary History* 6, no.2 (1975): 237–72.

Bazin, André. "On the politique des auteurs." In *Cahiers du cinéma, the 1950s: Neorealism, Hollywood, New Wave*, edited by Jim Hiller, 248–59. Cambridge, MA: Harvard University Press, 1985.

——. *Orson Welles: A Critical View*. Los Angeles: Acrobat, 1991.

——. *What Is Cinema?* Translated by Hugh Gray. 2 vols. Berkeley: University of California Press, 1967–71.

Beardsley, Monroe C. "*Languages of Art* and Art Criticism." *Erkenntnis* 12, no. 1 (1978): 95–118.

Beugnet, Martine. *Claire Denis*. Manchester: Manchester University Press, 2004.

Billard, Pierre. "An Interview with Michelangelo Antonioni." In *Blow-Up; a Film*, 5–10. London: Lorrimer, 1971.

Biro, Yvette. *Turbulence and Flow in Film: The Rhythmic Design*. Bloomington: Indiana University Press, 2008.

Bloom, Paul, and Deena Skolnick. "The Intuitive Cosmology of Fictional Worlds." In *The Architecture of the Imagination: New Essays on Pretence, Possibility, and Fiction*, edited by Shaun Nichols, 73–88. Oxford: Oxford University Press, 2006.

Bonitzer, Pascal. "Deframings." In *"Cahiers du cinéma." Volume Four, 1973–1978: History, Ideology, Cultural Struggle*, edited by David Wilson, 197–204. London: Routledge, 2000.

Bordwell, David. "Contemporary Film Studies and the Vicissitudes of Grand Theory." In Bordwell and Carroll, *Post-Theory*, 3–37.

——. *Making Meaning: Inference and Rhetoric in the Interpretation of Cinema*. Cambridge, MA: Harvard University Press, 1991.

——. *Narration in the Fiction Film*. Madison: University of Wisconsin Press, 1985.

——. "Sarris and the Search for Style." In *Citizen Sarris, American Film Critic: Essays in Honor of Andrew Sarris*, edited by Emanuel Levy, 165–73. Lanham, MD: Scarecrow, 2001.

——. *The Way Hollywood Tells It*: Story and Style in Modern Movies. Berkeley: University of California Press, 2006.

Bordwell, David, and Noël Carroll, eds. *Post-Theory: Reconstructing Film Studies*. Madison: University of Wisconsin Press, 1996.

Bordwell, David, Janet Staiger, and Kristin Thompson. *Classical Hollywood Cinema: Film Style and Mode of Production to 1960*. New York: Columbia University Press, 1985.

Bordwell, David, and Kristin Thompson. *Film Art: An Introduction*. 5th ed. New York: McGraw-Hill, 1997.

——. *Minding Movies. Observations on the Art, Craft, and Business of Filmmaking.* Chicago: University of Chicago Press, 2011.

Branigan, Edward F. *Narrative Comprehension and Film.* London: Routledge, 1992.

Bresson, Robert. *Notes on the Cinematographer.* Translated by Jonathan Griffin. Copenhagen: Green Integer, 1997.

Brody, Richard. *Everything Is Cinema: The Working Life of Jean-Luc Godard.* London: Faber and Faber, 2008.

Brooke, Michael. "Robert Bresson: Alias Grace." *Sight and Sound* 17, no. 11 (2007): 26.

Brown, Robert. "Greenaway's Contract." In *Peter Greenaway: Interviews,* edited by Vernon Gras and Marguerite Gras, 6–12. Jackson: University Press of Mississippi, 2000.

Buckland, Warren. *The Cognitive Semiotics of Film.* Cambridge: Cambridge University Press, 2000.

Burch, Noël. *Life to Those Shadows.* Translated and edited by Ben Brewster. Berkeley: University of California Press, 1990.

——. *Theory of Film Practice.* Translated by Helen R. Lane. New York: Praeger, 1973.

——. *To the Distant Observer: Form and Meaning in Japanese Cinema.* Berkeley: University of California Press, 1992.

Burgoyne, Robert, Sandy Flitterman-Lewis, and Robert Stam. *New Vocabularies in Film Semiotics: Structuralism, Post-Structuralism, and Beyond.* London: Routledge, 1992.

Carroll, Noël. *Engaging the Moving Image.* New Haven, CT: Yale University Press, 2003.

——. *Philosophy of Art: A Contemporary Introduction.* New York: Routledge, 1999.

——. *A Philosophy of Mass Art.* Oxford: Clarendon, 1998.

——. *The Philosophy of Motion Pictures.* Oxford: Blackwell, 2008.

——. *Philosophical Problems of Classical Film Theory.* Princeton, NJ: Princeton University Press, 1988.

——. "Prospects for Film Theory." In Bordwell and Carroll, *Post-Theory,* 37–68.

——. *Theorizing the Moving Image.* Cambridge: Cambridge University Press, 1996.

Carroll, Noël, and Jinhee Choi, eds. *Philosophy of Film and Motion Pictures: An Anthology.* Oxford: Blackwell, 2006.

Casey, Edward S. Foreword to *The Phenomenology of Aesthetic Experience,* by Mikel Dufrenne. Translated by Edward S. Casey, xv–xlii. Evanston, IL: Northwestern University Press, 1973.

Cassirer, Ernst. *An Essay on Man: An Introduction to a Philosophy of Human Culture.* New Haven, CT: Yale University Press, 1944.

——. *Language and Myth.* Translated by Susanne K. Langer. New York: Dover, 1946.

———. *The Philosophy of Symbolic Forms*. Translated by Ralph Manheim. 4 vols. New Haven, CT: Yale University Press, 1953–96.

Cavell, Stanley. *The World Viewed: Reflections on the Ontology of Film*. New York: Viking, 1971.

Cecchi, Alessandro. "Diegetic versus Nondiegetic: A Recognition of the Conceptual Opposition as a Contribution to the Theory of Audiovision." *Worlds of Audiovision* (2010): www.worldsofaudiovision.org.

Chatman, Seymour. *Coming to Terms: The Rhetoric of Narrative in Fiction and Film*. Ithaca, NY: Cornell University Press, 1990.

Chion, Michel. *Kubrick's Cinema Odyssey*. Translated by Claudia Gorbman. London: BFI, 2001.

Collingwood, R. G. *The Principles of Art*. London: Oxford University Press, 1958.

Collinson, Diané. "Aesthetic Experience." In *Philosophical Aesthetics: An Introduction*, edited by Oswald Hanfling, 111–78. Oxford: Blackwell, 1992.

Constantini, Constanzo, ed. *Conversations with Fellini*. New York: Harvest, 1995.

Croce, Benedetto. *The Essence of Aesthetic*. Translated by Douglas Ainslie. London: Heinemann, 1921.

Currie, Gregory. *Image and Mind: Film, Philosophy, and Cognitive Science*. Cambridge: Cambridge University Press, 2008.

———. "The Long Goodbye: The Imaginary Language of Film." In Carroll and Choi, *Philosophy of Film and Motion Pictures*, 91–99.

Danto, Arthur C. "Moving Pictures." In Carroll and Choi, *Philosophy of Film and Motion Pictures*, 100–12.

Deleuze, Gilles. *Cinema 1: The Movement-Image*. Translated by Hugh Tomlinson and Barbara Habberjam. Minneapolis: University of Minnesota Press, 1986.

———. *Cinema 2: The Time-Image*. Translated by Hugh Tomlinson and Robert Galeta. Minneapolis: University of Minnesota Press, 1989.

Dickie, George. *Aesthetics: An Introduction*. New York: Bobbs-Merrill, 1971.

Dufrenne, Mikel. *The Phenomenology of Aesthetic Experience*. Translated by Edward S. Casey. Evanston, IL: Northwestern University Press, 1973.

Dunne, Nathan, ed. *Tarkovsky*. London: Black Dog, 2008.

Dupré, Louis. "Cassirer's Symbolic Theory of Culture and the Historicization of Philosophy." In *Symbolic Forms and Cultural Studies: Ernst Cassirer's Theory of Culture*, edited by Cyrus Hamlin and John Michael Krois, 35–49. New Haven, CT: Yale University Press, 2004.

Dyer, Richard. "Introduction to Film Studies." In *Film Studies: Critical Approaches*, edited by John Hill and Pamela Church Gibson, 3–10. Oxford: Oxford University Press, 2000.

Ebert, Roger. "Review of *El Topo*." RogerEbert.com. Oct. 6, 2007. www.rogerebert.com/reviews/great-movie-el-topo-1970.

Eisenstein, Sergei. "A Dialectical Approach to Film Form." In *Film Theory and Criticism*, 3rd ed., edited by Marshall Cohen and Gerald Mast, 103–24. Oxford: Oxford University Press, 1985.

———. *Film Form [and] The Film Sense: Two Complete and Unabridged Works.* Edited and translated by Jay Leyda. New York: Meridian, 1957.

———. "The Montage of Film Attractions." In *S. M. Eisenstein: Selected Works.* Edited and translated by Richard Taylor. Vol. 1, *Writings, 1922–1934*, 39–58. London: BFI, 1988.

Elgin, Catherine Z. "Reorienting Aesthetics, Reconceiving Cognition." *Journal of Aesthetics and Art Criticism* 58, no. 3 (2000): 219–25.

Elliott, R. K. "Aesthetic Theory and the Experience of Art." In *The Philosophy of Art: Readings Ancient and Modern*, edited by Alex Neill and Aaron Ridley, 153–64. New York: McGraw-Hill, 1995.

Ellis, John M. *Language, Thought, and Logic.* Evanston, IL: Northwestern University Press, 1993.

Elster, Jon. *Alchemies of the Mind: Rationality and the Emotions.* Cambridge: Cambridge University Press, 1999.

Files, Craig. "Goodman's Rejection of Resemblance." *British Journal of Aesthetics* 36, no. 4 (1996): 398–412.

Frampton, Daniel. *Filmosophy.* London: Wallflower, 2006.

Friedman, Michael. *A Parting of the Ways: Carnap, Cassirer, and Heidegger.* Peru, IL: Open Court, 2000.

Gadamer, Hans-Georg. *Philosophical Hermeneutics.* Edited and translated by David E. Linge. Berkeley: University of California Press, 1976.

———. *Truth and Method.* Translated by Joel Weinsheimer and Donald G. Marshall. 2nd ed. New York: Continuum, 1989.

Gaut, Berys. *A Philosophy of Cinematic Art.* Cambridge: Cambridge University Press, 2010.

Gaut, Berys, and Dominic McIver Lopes, eds. *The Routledge Companion to Aesthetics.* 2nd ed. New York: Routledge, 2005.

Godard, Jean-Luc. *Godard on Godard.* Edited and translated by Tom Milne and Jean Narboni. New York: Da Capo, 1986.

Goldman, Alan. "The Aesthetic." In Gaut and Lopes, *The Routledge Companion to Aesthetics*, 255–66.

Goodman, Nelson. *Languages of Art: An Approach to a Theory of Symbols.* 2nd ed. Indianapolis, IN: Hackett, 1976.

———. *Of Mind and Other Matters.* Cambridge, MA: Harvard University Press, 1984.

———. *Ways of Worldmaking.* Indianapolis, IN: Hackett, 1978.

Goodman, Nelson, and Catherine Z. Elgin. *Reconceptions in Philosophy and Other Arts and Sciences.* Indianapolis, IN: Hackett, 1988.

Gracyk, Theodore. *The Philosophy of Art: An Introduction.* Cambridge: Polity, 2012.

Greenberg, Clement. "The Avant-Garde and Kitsch." In *The Collected Essays and Criticism*. Vol. 1, *Perceptions and Judgments, 1939–1944*, edited by John O'Brian, 5–23. Chicago: University of Chicago Press, 1986.

Greene, Naomi. *Pier Paolo Pasolini: Cinema as Heresy*. Princeton, NJ: Princeton University Press, 1990.

Greene, Roland, Stephen Cushman, Clare Cavanagh, Jahan Ramazani, and Paul Rouzer, eds. *The Princeton Encyclopedia of Poetry and Poetics*. 4th ed. Princeton, NJ: Princeton University Press, 2012.

Gunning, Tom. "The Cinema of Attractions: Early Film, Its Spectators, and the Avant-Garde." *Wide Angle* 8, no. 3–4 (1986): 63–70.

Hamlin, Cyrus, and John Michael Krois, eds. *Symbolic Forms and Cultural Studies: Ernst Cassirer's Theory of Culture*. New Haven, CT: Yale University Press, 2004.

Harman, Gilbert. "Semiotics and the Cinema: Metz and Wollen." In *Film Theory and Criticism*, 5th ed., edited by Leo Braudy and Marshall Cohen, 90–98. Oxford: Oxford University Press, 2004.

Heidegger, Martin. "The Origin of the Work of Art." In *Poetry, Language, Thought*. Translated by Albert Hofstadter, 17–87. New York: Harper and Row, 1971.

Herman, David. *Story Logic: Problems and Possibilities of Narrative*. Lincoln: University of Nebraska Press, 2002.

Hoberman, J. "*Psycho* Is 50: Remembering Its Impact, and the Andrew Sarris Review." *Village Voice* Blogs, http://blogs.villagevoice.com/runninscared/2010/06/psycho.php.

Hofstadter, Albert. *Truth and Art*. New York: Columbia University Press, 1965.

Holmes, Diana, and Robert Ingram. *François Truffaut*. Manchester: Manchester University Press, 1998.

Jameson, Fredric. *Postmodernism, or, The Cultural Logic of Late Capitalism*. London: Verso, 1993.

Kaelin, Eugene. *An Existentialist Aesthetic: The Theories of Sartre and Merleau-Ponty*. Madison: University of Wisconsin Press, 1962.

Kant, Immanuel. *Critique of the Power of Judgment*. Edited by Paul Guyer. Translated by Paul Guyer and Eric Matthews. Cambridge: Cambridge University Press, 2001.

Kawin, Bruce F. *Mindscreen: Bergman, Godard, and First-Person Film*. Princeton, NJ: Princeton University Press, 1978.

Kovács, András Bálint. *The Cinema of Béla Tarr: The Circle Closes (Directors' Cuts)*. New York: Wallflower, 2013.

——. *Screening Modernism: European Art Cinema, 1950–1980*. Chicago: University of Chicago Press, 2007.

Kracauer, Siegfried. *Theory of Film: The Redemption of Physical Reality*. Princeton, NJ: Princeton University Press, 1997.

Kristeva, Julia. *Desire in Language: A Semiotic Approach to Literature and Art*. Edited by Leon S. Roudiez. New York: Columbia University Press, 1980.

Krois, John Michael. *Cassirer: Symbolic Forms and History*. New Haven, CT: Yale University Press, 1987.

Lamarque, Peter. *The Philosophy of Literature*. Oxford: Blackwell, 2009.

Lamarque, Peter, and Stein Haugom Olsen. *Truth, Fiction, and Literature*. Oxford: Clarendon, 1994.

Langer, Susanne K. *Feeling and Form*. New York: Scribner, 1953.

——. *Philosophy in a New Key*. Cambridge, MA: Harvard University Press, 1942.

——. *Problems of Art*. New York: Scribner, 1957.

Le monde enchanté de Jacques Demy. Edited by Matthieu Orléan. Exhibition catalog. Paris: La cinémathèque française/Flammarion, 2013.

Lewis, Brian. *Jean Mitry and the Aesthetics of Cinema*. Ann Arbor, MI: UMI Research Press, 1984.

Linge, David E. Introduction to Gadamer, *Philosophical Hermeneutics*, xi–lviii.

Livingston, Paisley. *Art and Intention*. Oxford: Clarendon, 2005.

——. "Cinematic Authorship." In Allen and Smith, *Film Theory and Philosophy*, 132–48.

Lopes, Dominic McIver. "From *Languages of Art* to Art in Mind." *Journal of Aesthetics and Art Criticism* 58, no. 3 (2000): 227–31.

——. *Understanding Pictures*. Oxford: Clarendon, 1996.

Lynch, David. "Action and Reaction." In *Soundscapes: The School of Sound Lectures, 1998–2001*, edited by Larry Sider, Diane Freeman, and Terry Sider, 49–53. London: Wallflower, 2003.

MacCabe, Colin. "Realism and the Cinema: Notes on Some Brechtian Theses." *Screen* 15, no. 2 (1974): 7–27.

Marchant, Steven. "Nothing Counts: Shot and Event in *Werckmeister Harmonies*." *New Cinemas* 7, no. 2 (2009): 137–54.

Margolis, Joseph. "Art as Language." *Monist* 58, no. 2 (1974): 175–86.

——. *The Cultural Space of the Arts and the Infelicities of Reductionism*. New York: Columbia University Press, 2010.

——. "The Deviant Ontology of Artworks." In *Theories of Art Today*, edited by Noël Carroll, 109–27. Madison: University of Wisconsin Press, 2000.

——. *What, After All, Is a Work of Art?* University Park: Pennsylvania State University Press, 1999.

Marks, Laura U. *The Skin of the Film: Intercultural Cinema, Embodiment, and the Senses*. Durham, NC: Duke University Press, 2000.

Massumi, Brian. "The Autonomy of Affect." In "The Politics of Systems and Environments, Part II," edited by William Rasch and Cary Wolfe. Special issue, *Cultural Critique* 31 (Fall 1995): 83–109.

——. *Parables for the Virtual: Movement, Affect, Sensation*. Durham, NC: Duke University Press, 2002.

Mast, Gerald. "What Isn't Cinema?" *Critical Inquiry* 1, no. 2 (1974): 373–93.

McBride, Joseph. *Orson Welles*. New York: Da Capo, 1996.

McKay, Thomas, and Michael Nelson. "Propositional Attitude Reports." In *The Stanford Encyclopedia of Philosophy (Winter 2010 Edition)*, edited by Edward N. Zalta, http://plato.stanford.edu/archives/win2010/entries/prop-attitude-reports/.

McLaughlin, Brian, and Karen Bennett. "Supervenience." *Stanford Encyclopedia of Philosophy*, edited by Edward N. Zalta. http://plato.stanford.edu/entries/supervenience/.

Merleau-Ponty, Maurice. *Sense and Non-sense*. Translated by Hubert L. Dreyfus and Patricia Allen Dreyfus. Evanston, IL: Northwestern University Press, 1964.

——. *The World of Perception*. Translated by Oliver Davis. London: Routledge, 2004.

Meskin, Aaron. "Style." In Gaut and Lopes, *The Routledge Companion to Aesthetics*, 489–500.

Metz, Christian. *Film Language: A Semiotics of Cinema*. Translated by Michael Taylor. Chicago: University of Chicago Press, 1974.

Mitry, Jean. *The Aesthetics and Psychology of Cinema*. Edited by Benoît Patar. Translated by Christopher King. Bloomington: Indiana University Press, 1997.

——. *Semiotics and the Analysis of Film*. Translated by Christopher King. Bloomington: Indiana University Press, 2000.

Monaco, James. *The New Wave: Truffaut, Godard, Chabrol, Rohmer, Rivette*. Oxford: Oxford University Press, 1976.

Morin, Edgar. *The Cinema, or, The Imaginary Man*. Translated by Lorraine Mortimer. Minneapolis: University of Minnesota Press, 2005.

Orr, John. *Contemporary Cinema*. Edinburgh: Edinburgh University Press, 1998.

Oumano, Ellen. *Film Forum: Thirty-Five Top Filmmakers Discuss Their Craft*. New York: St. Martin's, 1985.

Panofsky, Erwin. *Meaning in the Visual Arts*. Garden City, NY: Doubleday, 1955.

——. "Style and Medium in the Motion Pictures." In *Aesthetics: A Critical Anthology*, edited by George Dickie and R. J. Sclafani, 351–65. New York: St. Martin's, 1977.

Pascoe, David. *Peter Greenaway: Museums and Moving Images*. London: Reaktion, 1997.

Pasolini, Pier Paolo. "The 'Cinema of Poetry.'" In *Heretical Empiricism*, edited by Louise K. Barnett, translated by Ben Lawton and Louise K. Barnett, 167–86. Bloomington: Indiana University Press, 1988.

Perkins, Victor F. *Film as Film: Understanding and Judging Movies*. New York: Penguin, 1972.

——. "Where Is the World? The Horizon of Events in Movie Fiction." In *Style and Meaning: Studies in the Detailed Analysis of Film*, edited by John Gibbs and Douglas Pye, 16–41. Manchester: Manchester University Press, 2005.

Plantinga, Carl. "Art Moods and Human Moods in Narrative Cinema." *New Literary History* 43, no. 3 (2012): 455–75.

——. *Moving Viewers: American Film and the Spectator's Experience*. Berkeley: University of California Press, 2009.

——. "Notes on Spectator Emotion and Ideological Film Criticism." In Allen and Smith, *Film Theory and Philosophy*, 372–94.

Plantinga, Carl, and Greg M. Smith, eds. *Passionate Views: Film, Cognition, and Emotion*. Baltimore: Johns Hopkins University Press, 1999.

Prinz, Jesse I. *Gut Reactions: A Perceptual Theory of Emotion*. Oxford: Oxford University Press, 2004.

Proust, Marcel. *In Search of Lost Time*. 7 vols. Translated by Andreas Mayor and Terence Kilmartin. London: Vintage, 2000.

Pudovkin, V. I. *Film Technique and Film Acting*. Edited and translated by Ivor Montagu. London: Vision, 1968.

Ricœur, Paul. "*Ways of Worldmaking* (Nelson Goodman)." *Philosophy and Literature* 4, no. 1 (1980): 107–20.

Robinson, Jenefer. *Deeper Than Reason: Emotion and Its Role in Literature, Music, and Art*. Oxford: Oxford University Press, 2005.

——. "Goodman." In Gaut and Lopes, *The Routledge Companion to Aesthetics*, 185–97.

——. "Style and Personality in the Literary Work." *Philosophical Review* 94, no. 2 (1985): 227–47.

Rockmore, Tom. *In Kant's Wake: Philosophy in the Twentieth Century*. Oxford: Blackwell, 2006.

Rodowick, David N. *The Virtual Life of Film*. Cambridge, MA: Harvard University Press, 2007.

Ryan, Marie-Laure. *Narrative as Virtual Reality*. Baltimore: Johns Hopkins University Press, 2001.

Sarris, Andrew. "Notes on the Auteur Theory in 1962." In *Film Theory and Criticism*, 6th ed., edited by Leo Braudy and Marshall Cohen, 561–64. Oxford: Oxford University Press, 2004.

Schaeffer, Jean-Marie. *Art of the Modern Age: Philosophy of Art from Kant to Heidegger*. Translated by Steven Rendall. Princeton, NJ: Princeton University Press, 2000.

Schutz, Alfred. "On Multiple Realities." In *Collected Papers*, edited by Maurice Natanson, 207–59. The Hague: Martinus-Nijhoff, 1971.

Sebeok, Thomas A. *Signs: An Introduction to Semiotics*. 2nd ed. Toronto: University of Toronto Press, 2001.

Shaviro, Steven. *The Cinematic Body*. Minneapolis: University of Minnesota Press, 2011.

Sherover, Charles M., ed. *The Human Experience of Time: The Development of Its Philosophic Meaning*. Evanston, IL: Northwestern University Press, 2001.

Sircello, Guy. *Mind and Art: An Essay on the Varieties of Expression*. Princeton, NJ: Princeton University Press, 1972.

Sinnerbrink, Robert. "Stimmung: Exploring the Aesthetics of Mood." *Screen* 53, no. 2 (2012): 148–63.

Smith, Murray. *Engaging Characters: Fiction, Emotion and the Cinema*. Oxford: Clarendon, 1995.

——. "Film." In Gaut and Lopes, *The Routledge Companion to Aesthetics*, 597–609.

——. "Imagining from the Inside." In Allen and Smith, *Film Theory and Philosophy*, 412–31.

Sobchack, Vivian. *The Address of the Eye: A Phenomenology of Film Experience*. Princeton, NJ: Princeton University Press, 1992.

Sontag, Susan, "A Century of Cinema." In *Where the Stress Falls*, 117–22. London: Jonathan Cape, 2003.

Stam, Robert. *Reflexivity in Film and Literature: From Don Quixote to Jean-Luc Godard*. New York: Columbia University Press, 1992.

Stilwell, Robynn J. "The Fantastical Gap Between Diegetic and Nondiegetic." In *Beyond the Soundtrack: Representing Music in Cinema*, edited by Daniel Goldmark, Lawrence Kramer, and Richard Leppert, 184–202. Berkeley: University of California Press, 2007.

Tan, Ed S. *Emotion and the Structure of Narrative Film: Film as an Emotion Machine*. Mahwah, NJ: Erlbaum, 1996.

Tarkovsky, Andrey, *Sculpting in Time: Reflections on the Cinema*. Translated by Kitty Hunter-Blair. Austin: University of Texas Press, 1986.

Taylor, Charles. *Philosophical Arguments*. Cambridge, MA: Harvard University Press, 1995.

——. *A Secular Age*. Cambridge, MA: Harvard University Press, 2007.

Thompson, Kristin. *Breaking the Glass Armor: Neoformalist Film Analysis*. Princeton, NJ: Princeton University Press, 1988.

——. "The Concept of Cinematic Excess." In *Film Theory and Criticism*, 6th ed., edited by Leo Braudy and Marshall Cohen, 513–24. New York: Oxford University Press, 2004.

Tolkien, J. R. R. *Tolkien on Fairy-Stories*. Edited by Verlyn Flieger and Douglas A. Anderson. London: Harper Collins, 2008.

Truffaut, François. *Day for Night*. New York: Grove, 1975.

——. "What Do Critics Dream About?" In *The Films in My Life*. Translated by Leonard Mayhew, 3–20. New York: Da Capo, 1994.

Turvey, Malcolm. "Seeing Theory: On Perception and Emotional Response in Current Film Theory." In Allen and Smith, *Film Theory and Philosophy*, 431–58.

Underhill, James W. *Creating Worldviews: Metaphor, Ideology, Language*. Edinburgh: Edinburgh University Press, 2011.

Van Fraassen, Bas C. "Lecture 1: Against Analytic Metaphysics." In *The Empirical Stance*, 1–30. New Haven, CT: Yale University Press, 2002.

——. *Scientific Representation: Paradoxes of Perspective*. Oxford: Oxford University Press, 2008.

Verne, Donald Phillip. "Cassirer's Concept of a Philosophy of Human Culture." In *Symbolic Forms and Cultural Studies: Ernst Cassirer's Theory of Culture*, edited by Cyrus Hamlin and John Michael Krois, 19–28. New Haven, CT: Yale University Press, 2004.

Verstraten, Peter. *Film Narratology*. Translated by Stefan van der Lecq. Toronto: University of Toronto Press, 2009.

Viviani, Maurizio. *A Certain Realism*. Berkeley: University of California Press, 1993.

Walters, James. *Alternate Worlds in Hollywood Cinema: Resonance Between Realms*. Bristol, UK: Intellect Press, 2008.

Walton, Kendall L. "How Remote Are Fictional Worlds from the Real World?" *Journal of Aesthetics and Art Criticism* 37, no. 1 (1978): 11–23.

——. *Mimesis as Make-Believe: On the Foundation of the Representational Arts*. Cambridge, MA: Harvard University Press, 1990.

Whittock, Trevor. *Metaphor and Film*. Cambridge: Cambridge University Press, 1990.

Wilson, George. "Comments on *Mimesis as Make-Believe*." *Philosophy and Phenomenological Research* 51, no. 2 (1991): 395–400.

——. *Narration in Light: Studies in Cinematic Point of View*. Baltimore: Johns Hopkins University Press, 1988.

——. *Seeing Fictions in Films: The Epistemology of Movies*. Oxford: Oxford University Press, 2011.

Winters, Ben. "The Non-diegetic Fallacy: Film, Music, and Narrative Space." *Music and Letters* 91, no. 2 (2010): 224–44.

Wittgenstein, Ludwig. *Philosophical Investigations*. 3rd ed. Translated by G. E. M. Anscombe. New York: Macmillan, 1958.

——. *Tractatus Logico-Philosophicus*. New York: Harcourt, Brace, 1922.

Wolf, Mark J. P. *Building Imaginary Worlds: The Theory and History of Subcreation*. New York: Routledge, 2013.

Wollen, Peter. *Paris Hollywood: Writings on Film*. London: Verso, 2002.

——. *Signs and Meaning in the Cinema*. London: Secker and Warburg, 1969.

Wolterstorff, Nicholas. *Works and Worlds of Art*. Oxford: Oxford University Press, 1980.

Yacavone, Daniel. "Space, Theme, and Movement in Kieslowski's *Trois couleurs: Rouge*." *Studies in French Cinema* 6, no. 2 (2006): 83–94.

——. "Spaces, Gaps and Levels: From the Diegetic to the Aesthetic in Film Theory." *Music Sound and the Moving Image* 6, no. 1 (2012): 21–38.

——. "Towards a Theory of Film Worlds." *Film-Philosophy* 12, no. 2 (2008): 83–108.

Yates, Christopher S. "A Phenomenological Aesthetic of Cinematic 'Worlds.'" *Contemporary Aesthetics* 4 (2006): http://hdl.handle.net/2027/spo.7523862.0004.007.

INDEX

Initial articles in all languages (e.g., The, *L'*, *Un*) are ignored in sorting titles. Footnotes are indicated by an *n* preceding the note number.